the digital art
technique manual

for illustrators & artists

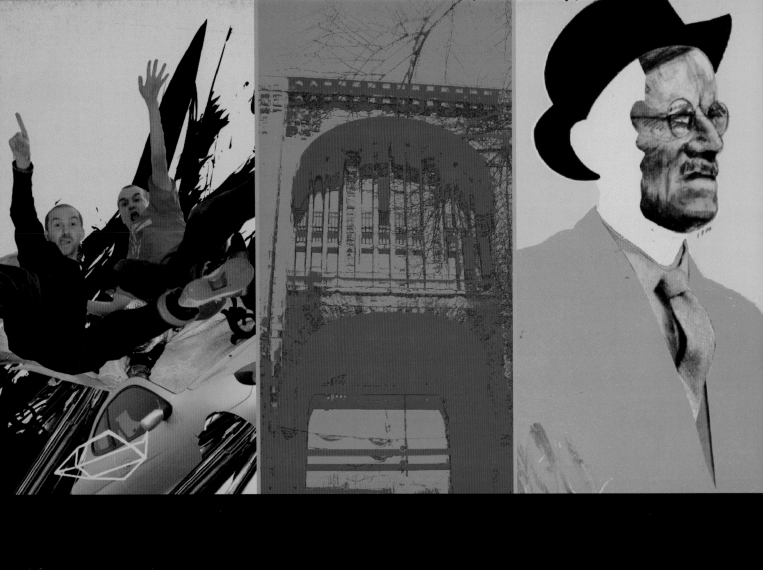

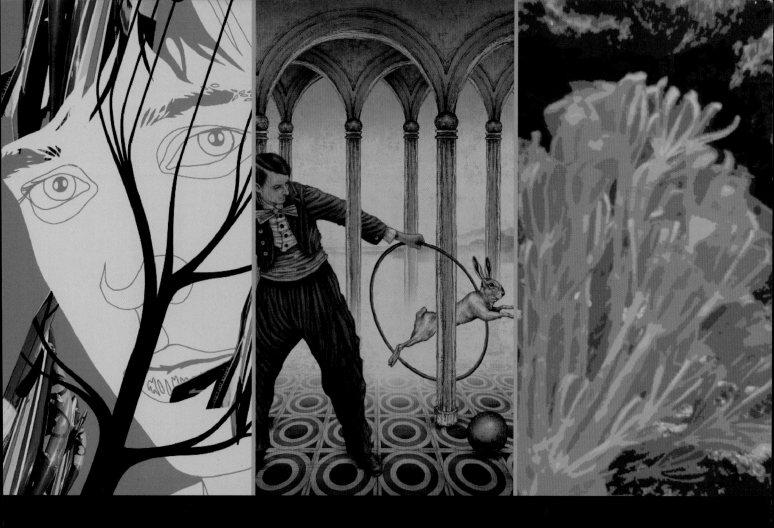

the digital art
technique manual

for illustrators & artists

The essential guide to creating digital illustration and
artworks using Photoshop, Illustrator, and other software

Joel Lardner and Paul Roberts

A QUARTO BOOK

Copyright © 2012 Quarto Publishing Inc.

First edition for North America
published in 2012 by
Barron's Educational Series, Inc.

All inquiries should be addressed to:
Barron's Educational Series, Inc.
250 Wireless Boulevard
Hauppauge, NY 11788
www.barronseduc.com

Library of Congress Control Number:
2011920142

ISBN: 978-0-7641-4790-6

Conceived, designed, and produced by
Quarto Publishing plc
The Old Brewery
6 Blundell Street
London N7 9BH

QUAR.DATM

Senior Editor: Ruth Patrick
Copyeditor: Steve Luck
Art Director: Caroline Guest
Designer: Tanya Devonshire-Jones
Illustrator: Kuo Kang Chen
Picture Researcher: Sarah Bell
Proofreader: Sally MacEachern
Indexer: Helen Snaith

Creative Director: Moira Clinch
Publisher: Paul Carslake

Color separation in Singapore by
Pica Digital Pte Ltd
Printed in Singapore by Star Standard
Industries (PTE) Ltd

9 8 7 6 5 4 3 2 1

contents

foreword 8

about this book 9

introduction 10

image gallery 12

part 1: **principles of digital illustration**

1. choosing software 22

2. introducing the interface: photoshop 24

3. introducing the interface: illustrator 26

4. all about hardware 28

part 2: **starting points**

5. art principles 32

6. sketches and roughs 38

7. developing a concept 40

8. using references 42

part 3: **image-making techniques**

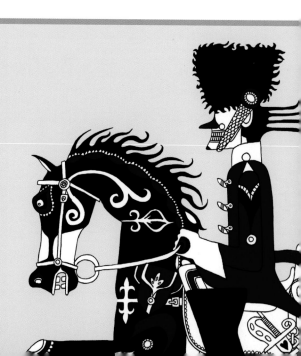

starting a new digital project 46

9. document formats 47

10. file types and output sizes 48

11. scanning a drawing 49

12. scanning unfamiliar objects 51

13. refining a scan 52

14. editing a scan 54

15. drag and drop 55

using layers 56

16. adding fill color 57

17. creating transparency 58

18. blending modes 59

19. using layer masks 62

vector art — 102

39. basic shapes — 103
40. the pen tool — 104
41. refining paths — 105
42. line weights and styles — 106
43. fills and gradients — 108
44. introducing the pathfinder tools — 110
45. making a logo with the pathfinder tools — 112
CASE STUDY: creating vector art — 114
46. importing sketches and references — 116
47. illustrator layers — 117
48. live trace — 118
49. custom brushes — 122
50. making pattern swatches — 126
51. making a patterned image — 128
CASE STUDY: patterns and details — 130

color and alterations — 64

20. selecting colors — 65
21. identifying and altering colors — 66
22. adding flat color — 68
23. image adjustments — 70
24. invert — 71
25. adjusting colors — 72
26. correcting mistakes — 74
27. scale and transformations — 76
28. cutout techniques — 80
29. cropping and cutting: marquee and lasso — 82
30. selecting elements: magic wand — 84
31. adding color: magic wand — 86
32. quick selection — 88
33. cutting out hair — 90
34. refining edges — 92
35. brush and pencil tool — 94
36. create your ideal brush — 95
37. layering, blending, and overlapping — 96
38. digital montage — 98
CASE STUDY: using layers creatively — 100

characters and figures — 132

52. references for character development — 133
53. creating movement — 134
54. figure interaction — 136
CASE STUDY: enhancing a figure — 138

location, landscape, and architecture — 140

55. location and landscape — 141
56. understanding lighting — 142
57. depth and perspective — 144
58. architectural detail — 147
CASE STUDY: creating architectural details — 150
59. textures: photographing materials — 152
60. building an image library — 153
CASE STUDY: using texture to build an image — 154
61. allowing for imperfections — 158

stylistic techniques — 160

62. creating texture and grain — 161
CASE STUDY: the artist's hand — 162
63. stylistic techniques: lino and woodcut — 164
64. screen print effects — 166
CASE STUDY: retro styles — 168

65. filters — 170
66. out-of-register duotone — 174
67. halftones and offsets — 176
68. coloring halftones — 178
69. replicating graffiti stencils — 180
70. creating spatter effects — 183
71. pixel art — 184
72. vector-based urban art — 188
73. 3D and digital graffiti — 190
CASE STUDY: digital graffiti — 194

new contexts — 196
74. making animated gifs — 197
75. saving animations — 199
76. stop-motion movies — 200
77. rotoscoping — 202
78. animating in photoshop — 204
79. finalizing your animation — 208
80. where to go from here — 210

part 4: **professional practice**

81. presentation and promotion — 214
82. web sites and online presence — 216

glossary — 218
resources — 221
index — 222
acknowledgments — 224

Foreword

The techniques and processes detailed in this book are the culmination of a number of years of experience in making and experimenting with digital art. We both come from backgrounds that started with the development of traditional processes, and learned digital technologies through trial and error, experimentation, and the realities of creating work for a number of different clients in various contexts. For a number of years, we have both worked within a teaching environment, and in many ways have learned just as much as we have taught about making images.

Creating art in any context relies on a passion for what you are doing, and a willingness to explore and develop your own practice, as well as trusting your instincts as a creative person. More so, creating art relies on a willingness and understanding that you will make mistakes, but often through those mistakes you will develop a better understanding of what you are doing, as well as learn new things. We also believe that mistakes are an inherent and often beneficial aspect of image making—because the mistakes, unintended glitches, misplaced layers, or awkward juxtapositions can sometimes make an image come to life or create effects that, while unplanned, add to the final outcome.

Digital technologies have often (although not always) led us to create images where mistakes are less likely. Computer programs don't spill ink or make coffee rings. They don't lose the pen you were using when you first started, they don't get torn, and paint doesn't bleed—unless we require these effects and instruct the computer to create them. That is not to say that digital images always do what you want, but the chances are they will do as they are told and little else.

However, we believe that in order to make digital imagery more exciting, and more personal, you have to allow for and even build in the unexpected. The lessons in this book often start with the handmade, or find ways of incorporating it as part of the process. On those occasions where this is not the case, we try to allow for these random events to creep in—using content to overlap in ways that throw up unexpected results, or using random settings to avoid the inevitable precision the computer provides.

We have aimed this book at beginners, and have set up easy-to-follow lessons to instruct you in the core techniques. But you should also experiment with these techniques and processes in your own way, with your own materials, and with your own creative interests in mind. You should try out new things, play around with different ways of doing the same thing once you feel confident, and not be afraid of making mistakes—because it is these mistakes that you will learn from, and from what you learn and discover will emerge a unique digital artist.

Joel Lardner and Paul Roberts

about this book

The book is organized into four parts covering all the foundational information and techniques necessary in contemporary digital illustration, introduced by an image gallery featuring inspirational finished examples by international artists.

Part 1: Principles of digital illustration
This part introduces the mechanics of the digital operation—software, hardware, and the Photoshop and Illustrator interfaces.

Part 2: Starting points
This part explores the artistic and conceptual principles that you need to consider before even touching a computer. It also details how to set up, organize, and use an image reference library for your digital work.

Part 3: Image-making techniques
This comprehensive chapter is a step-by-step guide to the fundamental digital techniques, organized into helpful subsections: starting a digital project; using layers; color and alterations; vector art; characters and figures; location, landscape, and architecture; stylistic techniques; and new contexts for digital artwork. Each lesson builds on the last and features a clear explanation accompanied by engaging artwork. A number of case studies are featured that examine successful pieces of artwork by working digital artists.

Part 4: Professional practice
Once you are familiar with the digital medium, you may want to launch a career as a digital artist, and this section shows you how. It covers aspects such as professional presentation and promotion and creating an online space in which you can advertise and market yourself to potential clients.

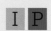

PHOTOSHOP OR ILLUSTRATOR?
At the beginning of each lesson is a colored icon, denoting whether the lesson covers Photoshop or Illustrator techniques. When the symbol doesn't appear, the lesson has application for both programs.

Dialog boxes detail the relevant stage in the process, making it easy to follow.

Clear and engaging photography details each point.

Each technique is accompanied by the relevant Photoshop or Illustrator icon for easy reference.

Handy professional tips from the authors provide extra information.

Case studies examine how and why particular pieces of digital artwork are successful in their aims, and the techniques used in their creation.

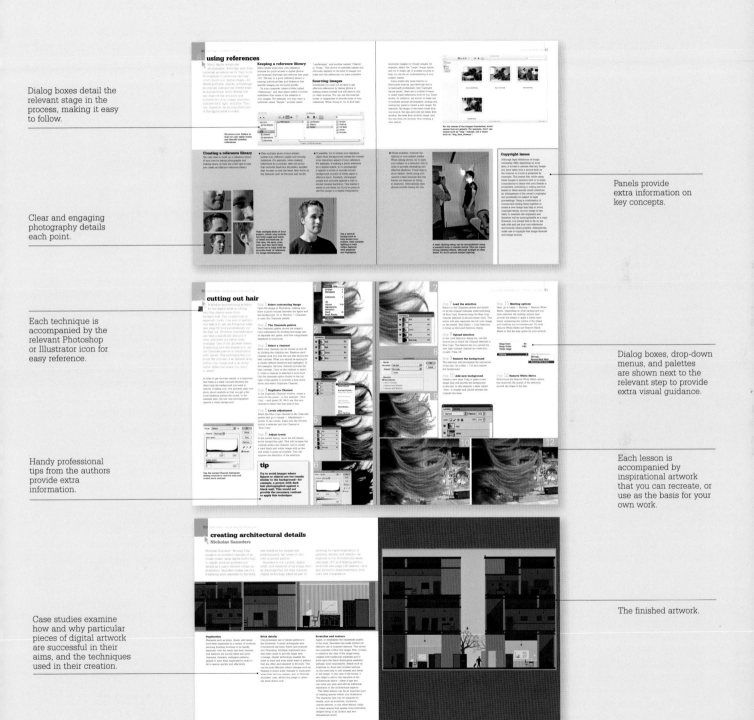

Panels provide extra information on key concepts.

Dialog boxes, drop-down menus, and palettes are shown next to the relevant step to provide extra visual guidance.

Each lesson is accompanied by inspirational artwork that you can recreate, or use as the basis for your own work.

The finished artwork.

introduction

This book is a beginner's introduction to digital art techniques and the possibilities presented by the computer to the aspiring illustrator or artist.

Digital technologies, combined with traditional approaches, have opened up many new avenues for artistic expression. More than ever before, affordable access to digital technology in terms of both the hardware and software has enabled a wide range of artists to explore digital techniques. Digital art is now no longer restricted to highly trained and affluent artists, and is increasingly being explored by people of all ages and all abilities. The seemingly limitless opportunities now offered by software packages such as Photoshop and Illustrator mean that high-quality artwork can be created and rendered quickly and professionally, providing an innovative and versatile tool for creative practitioners.

The aim of this book

While this book is aimed at artists who may be starting out in the art world, it is also created with traditional artists in mind, particularly those that are seeking to move over from the analog into the digital realm. Increasingly, proficiency with digital applications and technologies is expected of all artists and designers, and even the most traditional artists need an understanding of digital technology to adapt, amend, and publicize their work. This book is therefore aimed at introducing artists to the relevant technology and associated techniques, from those looking to move from analog to digital techniques, to those who have limited experience of art making in any form.

This book will explain the creative potential of digital techniques for output to both print and screen. It will introduce you to key concepts, technologies, and the processes required to make professional digital imagery. Starting from the basics of hardware and software requirements, it will explore aspects such as the differences between pixel- and vector-based programs, before moving on to more complex techniques, allowing you to develop a rounded understanding of various aspects

of contemporary digital art. Processes will be explained in clear step-by-step sequences with engaging artwork, and new lessons build upon techniques already covered, helping you to develop your confidence, so that you can move on to more complicated tasks and form your own unique visual language.

The digital manifesto

Underpinning this book is an understanding of the needs of contemporary artists, based on experience and practice. Through lessons and case studies examining work by practicing artists, this book will introduce and explore the techniques and methods used by professional artists, allowing you to recreate and successfully use the variety of approaches that characterize contemporary digital illustration, ranging from simple line art to complex digital compositions, and even animations. This book will enable you not only to improve your skills with digital software, but also to be able to use these attributes to develop, improve, and enhance your own work.

Also underpinning this book is a willingness to encourage artists who have something unique to offer that retains their personality and creativity. As artists, we believe the key to successful digital artwork is for the individual to remain visible. By this, we mean not to let the technology dictate the aesthetic or determine design decisions. The tendency to rely on the computer to constantly edit and correct artwork can leave artwork looking predictable and flat, so many successful artists and illustrators retain their voices by the inclusion of intentional mistakes, or through techniques that allow the qualities of materials and the artist's hand to remain. In this book, a variety of methods used by artists to retain their voices will be explored through case studies, and key techniques that you can use for your own artworks will be introduced throughout.

Later lessons in this book point to new avenues for exploration, including potential new directions to explore within the broader area of digital art and design. Lessons covering digital animation and aspects of three-dimensional image making give you introductions that may help you on your way into emerging areas of digital art, particularly for those seeking new challenges in pursuit of a unique voice, or out of pure curiosity.

This book also considers issues relating to pursuing digital art as a career, such as developing a professional practice as a digital artist, how and where to promote your work, and how you can push new boundaries through innovative practice.

Utilizing bold images and examples from a range of artists, this book will introduce a variety of techniques and styles that characterize contemporary digital illustration, offering a unique and essential guide to the budding digital illustrator.

Photoshop compositing
A range of drawing techniques and reference material are effectively combined in this image of Isaac Newton by Joel Lardner. Photoshop compositing provides the means to layer diverse imagery such as scientific diagrams, line drawing, scrawled text, and flat areas of color.

Image gallery

On the following pages, a wide selection of work by professional artists and illustrators is featured, demonstrating a range of techniques and treatments. Use it as an inspirational tool when approaching a new project in order to get your own creative juices flowing, and as a demonstration of the impressive pieces that can be achieved through the use of digital media.

Photoshop and photography
This image by Husam Elfaki is a great example of what can be achieved using quality studio photography and effective control and understanding of pixel-based software. Attention to detail, and a good understanding of selection, masking, and image refinement, is a must for this kind of approach to image compositing.

Retro print style
Hand-drawn lettering and bold simple colors are used to successfully create a retro print aesthetic in this piece by Nicholas Saunders. This faux-naïve style can make for arresting and striking images when used in the right context.

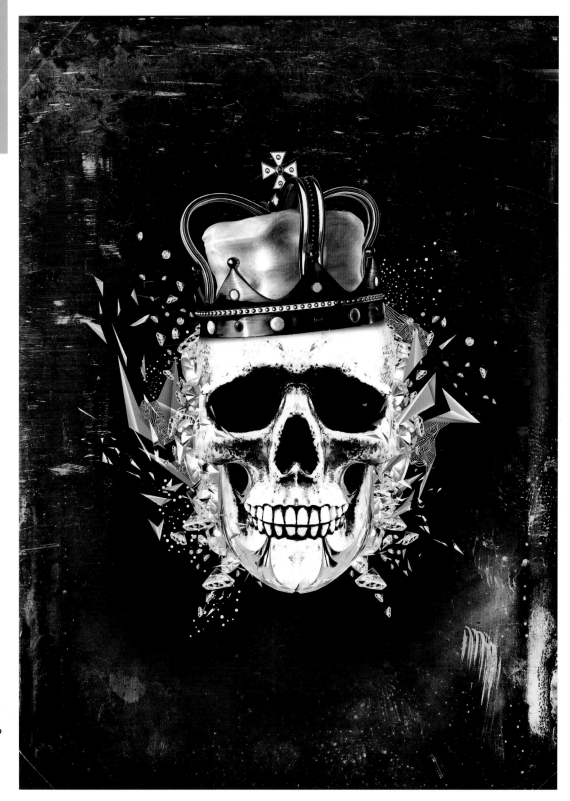

Digital and analog
Photography and the handmade are effectively combined in this Photoshop image by Perttu Murto. A limited palette and stark contrast add to the edgy feel of this contemporary illustration.

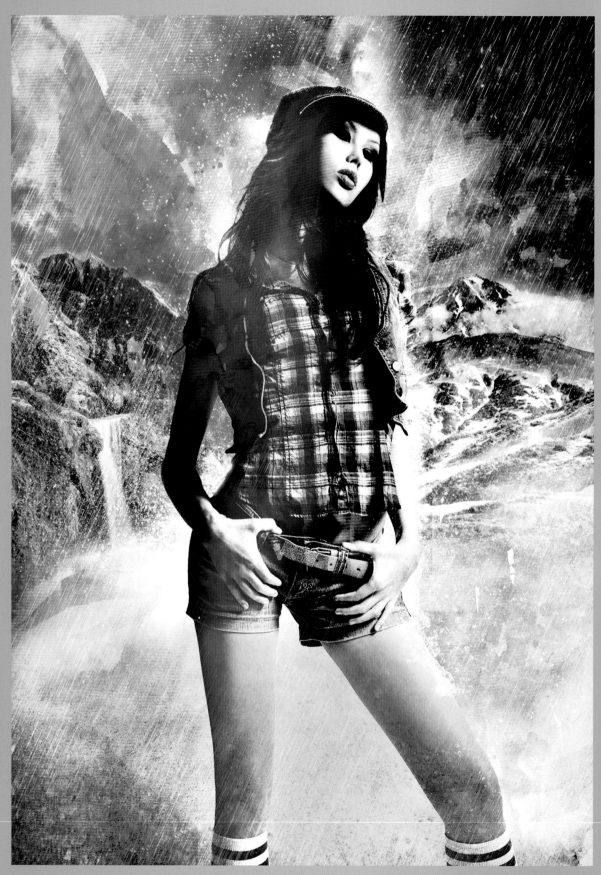

Photography and screen print
A combination of photography with aspects of screen print make this a dramatic visual by Pertto Murto. This style makes reference to the happy accidents that result from screen-printing experiments and belies the choices made in terms of composition.

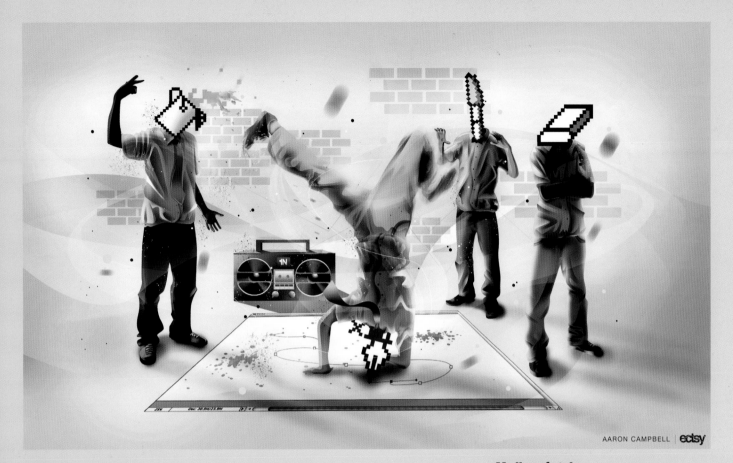

Medley of styles

This image by Aaron Campbell uses an interesting juxtaposition of digital and painterly styles, and uses an urban aesthetic uniquely combined with digital art references in the form of Photoshop tools. Textures have been utilized to create a gritty feel, as if the image is painted directly onto a wall or similar surface.

Photoshop realism

Intense realism is achieved in this image by Mike Harrison through a combination of good reference and source materials and an understanding of shade and texture to bring all of the elements together. The composition is highly considered, and the juxtaposition of unlikely characters creates an interesting narrative that allows the viewer to draw comparisons with mythical or fantastical stories.

Color, tone, and light

An understanding of light and tone helps to create a believable space within this image by Stephanie Belin, while the use of color palettes for the interior and exterior that directly mirror each other creates a space that is, if not 100 percent realistic, believable as well as desirable and pleasing to the viewer's eye.

Directing the eye

This image by Nicholas Saunders makes use of text to create movement, drawing the eye across the page to follow the journey of the characters. Variations in size, weight, and color of the lettering create interesting contrasts and help to create a sense of speech volume and individual character.

Painterly style
Traditional paint effects are
effectively recreated in this image
by Saeed Al Madani. It makes
use of texture and a sense of
tactility to help communicate
a sense of tranquillity and
peacefulness in what is an
otherwise quite stark visual.

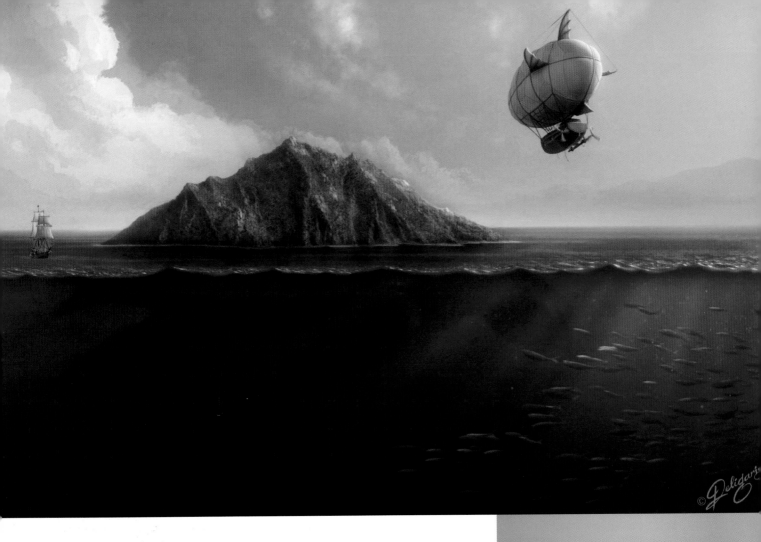

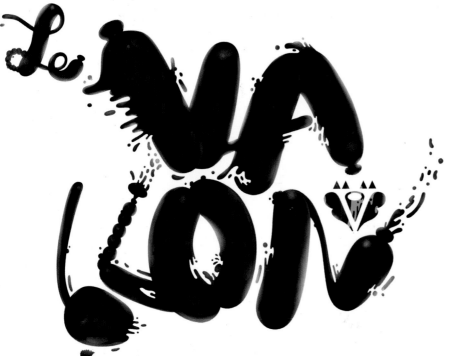

Art principles

Complex and intensely detailed images such as this example by Nick Deligaris require good references, an understanding of lighting and atmosphere, and a good ability to use and control color. Composition planning, either traditionally or within a digital application, is also key to creating engaging images that appear natural, uncontrived, and that can draw the viewer into the picture.

Vector graphics

Vector graphics are used effectively here to create a handmade type-based image by Valistika Studio. Lines and shapes appear fluid, and successfully create a wet paint feel that can be easily let down through inattention to detail and control of paths.

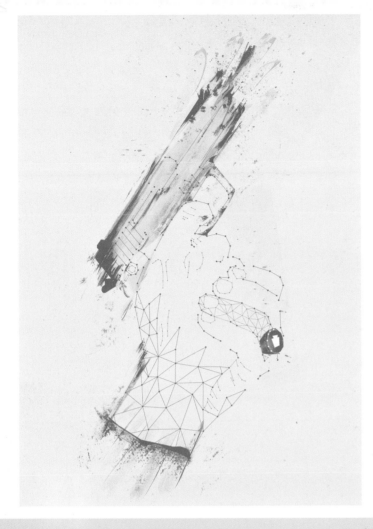

Analog/digital blend

Hand-drawn imagery is seamlessly combined with digital elements in this simple but effective illustration by Mike Harrison. The image alludes to the analog/digital mix in its use of visuals relating to 3D wireframe imagery, mixed with a rough hand-painted and spattered analog image. The single color enhances the message the illustration intends to convey, as do the scratches and stark, mechanical lines used to render the hand.

Digital painting

This image by Ian Essan is a good example of what can be achieved using digital painting methods. High levels of control over color and tone can be achieved in the digital environment that can take years to master using traditional materials. Opportunities to use time-saving tools and processes such as duplication of similar objects makes digital methods of image making popular for artists looking to retain or explore more traditional aesthetics.

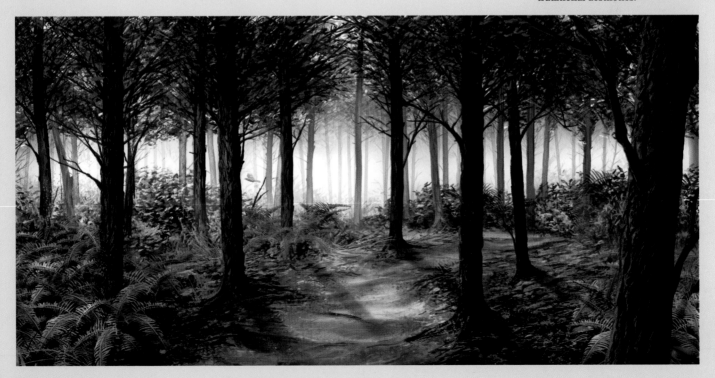

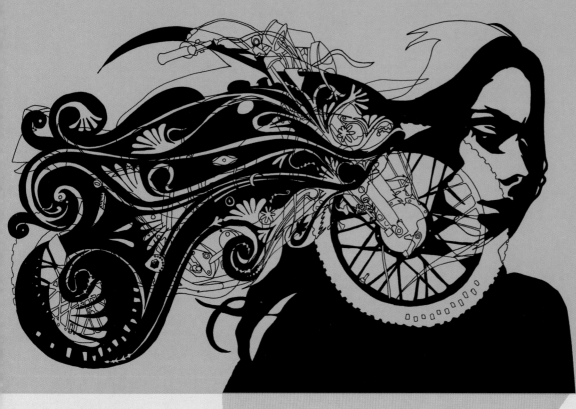

part 1

Principles of digital illustration

Perhaps more so than any other form of art, digital illustration and image making is reliant on a range of tools—from the basic hardware and software such as the computer and image-making applications, to the peripherals that help you to further expand your image-making opportunities. However, once equipped, the range of techniques and processes are virtually limitless, resulting in the indispensability of digital tools for almost all artists. While it is the creativity and imagination of the artist that gives each image its unique qualities, all digital artists need to ensure that they are using the right equipment to get them started in the digital environment.

choosing software

The majority of this book focuses upon two applications, Adobe Photoshop and Adobe Illustrator. However, the techniques and methods outlined can be performed using a variety of other image-editing applications. Here's a rundown of the most popular software available to the digital artist.

Pixel-based image creation

Pixel-based software works by manipulating the color of pixels or groups of pixels. Pixels are best thought of as individual dots that make up an image, much like mosaic tiles, although with many more pieces! Pixels can be manipulated in a number of ways, although at a basic level, brush and pencil tools change the individual color.

Adobe Photoshop

Photoshop is broadly considered the industry standard for image editing. The software has become so well known that retouched images in glossy magazines and newspapers are often said to have been "Photoshopped." Photoshop offers a broad variety of tools for image creation and manipulation, and while its origins may have been in the editing of photographs (hence the name), it has developed into a creative tool that has a wide number of applications, from the creation of images from scratch, to the editing and manipulation of much broader source materials.

References in this book are based on the CS5 version of the software; however, the methods and tools used are available in most of the earlier versions, although the location of some items within the menus may have changed, as may some of the options available to you.

Adobe Photoshop Elements

Photoshop Elements is a cut-down version of Photoshop. It retains many of the functional elements discussed in this book, but does not have some of the more advanced features, such as the range of filters or image-manipulation tools. However, it is a much cheaper alternative to Photoshop, and often comes bundled with printers, scanners, or tablet devices, making it excellent entry-point software to the digital arts or even an effective alternative for those not requiring the full range of features in Photoshop.

Corel PaintShop Photo Pro

PaintShop Photo Pro shares many similarities with Photoshop, being a powerful image editor and image-creation tool. What it lacks in terms of advanced features when compared with Photoshop, it makes up for in terms of price. As with Photoshop Elements, many of the tools and commands used in this book will work in PaintShop Photo Pro; however, the names, icons, and menu locations will differ.

Corel Painter

Painter has established itself as a key piece of software within certain areas of the digital arts community for one main reason—it provides the ability to work with pixels as if they were paint. Painter allows you to use tools based on traditional practices such as paint brushes, palette knives, and even water, to dramatic effect. Furthermore, the "paint" can be set to remain pliable and liquid so that it interacts with successive brush strokes, and colors will bleed and blend just like real paint. Painter may, therefore, be a good option for those wishing to pursue more painterly methods of digital art creation, and is definitely superior to Photoshop when it comes to its painting options. For those looking for a more general approach to digital-image creation or manipulation, however, Painter may not be the right choice.

Vector-based image creation

Vector-based software uses mathematically defined shapes to build images. These images traditionally tend to look more blocky, although advances in both the software and the methods used by artists have led to complex and often painterly uses of vector software.

GIMP

GIMP is a free image-creation and editing tool that comes with a number of features, which are ever expanding. Although it is not as powerful or doesn't pack as many features as the software we've already discussed, it does offer a free and easy-to-use entry point into digital art. GIMP is not the only free application for the digital artist, so for those on a limited budget or wanting to try something new, it's worth browsing the Internet to see what's available.

Adobe Illustrator

In a similar way to Photoshop, Illustrator has developed greatly over its lifespan, and many of its tools have pushed the software far beyond a simple block-graphic image creator into a powerful tool for producing a variety of graphic styles. Although many features described in this book are available in older versions, Autotrace, 3D tools, and some of the more advanced features of the programs may be limited or unavailable in pre-CS5 versions.

CorelDraw

CorelDraw is a viable alternative to Illustrator. Numerous debates exist over which is better in a similar way to those between Photoshop and PaintShop Photo Pro. While both offer some unique features, the basic elements are similar enough for the entry-level user that the differences are unlikely to matter.

On the plus side for CorelDraw, there are arguments for better tools and a shallower learning curve. On the negative side, Illustrator's easy integration with Photoshop and other products may make a Photoshop owner consider Illustrator over CorelDraw.

There are also a number of free or cheaper vector-graphics applications available, although the choice may be limited by your operating system.

Other software

Besides the main design packages, there are numerous other applications that could help you expand your digital art creativity. Web-creation software such as Dreamweaver or Flash, for example, will help you create web sites or other online platforms to show off your work. Flash, AfterEffects, Premiere, FinalCut, and a host of other programs let you manipulate and edit both still and animated digital imagery, allowing you to take two-dimensional work into time-based outcomes and expand the possibilities of your work. Three-dimensional software such as 3D Studio Max, Maya, or Blender can help you to create a variety of objects that can both be imported into your chosen two-dimensional editor or be developed from two dimensions into a wider three-dimensional world.

Other functional software to consider includes image organizers or image galleries that can store, arrange, and organize your artworks, references, and sources. iPhoto on the Mac is one such application that offers image importing, photo galleries, the ability to tag images for retrieval, and some basic image editing, as does Picasa for Windows PCs.

All the software mentioned here is available for trial. Simply go to the software developer's home page and look for the Trial or Downloads tab.

introducing the interface: photoshop

Photoshop's Toolbox

Photoshop's Toolbox is the hub and focal point for making selections and amendments, retouching, and drawing, and has similar features to Adobe Illustrator's Toolbox (see pages 26–27). A professional illustrator or photographer will be familiar with all the icons in this panel and the functions they perform.

Notice that some of the icons have a small triangle in the bottom right-hand corner of the button. This triangle indicates there is a group of tools hidden within the button.

You can drag the Toolbox to different locations on the screen, and display it in a single column as shown here, or in two columns. These features help you maximize the full scale of your screen if the position of the Toolbox is problematic when composing an image.

The diagram shown here explains the key functions available in the Toolbox and all the tools referred to in this book.

1 Switch arrows
The Toolbox can be altered to a single column or double column format by clicking.

2 Move tool
Moves selected objects, layers, and controls.

3 Marquee tools
Make rectangular, elliptical, row, and column selections.

4 Lasso tools
Make freehand, Polygonal (straight line), and Magnetic (snap-to) selections.

5 Magic Wand tool
Selects defined color areas within your composition.

6 Crop tool
Trims and crops artwork.

7 Eyedropper tool
Samples a specific pixel's color.

8 Healing Brush tools
Repair and amend artwork.

9 Brush
Dictates how the "paint" is applied to your artwork.

10 Clone Stamp
"Paints" with a cloned area of your image.

11 History Brush tools
Paint back the areas of your image to the history state selected in the History window.

12 Eraser
Erases pixels.

13 Fill tools
Gradient and Paint Bucket tools fill defined areas.

14 Blur tools
Blur, sharpen, and smudge areas that require retouching.

15 Dodge tools
The Dodge tool lightens and the Burn tool darkens areas you brush over.

16 Pen tool
Click to create forms with anchor points (paths).

17 Type tool
Applies typography to your composition.

18 Path Selection tool
Moves paths around the canvas.

19 Shape tools
Create vector masks.

20 (3-D) Object Rotate tool
To navigate within 3-D Photoshop files.

21 (3-D) Camera Rotate tool
To control viewpoints within 3-D Photoshop files.

22 Hand tool
To move your view of the canvas.

23 Zoom tool
To zoom in and out of the canvas.

24 Default Foreground and Background Colors
Sets Foreground Color to black and Background Color to white.

25 Switch Foreground and Background Colors
Swaps the current Foreground and Background Colors.

26 Set Foreground Color
Brings up Color Picker to set Foreground Color.

27 Set Background Color
Brings up Color Picker to set Background Color.

28 Edit in Quick Mask Mode
To create a mask.

29 Brush Presets
Save tool settings and create libraries.

30 Brush
Modify brush tips, select brush presets, and control how color is applied.

31 Swatches
Store colors that you use often.

32 Color
Mix and control color.

33 History
Return to any previous stage of the creative process.

34 Info
Describes the color values as a tool passes over the image.

35 Adjustments
Tools for adjusting color and tone.

36 Layers
Lists all layers that form an image.

37 Navigator
Change the view of your image quickly.

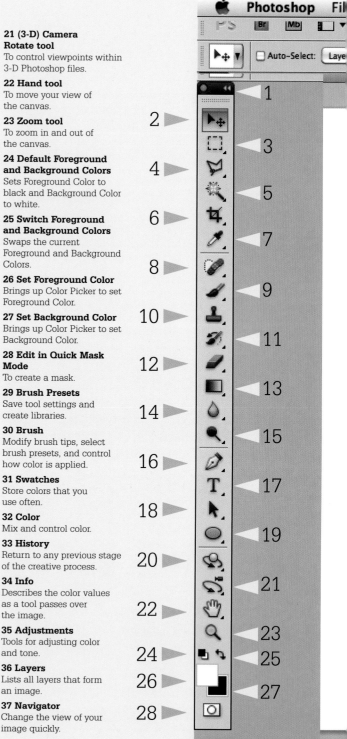

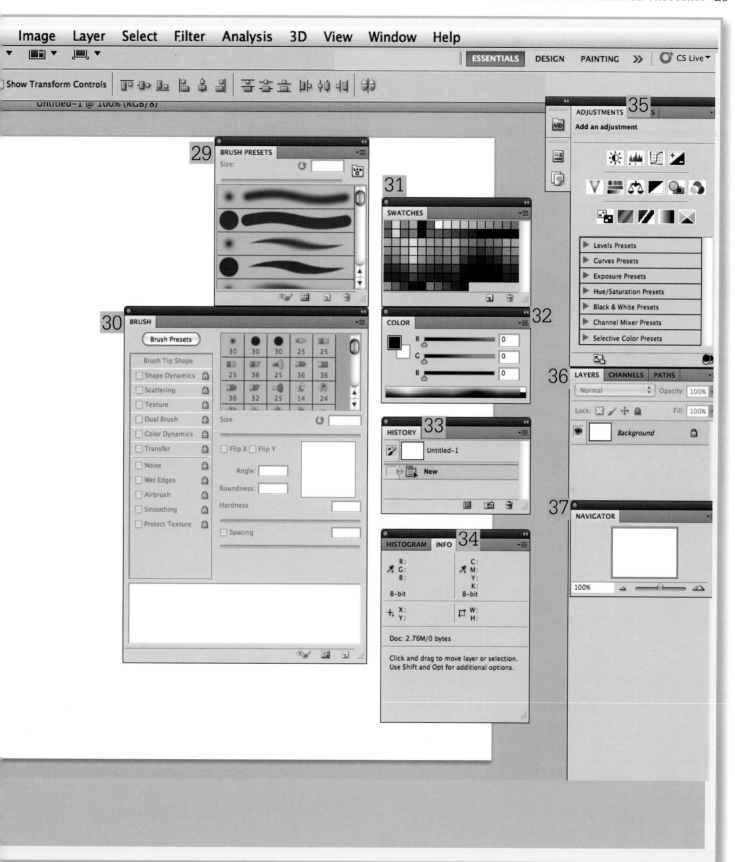

3 introducing the interface: illustrator

Illustrator's Toolbox

The Illustrator interface shares many similarities with that of Photoshop. However, since Illustrator uses vector-based rather than pixel-based image-creation processes (see page 22), the tools you use may not always work in exactly the same way. Furthermore, tools such as the Pen tool and Selection tools are used more prominently and feature closer to the top of the palette.

1 Selection tool
Selects, moves, scales, and rotates objects.

2 Direct Selection tool
Selects individual vector points.

3 Magic Wand tool
Selects multiple shapes where they share a similar color.

4 Lasso tool
Selects individual or groups of vector points using a drawn lasso.

5 Pen tool
Creates and adjusts vector points and straight and curved paths.

6 Type tool
Adds text to your image.

7 Line Segment tool
Draws lines.

8 Rectangle [shape] tool
Includes Rectangle, Rounded Rectangle, Ellipse, Polygon and Star shape tools.

9 Paintbrush tool
Creates paths by hand rather than point by point.

10 Pencil tool
Similar to the Paintbrush tool but without brush effects applied.

11 Blob Brush tool
Similar to Paintbrush tool but adds to the path when objects intersect.

12 Eraser
Erases paths.

13 Rotate tool
Rotates objects.

14 Scale tool
Rescales objects.

15 Width tool
Alters the width of objects.

16 Free Transform tool
Alters the shape of objects.

17 Shape Builder
Used for building complex shapes.

18 Perspective Grid
Helps you to construct 3D shapes by setting out guides that work within a 3D perspective.

19 Mesh tool
Adds Spot colors to objects and creates complex gradients.

20 Gradient tool
Adjust gradients.

21 Eyedropper tool
Selects and applies Stroke/Fill colors from clicked object to currently selected object.

22 Blend tool
Blends two shapes together.

23 Symbol Sprayer
Allows you to spray and adjust predefined symbols.

24 Column Graph tool
Adds an editable graph to the artboard.

25 Artboard tool
Changes the artboard (page) settings.

26 Slice tool
For cutting objects into separate parts.

27 Hand tool
To navigate around the artboard.

28 Zoom tool
To zoom in and out of the artboard.

29 Default Fill and Stroke
Sets Fill to white and Stroke to black.

30 Swap Fill and Stroke
Sets Fill to black and Stroke to white.

31 Fill
Sets the fill color of shapes and paths.

32 Stroke
Sets the line color of shapes and paths.

33 Color/Gradient/None
Choose fill mode.

34 Change Draw Mode
Determines whether new objects are placed in front, behind, or inside existing objects.

35 Artboard
The area where the image is created.

36 Pathfinder
Used for combining and editing shapes.

37 Navigator
Zoom and move around the artboard.

38 Stroke
Set Stroke options for paths and shapes.

39 Gradient
Set Gradient Fill options.

40 Color
Mix colors for Stroke and Fill.

41 Swatches
Contains default and custom colors, gradients, and patterns for Fill and Stroke.

42 Brushes
Contains default and custom brushes to be applied to paths.

43 Layers
Displays all layers and sublayers within the artboard.

44 Dock
Contains collapsible palettes for quick access.

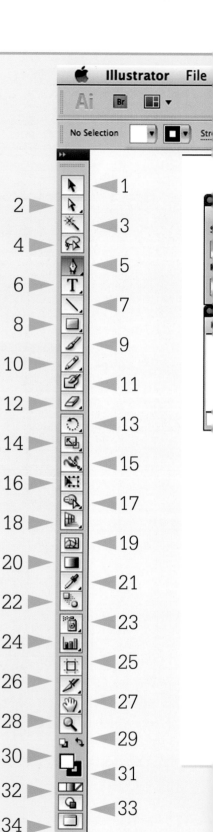

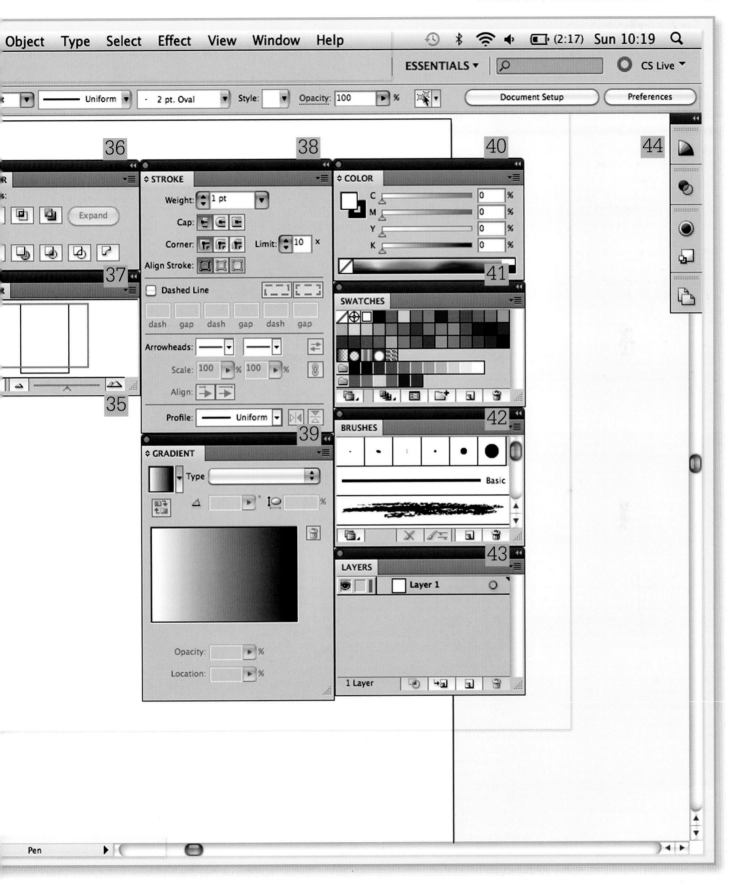

4

all about hardware

When creating digital illustrations, hardware requirements, such as computers, printers, and other physical equipment, vary depending on the software you are using as well as the complexity and size of the illustrations. It's important to remember, however, that you don't have to spend a fortune on computer hardware. Many digital artists get by with the bare basics.

Laptop or desktop?

Your choice in using a laptop or desktop system may be based upon personal preference, budget, or the need for portability and space. Laptop prices today are roughly equivalent to those of desktop computers, and laptops now come with some impressive specifications. There are some things worth considering, however, when making your choice if you are selecting a computer for dedicated digital artwork. First, laptops are often limited in terms of screen size, and therefore a desktop computer with a large monitor or an additional screen may be preferable. Secondly, laptops tend to have less ability to support a large number of peripheral devices. Adding a printer, scanner, drawing tablet, and external storage device may not be possible without a lot of lead swapping. Thirdly, laptops are less expandable should you require a new hard drive or RAM upgrade.

RAM

One of the most important aspects in terms of making software run effectively is the amount of RAM (Random Access Memory) that your computer has. RAM is the workhorse of your

Apple Mac or Windows PC?

Within the design world, there has been a tradition of using Macintosh computers over Windows PC computers. Although this tradition still holds sway in a number of design industries, there is no requirement either way in terms of which make of computer you use—both operating systems will run Adobe software and many of the alternative design software applications. Do be aware, however, that a Windows version of Photoshop will not run on a Mac and vice versa.

computer when it comes to using software, and Photoshop in particular can be particularly RAM hungry when performing transformations or rendering effects. You should therefore aim for as much RAM as is possible in your machine to help speed up software performance. The current (CS5.5) version of Photoshop requires 1GB of RAM; however, 2GB or more would be better for more intensive use. Animations, and the 3D and Live Trace functions in Illustrator, are also quite RAM demanding.

Hard drive

 Your computer's hard drive is the place where files are stored. Files are saved and opened from this drive, and it is also where the design software resides. More hard drive space (that is more gigabytes) means more space in which to store your files. Most computers come with more than sufficient storage space for the average digital artist, although animators or those regularly producing very large images may need to consider adding extra space to their computers to successfully store all of their files. This can be in the form of additional or larger hard drives or removable storage space such as an external hard drive.

Screens and monitors

 If you are using a laptop as your main computer, your choice in screen size is limited. However, for desktop computers, you have the option of selecting a variety of screens and monitors to suit your needs. While the physical size of your screen is important, of greater importance is its resolution (the number of pixels horizontally and vertically). In short, more is better. Resolution is also determined by the graphics card, and therefore a screen/monitor and graphic card that support higher resolutions is often the best option. Some artists are also known to use multiple screens to help them more effectively produce their digital images, using one screen solely for the

image and another for toolboxes and other dialogs. If you wish to use multiple screens, check that your graphics card is capable of supporting this.

Storage media

Storage media that supplement your hard drive space or enable you to move files around come in a variety of formats. These include portable hard drives, CD-R and DVD-R media, and flash drives. Although not essential, additional storage is particularly useful for archiving old work, backing up existing work, and for adding portability to files by allowing you to move them between your work and other computers.

Removable hard drives

 Removable hard drives are particularly useful for storing old work or collections of photographs and textures that can be used as elements of your design. Some are USB powered, others tend to be mains powered and are often bulky and less portable—although these often provide significantly more storage space for your money.

CDs and DVDs

CD-Rs are useful for backup of important files and most computers are equipped with a CD writer to enable the quick burning of discs. However, the space on an average CD-R is limited to 750MB. This may prove suitable for a small photo image archive, but won't be suitable for numerous multilayered Photoshop files. DVD-R discs provide more storage and may be a better option for archiving.

USB flash drives

USB flash drives are small and portable solid state (no moving parts) storage devices. These are relatively inexpensive, often hold more files than a CD-R or DVD-R, and are also somewhat damage resistant, making them a good choice

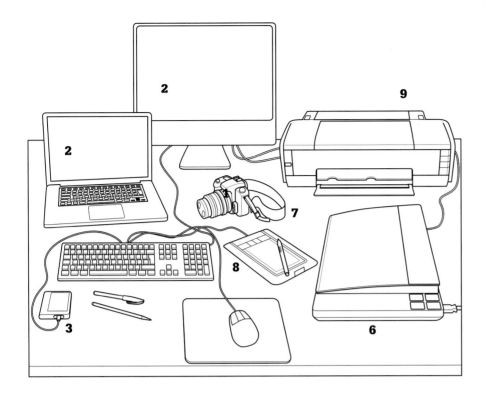

for moving and storing important files or archives. A similar option is to use any of the available camera storage cards such as SD or microSDHC cards to store files. These can offer significant amounts of storage space and can be connected to your computer using a USB-powered card reader if your computer does not have one built in.

Input devices

Scanners

 A scanner allows you to produce high-resolution digital copies of photographs, drawings, and paintings. Depending on how you choose to work, it can be a vital tool, particularly for developing drawings into final digital work, or providing textures and additional layers for your digital illustration. Prices tend to limit the size of scanner to letter (A4) for the majority of artists, although legal (A3) scanners are available for those with a larger budget.

Digital camera

Like scanners, a digital camera can help provide source materials for your digital work. You can use photographs as references, backdrops, details, or textures for your images, or in lieu of a scanner, allow you to convert analog work to digital. Most digital cameras come with their own software to help you import images to your computer and cables for connecting.

Most mobile phones now include digital cameras and many provide reasonably high-quality imagery.

Drawing tablet

 Tablet devices such as those made by Wacom let you draw directly into digital applications. Tablets make use of a stylus device, which is much like drawing with a pen or pencil. Many devices offer pressure sensitivity and angle control and allow you to recreate brushlike effects and add fine control to your drawing tools. With both Photoshop and Illustrator, you can define the input of these devices, thereby allowing you to expand the control of many of the tools. Tablets take some time to master, but offer levels of control that are difficult or impossible to recreate with a mouse.

Output devices

Printers

If you want to make prints of your artwork, you'll need to consider buying a home printer. There are numerous makes available in a range of prices, and naturally the quality of the prints will vary—although this can also be determined by the quality of the print media and inks that are used. A4 printers are readily available and relatively inexpensive. Larger format printers are available; however, the price tends to increase exponentially as the print size increases. So while larger format printers may be a necessity for professional digital artists, for budding artists or those on a tight budget, A4 printers are likely to be the answer.

Printers come in two main varieties—inkjet and laser. Laser printers are faster, but, in terms of print quality and value for money, rarely match inkjet printers.

Print quality and media compatibility are usually the determining factors in your choice of printer, so you may wish to consider established brands such as Epson or HP, and printer types that can allow for a variety of inks and media to suit your chosen output needs. These can range from glossy or matte papers, as well as specialist papers in a variety of weights and textures, and specialist pigment or colorfast inks to help improve the quality and durability of your prints.

Traditional materials

Even for the most digital of digital artists, traditional materials are still a key part of the workflow. Many start with a sketch, drawing, or even a painting before moving on to the computer. It is therefore advisable that you keep a selection of tools to allow you to start the creative process. Paper and pencils, for example, are a given, but you should also consider a selection of fine liner pens or markers for creating drawings that can be digitally scanned, paints and brushes for image development or to provide textures and image samples, and perhaps even a dedicated work area. A range of colored pencils, felt tips, brush pens, Chinagraph pencils, chalks, and charcoals can all provide effective starting points for your digital artwork, or key sources of analog textures for your images.

part 2

Starting points

All artists need a starting point for their work. While some artists use the computer as an entry point for their first image, others make use of analog techniques (sketches and thumbnails on paper) to start the process. No matter what technique is used, however, basic principles such as composition, color, space, and perspective underline the creation of all images, and understanding and mastering them can make the difference between a mediocre and a great artist.

This section will start by outlining some key principles that underpin all forms of image making to introduce you to the concepts. It will then explore the starting point used by many artists—preliminary sketches and roughs. It will then look at how an illustration can be developed using different methods and creative processes. Finally, it will explore the use of references to support your image making, offering helpful advice about using digital photographs.

5 art principles

An awareness of the principles of composition is fundamental to your development as a digital artist. These principles inform the arrangement of visual elements within an image. The successful artist, however, although aware of these principles, will not apply them too methodically. In an ideal scenario, composition should be intuitive. So absorb these guidelines, but don't enforce them in a systematic way.

The elements of design

The key elements of artwork design define the vocabulary with which the artist composes an image. An image can employ any combination of these elements in such a way as to draw the viewer's attention to key points of interest. It is the artist's skill and decision making that determines how the elements are positioned within the frame. Use this guide to analyze the elements and then deconstruct and analyze your own artwork.

Line

Lines are the fundamental means of defining space on paper or on a computer screen. Thick or thin lines are created using a variety of tools that move in a direction across a surface. Lines can also be created by the edges of shapes and objects, and are used to provide detail and areas of focus.

Color

Our perception of color defines how we read images. Color can be used in combinations to provide harmony (analogous colors) or contrast (complementary colors). The artist will understand the significance of color and how it can be used to draw attention toward a composition. Modern digital software provides an infinite range of colors and hues from which to choose.

Shape

Shapes are forms contained by edges. Shapes are used to define content within the artist's frame. How the shapes are arranged creates a sense of balance within the composition. They can produce perspective by appearing to be close or distant.

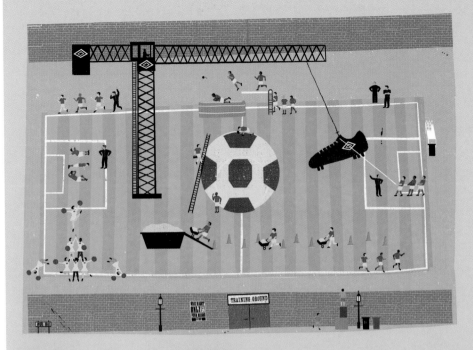

Shape

In this image by Nicholas Saunders, a wide variety of shapes are employed to convey an absurd soccer stadium. Rectangles, circles, and triangles are used to construct meaning and convey the message.

Line

In this example by Dunya Atay, photographic imagery is enhanced by the application of decorative line work. This combination of drawing and alternative media is made possible by digital technology.

Texture

Texture is the real or implied quality of a surface. The digital artist has the opportunity to gather a wide range of sample textures. These can be imported directly into your computer by means of a camera or scanner.

Form

Form is the perception of three dimensions. Form can suggest space and depth within a composition.

Tone

Tone is used to define how light falls upon an object. It suggests form and depth. Gradients of tone describe the relationship between highlights and shadows. The digital artist can apply tone with control and accuracy.

Color

This image by Valistika Studio uses color to maximum effect. Vivid hues juxtapose with one another, drawing our attention to the shapes within the letterforms. The opposing, contrasting colors are vibrant, and suggest energy and fun.

Texture

Texture is used in this image by Perttu Murto to create a sense of motion and drama. The streaks and smears of grainy paint sit in opposition to the stark white negative space.

Form

Three-dimensional objects are presented within this abstract composition by Benjamin White. The shapes are clearly defined by color, texture, and tone. The digital artist has the opportunity to apply mathematical precision when constructing form within an image.

Tone

In this image by Martin Muir, shadows surround the figure, mid-tones create areas of interest within the body, and highlights are used to define facial features and, crucially, the eyes.

The principles of composition

The principles of composition can be thought of as ways in which the elements of design can be used in a composition. They are a list of strategies that the artist can use to organize an image. The artist relies on these principles to enhance an image and create a sense of balance within the composition.

These principles have been established during the course of the development of art, and have been used by generations of artists As a formula, they still apply today to practitioners working within a digital context. In some senses, because the computer screen determines the rectangular frame within which computer artwork is confined, the digital artist is even more governed by these principles than artists of the past.

Some of these principles seem contradictory and not all can be successfully applied in the same composition, but using clever and subtle combinations produces effective results.

Balance

Balance refers to the arrangement of elements to satisfy the eye. The proportion of the elements is considered and emphasis is given to key components within the image. Objects are used in conjunction with negative space to create a sense of congruity. Tone, color, and pattern are used in combination with areas of negative space to achieve balance.

Harmony

Harmony is achieved by arranging elements that have similar properties, such as color or tone. With the vast array of visual effects on offer to the digital artist, limiting options is sometimes a tactical advantage. This decision can provide the necessary parameters to guide creativity, producing satisfying and harmonious effects.

Contrast

Combining a variety of disparate elements within an image creates contrast. This could include components that differ in size, color, and also media. Used in conjunction, these contrasting elements will create interest and encourage the viewer to explore the image.

Balance

All the elements of design are used in combination with areas of negative space to achieve balance in this image by Joel Lardner. A variety of shapes and letterforms are arranged in such a way that the viewer has many points of interest upon the page. Corresponding, tonal colors demonstrate the effectiveness of a limited color palette.

Harmony

A harmonious effect is achieved in this image by Nicholas Saunders by selecting corresponding tonal and color values throughout. A limited color palette is employed to great effect. The arrangement of shapes within the page is symmetrical; this creates a sense of order and clarity. This results in a visually satisfying image.

Contrast

This is a diverse and intriguing composition by Benjamin White that utilizes a broad range of media and materials. The inclusion of photographic material is shown in the facial references. These familiar shapes are combined with organic abstractions that use pattern and line to suggest form and movement.

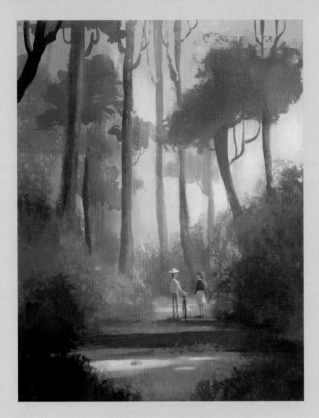

Depth

This image of figures within a forest by Jennifer Bricking provides a great example of how the illustrator can employ depth to create atmosphere. The empty foreground at the front of the composition exaggerates the sense of distance and isolation of the figures. The rigid vertical lines of the tree trunks emphasize this sense of scale and suggest foreboding or potential vulnerability of the characters.

Depth

Depth is created by employing lines and tone to create a sense of perspective. This principle uses a vanishing point in an implied horizon to determine where objects are placed within a composition. The foreshortening of objects toward this vanishing point alludes to how we experience three-dimensional space in reality, suggesting shape and form.

Movement

Movement is achieved by using visual elements to guide the viewer around the image, creating a dynamic composition that suggests energy and motion. Shapes and tones can convey movement and lead the eye toward the key components.

Pattern

Elements can be repeated to create pattern and rhythm within the composition. Pattern can convey order, but also create hypnotic effects or a sense of unease. The mathematical precision offered by computer software is ideally suited to this task. Shapes can be duplicated and intricate patterns generated quickly.

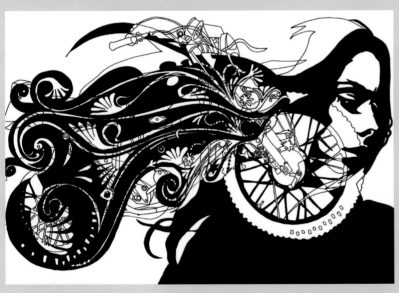

Movement

This example by Joel Lardner uses flowing, circular shapes to create a sense of movement. The decorative flourishes cut across the composition and place emphasis on the face within the image. Such dynamic and rhythmic forms are an enjoyable visual effect, which draw viewers' attention toward the artwork.

Pattern

This intricate artwork by Catalina Estrada seems to play on the contradictory understanding of how patterns work. The image is at once decorative and balanced; but, as the viewer spends more time with the image, the intricate detail becomes overwhelming.

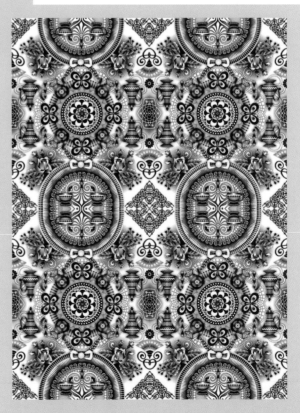

How to compose objects within a frame

How you chose to compose an image within a predetermined area, or frame, is very important. The placement of objects conveys specific meanings, and the digital artist must be very conscious of how best to construct images that will express particular moods and ideas. A formal or informal approach to composition is a fundamental decision for any creative practitioner to make when initiating a new project.

If an artist choses to place the subject in the center of the frame, this is called a symmetrical composition. A symmetrical composition conveys order and tranquility, sometimes also a monumental quality. Alternatively, if the subject is placed either side of the center, it is called an asymmetrical composition. An asymmetrical composition can convey action and tension, so gaining the viewer's attention.

It is for this reason that artists will usually favor the asymmetrical approach when composing an image. The dynamic forms and sense of anticipation suggested by an asymmetrical approach are preferred to the predictability and formality of symmetry.

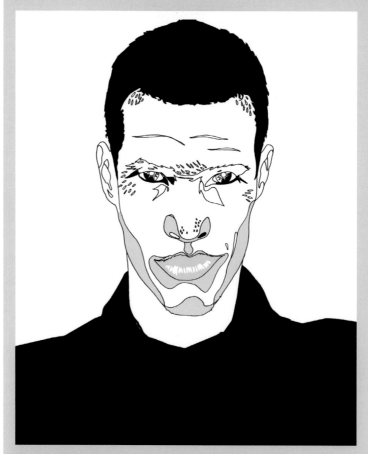

Symmetrical
By deciding to situate the figure in the center of the frame, Joel Lardner creates a sense of stillness and order. This gives the character a very formal, almost monumental quality. A symmetrical composition is read quickly and communicates directly to the viewer.

Asymmetrical
An asymmetrical composition such as this one by Lucy Evans creates a sense of dynamism. As the eye moves across the image, a suggestion of movement or tension is created. The unfamiliar and asymmetrical pose provides intrigue for the viewer. The intention is for the viewer to enjoy decoding and comprehending what is happening within the image.

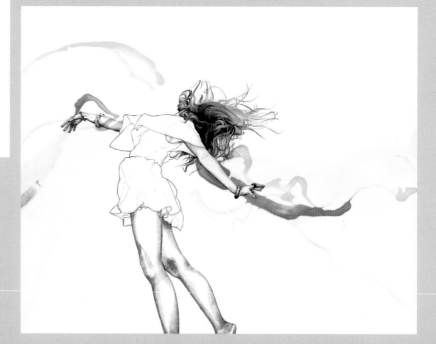

Closed

In this example by James Hadley, all the artwork is contained within the frame. This conveys a sense of flatness and distance between the viewer and the image. Use this technique if all the content of your image is necessary to explain an idea.

Open

Here the same image is cropped, and the content is extending outside of the frame. Notice how this creates a sense of intimacy and depth, drawing us toward the figure and its facial expression. In this example, an open composition provides more emotional connection between the viewer and the subject of the image.

Picking the viewpoint

The interpretation of an image can be also be informed by where the artist chose to place the viewer. Illustrator Robert Proctor's image of a sea monster provides an example of how a viewpoint can suggest depth. In order to provoke a sense of dread and menace, Proctor chose to place the viewer below the waves looking up toward a small fishing boat being engulfed by a titanic creature filling the sky. Perspective is used to accentuate the scale of the monster in the horizon and draw our attention to the vulnerable sailor in the foreground.

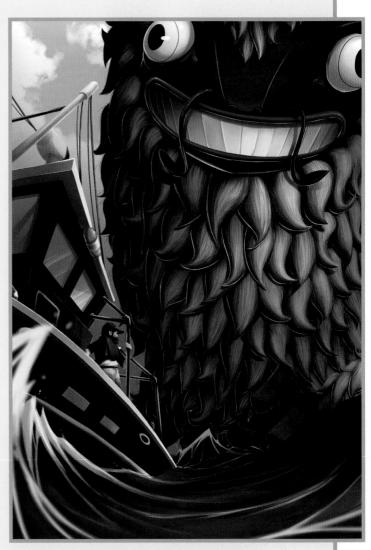

The fisherman provides the key point of focus within the composition. This illusion is created by a circular composition, leading the eye to the figure in the boat; the circular shapes of the waves and distorted boat also help to emphasize the movement toward the center of the image.

6 sketches and roughs

When you have an idea that has potential, it's important to get it down on paper. Drawing is a very subjective practice. Good illustrators will have their own very particular means of expression, and this activity will differ from artist to artist. Pens, pencils, brushes, tablets, and spray paint can all be used to express an idea. Try and expand your notions of drawing, and find mediums and materials that feel right for you. Also, be aware that the tool you select to make your drawing will imply an emotion and express a particular attitude.

Try not to differentiate between a sketch and a "worked up" or refined drawing. A simple intuitive sketch can sometimes possess a vitality that a more refined and reworked image finds difficult to capture. Instead, try to think in terms of a good drawing and a not-so-good drawing. The time you spend laboring over a drawing is irrelevant; what you need to concern yourself with is making images that communicate directly and effectively, with intelligence and finesse.

As well as the physical activity of drawing, the digital illustrator has the added benefit of being able to draw within graphic software packages, such as Photoshop and Illustrator. This facility allows the artist to construct drawings with mathematical precision and also amend images without having to literally return to the drawing board.

However, you should not forget that skill and the fundamental principles of composition determine a great drawing, not a digital special effect. The computer is a flexible and important tool for the professional illustrator, but the time has not yet arrived when it can intuitively draw. The cognition and skill of the artist is still necessary to solve problems and communicate ideas using visual language.

In the example opposite, you can observe how a variety of drawings and character studies are considered in order to illustrate a page within a picture book. This particular sequence within the book refers to a soldiers' card game, and the action is set in nineteenth-century Russia. The drawing is stylized and symmetrical in order to resemble the artwork found on antique playing cards. The artist uses drawing to examine characteristics and poses. Various options and viewpoints are explored through these drawings, which go on to be combined digitally using Photoshop layers.

Successful illustrators will understand why a particular drawing approach is appropriate to an audience. They will be aware of how different methods of mark making influence how an image is read, and be able to select the appropriate tool for a specific job.

1 **Julian De Narvaez uses intricate pencil line to produce sharp, representational, and accurate images. His refined and accomplished skills have a curious, antique quality and demonstrate significant ability that will impress the viewer. Although constructed digitally, this image appeals to an audience that may not be aware of digital technology, because it refers to illustration heritage.**

2 **Leigh Flurry uses a bold, thick, black outline to define the creatures in the drawing. The content is stylized and utilizes a very direct, graphic language appropriate for children's and youth markets. The consistent black outline flattens the objects and reduces the jungle environment to a pattern. The fluid quality of the line work also contributes to this reading. This image is not meant to accurately represent wildlife but to create a mood and atmosphere.**

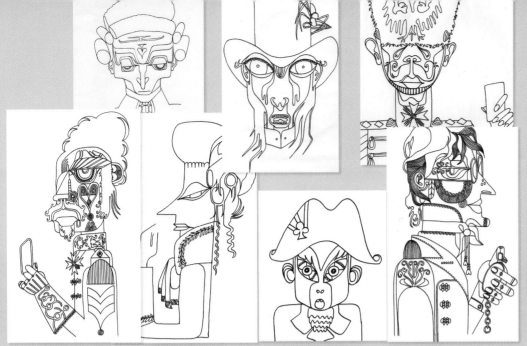

Phase 1 **Sketching**

Initial character studies are produced on paper using appropriate media (ink in this example). Expressions and poses are considered. Costume and setting are examined.

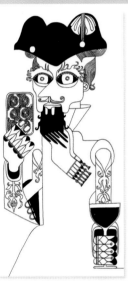
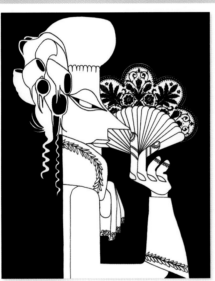
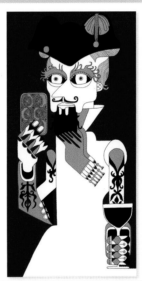

Phase 2 **Editing**

A number of drawings are evaluated, and a decision is made to select the most effective artwork for the final piece. Thought is given to balance, viewpoint, and color.

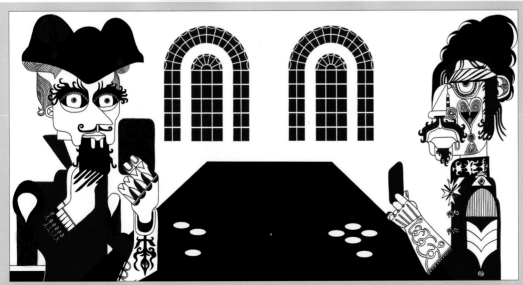

Phase 3 **Construction**

The edited artwork is used to construct the final image in an illustration application. Photoshop layers provide the means to float separate components within the frame in order to achieve balance and an effective end result.

developing a concept

7

A good idea is fundamental to any form of creative practice, and despite all the impressive visual effects that software packages have to offer, this is still true for the digital illustrator. In order to get noticed, illustrators have to use visual language to respond to problems and communicate ideas. The modern illustrator has to digest information provided by a client quickly and then produce innovative solutions that engage and stimulate the intended audience.

Employing a variety of techniques to kick-start your imagination can encourage creative thinking. This could include exploring an unfamiliar medium, visiting a gallery or museum, researching themes in a library or on the Internet, or even taking a long walk. The key is to recognize a good idea when it hits.

In the examples shown at right, we examine how two separate images have developed that respond to very different briefs. The images demonstrate how an idea can evolve in different directions by utilizing alternative visual concepts.

Concept 1

The brief here was to illustrate an article describing Albert Einstein's impact on the world of science. The illustrator decides to produce a contemporary portrait that utilizes familiar imagery associated with this famous figure to produce a montage image.

The image portrays the themes within the article, aiming to capture a sense of excitement and menace that reflects this man's importance in world history. This concept is achieved by combining iconic and recognizable imagery with expressionist, abstract marks.

Step 1 **Add iconic imagery**
An iconic image of Albert Einstein is drawn on paper and scanned. This portrait provides the basis for the image.

Step 2 **Create the background**
A vivid green color and abstract marks are applied to the drawing in order to provide an interesting background. The hair area is filled with white, and this emphasizes a key recognizable feature of the subject within this image.

Step 3 **Add references**
A scientific grid is then introduced. This element refers to the practice and explanation of scientific theory. It also creates a dynamic tension within the composition.

Step 4 **Introduce signage**
Bold, silhouette images of the first atomic bomb are used to reference the devastating outcomes of a scientific discovery.

Step 5 **Colors and letters**
Einstein's most famous equation "$E=mc^2$" and a symbolic reference to the atom are introduced as final components. They are written as if on a blackboard, suggesting urgency and providing contrast with the accurate portrait.

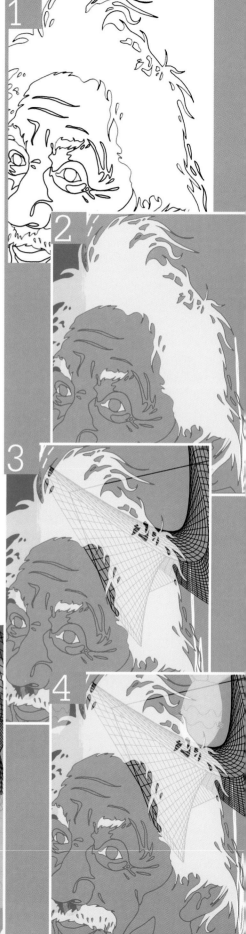

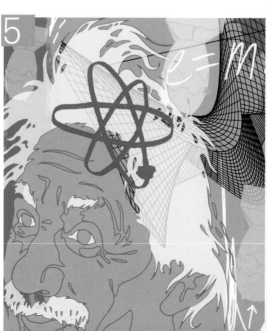

Concept 2

In this example, an illustrator is required to produce a graphic identity for a publisher. The brief requires a simple, bold shape that will be recognized when reduced to a small size—for example, if used on letterheads and business cards. The brief states that the image must refer to publishing or book culture. The illustrator decides to use a traditional bookend as a motif.

The conceptual development of the piece begins with a pencil sketch that is then adapted and transformed using digital software. An ornamental and folk aesthetic is sought out, and this effect is achieved by using a silhouette technique that refers to traditional, antique wood block printing and arts-and-crafts techniques.

Step 1 **Rough sketch**
An initial rough drawing is made by the client to explain the concept and consider the form and content of the artwork. Notice how the artist uses crosshatch red pen marks to suggest areas of tone.

Step 2 **Refining sketches**
The concept is refined through further drawings that describe the shapes in greater detail. This process begins to provide order to the objects within the composition.

Step 3 **Digital reproduction**
The final drawing is recomposed digitally by the illustrator. Notice how the introduction of the computer has formalized and sharpened the composition. This image demonstrates work in progress. Design decisions are in the process of being made (this is evident when we notice the blue areas being considered with the frame).

Step 4 **Design development**
A solid black artwork is then produced. A decision was made to use more pronounced fruit as a symbolic emblem. The bird's tail is also embellished to provide a more stylized and decorative solution.

Step 5 **Character drawing**
The final image as silhouette can be inverted, duplicated, and flipped to resemble bookends. The artist also reintroduced the frame around the image that was identified in the initial sketches. This frame acts to contain the graphic image and creates a solid form around the illustration.

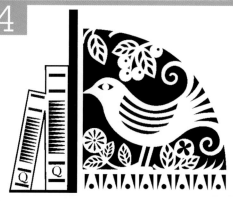

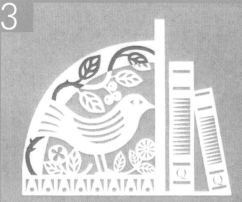

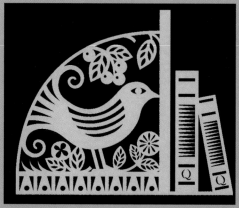

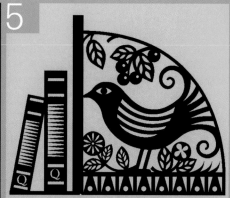

8. using references

Many digital artists use photographs, drawings, and other materials as references for their work. Photographs in particular can help you to build your digital image—for lifelike portraits, objects, or buildings photos can indicate the correct scale and proportions, show details that can improve the accuracy and authenticity of an image, and even indicate color, light, and tone. They can, therefore, be an important part of the digital artist's toolkit.

Keeping a reference library

Many artists build their own reference libraries for quick access to digital photos and scanned drawings and textures (see page 153). The key to a good reference library is naming individual files and folders so that specific images can be found quickly.

On your computer create a folder called "References," and then place within it further subfolders that relate to the subjects of your images. For example, you may want a subfolder called "People," another called "Landscapes," and another named "Objects" or "Props." The choice of subfolder names will obviously depend on the kind of images you make and the references you have available.

Sourcing images

Sometimes you may not be able to get effective references by taking photos or making scans yourself and will have to rely on other sources. You can use the Internet, books, or magazines to provide some of your references. When doing so, try to find high-

Structure your folders so that you can easily locate and identify suitable references.

Creating a reference library

You may need to build up a reference library of your own by taking photographs and making scans, so here are a few tips to help you create an effective reference library.

● Take multiple shots of your subject matter from different angles and varying distances. For example, when making references for a portrait, take one photo that includes head and shoulders, another that focuses on just the head, then focus on key features such as the eyes and mouth.

● If possible, try to isolate your reference object from backgrounds unless the context is an important aspect of your reference. For example, if making a photo reference for a digital watch, try to photograph it against a white or neutral-colored background (a piece of white paper is effective here). Similarly, photograph people and portraits against a wall or similar neutral backdrop. This makes it easier to cut them out if you're going to use the image in a digital composition.

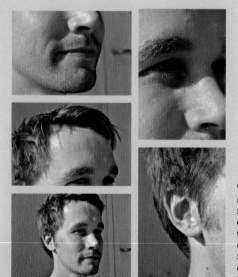

Take multiple shots of your subject, which may include full body poses and areas of detail and features. In this case, the eyes, nose, ears, and hair have been focused on to help build an accurate body of reference for image development.

Use a neutral background to help isolate your subject. Also consider lighting to help define features with shadows and highlights.

resolution images (in Google images, for example, select the "Large" image option) and try to make use of multiple sources to help you secure an understanding of your subject matter.

Some artists rely quite heavily on third-party sources, and although this is occasionally problematic (see Copyright Issues panel), there are a number of ways to make these references work for you. Some artists, for instance, are known to make use of multiple portrait photographs, picking and mixing key parts to create a new image. For example, the shape of the head comes from one source, the lips and nose are taken from another, the eyes from another image, and the hair from yet another, thus creating a new person.

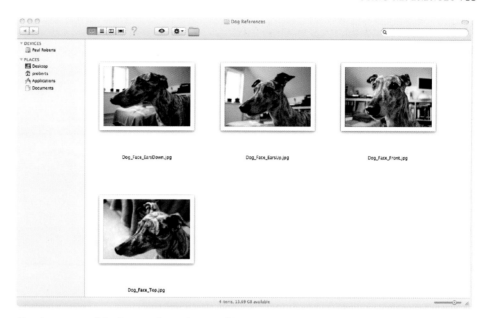

For the names of the images themselves, avoid names that are generic. For example, don't use names such as "dog." Instead, use a name such as "dog_face_closeup."

● Where possible, consider the lighting of your subject matter. When taking photos, try to light your subject in a dramatic way in order to provide interesting and effective shadows. These help to show details. Avoid using your camera's flash because this can flatten out features by filling in shadows. Alternatively, take photos outside during the day.

A basic lighting setup can be accomplished using a poseable lamp or similar device. This can create strong lighting effects, although sunlight is often better for more natural subject lighting.

Copyright issues

Although legal definitions of image ownership differ depending on local laws, it is best to assume that any image you have taken from a source such as the Internet or a book is protected by copyright. This means that while using these images to practice with or to make compositions to share with your friends is acceptable, publishing or selling artwork based on these sources could constitute an infringement of the owner's copyright, and potentially be subject to legal proceedings. Using a combination of sources and mixing these together to create a new image may help to avoid copyright issues, as your image is less likely to resemble the original(s) and therefore will be unrecognizable as a copy. However, it is always best to be on the safe side and use your own references and sources where possible. Alternatively, make use of copyright-free image libraries and image sources.

part 3

Image-making techniques

This section covers a variety of techniques to introduce you to the world of digital art. The first lessons cover the basics of working in Adobe Photoshop, showing you how to set up your files, start to create your first line-art images, add color, and adjust your images. As the lessons progress, more complex techniques are introduced that help you to explore a variety of methods used by professional image makers. You will also be introduced to vector art using Adobe Illustrator, and you will learn how to create patterns and images that are scaleable. Finally, you will be able to explore image-making methods that mimic more traditional techniques, as well as learn about new styles of image making that have recently emerged within the digital context such as pixel art, digital graffiti, and animation.

Lessons are progressive, so it is a good idea to start at the beginning and work your way through the book.

starting a new digital project

The key to effective and efficient image making is to make sure that you are correctly set up for the task in hand. Digital image making can be used in a number of contexts, from print- to screen-based outcomes. This section starts by introducing you to digital file setup to help you get off to a good start, as well as providing a handy reference for later work.

Working in Photoshop often requires an understanding of the context in which your work will be used, be that as a printout, an image on a web site, or as part of an animation. While it is possible to make adjustments to your image during or after the artworking stage, it is best practice to start a new document correctly. Reformatting is sometimes a simple task, but it can often be time consuming or even require an entirely new start to your project.

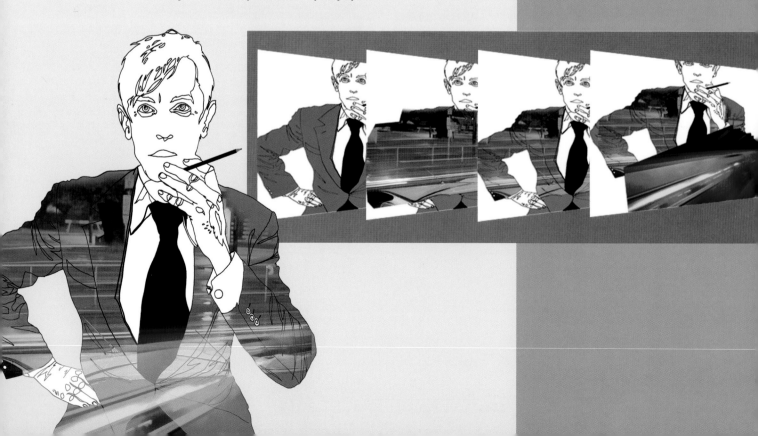

document formats

When starting a new document, it is important to consider how your image is going to be displayed. Some file formats are best for printing, others for viewing onscreen. Getting the right format can affect how good your image looks in its final form, how much detail is preserved, or how long it takes to download or view on your computer. Similarly, the output size of the final document affects how large your image can be printed or how big it looks onscreen. Let's look at how to set up documents in Photoshop and Illustrator.

Photoshop files are pixel-based. That means they record information for each individual pixel (dot) within the file. Increasing the number of pixels by using large values for width and height, increasing the resolution (pixels per inch), and/or including multiple layers, all increase the file size of your final document.

Illustrator documents are vector-based. That means they record information about the entire image mathematically. They therefore tend to have lower file sizes than Photoshop images. Illustrator documents are scale-independent, and retain quality at any size; however, they are less good at reproducing gradients and fine photographic detail compared with Photoshop files. Illustrator files are typically used for strong graphic images that use block color or typographic elements.

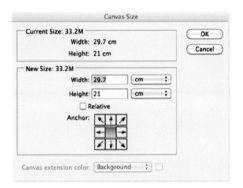

You can use the Canvas Size window to adjust an existing document to make it larger or smaller. Use the Anchor to scale in any direction.

Creating a new document in Photoshop

In Photoshop, create a new document by going to File > New. The New document window will appear. Give your document a name. The window also includes Width, Height, and Resolution setting boxes. Normally, you will have an output size in mind when setting up your new document, and you will know whether it's for print or for viewing onscreen.

Creating a document for print

For files that you intend to print, use the drop-down menu next to Width or Height to set units to centimeters, millimeters, or inches, and input the width and height of the document. You can also select either U.S. Paper, International Paper, and Photo under Photoshop's Preset pull-down menu and choose a standard paper size. Check Resolution is set to 300 pixels/inch. This is the industry standard for printing—lower resolution is possible, but may result in poorer print quality. 72 pixels/inch is adequate Resolution for web viewing.

Note you can also set the Background Contents of a new document—choose among White, Black, and Transparent.

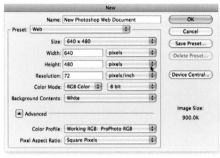

A web-based document format. Use pixels rather than inch or cm measurements for screen-based formats.

Creating a document for web

For outputs intended for screen, set units to pixels and Resolution to 72 pixels/inch. Again, set the width and height to an appropriate size—the Preset options allow you to set up for Web, Mobile & Devices, and Film & Video. Be aware that screen-based images are limited to the screen size of your intended viewing device. For animations and film, the screen size will range from 720 x 480 pixels up to 1920 x 1080 pixels (HDTV). Web-based formats range from 640 x 480 up to 1600 x 1200 depending on screen resolution.

Select the appropriate color mode

Use CMYK for print outputs and RGB for screen-based outputs. The appropriate mode will already be selected if using the Preset options, although it is best however to check that your color mode reflects your intended output. CMYK color mode can affect the options available to you in Photoshop, such as the effects you are able to apply. One way around this is to set the new document to RGB, and convert to CMYK before saving by going to Image > Mode. Be aware that this change may affect the colors within your image.

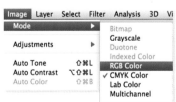

Color Modes can be switched while a document is open, which is helpful for converting RGB screen images to CMYK print images.

A new Photoshop setup using preset Paper sizes. Use Presets for common print- and screen-based formats.

Creating a new document in Illustrator

Go to File > New to bring up the New Document window. Give your file a name. Under New Document Profile, select the most appropriate option for your document. It's likely to be either Print or Web.

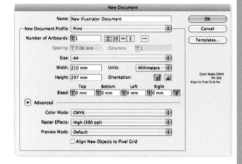

Creating a document for print

For print, either select one of the presets in the Size pull-down menu, or use the Width and Height boxes to input a custom size. For print projects, Illustrator sets units to millimeters by default, but you can change this under Units if you wish. Click on the Advanced button to reveal further options. Color Mode defaults to CMYK and Raster Effects (resolution) to 300 ppi for print projects.

Creating a document for web

For Web projects, Illustrator offers some common pixel-based presets under Size, or input your own custom size if necessary. Note how Units defaults to Pixels when Web is selected. Clicking the Advanced options reveals Color Mode set at RGB and Raster Effects (resolution) set to 72 ppi—as you would expect for screen-based documents.

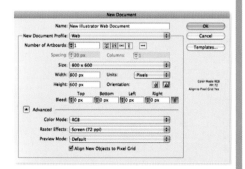

New Illustrator documents are created in a similar way to Photoshop, although offer more options linked to print outputs such as bleed and multiple Artboards.

10 file types and output sizes

When saving or exporting (Illustrator) your file, there is a number of file types to choose from. The file type you select depends on the intended usage.

The standard Photoshop PSD (.psd) and Illustrator AI (.ai) formats retain layers and other program-specific information, allowing you to save and edit your work at a later date should you wish to. Other formats (described below) are available; however, once saved in most of these formats, you will lose the ability to edit layers or other program-specific elements.

Print formats

Assuming you've finalized your artwork and won't want to return to it, file formats such as TIFF and PDF are effective for printing, as they retain the quality of the image. They are also good for sharing, as they are accessible across different software and hardware platforms. JPEGs can also be used for printing, but make sure compression settings are set to minimum (for highest-quality print).

Screen formats

JPEGs are a standard format used on the Internet alongside GIF and PNG files. These files take up less physical space on your computer and are quicker to download; therefore, they are superior for screen-based methods of presentation. JPEGs are best used for photographic images. Use GIFs for line art and block color images, and PNG where transparency is required—PNG files are also used within Flash animations and web applications.

Photoshop has a specific Save for Web & Devices option (File > Save for Web & Devices) that allows you to optimize files for web-based use. This allows you to adjust JPEG compression (higher compression for smaller file size), the number of colors used by GIF images, or make use of PNG file transparency settings.

Illustrator uses Export (File > Export) to convert vector-based images to pixel-based images. An additional export option window allows you to set output options for files such as JPEG or TIFF formats, including

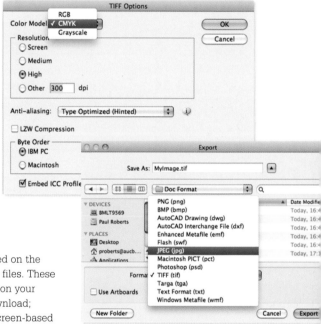

Try to choose the correct file format and color mode when saving your files. Popular and versatile formats include JPG, PNG, and TIFF.

compression, color mode, and the physical dimensions of your file. These are dependent on the file type you select.

You may also encounter SWF, AVI, MOV, and MPG files, which are primarily for animation and interactive formats. These will be discussed in later chapters of the book.

P

scanning a drawing

The scanner is a vital and versatile tool for the illustrator. It provides a bridge between analog and digital techniques—a means by which the artist can capture sketches, textures, photographs, and other components so that he or she can compose them digitally. Scanning equipment and software comes in many shapes and sizes, and for the purposes of this book, we are going to look at the conventional desktop, or flatbed, scanner.

A direct high-resolution scan offers a much more accurate and precise reproduction of your flat artwork than a studio photograph could ever capture. This is due to how the scanner works: flat artwork is placed on the glass of the scanner and a lens moves slowly under the glass, digitally recording the qualities of the artwork in fine detail.

For the purposes of simplicity, we will follow the scanning process for a black-and-white image, ink drawing on paper.

SCANNING TIP

If given a scanning mode option, always use the advanced mode when making a scan. This advanced interface provides you with the best options with which to prepare and manipulate your image.

Step 1 **Place drawing on scanner**

Place a drawing face down onto the glass surface of your flatbed scanner. In this example a black-and-white line drawing is used. Open your scanning software—here we're using Image Capture. In the software, select the scanner. With Image Capture, the device is visible in the top left corner of the Image Capture window. Ignore the automatic prompt and do not press Scan right away.

Step 2 **Controls**

To get the best-quality scan, find the advanced scanning controls. In this example, these are found by pressing the Show details button, with the advanced controls appearing on the right-hand side of the window. A preview scan will begin automatically and provide you with a quick, provisional representation of your image.

Step 3 **Preview scan**

Using the preview scan, the scanner software will automatically select what it deems to be the image area, and a cropped selection will frame the drawing. This selection may not always pick up delicate areas of tone, so you should aim to provide a greater surface area around your artwork to be controlled and cropped at a later date. This selected area can be expanded and controlled by circular anchor points. Click and drag these points further from the edges of the drawing until you are satisfied that the whole artwork is contained within the selection box.

Step 4 **Image type**

In the advanced scanning controls, select the appropriate image type, which for a line drawing is Black & White.

Step 5 **Resolution**

Because this image will be printed, set the Resolution to 300dpi.

The advanced interface at Step 5 provides you with more control as to how your original artwork is recorded.

Press "Scan" to start...

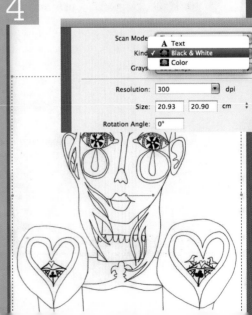

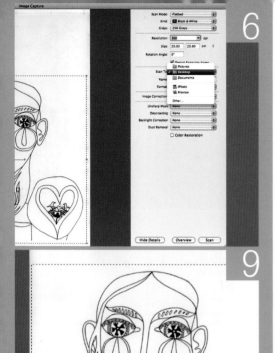

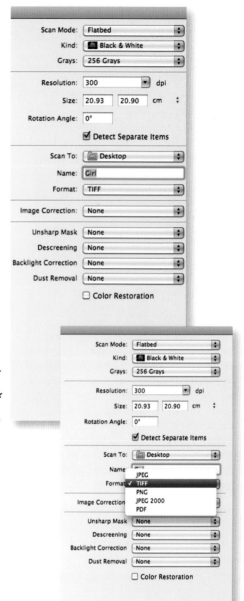

Step 6 **Location**

Next you need to select the location for the scanned image. The Desktop is usually a convenient place; from there, you can access the scanned image quickly.

Step 7 **Name**

Now give the file a name—in this case "Girl."

Step 8 **File format**

In terms of file format, select Tiff, as this provides the best-quality scan.

Step 9 **Scan**

Having set the advanced options, you are now ready to press Scan. It should only take a matter of seconds for the scanning device to complete this task, and the final artwork will appear on your desktop labeled Girl.tif, ready for you to work on.

Use the scanner interface to name your file at Step 7. This will help you organize your documents once they appear on the desktop.

At Step 8, use the drop menu called Format to select the Tiff option. This file will be ideally suited to convert into a Photoshop document.

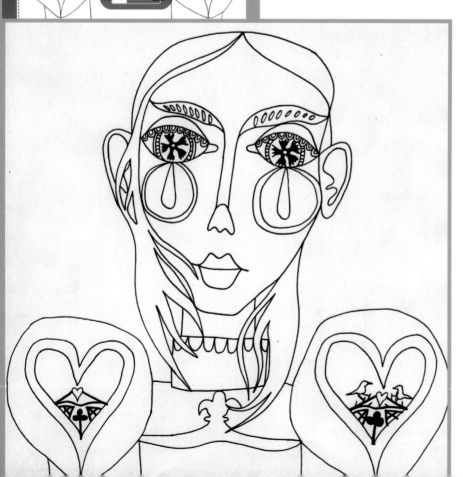

The finished scanned image should include all the content that you require. Be sure to check all the edges of the image to ensure you have not missed anything or clipped an edge by accident.

scanning unfamiliar objects

Desktop scanners are almost always designed for letter (A4), or in some cases legal (A3), size paper. This should always be taken into account when selecting a surface on which you make your drawing. However, this should not limit you in terms of the surface you select to make your drawing. Don't feel you always have to work directly on white paper. Your scanner is a versatile tool, so try and scan a variety of objects and surfaces.

Be innovative. If an image requires the texture of metal, don't spend hours trying to recreate this effect with brushes. Find a metal surface that fits your machine and scan it. Try to surprise yourself and consider all the objects that could fit. Plastics, glass, coins, circuit boards—all of these objects could provide content for your images.

If you are going to scan any objects that may scratch your scanner, you should first lay a transparent acetate sheet over the glass surface. This acetate sheet must fill the whole scanner window so that when you lay these foreign objects upon the machine, you will avoid scratches and abrasions.

The example provided here uses a real broken audio cassette in order to add contrast and visual interest. The image captures the broken, raw energy of contemporary sampled dance music.

Step 1 Scan the object
Lay a transparent acetate sheet and a white paper background (if required) on the scanner glass and place your object onto the scanner between the acetate and paper. Close the scanner lid. Scan the object and open a new Photoshop file.

Step 2 Import a line drawing
Scan a line drawing and import it into the composition (see page 49).

Step 3 Arrange your images
Make the drawing transparent using the Blending mode found in the Layer window (see page 59) and place it above the scanned object.

Step 4 Import additional imagery
Additional photographic imagery is imported in a separate layer (see page 153). These brass horns refer to the eclectic and diverse qualities found in contemporary dance music.

tip

If you want to scan printed material such as imagery in books or magazines, use the Descreen options found on the scanner interface (see opposite).

13 refining a scan

Once you have scanned your artwork, it may be that the raw data will need to be refined. The artwork may look a bit dirty or fuzzy. This is because scanning devices are so sensitive that they record the paper grain and every blemish on the surface of your drawing. These extra textures can distract from your original drawing and may need correcting. This is an important skill to acquire and fundamental to composing effective digital artwork.

Curves and Levels commands provide means of achieving these adjustments. Both these tools work by adjusting the tonal range of an image. This means they essentially perform the same task. The difference between them is that Levels controls are essentially linear and therefore apply in a broad and non-specific way to the artwork. Whereas Curves' geometric adjustments offer more precision, allowing you to control which elements of the image you want to enhance.

Experiment with each tool in order to find the right degree of image modification to suit your needs. There are no hard-and-fast rules here. It's down to the requirements set in the brief and your critical judgment as to what constitutes the correct effect. Try to retain a light touch, as even minor adjustments to either Curves or Levels can have a significant effect on how your image looks.

Refining with Levels

One means of refining a scan is the Levels command. Levels uses a histogram and three sliders to control the brightness levels within your image. The three triangular-shaped sliders let you specify the amount of black, gray, and white you require.

Step 1 Open the levels command
Go to Image > Adjustments > Levels to open the Levels dialog window.

Step 2 Levels control
The Levels dialog includes a histogram that you can use to adjust your image as required. There are two means with which to operate this tool—Input levels and Output levels. Make sure the Preview option is selected so you can observe how the tool affects the artwork.

Step 3 Output levels
Output Levels are controlled by two sliders at the bottom of the Levels window. These sliders adjust the tonal qualities of the whole image. As with the Curves command, drag the white slider from left to right. This will darken the entire image.

Step 4 Input levels
Input Levels offer much greater control via three triangular arrows found under the histogram. Notice the three arrows are each identified by tone—black, gray, and white. Drag the black and white arrows toward the center of the control slider so that they're almost touching the gray arrow. Notice how the contrast is heightened and again how the line work is much more clearly defined out of a pure white background.

Step 5 Final result
What you should be aiming for is a crisp image with stark definition between black and white areas. The original gray paper texture should no longer be visible.

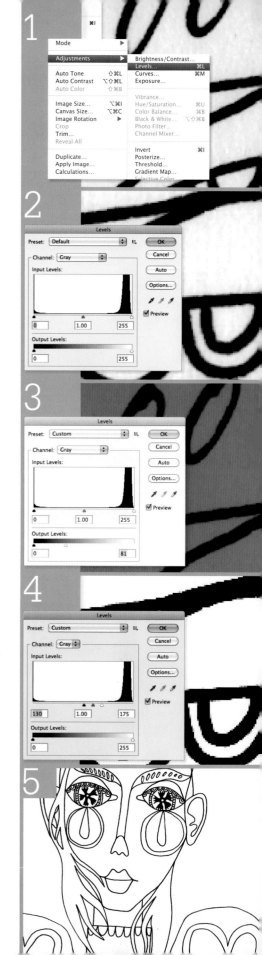

Refining with Curves

The Curves command controls tone and contrast, and is a powerful yet versatile image-editing tool. It takes the existing tonal qualities within an image and lets you stretch or compress them. The tonal curve is controlled by any number of anchor points. In this example, we will be applying an "S" curve. This adds contrast to the midtones while doing the opposite to the shadows and highlights. This simple adjustment creates a more defined image.

Step 1 **Zoom into the scan**
Once you have opened your scan in Photoshop, use the Zoom tool to magnify your image. As you zoom in, you will notice that the paper texture is clearly visible and the ink lacks definition. This needs to be cleaned up to improve the quality of the artwork.

Step 2 **Open the Curves command**
Go to Image > Adjustments > Curves to open the Curves dialog window.

Step 3 **Curves control**
The Curves dialog includes a histogram that you can use to adjust your image as required. There are two means with which to operate this histogram—a graph and two sliders, one black and one white, located under the graph. Make sure the Preview box is selected so you can watch how the tool affects your artwork.

Step 4 **Adjust the slider**
The sliders adjust the tonal qualities of the whole image. Drag the white slider from left to right to examine its effect on the artwork. Using the sliders creates drastic adjustments and should be used with caution and very rarely.

Step 5 **Adjust the graph**
The graph is the preferred means of adjustment for this particular technique. Use the mouse or touchpad to pull the points and drag the graph to form a subtle "S" shape as shown here. The texture of the paper has disappeared and the line work is much more clearly defined.

tip
Never use the Brightness/ Contrast command to adjust or amend raw scans. It can severely affect the contrast of your image and is a blunt tool in comparison with Curves or Levels.

Make sure the preview box is checked so that you can view how the curve adjustment is affecting your artwork.

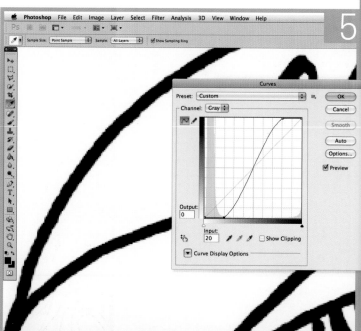

14 editing a scan

Having achieved a clean and defined image of a drawing, it's now possible to amend any details or errors within your original artwork. Photoshop lets you revise your artwork at any point during the design process, but it is a good habit to check your scanned image at this early stage. Use the Zoom tool to make sure there are no errors or blemishes that could cause problems when the artwork is complete and outputted at a later date.

There are many ways to correct mistakes in your artwork with Photoshop, but the most appropriate for this specific task is the Polygonal Lasso.

Step 1 **Polygonal lasso**
Click on the Lasso icon in the Toolbox. A small drop-down menu will appear from which you select Polygonal Lasso.

Step 2 **Select area**
Return to the Zoom tool and magnify the area that requires attention. Reselect the Lasso and, using a mouse or touchpad, click points to create a shape that encompasses the area you wish to correct.

Step 3 **Fill**
Go to Edit > Fill or click the Paint Bucket tool in the Toolbox and then click in the selected area.

Step 4 **Fill dialog box**
The Fill dialog box will appear on your screen. Using the options available within this box, set Contents Use: White and Blending Mode: Normal, and Opacity: 100%, then select OK.

Step 5 **Deselect**
The unwanted line is now erased. To deselect the area go to Select > Deselect in the Menu bar.

There are two options available when you need to fill areas with color. The Paint Bucket found in the Toolbox, which is the quickest route, or Menu > Edit > Fill, which provides more control over how you want the fill to be applied.

The Fill dialog box lets you determine the contents color and the Opacity of the filled area. Use the drop-down menus to make your selection.

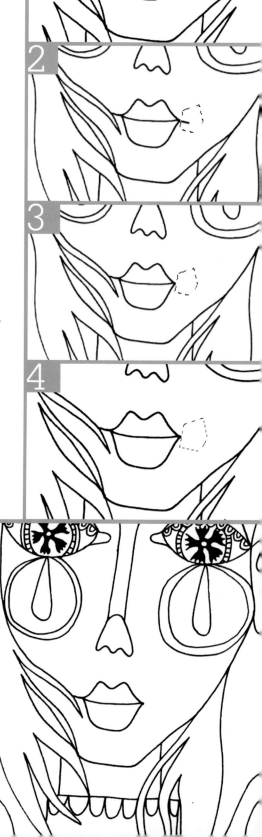

drag and drop

A useful Photoshop feature is the ability to drag layers between image files. This simple technique allows you to experiment with and arrange images quickly. Of course, you can use the copy and paste commands found in the menu, but the quickest way to move elements between image files is to use the drag-and-drop method described here.

When you open more than one Photoshop image file, you'll notice that they open within the same document window. Each file appears with a separate tab at the top of the window, within which is the file name. Click on the tab to select the file you want to work on.

Step 1 Open the image files
Here we're going to float a silhouette image of a band over a textured background. The two image files are called "band" and "background." Notice how you can navigate between the two files by clicking the relevant tabs at the top of the window.

Step 2 Select the file content
With the file open, go to Select > All. This will select the content in the image.

Step 3 Move the band content
Select the Move tool and click within the band image. Hold the mouse button and drag the layer content toward the file tab Band and then across the top of the window toward the background tab. When the Move tool is above the background tab, you should notice that the tab turns light gray and the background file will be selected.

Step 4 Release the mouse button
Once you release the mouse button, the selected layer content from the first file (Band) will appear in the background image. Notice that the Band image appears in a separate layer (Layer 1) in the background Layers palette.

Step 5 Position the band
Use the Move tool to place the Band layer in the composition.

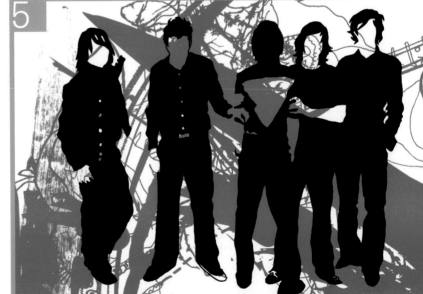

Select	Filter	Analysis	3D
All			⌘A
Deselect			⌘D
Reselect			⇧⌘D
Inverse			⇧⌘I
All Layers			⌥⌘A
Deselect Layers			
Similar Layers			
Color Range…			
Refine Mask…			⌥⌘R
Modify			▶
Grow			
Similar			
Transform Selection			
Edit in Quick Mask Mode			
Load Selection…			

The keyboard shortcut for Select All is Command + A.

using layers

Layers are a fundamental aspect of digital composition. They give the artist the means to isolate and manipulate compositional components within a picture, thereby creating infinite options when it comes to constructing complex images. Crucially, layers allow the artist to adapt and amend the artwork at any point in the design process.

A good way of understanding how layers work is to think of them as layers of paint that are applied at various stages throughout the creative process—similar to the way in which silkscreen printers apply layers of ink to build an image. Transparent and opaque inks are layered in sequence to provide variety and depth within the composition.

Working in layers ensures that a diverse variety of media can be combined within one artwork. The example shown here demonstrates how high-resolution photographic material can be blended with detailed line artwork and flat color.

PHOTOSHOP LAYERS PALETTE

Layer
A solitary component within your image.

Eye symbol
This icon indicates whether the layer is visible or invisible. Click on it to turn the layer "on" or "off."

Background layer
This layer provides a permanent flat color filling your canvas. Although usually locked, it can be deleted if you want your image to float within the edges of the canvas.

Type layer
This layer contains type only. Type is applied using the Type tool in the Toolbox.

Blending mode
Changes the way layers interact with each other.

Opacity
Controls the transparency/opacity of the layer.

Locks
Means by which you can protect layers within the composition.

Waste bin icon
Click to delete any selected layer.

New layer icon
Click to create a new layer.

New adjustment layer
Allows a variety of adjustments to be made to specific layers.

Create a new group
Lets you put selected layers into folders.

Layer mask
Allows you to mask and protect areas before amending your composition.

Layer styles
Lets you apply a variety of effects to your image.

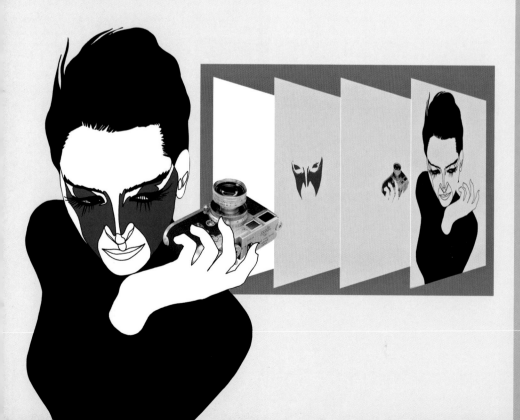

adding fill color

The immediacy with which flat areas of color and tone can be applied to an image is a real advantage for the digital artist. This ability is made possible by the selection tools available in Photoshop. These tools include Quick Mask, Rectangular Marquee, Elliptical Marquee, Lasso, Polygonal Lasso, and Magnetic Lasso—however, the quickest and easiest means with which to add color to a line drawing is with the Magic Wand tool.

The Tool options bar provides all the controls necessary to make a selection. You can even change the Tolerance settings as you make multiple selections.

The Set foreground color icon displays the current color in use. When clicked, it provides access to the Color picker dialog box.

The small arrow to the top left of the color icon lets you switch between background and foreground colors. The small diagram of squares to the top left of the color icon returns the colors to their default setting (Black & White).

Step 1 **Select areas**

Open a line drawing in Photoshop. Name this layer "Line drawing." With the Magic Wand tool begin selecting areas of the drawing.

Step 2 **Multiple selections**

To make multiple selections, go to the Tool Options bar at the top of the screen and click the Add to selection icon (second from the left).

Step 3 **Magic wand**

You can also control the sensitivity of the Magic Wand tool via the Tolerance setting in the Tool Options bar. It should usually be set to around 32, a generic setting. It is worth experimenting with Tolerance to get an understanding of how this feature works. Put high and low numbers into this dialog box and see how it affects the scale of your selection.

Step 4 **Set foreground color**

Click on the Set foreground color icon at the bottom of the Toolbox to bring up the Color Picker dialog box. Explore this interface to look for appropriate colors. When you have selected a color, press OK.

Step 5 **New layer**

Go to Layer > New > Layer to create a new layer ("Fill color"), or click the Create a new layer icon at the bottom of the Layers palette.

Step 6 **Fill**

With the new layer highlighted apply the color to your selection. Either go to Edit > Fill or click the Paint Bucket tool (it shares the same location as the Gradient tool) in the Toolbox and then click within the selected area.

tip

Always make sure you fill color into a new layer above your drawing; otherwise, you will permanently alter your original artwork and this will have implications if you are going to make amendments later.

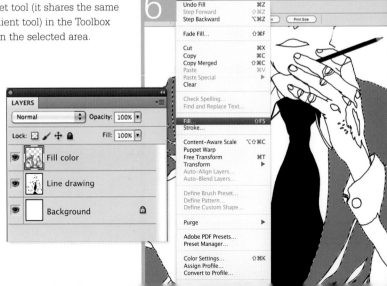

creating transparency

P Layer opacity is a useful Photoshop feature. It can create the illusion of transparency and make layer content blend and interact visually. The effect replicates layers of ink and the analog practice of collage in that objects can appear behind other objects and shapes can become visible through layers of imagery.

Layer opacity provides a means to construct images using many different components and materials. You can use Opacity to blend complex combinations of layers and produce harmonious and balanced outcomes.

Transparencies can be used to create the illusion that the viewer is looking at something authentic, rather than digitally enhanced. This technique can be understood in terms of traditional liquid media such as paint or ink.

The example shown below demonstrates how Opacity is adjusted by the sliding control found in the Layer window. Notice how, as the percentages in the input box decrease, the layer content's color fades and lightens.

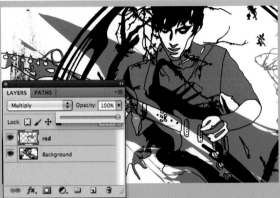

1. A Photoshop document is opened with two layers. The top layer contains a red filled area. This layer content is opaque, as the Opacity sliding control is set at 100%.

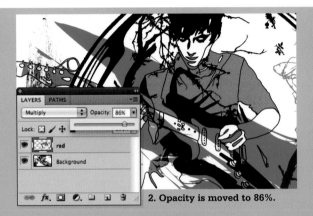

2. Opacity is moved to 86%.

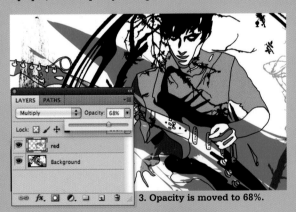

3. Opacity is moved to 68%.

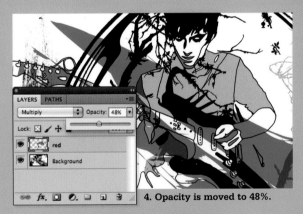

4. Opacity is moved to 48%.

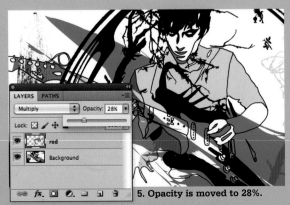

5. Opacity is moved to 28%.

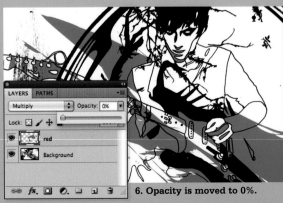

6. Opacity is moved to 0%.

blending modes

Blending modes can add special effects to artwork, and are a great way of distorting and adding depth and richness to content. They provide the illustrator with numerous ways in which to merge and combine layers. Without these modes, layer content would simply overlay opaque shapes and would obscure objects within a composition. The transparent qualities of blending modes mean that layer content can fuse and intertwine.

There are a number of different blending modes, so explore the potential of each by examining how they create different interactions between the layer content.

In this example, we will use a portrait of Charles Darwin that has already had color applied, yet requires further points of interest around the face. Hue and Saturation blending modes are used to provide texture, fusing colors with harmonious effects.

Hue and saturation blending modes

Hue and saturation are blending modes that have been designed for digital photographers and artists to provide very subtle alterations to photographic imagery in post production.

Step 1 Open a file
Open a Photoshop file that requires attention—in this case, a portrait of Charles Darwin.

Step 2 Add a second image
Now open another file in Photoshop and drag this into your composition. In this example, we are using an image of cell organisms taken by a microscope. This new layer is called "microscopic" and can be positioned above the other layer using the Move tool found in the Toolbox. In the Layers window, notice that the Blending Mode default setting for this new layer is Normal and the image is 100% opaque.

Step 3 Hue
Using the Blending Mode drop-down menu, select the Hue mode. This will automatically alter the layer content, and results in a subtle fusion of color properties. Notice how this particular mode acts as a mask when used on a white background; layer content is only visible on tonal areas.

Step 4 Saturation
In order to examine how further alterations could improve this image, return to the layers window, find Blending Mode, and select the Saturation mode. Notice how this mode also acts as a mask on white and provides an alternative to the Hue mode.

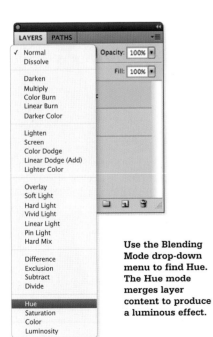

Use the Blending Mode drop-down menu to find Hue. The Hue mode merges layer content to produce a luminous effect.

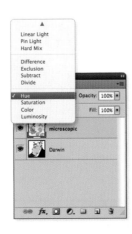

Use the Blending Mode drop-down menu to find Saturation. The Saturation mode merges layer content to produce an alternative luminous effect.

Overlay and lighten blending modes

The Blending Modes available in the layer window have often been created for very specific purposes. Overlay and Lighten blending modes work by merging images in striking ways.

In this example, we show how Blending Modes can be used to fuse line artwork and color photography to create texture and depth. This is also a good example of how a library of textures can be utilized to add visual impact to your artwork.

Step 1 Open
Open an example of line artwork.

Step 2 Add a photo
Now open a color photograph and drag this into your composition using the Move tool. Ensure the new image's layer (it will have the default name Layer 1) is positioned at the top of the Layers palette; click and drag it to the top if necessary.

The Photoshop layers palette at Step 2, showing the imported photo as a new layer.

Step 3 Overlay
The Blending Mode drop-down menu is found at the top of the Layers palette. Experiment with the various modes. In this example, an Overlay blending mode is selected. Notice how this particular mode acts as a mask and the layer content follows the contours of the artwork below.

Step 4 Add another layer
Add another color image to the composition and create another new layer. As before, this new image should be placed at the top of the existing layers.

Step 5 Lighten
Return to the Blending Mode menu and experiment with some alternative effects. In this instance, the Lighten blending mode has been used.

Use the drop-down menu found in the layer window to select Overlay. This will instantly affect the content of your image.

A blurry photo is taken from the image library (see page 153) and applied to the composition.

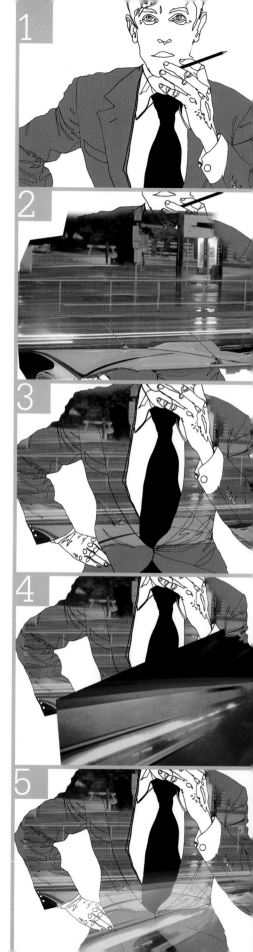

Screen and multiply blending modes

A successful digital illustrator relies on familiar textures, brushmarks, and reference material that signify artistic voice (see pages 152–153). Blending modes such as Screen and Multiply merge this disparate content. These modes provide special effects that help define the form and contours of shapes, and use transparency to fuse and blend components within an image.

This example demonstrates how blending modes can be used to combine photographic elements and textures to enhance artwork, creating depth, contrast, and points of interest.

Use the drop-down menu in the Layer window to select Screen. Experiment with all the modes and begin to understand how they can enhance your images.

Step 1 **Open**
Open a Photoshop file that would benefit from the addition of transparent elements.

Step 2 **Add a photo**
Open another file in Photoshop (in this example, a black-and-white photograph) and drag this into your composition. This new layer is called Building and can be positioned above the other layer using the Move tool found in the Toolbox. In the Layers palette, notice that the Blending Mode default setting for this new layer is Normal and the image is 100% opaque.

Step 3 **Screen effect**
Using the Blending Mode drop-down menu, select Screen effect. Notice how this mode acts as a mask. Layer content is only visible on areas with tone, not on white.

Step 4 **Add another graphic element**
Drag another Photoshop file into the composition, creating a new layer called "Silver Paint." This new layer should be placed on top of the existing layers. This example uses a scanned paint mark. The Blending Mode menu reads Normal.

Step 5 **Multiply**
Set blending mode to Multiply. The Silver Paint layer will now appear transparent, with the original artwork visible beneath.

Step 6 **Change the opacity**
Use the Opacity slider in combination with blending modes in order to reduce the starkness of the layer content. In this example, a subtler blend is achieved by reducing the opacity of the Silver Paint layer.

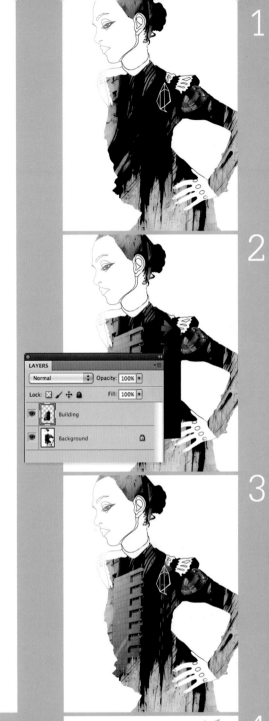

19

using layer masks

P Layer masks provide a way to isolate and amend elements within a digital image. They mask-out selected areas within a picture and give you more control over how layers interact with each other. Layer masks work by letting you control the transparency/opacity within defined areas.

Masks are especially useful when making amendments. You can adjust and edit images using layer masks without deleting any of the original layer content, and you can also turn them on and off when reviewing your artwork.

Here we'll use layer masks to combine photographic imagery and flat color to create striking graphic images. We'll use a silhouette layer mask that can be inverted and turned off if required.

Step 1 Cut
Find a bold, graphic shape you want to use as a layer mask (in this example, a silhouette). Using the Rectangular Marquee tool, click and drag to provide a selected area around your chosen image, and go to Edit > Cut.

Step 2 Open photo
Now open a detailed photographic image to use to fill your silhouette. Go to Edit > Paste and the original graphic will now appear as a new layer, concealing the photo beneath. Name this new layer (we've named ours "floating girl") and select it.

Step 3 Magic wand
Select the Magic Wand tool from the Toolbox, and in the Tool Options bar check that Tolerance is set to 32. Click within the black graphic image to select the silhouette.

Step 4 Layer visibility
In the Layers palette, click the visibility (eye) icon on the "floating girl" layer. This button indicates layer visibility, and if clicked will turn off the layer content. The floating girl silhouette will disappear; however, the selected area around the figure is retained.

Step 5 Add layer
Select your photographic layer (in this case "the street") and click the Add layer mask button at the bottom of the Layers palette. A layer mask containing the outline of the silhouette is applied to the photograph, masking out everything other than what appears within the silhouette.

Step 6 Unlink mask
Click the small chain icon that indicates the layer mask is linked to the layer. This will remove the link between the layer and the mask. Select the Move tool and you can now move the mask freely across the photographic content on "the street" layer.

Step 7 New layer
Go to Layer > New > Layer. In the New Layer window, create a new layer entitled "color."

Step 8 Fill color
Next go to Edit > Fill. Bring up the Fill dialog box. Under Contents, select Color in the Use drop-down menu.

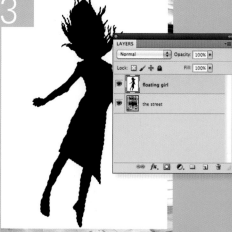

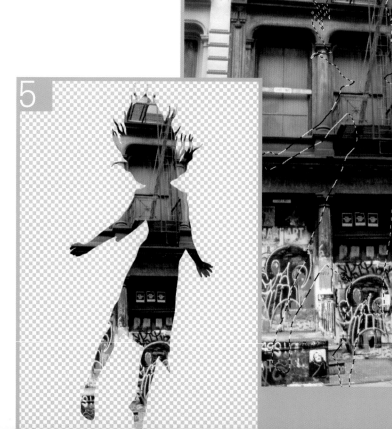

Step 9 **Fill layer**

In the resulting Choose a color window, use the picker to select a color. Press OK. You will return to the Fill dialog box. Press OK and this will fill the layer entitled "color" with your chosen color.

Step 10 **Layers palette**

Return to the Layers palette. Drag the "color" layer below "the street" layer. This will provide a flat color background and emphasize the detailed content within the silhouette.

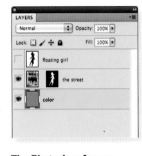

The Photoshop Layers palette at Step 10, showing the new arrangement of the layers.

Step 11 **Turn off layer mask**

To turn the layer mask off at any point, select the layer mask icon in the Layers palette and go to Layer > Layer Mask > Disable.

Step 12 **Turn on layer mask**

To turn the layer mask back on select Layer > Layer Mask > Enable.

Step 13 **Invert**

If you want to see the image inverted, check the layer mask icon is selected in the Layers palette, and go to Image > Adjustments > Inverse.

Step 14 **Apply**

Once you are happy with the composition within the mask layer, compress the mask and the original content with Layer > Layer Mask > Apply.

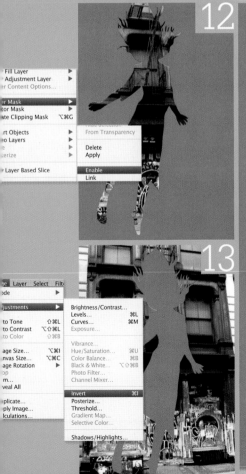

color and alterations

The following lessons form one of the major sections of this book and will introduce you to a number of techniques that will allow you to create stunning visual imagery. They start by introducing you to some of the basic tools relating to adding and refining color. They then build by exploring editing techniques such as the Marquee and Lasso cutout and selection tools that will enable you to refine your image and make precise use of image elements and adjustments.

A case study of Julian De Narvaez's work rounds off this section, looking at how a variety of the preceding techniques are used by a professional digital artist.

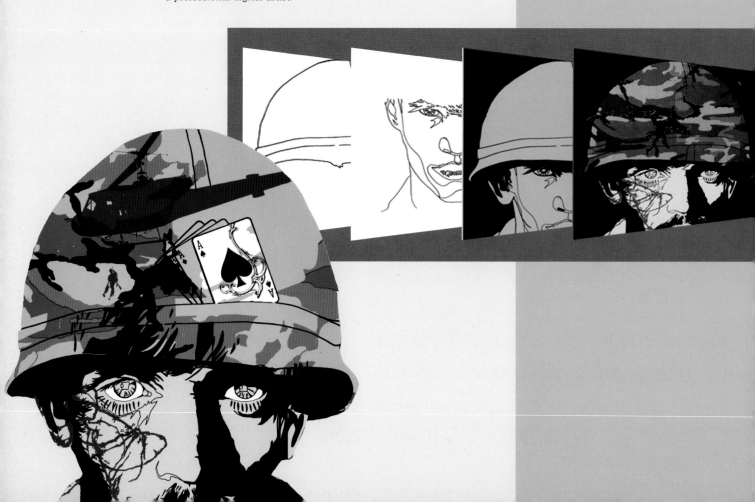

selecting colors

Photoshop provides a variety of ways to select colors. The quickest is to click the Set foreground color icon found at the bottom of the Toolbox. However, two other palettes can be selected via the Photoshop menu, which provide alternative means of selection and application.

The Color and Swatches palettes allow you to alter and store color information. They are accessed via the Window menu and can be dragged around while the artwork is being assembled. This provides ease of access to your "paint," and replicates the experience of the traditional painter in that specific colors are close to hand and surrounding the canvas.

In this lesson, you will learn how to pick and store color information using the Eyedropper tool and the Swatch palette. You will also open the Color palette to amend color settings.

Step 2 **Select a color**
To upload a new swatch, select the Eyedropper tool in the Toolbox. The Eyedropper allows you to pick colors from artwork and other palettes. Now use the Eyedropper to select a specific color within your artwork. Notice how the Set foreground color icon in the Toolbox changes, indicating a new selection.

Step 3 **Define a new color swatch**
A new color selection can be added to the Swatches palette by simply clicking the Create new swatch of foreground color icon at the bottom of the palette. This color information is now saved and can be selected at any time during the creative process.

Step 4 **Open the Color palette**
Go to Window > Color. The settings in the Color palette represent the selected color found in the Set foreground color icon.

Step 5 **Adjusting and selecting colors**
The Color palette uses sliding controls and a color ramp to control color settings. The Eyedropper will let you pick any color available in the ramp spectrum. Notice the black-and-white squares at the right end of the color ramp. These can be used to quickly select black and white.

Step 1 **Open the Swatches palette**
Go to Window > Swatches. The Swatches palette will have a sequence of default colors already in place. The colors are contained within small squares. By uploading your own color ranges, you can define your own limited palettes.

Step 6
Alternative color modes
Additional color modes can be accessed via the button in the top right of this palette. The drop-down menu includes a variety of options and should be used if you intend to work within a specific color range; otherwise, stick to the RGB slider. This will give you the broadest and most vivid palette.

indow | Help
Arrange ▶
Workspace ▶

Extensions ▶

3D
Actions ⌥F9
Adjustments
Animation
Brush F5
Brush Presets
Channels
Character
Clone Source
Color F6
Histogram
History
Info F8
Layer Comps
Layers F7
Masks
Measurement Log
Navigator
Notes
Patagraph
Paths
Styles
Swatches
Tool Presets

Application Frame

Find the Swatches window at the bottom of the Window menu. A tick next to the title identifies open windows.

The RGB color sliders provide the most vivid and extensive range. Use the CMYK option when preparing images for printing.

Grayscale Slider
✓ RGB Sliders
HSB Sliders
CMYK Sliders
Lab Sliders
Web Color Sliders

Copy Color as HTML
Copy Color's Hex Code

RGB Spectrum
✓ CMYK Spectrum
Grayscale Ramp
Current Colors

Make Ramp Web Safe

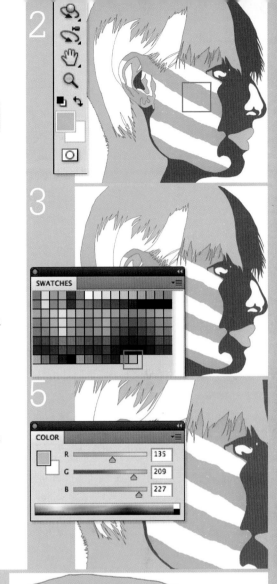

21

identifying and altering colors

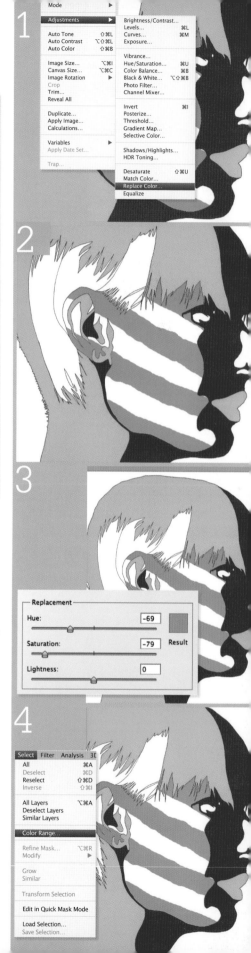

P The Replace Color and Color Range commands are very effective ways to identify and alter areas of color without having to resort to any painting or selection tools. Both commands can identify specific areas of color and tone within an image, replacing selected areas quickly and efficiently.

In this lesson, we will use a bold graphic image to demonstrate how areas of color on separate layers can be selected and quickly amended.

Step 1 Select a color
In the Layer window, select a layer that needs to be amended. Use the Eyedropper tool to select the color to be altered. This color will be visible in the Set foreground color icon at the bottom of the Toolbox. Go to Image > Adjustments > Replace Color.

Step 2 The Replace Color dialog
In the Replace Color dialog box, ensure the Preview button is checked so that you can view any alterations. In the Selection box, you'll see a black-and-white image. This identifies the areas that have been selected—white being the selected area. The Fuzziness sliding scale lets you expand or contract the selection. Use the + and – eyedropper icons to add or delete selected areas.

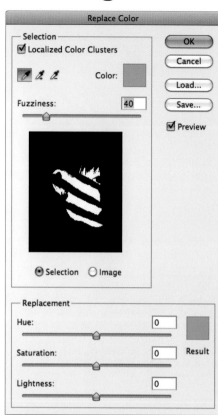

The Replace Color dialog box allows you to control the selected area you want to amend.

Step 3 Slider controls
Use the Hue and Saturation sliding controls in the Replacement section to alter original color settings. These work in the same way as the Hue/Saturation command (see page 59), and provide an infinite range of colors and tones to apply. The Lightness slider increases the luminance of the selected colors. When you are satisfied with the result, press OK.

Step 4 Open Color Range
Go to Select > Color Range to open the Color Range dialog.

Step 5 **The Color Range dialog**

In the Color Range dialog, the black-and-white image indicates the selected areas, as with the Replace Color command.

Use the + and − eyedropper tools to add to or subtract areas within the selection.

Step 6 **Increase the range**

Click the + eyedropper icon within the dialog box and add to the selected area by picking out other parts of the image in the viewer. The Fuzziness slider can be used to expand or contract the selected area.

Step 7 **Select Invert**

Click the Invert check box to invert the selection. This will be evident in the viewer. When satisfied, press OK.

Step 8 **Set a new background color**

Return to your image, and use the Color palette to set a new foreground color. Move the sliders to make your selection. In this example, yellow is set as the new foreground color. Go to Layer > New > Layer, and in the Layers palette call the new layer "Yellow."

Step 9 **Fill the yellow layer**

With the Yellow layer selected in the Layers palette, use the Paint Bucket tool to fill the selected areas with your new color.

22 adding flat color

P In this lesson, we're going to show you how to select and apply color to flat areas. This technique lets you replicate traditional silk-screen processes by producing flat, solid areas of color that can be built up using layers.

This technique is most effective when utilizing very stark, contrasting images, such as bold drawings and silhouettes.

The Select menu lets you define the content you want to use.

Step 1 **Open an image**
Open a black-and-white image with clearly defined, contrasting areas.

Step 2 **Open Color Range dialog**
Go to Select > Color Range to bring up the Color Range dialog box. Use this box to control the selection of the area you're intending to color.

Step 3 **Select black**
Use the drop-down menu at the top of the Color Range dialog box to select Shadows. The Shadows option will select any black or similarly dark areas within your artwork. Click OK.

Always create a new layer when applying a color fill. This provides you with more options and creative control.

Step 4 **Isolate the artwork**
Your artwork will now be selected. In order to isolate this selection, go to Layer > New > Layer. In the New Layer dialog box, click OK. A new layer will appear above the Background layer in the Layers palette. Select this layer.

Step 5 **Select a color**
Click the Set foreground color box at the bottom of the Toolbox to activate the Color Picker. Use the picker within the large square color map to select a color. The spectrum slider lets you choose the hue. Once you have made your selection, press OK.

Step 6 **Select the Paint Bucket tool**
With the Paint Bucket tool, click within the selected area. This will apply a fill to the area within the new layer. Deselect the filled area with Select > Deselect.

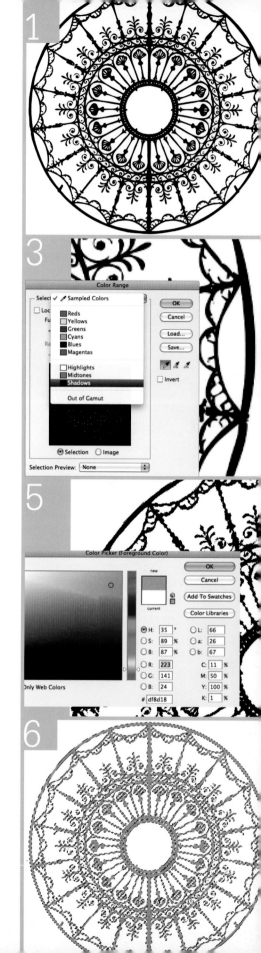

Step 7 **Copy the selection**

With the Rectangular Marquee tool, draw a rectangular shape around the filled area and then go to Edit > Cut. This command means you can apply the color shape to any other Photoshop document.

Edit	Image	Layer	Select	Filte
UndoRectangular Marquee				⌘Z
Step Forward				⇧⌘Z
Step Backward				⌥⌘Z
Fade...				⇧⌘F
Cut				⌘X
Copy				⌘C
Copy Merged				⇧⌘C
Paste				⌘V
Paste Special				▶

Select the required area and use the cut command to move content.

Step 8 **Open a new document**

Within a new document, go to Edit > Paste to add the flat color artwork.

Step 9 **Arrange the artwork**

The color art will now be applied to a layer within the new document. Select this new layer and use the Move tool to finalize its position.

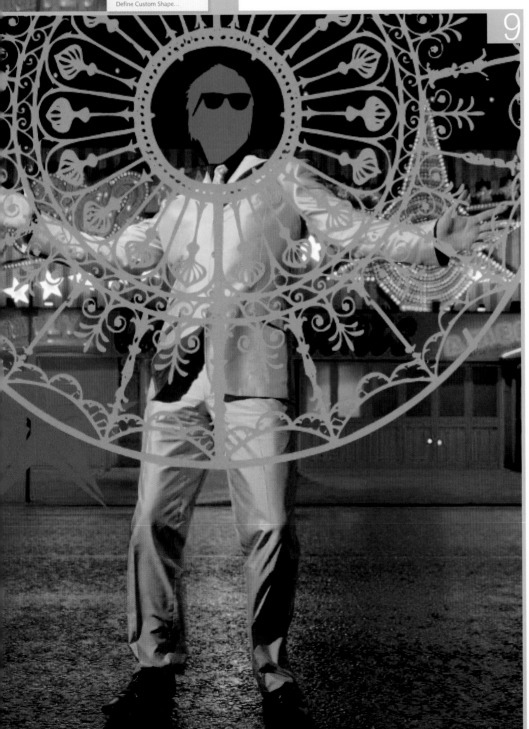

The final artwork utilizes photography and flat color shapes to provide depth and contrast.

23 image adjustments

You can use Photoshop to adjust color and transform your artwork at any stage in the design process. You can alter the whole image or just specific areas. This fluid and spontaneous approach to the application of color provides limitless opportunities for the illustrator. This section explains how image adjustments are carried out and also which of the various tools on offer are the most useful for the illustrator.

Hue/Saturation

Hue/Saturation is one of the most effective means of color alteration. It is the Hue slider in particular that has the most creative potential. The Hue slider allows the artist to apply the whole spectrum of colors to a particular object.

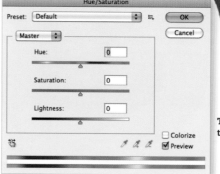

The original image file. Notice all the sliders are set at 0.

Hue/Saturation dialog box

To bring up the Hue/Saturation dialog box, go to Image > Adjustments > Hue/Saturation.

Hue/Saturation also allows you to control the saturation of color and lightness of the overall image. These examples describe how the sliding controls affect the original image.

A selection of hue adjustments are shown at right, demonstrating the range of color and saturation changes that can be easily achieved by experimenting with the Hue and Saturation sliders. The Lightness slider controls the amount of light in the image. All can be used to create varied and interesting effects.

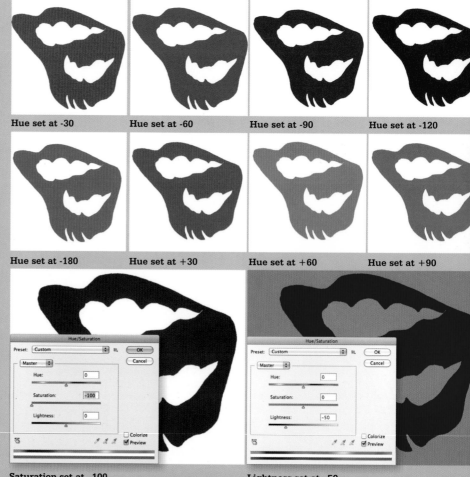

Hue set at -30

Hue set at -60

Hue set at -90

Hue set at -120

Hue set at -180

Hue set at +30

Hue set at +60

Hue set at +90

Saturation set at −100
A desaturated image. All color information has been removed.

Lightness set at −50
Light is removed from the whole image, creating a darker image.

invert

It is very easy to get bogged down when constructing an image in Photoshop. The nature of the technology means that you can waste hours examining and refining your artwork, pixel by pixel, while neglecting the message your image should be communicating. You need to develop strategies to prevent this from occurring.

A quick way to revise and remix an image is to invert it. Invert provides a very simple means with which to adapt an artwork and change how you feel about it. Use this feature at regular intervals through the design process to help you evaluate and assess how the image is read.

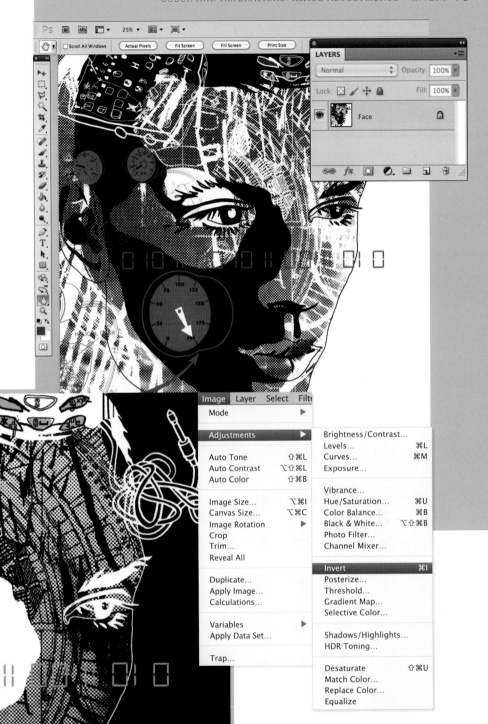

Invert can be found in the Menu by following Image > Adjustments > Invert. Remember that it will only affect the layer you have selected in the layer window. If you want to invert the whole image you have to flatten it first (Menu > Layer > Flatten image).

25 adjusting colors

The Replace Color command lets you identify and alter color areas within your image. It works in a similar way to Image > Adjustments > Hue/Saturation (see page 70), providing an infinite range of colors and tones with which to alter your artwork. However, the advantage of this tool is that you can define specific areas within the composition that you wish to adjust.

With the Replace Color dialog open, colors are initially selected using an eyedropper tool. This initial selection can be adjusted using the Fuzziness slider control to expand or contract the required area of pixels; it works in much the same way as the Tolerance option that controls the Magic Wand tool. A preview of the image shows the extent of the selected area. With the color range identified, you can then specify the new color.

Use the squares called color and result to identify the original color and its replacement.

Step 1 Open an image
Open a suitable color image file. This image should include a variety of color hues and tones.

Step 2 Open Replace Color
Go to Image > Adjustments > Replace Color to open the Replace Color dialog.

Step 3 Preview
In the Replace Color dialog box, select the Preview button so that you can view the color alterations as you make them. Under the preview box, click the Selection button to view a black-and-white image. This lets you identify what areas have been selected. The Image button simply previews the color image.

Step 4 Select a color
Click the small eyedropper icon found near the top left of the dialog box. Now you can use the mouse or touchpad to click within a defined color area of your image. In this example, we have selected a bright yellow area. This selection is identified in the black window within the Replace Color dialog box.

Step 5 Change color
Use the sliding controls called Hue found in the Replacement section to alter the original color settings. In this example, the Hue slider is moved along to +139. A light blue is generated and identified in the square named Result. Notice how this adjustment directly affects the original image because the Preview button has been activated. When you are satisfied with the result press OK.

Step 6 **Expand selection**

The Fuzziness slider lets you expand or contract the selection by increasing or decreasing the tolerance of the color area. In this example, the slider is moved along from 48 to 188. Notice how the selection expands to encompass more yellow pixels within the image. This expansion is displayed in the black window within the dialog.

Step 7 **Choose additional colors**

Select the Add to (+) eyedropper. You can use this tool to select additional areas of color. Here we've used the Add to eyedropper to select orange and red areas. Because the Hue slider has been moved to +139 this color adjustment is applied to the new selected areas.

Step 8 **Deselect colors**

If you want to remove areas from the selection, select the Subtract from (–) eyedropper icon and click selected areas that you want to deselect. In this example, we've used the Subtract from eyedropper to deselect the orange and red areas previously identified in Step 7.

Step 9 **Saturation**

You can desaturate or enhance specified colors using the Saturation sliding control. In this example, the Saturation control is moved to –100. The original vivid yellow color is replaced with a muted, gray tone identified in the Result square.

26

P

correcting mistakes

Because of the limitless and exciting options available to the digital illustrator, a familiar tendency is to keep going—to keep amending an artwork until it becomes overly complex and labored. It is very important to recognize when an image is complete.

This issue applies to all visual arts practice, and is not unique to the digital realm. However, there is something seductive about compositing using imaging software, with its varied effects and filters, that encourages the creative impulse to keep pushing an image and not to recognize when its time to put down the paint brush.

Keep in mind the fundamental principles explained earlier (see pages 32–37) and remember that always to fill an entire page may be denying the image its natural tension. The dynamic qualities of an initial sketch, for example, can be obscured by an overly labored or complex approach.

Using Photoshop History panel

The History panel provides a means of tracking back and reflecting on the choices you have made while building up an image. It is good practice to use this tool at regular intervals throughout the design process to assess if the amendments you are making are improving the quality of the image or not.

The History panel is accessed by selecting Window > History. In the example at right, we can see how the History panel can enhance the creative process. As an image is amended and transformed, we can track the changes on the History panel. However, in the last shot, the decision is made to return the image to its original state.

Step 1 **Open the History panel**
Open a Photoshop file with content divided between layers. The example shown includes a variety of different components, such as line drawing, abstract marks, and flat color. Open the History panel.

Step 2 **Alter the hue**
Select the layer entitled Flat color fill. Notice this layer uses blending mode Screen, applying flat color to the layer below. Use the menu to find Image > Adjustments > Hue/Saturation. The Hue/Saturation dialog box will appear. Use the Hue sliding control to alter the color to –45. Press OK.

Step 3 **Merge layers**
Use the Layer window to select the layer called Abstract mark 2. Use the menu to find Layer > Merge down. This will merge this layer into the layer below and form a new layer called Abstract mark 1. Select this layer.

Step 4 **Free transform**
Manipulate the abstract shape by selecting Menu > Edit > Free transform. When you are satisfied with the transformation, click return on your keyboard. The transformation will be applied.

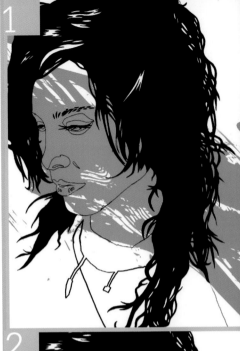

Step 5 **Alter opacity**
Select the layer entitled Flat color fill. Use the Opacity box found in the top right-hand corner of the layer window to alter the opacity of the layer. This reveals more black below the color, making it appear darker. The Opacity for this layer is set at 59%.

Step 6 **Duplicate layer**
Use the Layer palette to delete the layer called Abstract mark 1. Select the Hair black fill layer. Go to Menu > Layer > Duplicate layer. The Duplicate layer dialog box will appear. Press OK. A layer called Hair black fill copy will appear. Select this layer.

Step 7 **Free transform**
Rotate the black hair shape by selecting Menu > Edit > Free transform. When you are satisfied with the transformation, click return on your keyboard. The transformation will be applied.

Step 8 **Alter opacity**
Select the layer entitled Flat color fill. Use the Opacity box found in the top right-hand corner of the layer window to alter the opacity of the layer. This reveals less black on the white background below, making it appear gray. The opacity for this layer is set at 35%.

Step 9 **Return to original image**
Having applied a variety of adjustments and alterations to the image, the History palette lets you return to any stage within the design process. In the example provided, the History palette is returned to Open and the artwork is returned to its original state.

27 scale and transformations

Applying transformations to objects in Photoshop is another useful technique for the digital artist. The Transform control (found under Edit > Transform) provides a variety of commands that influence the shape or form of an object. It does this by manipulating the pixels that make up the object, and so may have some effect on the image quality when applied.

Transform commands let you scale, rotate, skew, distort, and warp an image. You can apply transformations to a selection, an entire layer, multiple layers, or even a mask. Transforming provides the opportunity to dramatically distort layer content and produce striking imagery.

The following steps explain how each of the Transform commands functions.

A wide variety of transform tools can be found at Menu > Edit > Transform. Explore all these tools and examine how they alter layer content.

Rescaling objects

Step 1 Open
Open a Photoshop file with components separated between layers. Do not open a flattened file, as objects need to be isolated within layers in order to transform and distort them. This particular example uses one isolated element—a silver reindeer—within a layer on top of a black background layer. In the Layers palette, select the layer containing the object you want to transform, in this case the reindeer.

Step 2 Scale
In order to change the scale of the reindeer go to Edit > Transform > Scale.

Step 3 Maintain aspect ratio
A rectangular selection known as the "bounding box" is automatically made around the layer content. If you need your image to retain its original proportions, make sure you click the Maintain aspect ratio icon in the Tool Options bar.

Step 4 Resize
To begin resizing your image, locate one of the small square shapes known as "handles" on the outer edge of the selected area. The numeric percentages on the Tool Options bar can also be used to perform an exact scale transformation. Use the pointer to drag a handle in the appropriate direction in order to reduce the image. To apply the transformation, click on the Commit transformation (Return) tick icon in the Tool Options bar or press the Return/Enter key on your keyboard. You can cancel the transformation by clicking the Cancel transform (Escape) icon in the Tool Options bar or by pressing the Escape key.

Step 5 Duplicate layer
Next we're going to duplicate the original Reindeer layer. Go to Layer > Duplicate Layer. A dialog box will appear called Duplicate Layer. Click OK.

Step 6 Repeat
Repeat Step 5 until you have duplicated your original layer four times. You can then use the Layer window to select each individual layer and the Move tool to assemble the composition.

Distorting and rotating objects

Now explore how the other Transformation commands work. Examine the fluidity and ease with which an object can be manipulated and distorted. You can perform several commands in succession before applying the final amended transformation. For example, you can choose Scale and drag a handle to resize, and then choose Warp to dramatically distort your image. Then press Enter or Return to apply both transformations.

Step 7 Rotate

The Rotate command lets you move your object clockwise or counterclockwise. Select Edit > Transform > Rotate.

Step 8 Apply rotation

Locate one of the handles on the corner of the bounding box. Use the pointer to drag a handle clockwise or counterclockwise. The numeric controls called Set Rotation in the Tool Options bar can also be used to perform an exact scale rotation. Press the Return/Enter key. By default, the object will rotate around a center point; however, you can select alternative rotation points using the Reference point location control in the Tool Options bar.

Step 9 Skew

Skew, Distort, and Perspective transformations are very similar. They all use specific handles on the bounding box to allow the shape to be modified. Skew applies vertical and horizontal slants to objects. Go to Edit > Transform > Skew. Locate one of the handles on the corner of the bounding box. Use the pointer to drag a handle in the appropriate direction. The numeric controls in the Tool Options bar can also be used to perform an exact transformation. Apply the transformation as before.

Step 10 Distort

To apply a distorted transformation, select Edit > Transform > Distort. Distort allows you to stretch an edge in any direction freely. Use the pointer to drag a handle in the appropriate direction. Apply the transformation.

Step 11 Perspective

Perspective allows you to adjust the perspective of an object. Go to Edit > Transform > Perspective. Locate one of the handles on the corner of the bounding box. Use the pointer to drag a handle in the appropriate direction. Notice how the opposite handle mirrors the movement of the handle you're manipulating.

Step 12 Warp

Warp is the most versatile Transformation command, in that it can modify an object in any direction and from any point within the bounding box mesh. To apply a warp transformation select Edit > Transform > Warp. Use the handles and associated control points on the selected area to twist and warp the image. Once you are happy with your amended image, click the Return/Enter key on the keyboard.

Step 13 Flip horizontally

To flip your object horizontally go to Menu > Edit > Transform > Flip Horizontal.

Step 14 Flip vertically

To flip your object vertically go to Menu > Edit > Transform > Flip Vertical.

tip

When creating digital artwork, it is good practice to retain and save your artwork as a Photoshop file. Flattening an intricate artwork with lots of layers will make it difficult (if not impossible) to amend at a later date.

Mirror duplication

Photoshop's Transform command also offers
the ability to mirror layer content. This allows
you to duplicate artwork quickly and easily
in order to speed up the creative process.

In this example, only one half of a drawing
is produced, scanned, and opened in
Photoshop. The drawing has been made with
the intention of creating a square final image.
The canvas height is twice the length of the
width, so doubling the width of the canvas
will produce a square image.

Step 1 Open

Open a flattened Photoshop file. Go to Layer
> Duplicate Layer, and press OK in the
Duplicate Layer dialog box. A new layer
called Background copy will appear in the
Layers palette. Rename this "Right side."

Step 2 Flip horizontal

Select Right side in the Layers palette, then
go to Edit > Transform > Flip Horizontal.
This will flip your image from left to right,
creating the right-half of the illustration.

Step 3 Canvas size

Next you need to double the size of your
existing canvas so that the two halves can
sit next to one another. Go to Image >
Canvas Size to bring up the Canvas Size
dialog box. Double the width of the canvas—
in this example, the width is increased from
4 in. (10 cm) to 8 in. (20 cm).

**A flattened image
compresses all layer
content and lets you
transform the whole
image rather than a
solitary layer.**

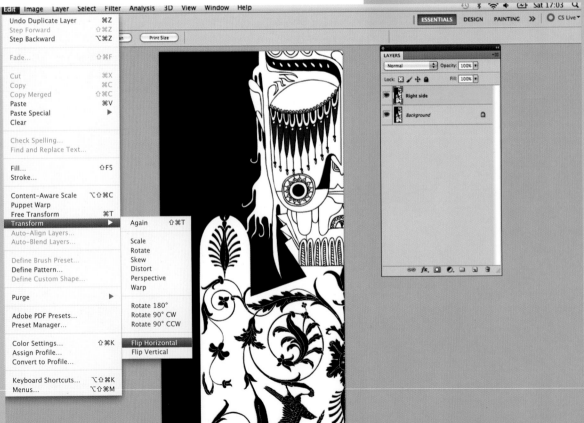

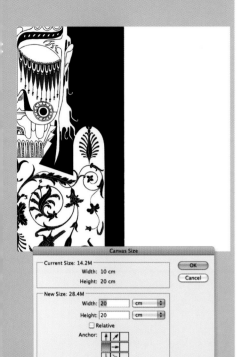

Step 4 **Anchor canvas**

Also in the Canvas Size dialog box use the Anchor command to dictate the point from where you want this enlargement to begin. The default setting for this command is the center square, and this will apply any alterations to every edge of the canvas. However, in this example, you want the extended canvas to appear on the right of the image, so select the middle left square. Click OK, and a new white right-half of the canvas will appear.

Step 5 **Move**

Select the Move tool in the Toolbox. Do not use the Move tool to drag the flipped layer across the canvas. You need to retain the exact position of your layer content in order that they match exactly. Use the arrow keys on the keyboard to move the layer content across the screen. The arrow keys provide a lot more control when it comes to aligning your two components.

Step 6 **Flatten image**

Use the center edge of the artwork to align and, when you are satisfied with the position, flatten the image by going to Layer > Flatten Image.

28 cutout techniques

Photoshop offers numerous ways to select and cut out specific areas from an image layer, allowing you to isolate key aspects of your subject from background clutter or other unwanted elements. The principal reason for using these tools is that they allow you to quickly and efficiently separate an object or area of your image. However, sometimes one tool just won't be enough, so you should make use of multiple tools to get the job done. Getting to know and understand how these tools work is a primary consideration of digital-image making.

These two pages offer an overview of cutout techniques, and pages 82–91 describe some of the ways in which to use these tools individually. However, you should also practice using a combination of the tools in order to master cutouts effectively.

The Rectangular and Elliptical Marquee tools provide an effective way of cutting out squares, rectangles, and circles. Although these tools are good for mechanical shapes and objects, or perfectly circular selections, they become less effective for more organic shapes, and are often best used in combination with other tools.

The Lasso, Polygonal Lasso, and Magnetic Lasso are probably the most versatile of the cutout tools. They allow you to select a variety of shapes effectively, including organic shapes.

Although the Lasso tool can be difficult to master if you do not have good mouse control, you can add to or remove from your selection to refine it, using either the Lasso, Polygonal Lasso, or Magnetic Lasso.

The Polygonal Lasso creates straight lines between points every time you click, and is therefore an effective method for selecting objects such as buildings, cars, and furniture. However, it can also be an effective way of quickly selecting more organic shapes that can then be refined using the Lasso tool.

The Magnetic Lasso is particularly effective for cutting out objects from contrasting backgrounds. It makes use of contrasting colors and tones to identify the selection, although it is used in a similar way to the Lasso, allowing you to define the area you want with the cursor.

The Quick Selection tool uses a user-defined brush size to create an initial selection area. As you start to move the cursor over the object, the selection area will expand automatically, creating selection boundaries based upon tonal and color differences between your chosen object and

surrounding areas of the image—much in the same way as the Magnetic Lasso tool. Once an initial selection is defined, the tool will recognize the boundaries of your selected image and rapidly expand the selection area. This tool can be very effective for clearly defined objects, but tends to become less effective where there is little contrast between your chosen selection area and the parts of the image.

The Magic Wand tool selects areas of the image based on color and tone. The Tolerance setting—found in the Tool Options bar—determines the variation between the pixel color you select and other similar colors, effectively limiting or expanding the selected areas of color within your image. This tool is good at selecting areas of generally flat color, such as skies, but is less effective where tolerances have to be set high—for example, where large contrasts in tone created by shadows or highlights are found. The Magic Wand tool is often best used in combination with the Lasso tools, as a way of quickly selecting areas that can be later refined.

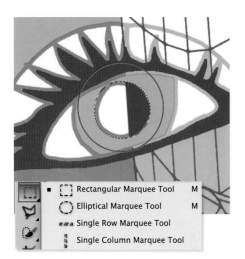

The Marquee selection tools allow for quick selection and editing, and are often best combined with others for refinement.

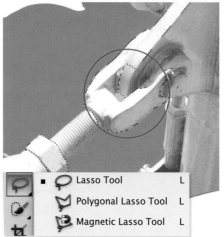

These tools form the backbone of selection and refining for many digital artists.

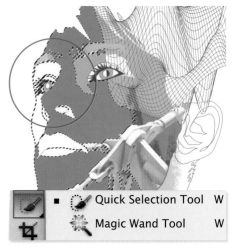

The Quick Selection and Magic Wand tools are effective for rapid selection of large areas of an image.

The Color Range command (Select > Color Range) makes a selection based upon a specific color or set of colors. While similar to the Magic Wand tool, it is less localized and samples the entire image. It also provides a selection preview that can be useful for adjusting and refining the selection. This tool is highly effective when used to separate sketches and drawings from their backgrounds, or selecting large areas of color from an entire image.

The Quick Mask lets you switch between the standard tools and the mask-painting mode. In this mode, you can paint a mask using the Brush, Pencil, and Fill tools, with the mask appearing as a red overlay on the selected image area. When you switch back to the normal mode (press the Quick Mask button again), areas that are not painted will be selected, and painted areas will be deselected. This tool is a powerful way of creating highly refined selections, although it relies to some extent on good mouse control. The ability to create selections that have different opacities, as well as use the variety of brush shapes and sizes to build your selection area, makes this a highly effective method of selection for complex cutouts.

The Layer Mask allows you to add a mask to a layer in order to reveal or hide parts of that layer. Although not strictly a cutout method, with a Layer Mask you can use similar techniques as the Quick Mask mode in application, and it is therefore an effective way of separating parts of a layer from unwanted elements. The advantage of a Layer Mask is that it is a non-destructive form of image editing—by simply hiding rather than deleting areas of your image, mistakes can be easily rectified later. This option, however, is not so effective when moving one part of a layer to a separate document, but is useful when compositing layers in a single document. Use other selection tools to define an area before creating the Layer Mask, and build a mask based upon that selection rather than a blank mask that needs editing.

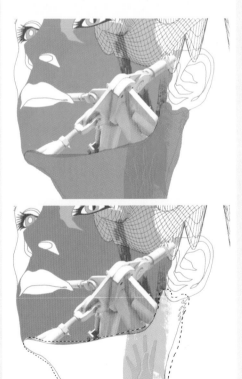

Use the Quick Mask mode (bottom of the Toolbar) in combination with the Brush, Pencil, and Fill tools to "paint in" areas for masking and selection.

29

cropping and cutting:
marquee and polygonal lasso

P

In this lesson, we'll show you how to crop and cut images, remove the background, and place objects into new compositions. These are vital functions for the montage artist, and Photoshop's various selection tools provide the means of performing the tasks quickly and precisely.

In this lesson, we will remove the background from a photograph and paste figures into a new layer.

The Marquee tools allow you to select areas, and an important function is cropping artwork. In this example, we will use the Rectangular Marquee, but when you select it from the Toolbox, you will be made aware of alternative shapes such as the Elliptical, Column, and Row Marquee options.

The Polygonal Lasso is very effective at selecting detailed and intricate areas of content. When automated selection tools such as the Magic Wand are not accurate enough or you have to select detailed areas from within a tonally similar artwork, this is often the best tool for the job. The Polygonal Lasso uses a linear path to select areas and, if used in conjunction with the Zoom tool, provides a highly accurate method for editing and cutting. Familiarity with this tool is beneficial, as the amount of time you take using it determines the refinement of the selection.

Step 1 Open
Open a photograph that requires cropping. Select the Rectangular Marquee tool from the Toolbox. Drag the Rectangular Marquee tool across the photograph, selecting the area you want to crop.

Step 2 Crop
In the Menu bar go to Image > Crop. When this action is complete, return to the Menu and find Select > Deselect.

Step 3 Duplicate layer
When deleting areas from an image you should always duplicate your original layer. This will provide back up in case you have to revise any decisions later on. Menu Layer > Duplicate Layer. In the Duplicate Layer dialog box, name your new layer and press OK. In the Layers palette, select your new layer and use the visibility (eye) icon to turn your Background layer off.

Step 4 Magnify
Use the Zoom tool to magnify your image. Check that the tool is set to + in the Tool Options bar.

Step 5 Select Polygonal Lasso
Select the Polygonal Lasso in the Toolbox. This tool lets you accurately draw around areas that would otherwise be difficult to select with the Magic Wand. Zoom right into areas you want to isolate so you can clearly see their edges.

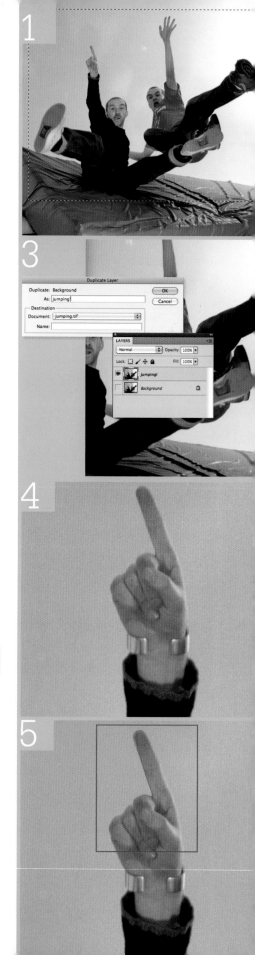

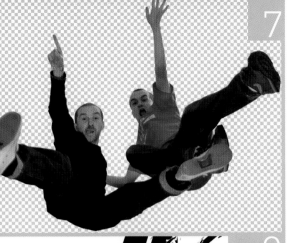

Step 6 **Cut**

Once you have used the Polygonal Lasso to select an area to remove, go to Edit > Cut. If the object is large or intricate, don't draw around it in one go. In this example, we just cut away the background from around the hand.

Step 7 **Zoom tool**

Continue with this process until you are satisfied that you have cut away all unnecessary content. Check that the Zoom tool is set to – in the Tool Options bar. Use the Zoom tool to minimize the artwork so that it fits the screen. You will be left with the object floating in the layer.

Step 8 **Rectangular marquee**

Return to the Rectangular Marquee tool and drag a selection box across the image to contain the whole object. Then go back to Edit > Cut.

Step 9 **Paste object**

Once you've isolated and saved the object, you can paste it into any other Photoshop document. In this example, we've opened a document with seven layers of content as shown in the Layers palette. Select and copy (Edit > Copy) your cutout image, return to the newly opened document, and go to Edit > Paste.

Step 10 **Move object**

The original object is now pasted into a new layer of the new document. Select this new layer and use the Move tool to arrange the image within the composition.

30 selecting elements: magic wand

P As well as selecting flat color within defined areas, the Magic Wand tool is also effective when trying to select areas of color within a tonal photograph or any image that lacks defined linear shapes. In this lesson, we'll show you how to use the Magic Wand to isolate an element and then how to refine your selection using the Tolerance and Refine Edges options.

Step 1 Open
Open a photograph in Photoshop. In this example, we're going to isolate the man's purple t-shirt.

The Toolbox in Photoshop, with the Magic Wand tool selected.

Step 2 Magic wand
Select the Magic Wand tool in the Toolbox. If you want to make multiple selections within the image, click the Add to selection icon in the Tool Options bar.

Step 3 Select
Use the Magic Wand to select the specific area you want to isolate; here it's the purple shirt.

Step 4 Tolerance
The Magic Wand's sensitivity is controlled by the Tolerance option found on the Tool Options bar. The default setting is 32. If you enter a tolerance value lower than 32, a smaller range of colors relative to the first pixel you click will be highlighted. If you enter a higher value, an increasing number of pixels will be selected, increasing the size of the selection. If you are making multiple selections, you can adjust the tolerance between clicks. In this example, the value 55 is entered. See how a greater number of pixels make up the selection, increasing its size.

Step 5 Increase tolerance
Increase the tolerance value still further and the selection enlarges again. In this example, the value 100 is entered. Experiment with this tool to find the tolerance that best encompasses the area you wish to isolate.

Step 6 Refine edge
In this example, the appropriate tolerance level is 33. The shape of the shirt is defined within the selection; however, the selected area needs to be refined. Click Refine Edge in the Tool Options bar.

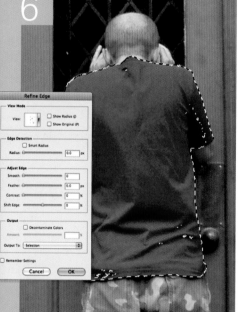

Step 7 **Refine edge controls**

The Refine Edge dialog box gives you more subtle controls over the selected area. Here the Smooth value is increased to 52 in the Adjust Edge box. Notice how the jagged edges of the original selection are softened. Experiment with the other settings to see how they impact on the selection.

Step 8 **Layer mask**

When you are satisfied with the selection, go to the Output box. Click on the drop-down menu to select New Layer with Layer Mask, and click OK. This will automatically place the selection into a new layer. This is an advantage because you can now drag, cut, and apply this new isolated element to any other potential artwork. The color shape is now clearly defined in its own layer above the original photograph.

Step 9 **Desaturate**

Finally select the Background layer in the Layers palette and go to Image > Adjustments > Desaturate. This adjustment will turn the original photographic image into black and white, leaving the purple shirt the only colorful element.

REFINE EDGE DIALOG BOX

View Mode
Lets you choose how the selection is displayed (on a black, white, or transparent background, or as a marching ants selection, for example).

Edge Detection

Smart Radius
Adjusts radius for hard and soft edges.

Radius
Defines the size of the selection border in which the refinement will occur.

Adjust Edge

Smooth
Reduces irregular areas along the edge to create a smoother outline.

Feather
Blurs the transition between the selection and neighboring pixels, softening the edge.

Contrast
Adds more contrast on the edges of the selection by making soft edges more defined.

Shift Edge
Contracts or expands the selection.

Output

Decontaminate Colors
Removes color fringes.

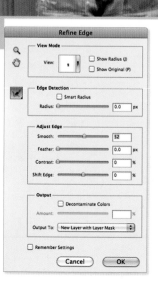

31 **adding color:** magic wand

P

In this example, we're going to use the Magic Wand and Paint Bucket tools to create flat color artwork. The Magic Wand is a very convenient tool. It will quickly select areas with consistent color or color range. The tool is most successful when selecting clearly defined areas within an image, such as a line drawing.

Step 1 **Open**
Open a line drawing with clearly defined lines and edges in Photoshop. Select the Magic Wand tool from the Toolbox.

Step 2 **Contiguous box**
Make sure the Contiguous box is selected in the Tool Options bar, then with the Magic Wand click within defined areas of the drawing. If you want to make multiple selections within the image, click the Add to selection icon in the Tool Options bar.

Step 3 **New layer**
Before you fill this selection with color, create a new layer. Entitle the new layer "Color." This will isolate your selected area and give you more options.

Step 4 **Define new layer**
In the New Layer dialog box, set Color to None, Mode to Normal, and Opacity to 100%, and select OK.

Step 5 **Select**
A new layer will appear in the Layers palette. Select this layer.

Step 6 **Foreground color**
Click the Set foreground color icon near the bottom of the Toolbox to bring up the Color Picker dialog box. Explore this interface to see how colors are chosen (see page 57). When you have navigated to black, press OK.

Step 7 **Paint bucket**
Find the Paint Bucket tool in the Toolbox, and click in the selected areas to fill them with black. Go to Select > Deselect to deselect the newly created black areas.

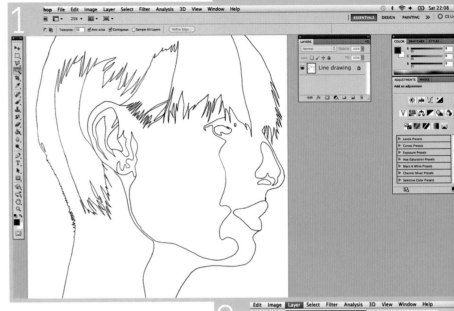

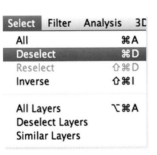

After you have applied a fill, you will need to deselect your selected areas. Menu > Select > Deselect. This will deactivate the Magic Wand and let you view the artwork as it was intended.

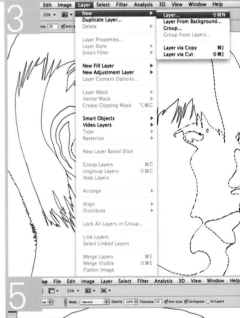

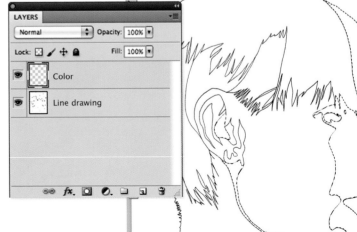

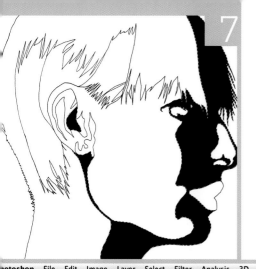

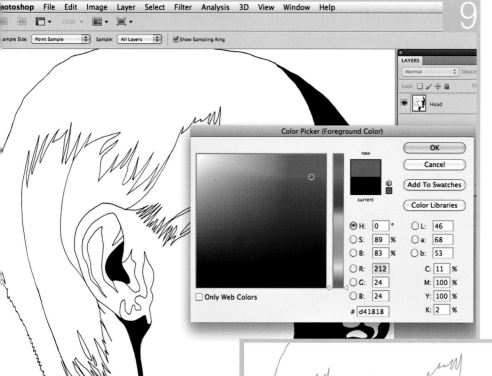

Step 8 **Flatten image**
Compress these two layers by going to Layer > Flatten image.

Step 9 **Color picker**
Click the Set foreground color icon again to bring up the Color Picker dialog box. This time choose a red color.

Step 10 **New layer**
Go to Layer > New > Layer. In the New Layer dialog box again set Color to None, Mode to Normal, and Opacity to 100%, and select OK.

Step 11 **Fill**
Select this new layer in the Layers palette and fill with red using the Paint Bucket tool.

Step 12 **Screen blending mode**
Return to the Layers palette and select the Screen blending mode. Now all the black areas, along with the line artwork itself, become red. If you want to transfer this new image and recompose it, go to Layer > Flatten image.

32 quick selection

P When speed rather than precision is required, the Quick Selection tool is perfect for selecting broad areas within a picture. This tool is best described as a combination of the Magic Wand tool and a brush. As you drag the brush over an image, it selects pixels that share similar color and luminance values. The width of the brush determines what content is absorbed into the selection. The brush is adjustable so that you can define particular areas within the picture.

Step 1 Open a Photoshop file
In this example, we have a photographic image of a skyscraper that we want to convert to a silhouette. Select the Quick Selection tool from the Toolbox.

Step 2 Select Add to selection
In the Tool Options bar, select the Add to selection (+ paintbrush) icon. This option adds new selections to any previously selected areas.

Step 3 Brush Picker
Again in the Tool Options bar click the Brush Picker icon. The Brush Picker dialog box controls specify the brush dimensions. Use the sliding controls to determine the appropriate diameter and sensitivity. The Brush Picker can be accessed throughout the creative process in order to adapt and capture all relevant content.

You will notice that the tool options bar changes as you select various tools. It displays information relevant to a specific tool and provides quick access to controls and functions.

The Brush Picker dialog box lets you be very particular in the tool you require. The nib shape, pressure, and flow of the brush can be very exact.

Step 4 Auto-Enhance
In this specific example, we've also checked the Auto-Enhance box in the Tool Options bar. This option makes automatic assumptions as to the boundary of the image, flowing the selected area out toward defined edges and applying edge refinement that can be applied manually with the Refine Edge command (see page 84).

Step 5 Making a selection
Begin to drag the tool over the areas you wish to select.

Step 6 **Expanding the selection**

Continue this process, noticing how the selection expands. Zoom in to check that all the required areas have been selected. Use the Subtract from selection (– paintbrush) icon to delete any erroneous selections, and/or click Refine Edge to further adapt and adjust selection edges if necessary.

Step 7 **Create new layer**

When you're happy with the selection, go to Layer > New Layer. In the New Layer dialog box, call the layer "Silhouette." Select this new layer in the Layers palette.

Step 8 **Fill the silhouette layer**

Next, go to Edit > Fill. In the Fill dialog box, select Black from the Use: drop-down menu. Press OK.

Step 9 **Deselect**

The buildings are now replaced with a black overlay, creating a bold silhouette against the sky. Go to Select > Deselect, and flatten the image (Layer > Flatten Image) if you want to save the image as a final artwork.

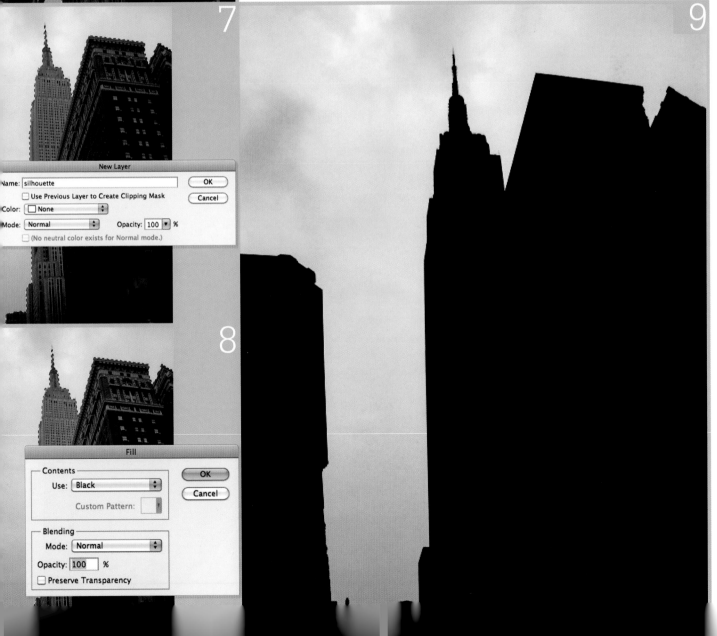

33 cutting out hair

A familiar and recurring problem for the digital artist is cutting very fine objects away from backgrounds. Hair in particular is especially tricky. One way to perform this task is to use the Polygonal Lasso (see page 82) and painstakingly cut the hair out. However, this technique can take a significant amount of time, and there are better tools available. One of the quickest means of selecting intricate shapes is to use the Channels palette in combination with Levels. This technique lets you boost the contrast of an isolated area within your image and in so doing better define the shape you want to select.

In order to get the best results, it is important that there is a stark contrast between the object and the background you want to remove. If taking your own pictures, plan your photo shoot carefully so that you get a flat tonal backdrop behind the model. In the example here, the hair was photographed against a white background.

Use the Levels Channel histogram sliding controls to remove tone and create more contrast.

Step 1 Select contrasting image
Open the image in Photoshop, making sure there is good contrast between the figure and the background. Go to Window > Channels to open the Channels palette.

Step 2 The Channels palette
The Channels palette shows the image's color information by dividing the image into its separate red, green, and blue components, displayed in monotone.

Step 3 Select a channel
Each color channel can be turned on and off by clicking the visibility eye. Examine each channel until you find the one that shows the best contrast. What you should be aiming for is clearly defined shadows and highlights. In this example, the blue channel provides the best contrast. Click on the channel to select it; when a channel is selected it turns blue. Use the channels option button in the top right of the palette to activate a drop-down menu and select Duplicate Channel.

Step 4 Duplicate Channel
In the Duplicate Channel window, create a name for the panel—in this example, "Blue Copy"—and press OK. We'll use this new channel to select the fine area of hair.

Step 5 Levels adjustment
Select the Blue Copy channel in the Channels palette and go to Image > Adjustments > Levels. In the Levels, make sure the Preview button is selected and the Channel is "Blue Copy."

Step 6 Adjust levels
In the Levels dialog, move the left (black) arrow toward the right. This will increase the contrast within the channel. Aim to create a stark black-and-white image with as few mid-tones or grays as possible. This will improve the definition of the selection.

tip

Try to avoid images where figures or objects are too tonally similar to the background—for example, a person with dark hair photographed against a black wall. This would not provide the necessary contrast to apply this technique.

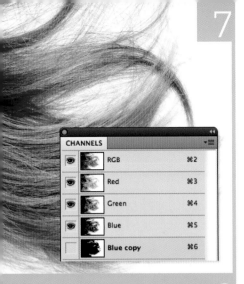

7

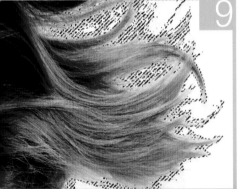

8

Step 7 **Load the selection**

Return to the Channels palette and switch on all the original channels while switching off Blue Copy. However keep the Blue Copy channel selected (it should remain blue). This action will also reactivate the full color image on the screen. Find Select > Load Selection to bring up the Load Selection dialog.

Step 8 **Upload selection**

In the Load Selection dialog box, use the Source box to check the Channel selected is Blue Copy. This feature lets you upload the new high contrast channel as a selection, or path. Press OK.

Step 9 **Remove the background**

The selection will encompass the intricacies of the hair. Go to Edit > Cut and remove the background.

Step 10 **Add new background**

Create a new layer. Drag or paste a new image that will provide the background to the hair. In this example, a layer called "Soho" is created and placed beneath the original hair layer.

Step 11 **Matting options**

Next, go to Layer > Matting > Remove White Matte. Depending on what background you have selected, the matting options here provide the means to apply a subtle layer blend, enhancing the outline of the shape and masking any inconsistencies. Try both Remove White Matte and Remove Black Matte to find the best option for your artwork.

Step 12 **Remove White Matte**

Notice how the Remove White Matte option has improved the quality of the selection around the edges of the hair.

9

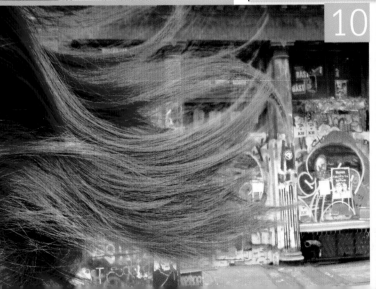

10

12

34 refining edges

When filling selected areas using the basic fill technique outlined on page 57, you may notice that where colors touch there is a discrepancy; the color at the edges is inconsistent and does not fully fill the shape as desired. This is caused by the sensitive way in which a selection recognizes pixel tone. Photoshop provides you with the tools to refine these edges and as a result improve the clarity of your image.

The example shows how this discrepancy can affect an image. Filled areas of color do not converge and the edges of shapes are ragged and inconsistent. To prevent this, Photoshop lets you modify your selected area so that the fill color expands and bleeds into the surrounding shapes within your image.

Step 1 Open
In Photoshop, open a file with clearly delineated and enclosed shapes, and begin selecting areas to which you want to add color using the Magic Wand tool. In the Tool Options bar set Tolerance to 32 and then click the Add to selection icon for multiple selections.

Step 2 Set foreground color
Click the Set foreground color at the bottom of the Toolbox to bring up the Color Picker window. Select an appropriate color, and click OK.

Step 3 New layer
Go to Layer > New > Layer to create a new layer, and in the New Layer dialog box call the layer "Blue Fill." Press OK.

Step 4 Zoom
Use the Zoom tool to magnify a detail within your artwork so that you can more clearly see the "marching ants" selection line.

This is an example of how edges can look if applying color directly into a selected area. Notice the fragmented quality of the edge where the colors meet.

Step 5 **Expand**

Go to Select > Modify > Expand to bring up the Expand Selection dialog box. This box allows you to control the modification of your selection. The number entered here corresponds to an increase in pixel size. In this example, the expansion should be minimal so that the color area will overlap but not disrupt the other features within the image. We've used a value of 2 pixels.

Step 6 **Notice**

Notice how this action expands the original selected area. This new selection will overlap but not go beyond the parameters set by the black line work.

Step 7 **Paint bucket**

Select the "Blue Fill" layer in the Layers palette, and use the Paint Bucket tool to fill the selected area.

Step 8 **Blending mode**

Go to Select > Deselect to turn off the selection. Then in the Layers palette, change the Blue Fill layer's blending mode from Normal to Multiply. Notice how the opaque fill color becomes transparent and seamlessly bleeds into the black line work.

The Modify selection tool provides you with a variety of means with which to transform the edge of a selected area.

In this example, when you magnify to visible pixel size, you can see that the color bleeds seamlessly into the black line. There should be no more white edges visible between the blue fill and the black line art.

brush and pencil tool

35

P

When you select the Brush or Pencil tool the Tool Options bar will appear and look like this.

The Brush and Pencil tools share the same position in the Toolbox, and allow the illustrator to "paint" directly onto an image. The tools replicate the traditional mediums and can be used by the artist to perform similar functions within a digital context. The basic distinction between the two tools is that the brushes tend to paint with soft edges, while the pencils create hard edges. However, the infinite variety of tips and nibs available in the Brushes palette means that this is only an approximation. Spend time exploring the Brushes palette to develop your own brush/pen combinations.

Both Brush and Pencil tools work in the same way. To make a mark, left click, then drag the mouse in any given direction. The tools can be used to amend a single pixel or provide broad areas of tone within a composition. The tools apply whatever color is selected in the Foreground Color box found at the bottom of the Toolbox.

Step 1 **Create a tool preset**
The Tool Preset picker lets you save and reuse your favorite tools. Click on the brush icon at far left of the Tool Options bar, then click the Create new tool preset button and in the New Tool Preset window enter a name for your specific tool (see above).

Step 2 **Brush presets**
Click in the brush number box in the Tool Options bar to bring up the Brush Preset picker. This reveals a variety of brush sizes and styles. These options are also available in the Brush panel. Go to Window > Brush.

Step 3 **Brush panel**
Another way to access the Brush panel is to click the Toggle on the brush panel button found on the Tool Options bar.

Step 4 **Brush tool**
Mode lets you apply a blending mode to your painted mark. However, these are for specialist effects, and for most of the time, you'll use the Brush tool with this option left on Normal.

Step 5 **Opacity**
Opacity controls color transparency. This option should be set at 100% if you intend to completely color over the existing imagery with your new paint (depending to some extent on the specific brush you're using). Alternatively, reduce the opacity if you want some of the existing image to show through.

Step 6 **Flow**
Flow controls the density with which the paint is applied. As you reduce this percentage, the paint is applied in lighter strokes.

Step 7 **Airbrush**
Airbrush lets you mimic how paint is applied with real spray paint, in that the paint builds up the longer it is held over one spot.

Step 8 **Tablet pressure**
Tablet pressure buttons are used to override settings if you are using a graphics tablet. These are specialist features and are not relevant for these initial lessons.

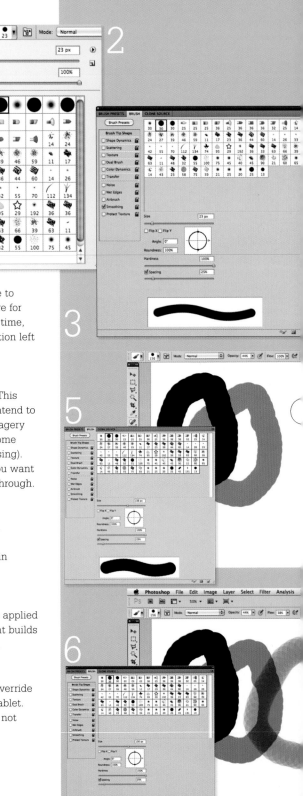

create your ideal brush

P The Brush panel lets you select and adjust the Brush and Pen tools. Also, it allows you to select preset tools from the Brush Preset panel and amend existing brush shapes so that you can design your own customized brushes. A grid of brush icons lets you select the appropriate brush tip with which to apply the paint. There is also a rectangular preview window at the bottom of the panel that lets you see how a particular brush works.

Use the Brush Tip Shape settings found in the Brush panel to explore the variety of marks on offer. The options available within the Brush panel mean that an infinite variation of nibs and tips can be created. This lesson will help you begin to navigate your way around this panel. Follow these steps to customize a brush specific to your needs.

The large Brush panel window provides preset shapes but also allows you to design your own tools.

tip

To draw straight lines with the Pencil tool, simply click a starting point, then hold down the Shift key on the keyboard. When you click to create the end point, the line will be applied.

Step 1 **Brush panel**
To activate the Brush panel go to Window > Brush, or click the Toggle on the Brush panel button in Tool Options.

Step 2 **Brush tips**
Find and click the Brush Tip Shape settings. Using the initial default settings, make a quick drawing. Observe the line quality and consider how you want to adapt your brush. Continue to make quick drawings utilizing the settings found in the Brush panel. Use these examples to create your ideal brush.

Window	Help
Arrange	▶
Workspace	▶
Extensions	▶
3D	
Actions	⌥ F9
Adjustments	
Animation	
Brush	**F5**
Brush Presets	
Channels	

Use the menu or the button on the Options window to open the Brush panel.

Step 3 **Shape Dynamics**
Shape Dynamics adjusts the tip variations and provides a jittery quality of line.

Step 4 **Scattering**
Scattering fragments and disrupts the line quality.

Step 5 **Airbrush**
Airbrush replicates the diffused quality of spray paint.

Step 6 **Angle and Roundness**
Angle and Roundness settings let you determine the width and radius of your brush tip.

Step 7 **Hardness**
The Hardness slider determines the hardness, or definition, of your line.

Step 8 **Spacing**
The Spacing slider divides your line up into individual points.

37

layering, blending, and overlapping

Due to the unlimited options layers offer the digital artist, an image can be created using a variety of drawings, photographs, and patterns. In this lesson, we can plot the journey the creative process has taken—from initial pen drawing, through various revisions, to the final composition.

Blending modes found in the Layers palette allow a variety of media such as scanned fabric, photographic reference, and line art to work in the composition. These disparate elements could potentially overwhelm the artwork. However, the various blending mode options, used in conjunction with a limited color palette, help generate a subtle outcome.

The Layers palette lets you organize your content in order to compose an effective image. A diverse range of reference material is used to construct a multilayered composition.

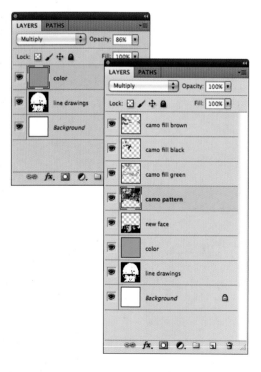

Step 1 **Open**
Scan a suitable line drawing and open it in Photoshop. Use Levels to correct any tone left by the fine paper grain (see page 52).

Step 2 **Import**
Scan and import a second illustration file that you want to introduce to your composition (in this instance, a face). Drag this new file into your Photoshop document and arrange.

Step 3 **Merge down**
Carefully place the two drawings together. It can be helpful to use the arrow keys at this stage to make fine adjustments to the position of each object. Once you are happy with their placement go to Layer > Merge Down.

Step 4 **Magic Wand**
Use the Magic Wand tool to fill shadows and create depth within the composition as shown on page 144. When this is complete, flatten your artwork with Layer > Flatten Image.

Step 5 **New layer**
Create a new layer to sit above your artwork. Use the Magic Wand tool to select the whole canvas and fill with flat color (see page 86). This will immediately obscure your artwork. Now return to the Layers palette and, with the color layer selected, choose the Multiply blending mode from the drop-down menu. This creates a transparent effect, and your artwork will now be visible under a color cast—in this case, green.

Step 6 **New scan**
At this point, a decision is made to alter the face entirely. A new line drawing is scanned and dragged into the composition.

Step 7 **Create camouflage**
In order to create an authentic pattern on the helmet, a piece of camouflage material was scanned and dropped into the composition. Elements of this fabric layer are highlighted using the Magic Wand tool and then new layers are created and filled in with corresponding tones and colors.

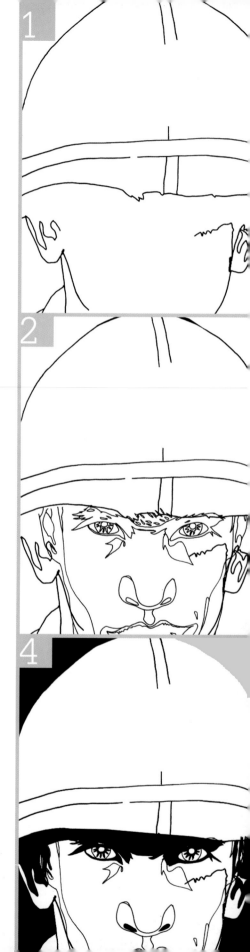

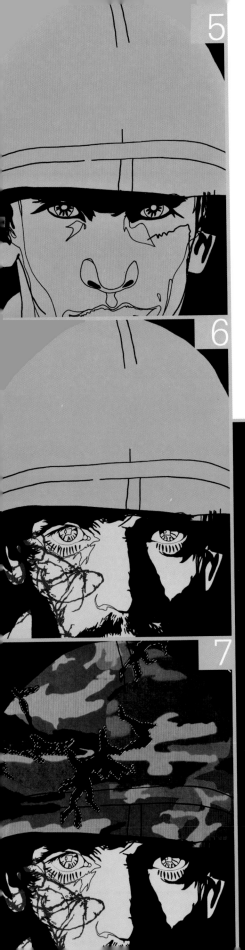

Step 8 **Blendng mode, multiply**

Another great source of alternative material to add to your montage artwork is copyright-free clip art. Here playing cards are introduced as a new layer. Layer transparency is achieved by selecting the Multiply option from the blending mode drop-down menu, as above.

Step 9 **Highlights**

Select the Brush tool and click on the Select foreground color icon at the bottom of the Toolbox to bring up the Color Picker. Select 100% white. With an appropriately sized brush, add highlights to your artwork (in this case, the playing cards and eyes). Always

remember to add pencil/paintbrush fills in a new layer, above your original line art, if you want the drawing to remain in the foreground and sit above the color and patterns.

Step 10 **Add elements**

Finally, more line art and photographic elements are introduced as separate transparent layers. In this instance, photographic silhouettes are reminiscent of the silkscreen process and eclecticism of 1960s pop art.

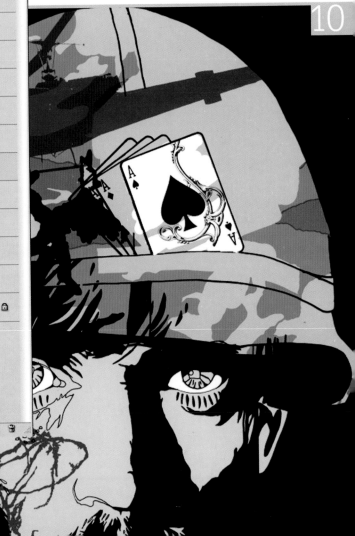

The final outcome uses 12 layers of diverse content to form the final image. Transparency is controlled by the Blending Modes and Opacity within the Layers palette in order to reveal and mask specific areas.

38 digital montage

P Drawings and photographs are easily combined using layers, but less easy is combining the two so that it is difficult to discern drawing from photo. When mixing artwork with photos, aim to produce a dynamic and visually satisfying outcome. Photographs can often disrupt a composition, so you need to find ways in which these disparate elements blend and fuse together.

In this lesson, we will draw together all the skills you have learned so far to show how a complex montage image is created in Photoshop using layers.

Step 1 New document

Create a new portrait document in Photoshop with a white background. Click on the background layer in the Layers palette and rename it "White background." Introduce a bold, simple line drawing as a separate layer. Here we've used a face drawing. Select the Magic Wand tool and in the Tool Options bar click the Add to selection icon.

Step 2 Fill with black

Use the Magic Wand to make multiple selections within clearly defined areas on the drawing. In the Layers palette, create a new layer called "Black Fill." Select this layer and go to Edit > Fill. In the Fill dialog box, select Black from the Use: drop-down menu. Press OK. The selected area will fill with black. Go to Select > Deselect.

Step 3 Pink layer

Create another new layer and call it "Pink Screen." Ensure the pink screen layer is the top layer, and then double-click the Foreground Color box at the bottom of the Toolbox. This will activate the Color Picker dialog box. Use the big, square color ramp and the sliding spectrum control to select a vivid pink. Press OK. This new pink color will appear in the foreground Color Picker square.

Step 4 Screen blending mode

Use the Paint Bucket tool to fill the Pink Screen layer with the selected color. This action will fill the whole image with the flat pink color. Change the Pink Screen layer's blending mode to Screen. This will create a pink overlay, masking any black beneath.

Step 5 Place photographs

Next, introduce a photograph to the illustration. Here an image of an airplane is duplicated and placed at various points on the page to create a sense of dynamism and to suggest diagonal motion from bottom left to top right of the composition. The Transform tools (Edit > Transform) are used to place and resize these components.

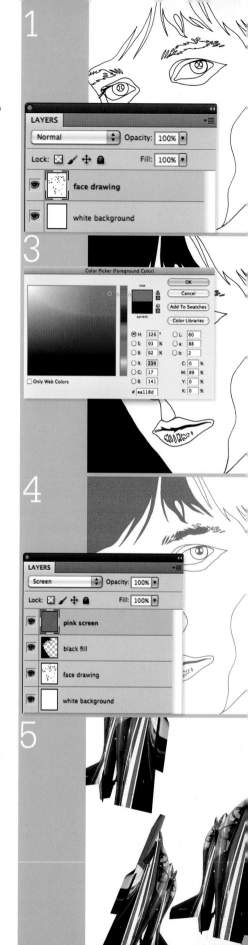

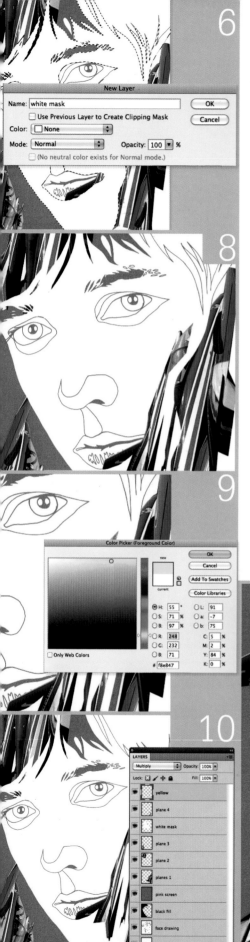

Step 6 **Create new face layer**

Select the face drawing layer in the Layers palette, and with the Magic Wand click within the center of the original face illustration. Create a new layer by going to Layer > New > Layer. In the New Layer dialog box, call the new layer "White Mask."

Step 7 **Fill new layer**

Select the White Mask layer in the Layers palette and go to Edit > Fill. In the Fill dialog window, select White as the Use: drop-down option. Press OK. The selected area will fill with white.

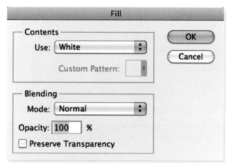

The Fill dialog box allows you to select color but also control the content opacity.

Step 8 **Erase white mask**

Use the Eraser tool to delete areas within the white face. Create areas that follow the diagonal direction of the aircraft. This action reveals underlying photographic imagery and helps to further integrate the components.

Step 9 **Yellow color**

Double-click the Foreground Color box at the bottom of the Toolbox to bring up the Color Picker. Select a vivid yellow and press OK. This new yellow color will appear in the Foreground Color square.

Step 10 **Create yellow layer**

In the Layers palette, create a new layer called "Yellow." Select this layer and use the Polygonal Lasso to draw geometric shapes that follow the same diagonal structure. Use the Paint Bucket tool to fill these shapes with yellow. Change the Yellow layer's blending mode to Multiply. This creates a transparent effect that reveals detail below.

Step 11 **Introduce a new illustration**

Go to your image library and find another illustration. Here a scientific diagram is selected and introduced to the composition. This further helps emphasize the dynamic, diagonal quality of the composition.

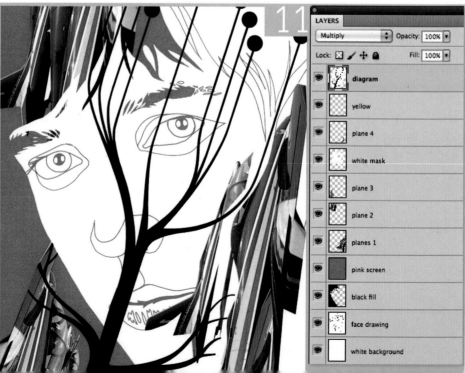

using layers creatively

Julian De Narvaez

In this wonderfully evocative piece by Julian De Narvaez, we see can how a digital illustration is constructed using Photoshop layers. As the image builds, you will recognize many of the techniques that have been introduced in previous lessons.

De Narvaez's visual approach replicates analog artistic media, such as watercolor and pen and ink. His work has a nostalgic quality that refers to art history and illustration in its most traditional sense; the static quality of the figure within this composition also helps emphasize a mood of formality.

De Narvaez uses peculiar folk symbols and curious ephemera in his work to convey a sense of unease, and despite these references to an antique era, he chooses to compose his imagery digitally. This is because of the control that Photoshop and other digital applications offer the modern illustrator. Balance, tone, texture, and light are all controlled and adjusted using such software, and the advantages of this process are particularly evident when we notice the attention placed on the hands within this image. De Narvaez creates separate drawings of the hands in order to accurately describe form and manipulate their position within the composition.

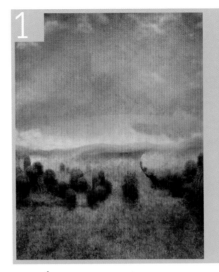

Step 1 Background
Photographic imagery of landscapes are blended together with textures to create the background. This effect has been created using various blending modes and Layer Opacity.

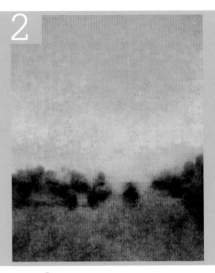

Step 2 Accentuate the foreground
The upper part of the landscape is masked in order to place more emphasis on the foreground. A large opaque shape is applied to the background. A new layer is created and brushes used to apply opaque texture.

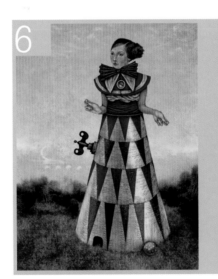

Step 6 Introduce clouds
Clouds are used to provide subtle definition in the sky (Layer window > Blending Modes > Lighten).

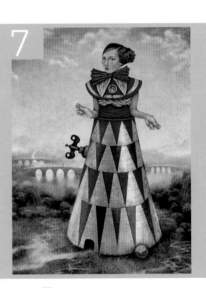

Step 7 Depth and scale
The landscape is extended and architectural forms are introduced to create a sense of depth to the image. This new content has been edited using the Eraser tool found in the Toolbox.

CASE STUDY

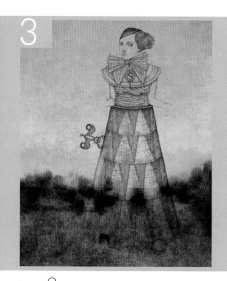

Step 3 **Add line art**

Pencil line art is scanned and introduced on a separate transparent layer, and the layer's blending mode is changed to Multiply (Layer window > Blending Modes > Multiply).

Step 4 **Introduce color**

Color is introduced behind the line art, which helps to fill shapes and define form. The color is applied using the Color Picker and various brushes.

Step 5 **Add hands**

Hands are added on a separate layer, which allows the artist to control how they are positioned in proportion with the figure.

Step 8 **Final elements**

Bird and snake drawings are introduced on separate layers. These peculiar, symbolic objects provide new points of interest within the composition, creating a triangular journey for the eye as it travels between the face and the animals. These objects have been cut out using the Selections tools.

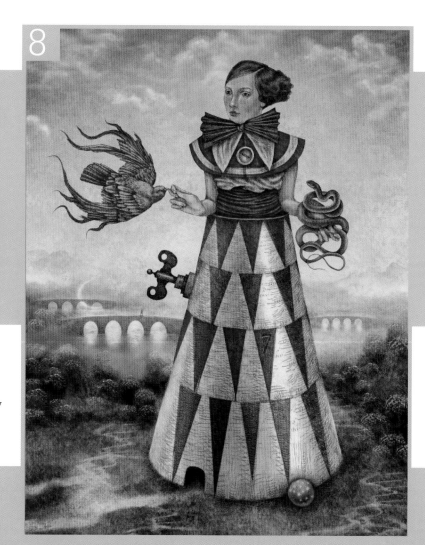

vector art

Vector art is both a style of artwork and a method of producing images. It is a form of digital artwork often characterized by bold shapes and flat colors, although its uses range from simple symbols to complex and detailed artworks. Artists also combine vector art with photography, digital montage, and lettering, creating an adaptable and powerful approach to digital illustration.

Vector art differs from pixel-based images in that it does not rely upon the description of individual dots arranged in a grid to form the picture. Instead, it uses shapes and paths defined by individual points or vectors. Color, opacity, or gradients are then assigned to these paths or areas, building the overall image. Although this sounds quite complex, in reality it is a simple system that can quickly produce bold, graphic imagery.

Pros of vector art

The advantages of vector-based images are that they are scale-independent. By this we mean that an image produced at the size of a postage stamp can be scaled up to the size of a skyscraper without any loss of image quality, sharpness of detail, or suffering an increase in file size. Pixel-based images by contrast lose resolution when they are rescaled. The easiest way to see this difference is to zoom in really close to an image on screen. A pixel-based image up close looks like a blurred mosaic, while a vector-based image looks crisp and clean no matter how far you zoom in. The most popular software for producing vector-based work is Adobe Illustrator and Corel Draw—although other programs make use of this system of image making, including elements of Photoshop and Flash. The techniques in this section are based on Illustrator, although the concepts and techniques largely apply across other platforms.

Vector art is often characterized by flat colors, bold shapes, and smooth lines and curves as seen in this image by James Hadley.

The difference between vector and pixel images can be seen in this close-up of a circle. Note the smoother edges on the vector version created in Illustrator (bottom) compared to the pixel image produced in Photoshop (top).

basic shapes

A good starting point for a vector image is often the simple shape tools. Clustered with Illustrator's Rectangle tool are the Rounded Rectangle, the Ellipse, the Polygon, and the Star tools. These allow you to add predefined shapes to your illustrations. The method for creating the shapes is easy, and allows you to rapidly create blocks or areas of color, often as the starting point for more elaborate images. Simple shapes can also be the starting point for more complex forms, as they are editable.

Step 1 **Select**

Click and hold the mouse button on the Rectangle tool. A box will appear showing you the available shapes. Select the desired shape.

Clicking and holding on the Rectangle tool reveals other available shape tools.

Step 2 **Make a shape**

Select a starting point for your shape, in this case a star, by moving the mouse over the artboard. This will become the first corner or edge of your shape. Click and hold the mouse button and drag to define your shape. Release the mouse button to finalize your shape.

Step 3 **Fine controls**

You have finer control over your shape by holding the Shift button while dragging out your shape. This will constrain the proportions of your selected shape: circles will be perfectly round, rectangles will become square, and so on. You can also hold down the Alt/Option key when dragging so that the initial point at which you click becomes the center rather then the edge of your new shape.

The Shape dialog box allows you to create shapes using numerical data— you can use this to make shape variations such as multisided objects or stars with any number of points.

Step 4 **More complex shapes**

An alternative method of making shapes is to select your desired shape, then click on the artboard where you wish your shape to appear. This will bring up a shape window that allows you to set exact sizes for your shape, allowing for more accuracy in terms of scale. Enter values for the width and height of your shape. For more complex shapes, you will also be able to set values for the number of points, and radius (Star) or number of sides (Polygon). Press OK to create your shape at the location where you first clicked. Press Cancel to stop creating this new shape.

Step 5 **Set color**

You can set the color of your new shape using the Fill and Stroke buttons in the Toolbox. First make sure that your object is selected by clicking on the Selection tool. A blue outline should now appear surrounding the last shape created. If not, click on your chosen shape using the Selection tools and it will become highlighted. In the Toolbox, double-click on either the Fill or Stroke buttons, and the Color Picker window will appear.

Use the Color Picker to set the Fill and Stroke colors. The Fill and Stroke buttons are easily accessed at the bottom of the toolbar.

Step 6 **The Color picker**

The Color Picker contains a large box with a range of colors to choose from. To the right is a vertical slider with arrows that allow you to move through the color spectrum. Value boxes allow you to enter specific values based upon different color modes. Use the slider on the vertical bar to define your color spectrum, and select your color from the main selection box. Your chosen color will appear to the right of the color spectrum slider. Press OK. Your object will now take on the fill or outline color selected.

the pen tool

I

The Pen tool offers a more advanced method of image making than offered by the various shape tools. It allows you to create and define your own lines and curves, and also comes with additional tools for editing shapes after construction. The Pen tool therefore represents the main method of constructing images in Illustrator. The line defined by the Pen tool is referred to as a Path.

Step 1 **Set fill and stroke**

Start by setting the Fill and Stroke colors for your new shape (see page 103, Steps 5–6). It is often beneficial to turn off Fill color when using the Pen tool. To do this first click on the Fill button in the Tool Options bar, then select the None button. Select the Pen tool from the Toolbox.

Set the fill color to none using the white cross with a red diagonal stroke in place of a fill color.

Step 2 **Straight line**

Place the cursor on the artboard and click. This will define the first anchor point of your new shape. To create a straight line, move to a new position on the artboard and click again. A second anchor point will be created, with a line running between the new anchor and the first.

Step 3 **Curves**

In order to create curves, move to a new position and click and hold the mouse button. Dragging the mouse away from this new anchor point will start turning the straight line into a curved line. Blue control points will emerge from this anchor point: one follows directly under your mouse pointer, while another will move in the opposite direction. These control points and the line in between define the direction and extent of your new curved line. Let go of the mouse button to finalize your new curve.

Step 4 **Add anchor point**

Adding a new anchor point will continue the curved line based upon the direction and length of your control points in the previous step. A larger distance between control points creates longer and more extreme curves, and the angle of the line in relation to the preceding and following anchor points defines the direction this curve takes.

Step 5 **Close shape**

Continue to build straight and curved lines until you are happy with your shape. You can close a shape (give it a solid unbroken outline) by clicking on your very first anchor point. The shape will now complete itself. Alternatively, to leave your shape open and move on to a new shape, click on the Selection tool in the Toolbox.

Step 6 **Fill**

With your new Path selected, use the Fill button to apply a fill color. For closed shapes, the fill area will be defined by the Path. For open objects, the fill will also be defined by the Path, but will continue in a straight line between the first and last anchor points of your path.

You can use the Color window or the Color Picker to add a fill color. The Color Picker gives you more control when trying to find an exact color, and also allows you to change the color format for precise selection using CMYK, RGB, or LAB color options for examples.

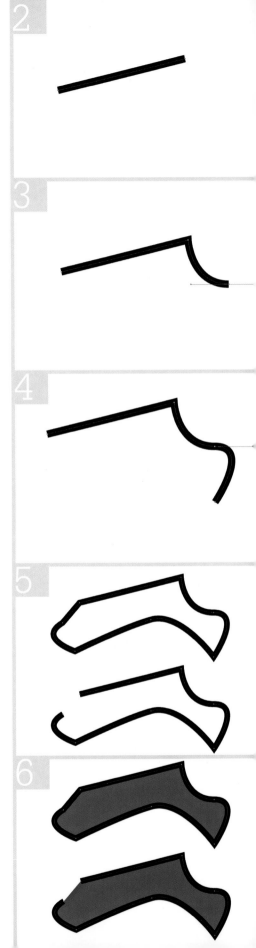

refining paths

Once you've created a shape using the Pen tool, you may need to refine or edit it. The Direct Selection tool allows for the selection and adjustment of existing anchor points and curves. Alternatively, the Pen tool has a number of extra options that allow you to further refine your shape by removing or adding anchor points, or converting straight lines to curves.

Step 1 **Direct selection**
One of the easiest and most common methods of editing a shape is through the Direct Selection tool. Start by selecting the Direct Selection tool in the Toolbox. Clicking on individual anchor points allows you to select them individually, and move them around to redefine your shape. Clicking and dragging on control points allows you to redefine your curved lines by adjusting their angle and direction.

Step 2 **Remove anchor points**
To remove unwanted anchor points select them using the Direct Selection tool, and then press the Delete/Backspace key. Note that this will break objects, making closed shapes into open shapes, or potentially splitting open objects into two separate objects.

Step 3 **Keep shape closed**
To remove unwanted anchor points without breaking your shape, click and hold the mouse button on the Pen tool, and select the Delete Anchor Point tool. Next click on an anchor point to delete it. Any lines between adjacent anchor points and the deleted point will be removed, and replaced with one line between the two remaining adjacent points.

Step 4 **Add anchor points**
You can add an anchor point between existing points by selecting the Add Anchor Point tool (hold down the mouse on the Pen tool), or by going to Object > Path > Add Anchor Points and clicking on the line extending between two anchor points. The

Direct Selection tool can now be used to move the new anchor point.

Step 5 **Convert anchor points**
The Convert Anchor Point tool (hold down the mouse on the Pen tool) allows you to convert straight lines to curves. Click and drag on an existing anchor point to convert it, using the emerging control points to define your new curved line.

Step 6 **Options**
Additional options for editing are available from Objects > Path. The illustration demonstrates the successive application of some of the options available from this menu to a simple rectangular object: 1. Simple square; 2. The Add Anchor Points option in this menu; 3. Direct selection and movement of these points; 4. Simplify option, with default settings applied in the dialog box; 5. Split into Grid option set to 3 rows and 3 columns.

The Direct Selection tool allows you to choose anchor points for manipulation.

The Path Menu option gives you more options for controlling your shape, including the automatic addition of anchor points or simplification of a shape.

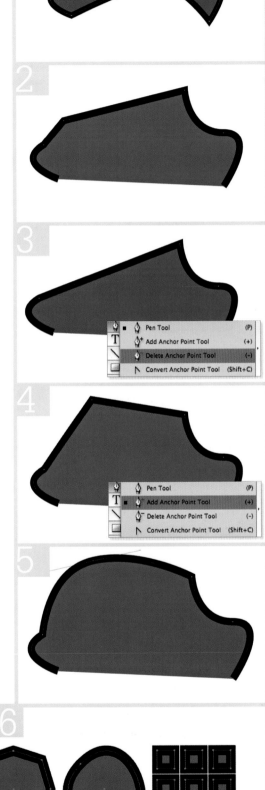

1 2 3 4 5

line weights and styles

42

I

Line weights (or thicknesses) are an important aspect of effective visuals—they communicate weight, substance, and depth, and can help delineate between objects. Therefore, it is important to know how to control the weight of lines created in vector software. In addition, it is important to consider other fine controls over a path's appearance, whether it has sharp or soft finishes and corners, or whether it's broken or solid. This section shows you how to make such adjustments and achieve effective results that will improve the aesthetics of your imagery.

The Stroke window lets you adjust the look of paths created with the Brush or Pen tool, including the overall width of the stroke and the way corners are drawn.

Dotted lines can be created by setting a width to the Dash and Gap boxes. If only one value is set in the first box, the dash and gap will be equal.

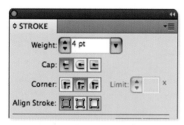

Use rounded corners to give your lines a softer edge at steep angles.

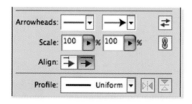

Arrowheads can be added to lines by selecting the head type from the drop-down menus. You can refine the look using the Align and Profile buttons.

Line weights

Step 1 Stroke

Using skills learned in the previous sections, create an image as shown. Select one of the paths you have drawn with the Selection tool and go to Window > Stroke to open the Stroke palette.

Step 2 Weight

In the Stroke palette, click on the Weight drop-down menu and select 6 pt (point) weight. This will change the weight of your selected line—larger weights make thicker lines.

Step 3 Dashed line

Using the Pen tool, create a long line running horizontally through your image. Click on the Dashed Line in the Stroke palette and enter the number 24 in the first box labeled "dash" and 12 in the box labeled "gap." Each dash will now measure 24 pts, with a gap in between of 12 pts. Above the Dashed Line tick box is a section labeled Cap. Click on the middle of the three buttons. The Cap option softens the edges of each individual dash.

Step 4 Corner options

Select one of your paths where there is a sharp (< 90 degrees) angle between the lines joining anchor points (4a). In the Stroke palette, select the Round Join button in the Corner options. This will round off the edges of the corners making them smooth, and less jagged and harsh (4b).

Step 5 Arrowheads

Create a small curved line using the Pen tool (roughly a quarter circle shape). Select the curved line with the Selection tool, then choose an arrowhead from one of the Arrowheads menu boxes in the Stroke palette. If the arrow faces the wrong way, set the first Arrowhead to none, and choose from the second Arrowhead menu. You can select the position of the arrowhead point in relation to the path by clicking between the two Align buttons on the Stroke palette (5a and 5b).

Line styles

Step 1 **Weight**

Additional options for setting line styles are available from both the Stroke and Brushes palettes, both accessed via Window. These allow you to move away from the limitations of uniform line widths by setting strokes to grow or fluctuate across their entire length. Varying line weights can help to suggest light and shadow, roundness or solidness, character, and personality.

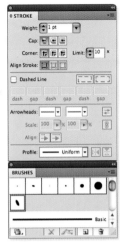

Use Brushes to add variety and weight to your lines.

Step 2 **Profile**

The top row of line and circle combinations, and the first three from the second row, represent Profiles set within the Stroke palette.

A variety of profiles allow you to change the look of each stroke.

Step 3 **Calligraphy**

The final three line and circle combinations have been made using custom Calligraphic brushes from the Brush palette. Custom Calligraphic brushes can be made by clicking on the New Brush button in the Brushes palette and selecting Calligraphic Brush. Adjust the brush by entering values into the Angle, Roundness, and Diameter boxes. The first two settings can also be adjusted by manipulating the brush preview at the top left of the Calligraphic Brush window. Set the Angle by clicking and dragging in the white area of the box, and adjust the Roundness by dragging either of the two dots that set the brush's radius.

Apply the brush by selecting your path or shape and clicking on the relevant brush in the Brushes palette.

43 fills and gradients

While vector art is often associated with flat colors, both the practices of digital artists and the software used to create vector art are not limited to the standard fill and outline. Graduated color fills are a simple method for creating texture or depth within your images. Gradients can be set to Linear, meaning a fade from one color to another in a linear way, or Radial, meaning the gradient expands outward from a central point. These can be further enhanced through the use of the Mesh tool, allowing you to add spot gradient colors to the surface of any shape.

Here you will learn how to create the impression of a three-dimensional object using gradients.

Step 1 **Create a circle**

Start by creating a circle with a red fill and no stroke. Add a second smaller circle on top of the first, approximately ⅓ from the top and left of the larger one. Make this circle white. This will represent a highlight for a 3D sphere. Go to Windows > Gradient to open the Gradient palette and Window > Swatches to open the Swatches palette. You'll need to drag the palettes away from the edge to keep both open at once. Select the white circle. In the Gradient palette in the Type drop-down menu select Radial. This will change the fill for this object from a solid fill to a radial gradient fill.

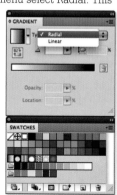

The Gradient window and Swatch window. Use these together to quickly add color to your gradient and to save gradient swatches.

Double click swatches to open the Swatch Options window, where you can name your swatch.

Step 2 **Set gradient colors**

In the Gradient palette is a preview window of the applied gradient. You can change gradient colors and their opacity by dragging colors from the Swatches palette onto the window, and then selecting the colored pointer. Drag a white swatch from the Swatches palette onto the left side of the Gradient Preview window. Remove the previous left side color by dragging the color pointer at the bottom of this window off the palette. Replace the color on the right side of the Gradient Preview window with a red color matching the color of your large circle. Remove the previous color pointer.

Step 3 **Gradient opacity**

Select the red pointer by clicking on it. Beneath the preview window you will notice a box labeled Opacity. Change the value in this box to 0% by either typing in the box, or clicking on the arrow to the right of the value and dragging the arrow on the pop-up value slider to the left until the box value reaches 0%. Above the preview window is a small diamond shape located horizontally half way between the two pointers you have now added. This allows you to set the blend between the two colors, which determines how quickly one color changes to the other. Drag this arrow to the left or right to change the blend until you are happy with the mix.

Step 4 **Set gradient swatch**

Now save this gradient as a new swatch. At the top left of the Gradient palette is a small thumbnail of your gradient fill. Drag the thumbnail image onto your Swatches palette. Double click on the new swatch in the Swatches palette to bring up the Swatch Options window. Add a new name for your swatch and click OK. You can now apply this swatch to other shapes by selecting Fill in the Toolbox, and choosing this swatch.

Next use the Gradient tool in the Toolbox to fine-tune the gradients. The Gradient tool allows you to set the direction and angle of linear gradients, or in this case, set the center and blend of radial gradients.

Step 5 **Fine-tuning**

Select the large red circle shape using the Selection tool. In the Gradient window, select Radial gradient. Drag two of the red colors from the Swatches palette onto the left and right side of the Gradient Preview window, and remove the existing colors by dragging them off the palette as before. Double-click on the rightmost pointer to bring up the Color Mixer and create a darker red color by increasing the Red channel.

You can change colors using the sliders or by entering numbers in the numeric boxes.

Step 6 **Radial gradient**

Click on the Gradient tool in the Toolbox. A white horizontal bar will appear over your image. The small circle to the left is the center of your radial gradient fill—the location from which your fill starts, represented in the Gradient palette by the left side of the Gradient Preview window. The square to the right represents the right side of your Gradient Preview window.

Step 7 **Radial gradient fill**

Click and drag from just above and to the left of the approximate center of the red circle toward the bottom right-hand side of your circle. This will reset the center and furthest extent of your radial gradient. Keep dragging until the expanding dotted line representing the radius of your gradient extends just beyond the radius of your circle. Release the mouse button.

Step 8 **Adjust gradient mixture**

Move the mouse over the white bar that represents the radius of your circle. You will notice two sliders that represent your gradient just below the bar. Drag these sliders to the desired location until a good mixture is found. You can also use the preview window in the Gradient palette to adjust the gradient mixture.

Step 9 **Experiment**

Experiment with different opacities, color mixtures, and the gradient radius. You can also add additional colors to the gradient to try out multicolored gradients.

Change the gradients mix using the color indicators and mix indicator at the bottom and top of the Gradient Preview.

introducing the pathfinder tools

Digital illustrations cannot solely rely on simple block colors and shapes. The ability to create complex objects is vital to the mastering of digital illustration. While the Pen and various shape tools available in Illustrator offer the ability to make and refine objects with sophisticated curves and detailed lines, it is often through the interaction of these forms that beautiful artwork is created.

Here we're going to look at the Pathfinder tool. This tool allows you to combine individual shapes in order to produce more complex forms or create shapes with cutouts such as donuts, rings, and windows.

First we'll create shapes using simple combinations before looking at more advanced uses of this tool in combination with the Align tools.

Step 1 Create shapes
Create the shapes shown here using the various shape tools. These will form the component parts of a key illustration—a complex shape created from simple objects. For the rounded diamond shape, create a rounded rectangle using the Rounded Rectangle tool. Click on the Selection Tool, then move to the corner of the new Rounded Rectangle shape until the rotate cursor icon appears. Hold the Shift key, and click and drag to rotate the object. Holding Shift allows you to constrain the rotation to set incremental angles. Rotate once to 45 degrees.

Step 2 Pathfinder
Go to Window > Pathfinder to open the Pathfinder palette. Click on the Selection tool, and select the long horizontal rectangle. Using the Selection tool, move the long rectangle so that it overlaps with the rounded diamond shape (2a). Select both the horizontal rectangle and the diamond by holding down the Shift key and clicking each object individually until both are highlighted by a blue box (2b). On the Pathfinder palette locate the button marked Unite (under Shape Modes). Click this button to join both objects together.

Step 3 Combine objects
Continue this process, arranging all objects except the circle into their respective positions. Combine objects by selecting pairs of objects and clicking the Unite button.

Step 4 Minus front
Pathfinder options often rely on the relationship between two objects in terms of which is above the other. In particular, the Minus Front option allows you to cut one shape from another, the uppermost shape being removed from that underneath. Select the circle shape using the Selection tool and move it over the diamond section of the key (4a). Ensure it is the uppermost object by selecting Object > Arrange > Bring to Front. Now select both the circle and the key shape. Click on Minus Front from the Pathfinder palette (under Shape Modes). This will cut the circle from the key (4b).

The Pathfinder window is a useful tool for creating complex shapes through the combination of overlapping areas.

Use Arrange to bring objects forward or backward in relation to each other. Relative positions can affect how the Pathfinder transforms your selected objects.

Recreating complex shapes and objects

The Pathfinder options do much more than simply combining or cutting out shapes. They are particularly valuable in cases where existing and often difficult to recreate shapes need to be adapted. The following example will show you how to make use of existing shapes in combination with the Intersect and Exclude Shape modes to further refine your objects and create even more complex shapes. These tools are particularly useful when complex curves or detailed areas need to be recreated accurately.

Use Reflect to make mirror images of objects. This tool is particularly useful for creating symmetrical objects when the Copy option is used.

The final image, which makes use of cutouts and additions.

Step 1 **Reflect**

Construct half of a heart shape similar to the one pictured here using the Pen tool (1a). Select this shape using the Selection tool, then choose Object > Transform > Reflect. Click on the Preview check box and choose Vertical to reflect this object vertically (1b). Click Copy to create a duplicate of this object.

Step 2 **Unite**

Move the copy so that both halves align at the center, then combine using the Unite Pathfinder button. Draw a

Use the Unite button (top left) to join two selected objects together.

second shape over the top of the first ensuring that it overlaps the edges of the heart shape. This shape will eventually become a shadow for the heart shape, although the overlapping areas will be removed.

Step 3 **Copy**

Make a copy of the heart shape by selecting it, and then choosing Edit > Copy from the menu. This will be required later when the overlapping shape is produced. Select both shapes. Open the Pathfinder window (Window > Pathfinder) and click on the Intersect button. A new shape will be created representing the areas where both shapes overlapped.

Step 4 **Paste**

Go to Edit > Paste in Place. This will replace the lost heart shape destroyed by the Intersect command. With the heart selected, choose Object > Arrange > Send to Back from the menu to send it behind the intersect shape. Note how the new shape follows perfectly the curves defined by the heart shape.

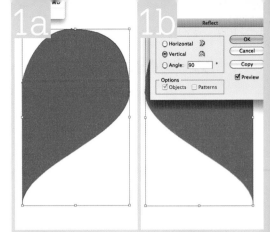

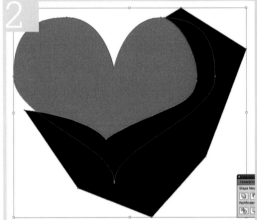

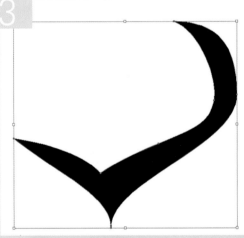

making a logo with the pathfinder tools

Possibly the best way to show the flexibility and versatility of Illustrator's Pathfinder tools is to put them into action to create a vector character. This lesson uses mainly simple shapes to create the character, and some of the Pathfinder objects to create combinations where these shapes overlap.

The aim of this lesson is to create a character logo. Logos tend to rely on simple colors and often need to be adaptable to color and background changes. This character will therefore be created so that areas that are not black are transparent and can be placed over another object so that background colors show through. This can be helpful for making rapid changes without finding and adjusting multiple objects.

Step 1 **New document**
Open a new landscape Illustrator document. Draw three ellipses using the Ellipse tool. These should each be slightly different sizes. The easiest way to do this is to create the largest of the shapes, duplicate it twice, and rescale to produce the other two.

Step 2 **Overlap two ellipses**
Place the middle shape over the largest so that their edges align near the bottom left. Open the Pathfinder window. Select both overlapping objects, then click on the Minus Front button.

Step 3 **Create a star**
Create two small overlapping circles, then select the Star tool. Click near the small circles to bring up the Star creation window. Set the number of points to 4, and use a 2:1 ratio for Radius 1 and 2 (i.e., Radius 2 is half of Radius 1). Scale the star if necessary and arrange near the small circles. Select all three objects and then use the Unite Pathfinder tool to combine them into one object. This will become a highlight for the smallest circle.

Step 4 **Combine the elements**
Locate the smallest circle created in Step 1, and move it on top of the original cutout shape—it should be placed aligning with the bottom left as before. Move the highlight object from Step 3 over the top of the smallest circle so that it slightly overlaps the top right as shown. Choose both the highlight and small circle and use the Minus Front Pathfinder tool to create the cutout. Finally, combine the two remaining objects together to create one single eye object.

Step 5 **Forming the neck**
Duplicate the eye object, then create three more shapes—one large circle, one shallower ellipse, and one narrow horizontal ellipse. Duplicate this last object by holding the Alt/Option and Shift keys and dragging so that both objects stay aligned vertically. Drag the large ellipse over the circle and use the Minus Front tool to remove it from the circle. Place the two eye objects over the cutout area. Make a third duplicate of the remaining ellipses, overlap two of them ensuring that they align vertically, and use the Unite button to combine the two together.

Step 6 **Creating the neck**
Select the Delete Anchor Point tool from the Pen Tool options. Locate the control point on the left side of where the two recently combined ellipses meet and click it to remove it. Your ellipses should now have a straight vertical line on the left side. Repeat with the right side to create a shallow dishlike silhouette.

Step 7 **Move the neck**

Select the remaining ellipse, rescale it so that it is slightly smaller, and place over the top of the combined ellipses from Step 6. Select both and use the Minus Front tool to cut it out from the dishlike shape. Drag and rotate it so that it sits at the bottom right of the emerging head shape as shown. Combine both the head and dish shapes using the Unite tool.

For the next stage, we will start to add details to our emerging character's head. This will again make use of simple shapes combined with the Pen tools to refine our objects.

Step 8 **Creating the nose**

Create one circle and then duplicate and place next to the first so that they are aligned vertically. Ensure that they just touch. Select both and combine with the Unite tool. Use the rectangle tool to create an overlapping rectangle that sits over the center points of both circles, extending beneath them. Select both the rectangle and combined circles, and use the Minus Back tool to create a curved triangular shape.

Step 9 **Locate the nose**

Rotate the new shape by approximately 15 degrees and place it so that it points to the space between the two eyes. The right side curve of this new object should just start to touch the inner edge of the head shape.

Step 10 **Start the antennae**

Create two new ellipses and place one at the 2 o'clock position on the head. Rotate it so that it sticks out like an ear. Duplicate and flip this object. In order to fit this object over the head without overlapping into the face area, it needs to be trimmed. Use the Pen tool to create a cutting shape to remove the excess area. In this example, we have moved the two objects to one side for easier viewing, although it may be best to do this while the shape overlaps in place. Use Minus Front to trim this object, then place. Combine the remaining shapes together.

Step 11 **Round off the cheeks**

Use the Direct Select tool to locate the join between the curved triangle shape and head from Steps 7/8. Drag the control point where the shapes converge so that the curve at the joint is more natural and rounded.

Step 12 **Add additional features**

Continue to add features and details such as the antennae. Again, use cutout shapes such as triangles and ellipses. Select any remaining objects and combine them using the Unite tool. Finally, create a rounded rectangle with a color fill to act as a background. Select and use Object > Arrange > Send to Back to place this behind the other objects.

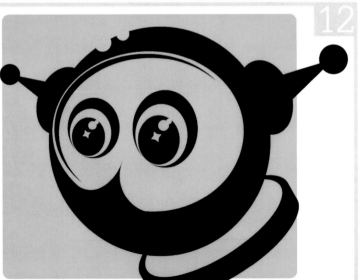

The final image, created solely using simple shapes and the Pathfinder tool.

creating vector art
Valistika Studio

Valistika's image is a great example of using the techniques in the previous lessons to create an effective digital illustration. It uses simple shapes, created with the Pen or Shape tools, and combines them using the Pathfinder. Shapes are duplicated and reflected, and fills are created using the Gradient tool to indicate depth and shape.

The image uses a simple design and composition, making use of layers and lighting to give the impression of depth to the objects.

This is broadly achieved by the use of gradient fills that make flat objects round and indicate a lighting source through highlights and shadows. This is particularly noticeable in the eyes and teeth that make use of an offset gradient to indicate not only shadows but also reflective surfaces. Highlights in the eyes, in the form of triangular and star shapes, give a glossy feel and help to define the textures for the image.

Symmetry has been created in this image by copying and flipping the mouth, eyes, and

tongue. However, the use of simple details allows this symmetry to be broken, adding interest and points of focus.

The background is incredibly simple but effective in creating a space that the character can inhabit. A simple horizon line is enhanced by the indication of some form of landscape beyond the image plane, and gives a sense of perspective and scale to the world.

Valistika has also made effective use of a limited palette, and chosen colors that enhance the idea of other-

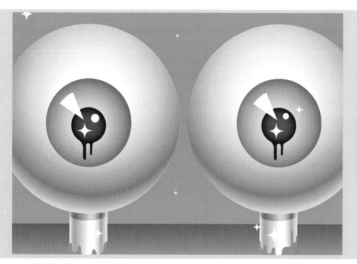

Cutout shapes
Cutout shapes indicate features such as the eyes, tongue, and throat, and the latter is particularly effective in its use of negative space to create form.

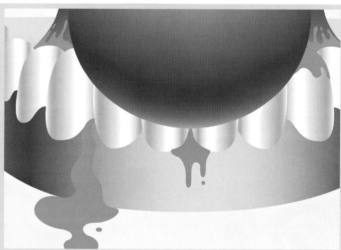

Curved lines
Fluid curved lines on the slime layers make a believable liquid, and simple changes in the shape help to indicate interaction with various surfaces—such as pooling onto the ground or running down vertical surfaces, helped by small dots of fluid indicating drips and traces of movement.

CASE STUDY

worldliness in this image. The use of vibrant greens against simple grays, and, in particular, the green sky and background, place us in a location that is strange and alien. The use of a limited palette means that we are not visually overwhelmed by numerous confusing or competing colors and can therefore focus upon the content of the image.

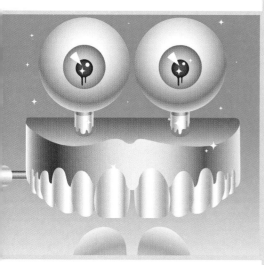

Details

Details such as the winder add an extra dimension to this object, transforming it into a surreal yet playful toy. It is details such as this, together with the stars and highlights, which help transform this image from a potentially flat and uninteresting work into an intriguingly layered illustration that works despite the simple shapes.

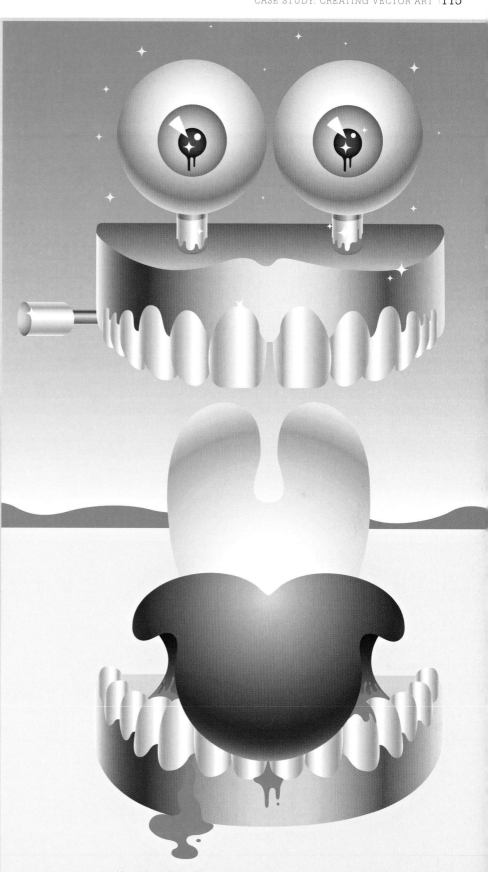

importing sketches and references

There are many ways in which to create digital images. Some artists prefer to work directly with digital illustration software, while others use traditional techniques such as drawings or photography as the starting point for their work. They then scan or download their work and import the digital files into image-editing software where the work of digital creativity begins.

Many character artists in particular use the latter way of working. They import sketches into programs such as Illustrator that form the initial basis for their work, before proceeding to render the final images digitally.

Illustrator supports a wide variety of image formats that can be imported and placed on the artboard, to be used either as reference materials, or directly traced. Here we'll show you how to place and handle imported images.

Step 1 **Scan**

If you're scanning in artwork, follow the steps outlined on pages 49–50 to scan, amend, and save a file in Photoshop. This will be the image you import. Make sure the file is saved in either JPEG or PSD format, and note where it's saved.

Step 2 **Place**

In Illustrator, go to File > New to create a new document. Set the document up according to your intended output format (see pages 47–48). Choose File > Place from the menu and locate the folder containing your scanned image file. Select the image, and then click Place. Your scanned document will appear on the artboard.

Step 3 **Position**

Illustrator will treat this image as a Rectangle Shape, meaning that it can be scaled, rotated, moved, or transformed like any other object. However, image details cannot be edited. Arrange your image within the artboard so that its scale and position are appropriate for the image you are about to create.

Step 4 **New layer**

Go to Window > Layers to open the Layers palette. This will display the layering for your current document. New objects are automatically placed on Layer 1. To see all of the layered objects in Layer 1, click on the grey sublayer arrow to the left of Layer 1's thumbnail image. Draw a rectangle on the artboard using the Rectangle tool and notice how a new sublayer is added. Deleting this object (using the Delete/Backspace key) will remove the object from the artboard and its sublayer.

Step 5 **Lock layer**

It is often beneficial to lock your reference layer. Locking this image will ensure that you do not accidentally move, delete, or edit the image while performing other actions. Lock a layer by clicking in the Lock box. A padlock icon will appear in the box, and you will now not be able to select or edit this sublayer. Click the Lock box to unlock the sublayer.

Step 6 **Hide layer**

It may also be necessary to hide this layer during construction of your image to make it easier to see new paths or check the quality of your emerging image. Click the Visibility box (with the eye symbol) in order to toggle visibility on/off. While invisible, this layer is also locked and therefore cannot be edited.

Images can be imported from a number of file formats using the Place menu option, including Photoshop images, JPEGs, and TIFFs.

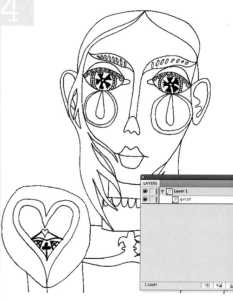

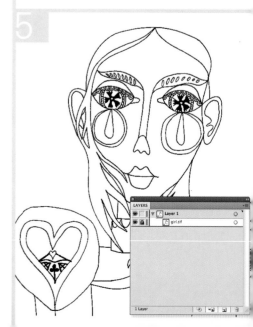

illustrator layers

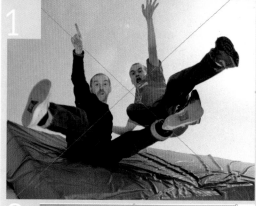

Although, like Photoshop, Illustrator supports layers, these are often not used in the same way as in Photoshop, and many Illustrator tutorials make little or no reference to them. While Illustrator's layers are not quite as essential to understand as layers in Photoshop, knowing how to create new layers in Illustrator to organize aspects of your image and quickly reveal and hide areas will improve your method of working.

Here we're going to use layers to organize workflow, in particular to isolate aspects such as scanned drawings and separate areas of an image.

Step 1 **Direct trace a photo**

A digital photograph has been imported into Illustrator for a direct trace. The Layers palette is opened by going to Window > Layers, and by default a new layer called "Layer 1" is created. All images are automatically added to this layer. Note how the "photo" layer exists as a sublayer of Layer 1.

Step 2 **Renaming layers**

Layers can be renamed by double-clicking on the name of the layer. This will bring up the Layer Options dialog, where you can change the name and other details such as the bounding box and path colors for objects on this layer. Here the layer has been renamed to "References" and will contain only the imported photograph.

Use the Layer Options window to name your layer, and adjust the colors for paths and outlines. Naming makes organizing your layers easier.

Step 3 **Add new layers**

By clicking the Create New Layer button at bottom right of the Layers palette, you can add new layers. Here two new layers are prepared and named ("Trace Character Right" and "Trace Character Left") as in Step 2. Each layer has its own unique color to help identify objects belonging to that layer.

Step 4 **Locking layers**

In order to keep the reference image still, the layer can be locked by clicking in the box to the right of the visibility (eye) symbol for that layer. All sublayers will automatically be locked for any locked layer, although you can individually lock sublayers for layers that are not locked if you wish to isolate objects. Locked layers cannot be added to or moved. In this case, locking the References layer allows us to create a trace without worrying about inadvertently selecting and moving the reference.

Step 5 **Using sublayers**

With the traces nearly complete, you can see the individual sublayers for each layer. Thumbnails of each object, such as the various paths, can help you to identify objects and help with the selection of specific elements where multiple and complex shapes are used. Layer visibility can also be turned on or off using the eye symbol next to the layer name. This can be helpful when tracing, in order to locate objects or to check the composition.

Step 6 **Select a layer**

To select an entire layer, click on the circle symbol to the right of the layer name. If selecting the layer in this way, all objects on that layer will be selected. Note the colored bounding box and paths of the selected objects associated with this layer. Finally, we can see how the trace looks by turning the visibility for the References layer off. Leaving the layer hidden and locked means that we can come back to edit our traces knowing that the reference has not moved; this allows for quick and accurate edits and additions.

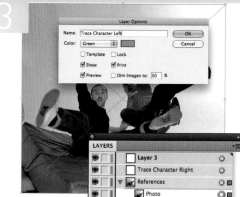

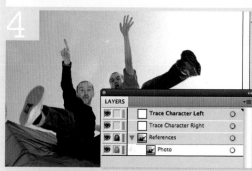

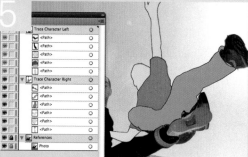

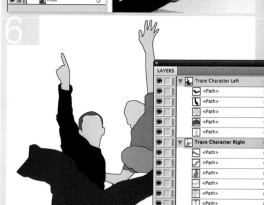

48 live trace

Live Trace allows you to create vector objects from pixel images, and is therefore a powerful method for creating scalable imagery for a variety of purposes. Live Trace can also be used to produce stylistic silhouettes and templates for more accurate or lifelike imagery, or as a basis for highly detailed patterned objects. This lesson will introduce you to the Tracing Options window, allowing you to create stylized silhouettes using monotones.

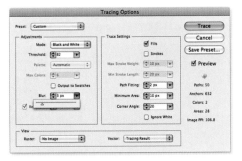

Understanding the Tracing Options window allows you to have greater control over your image traces.

Step 1 **Open a new document**

Start by creating a new Illustrator document, either landscape or portrait to match your image. Place a photograph using File > Place and scale to fit the artboard. Ensure that the image is selected and then select Object > Live Trace > Tracing Options. In the Tracing Options window, Mode will be set to Black and White. Ensure that Preview is ticked so that you can see adjustments as they are made to your trace.

Step 2 **Adjust the threshold**

Click on the Threshold box to bring up the adjustment slider and drag to choose a threshold setting. This allows you to change the balance between the dark and light areas of your image. Choose a setting that creates a nice balance and that allows you to see the details within your image—in this case, the face and hands.

Step 3 **Set blur**

The Blur option allows you to add a blur to your image before the trace is applied. This can help smooth out areas of fine detail that may look too rough. Settings of between 0 and 3 are usually appropriate—too much blur can obscure your image.

Step 4 **Apply resample**

Resample allows you to change the resolution of your image for the trace. Higher samples (measured in pixels) pick out finer detail while lower settings can act like the Blur setting in reducing noise and unwanted artifacts.

Step 5 **Path Fitting setting**

Path Fitting allows you to constrain the path of the trace closer to the original image and can help refine edges and areas of details. The default setting is usually fine, although a looser setting of 7 pixels has been used in this example.

Step 6 **Minimum area**

The Minimum Area setting determines how large an area of detail has to be for it to be included in the trace. Again, this can help you remove artifacts and unwanted details at higher settings. At lower settings, more detail will be preserved.

Step 7 **Corner Angle**

Corner Angle allows you to choose how angles are rendered and can create more refined curves and edges depending on the setting used.

Step 8 **Ignore White**

Ignore White, if selected, will make sure that the final trace only produces vector objects for nonwhite areas of the image. If left unselected, the white area in this image will also become a vector object. For example, if you wish to add color to the figure's hands and face, then leave this box unchecked. If you are merely interested in the shadow, then select this option.

Step 9 **Expand**

Once you are happy with your trace, click the Trace button to apply to your image. In order to edit your trace, however, you will need to expand it. Choose Object > Live Trace > Expand. You will notice that the paths and control points for your image are now visible.

Step 10 **Ungroup**

At the moment your trace forms one large object. To further allow you to edit your trace, you need to ungroup the separate objects that make up the trace. Choose Object > Ungroup to separate the individual vector objects.

Step 11 **Color the trace**

With your objects ungrouped, you can now select, color, and adjust individual areas using any of the Illustrator tools.

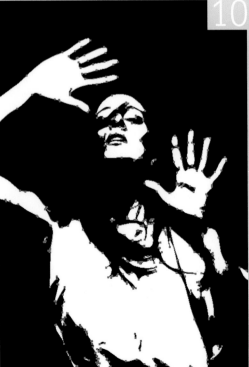

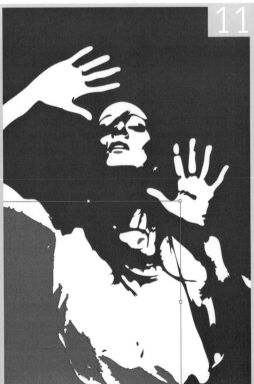

Live trace: Color settings

The Tracing Options also allow you to convert images to colored vector objects, creating a stylized tonal image as shown here, or highly detailed images that are difficult to tell from pixel versions (a useful technique for image enlargements). Using color for your trace can create more challenges than the monotone example seen on pages 118–119, and can take a while to preview at high settings if preview is turned on. However, it can also create dramatic imagery with numerous options for adjustment once vectorized.

Step 1 Create a new document

Create a new document and place your chosen photograph or image. Select it and choose Tracing Options. Click Preview, then change the Mode to Color. The trace will be shown applied to the image as a preview.

Step 2 Select colors

You can change the Max Colors setting to choose how many colors are sampled. The higher the number, the broader the range of colors incorporated into the trace. At higher settings, such as 124 or more, the image will start to resemble the photographic image.

Step 3 Blur settings

Adjust the Blur setting to help blend the colors and reduce the number of unwanted artifacts. However, be aware that, at higher color settings, this is likely to distort your image much more noticeably than for lower color numbers or when using the black-and-white mode.

Step 4 Resample

As this is a high-resolution image, we can adjust the Resample option to take advantage of the higher detail, or lower it to create rougher but faster traces. Notice how, at a lower resolution, details such as the edges of the fingers appear distorted and rough. Use higher samples to compensate alongside the other tools discussed in the previous lesson.

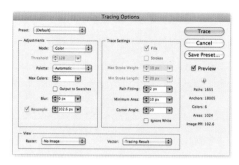

Change the Max Colors setting to control the number of colors produced by the trace. Fewer numbers produce more graphic images.

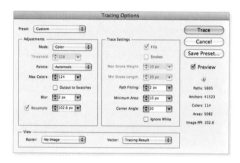

Use the Blur setting to help remove rough edges in your final image. Beware that too much blur may distort your final image. Try to find a happy medium.

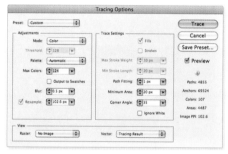

Resample adjusts the resolution at which the original image is sampled. Higher resolutions create more detailed traces, but may include more jagged edges and artifacts.

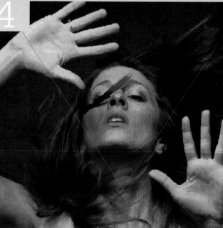

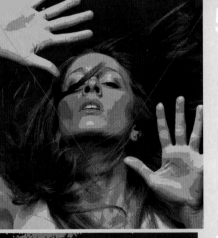

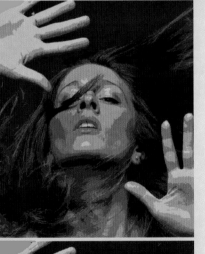

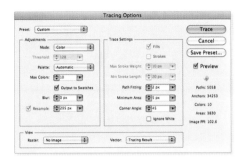

Step 5 Finalize settings

The final trace settings have been set. Colors have been limited to 10 and Resample at 295 pixels. Minimum Area has been set to 5 pixels to remove small artifacts, and a Corner Angle of 45 has helped remove harsh edges and created smoother curves. Finally, the box marked Output to Swatches has been ticked so that individual colors used in the trace can be reused or adjusted. Click OK to apply this trace.

Step 6 Expand

As before, use Expand to make the image editable and to ungroup the individual vector objects.

Step 7 Color swatches

Open the Swatches window (Window > Swatches). You will notice a number of swatches have been automatically added that match the colors used in your trace.

Step 8 Editing colors

Double-clicking on an individual swatch will open the Swatch Options window. From here you can adjust the colors to suit your needs.

Step 9 Identify a swatch

One of the colors visible within the face appears out of place and needs adjusting. Work your way through the swatches to identify the color used. In this example, we have adjusted the swatch color to black to show the location of this swatch in the image.

Step 10 Adjusting a color

Use the sliders in the Swatch Options to adjust the color until it fits better with the overall image, then close the Swatch Options window by clicking OK. Repeat for all areas until you are happy with the results.

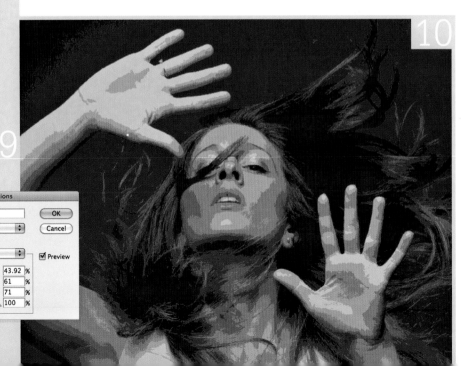

custom brushes

Illustrator's Brush tool does far more than replicate real-world brushes. It allows you to create brush strokes that have textures and shapes, as well as providing a way to apply a range of custom brush tools to any created path, including the outlines of shapes. This makes the Brush tool a valuable extension to all of the shape-making tools, besides a number of other functions.

Let's take a look at the Art, Scatter, and Pattern Brush tools. These allow you to create your own custom brushes for a variety of uses.

Art brush

The Art Brush allows you to create custom brush marks that will follow paths created with the Pen, Brush, or Shape tools.

Step 1 **Draw**

Draw your shape using the most appropriate tools. Here a combination of the Pen and Brush tools has been used to create a jagged brush mark. Set Fill to black and the Stroke to none.

Step 2 **Brushes palette**

When you're happy with your shape, select it with the Selection tool. Go to Window > Brushes to open the Brushes palette. Click and drag your brush onto the Brushes palette above any of the preset brushes. Let go of the mouse button.

Step 3 **New brush**

The New Brush dialog box will appear asking you to choose the kind of brush you wish to create. Select Art Brush and click OK. This will open the Art Brush Options window.

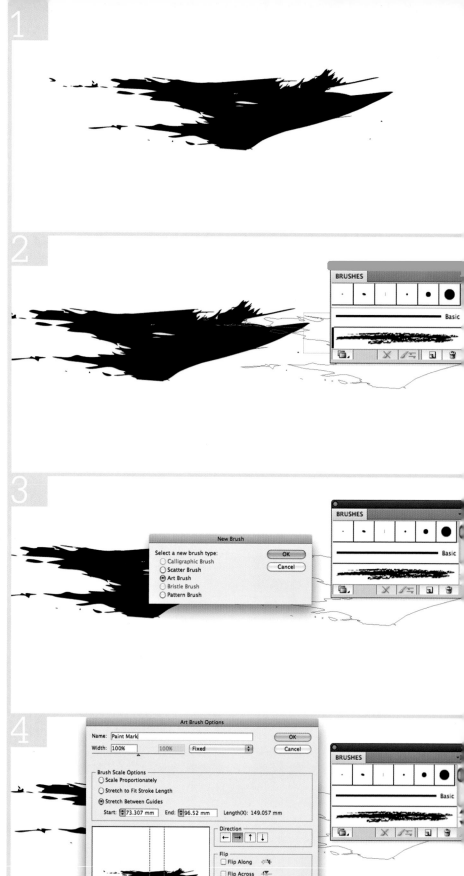

ART BRUSH OPTIONS

Colorization
The Colorization options allow you to set the color mode that applies to your new brush.

None
None does not allow you to change the color of your brush from that set when created.

Tints
Tints allows you to set the color of your brush to the Stroke color currently in use. This is the best option for flat color brushes and is selected for this brush.

Tints and Shades
Tints and Shades allows you to use grayscale colors from the original brush shape to adjust the shades of the applied brush based upon the Stroke color.

Hue
Hue shift allows you to define a key color that will match the Stroke color selected. All other colors will represent a corresponding hue shift away from the colors defined by the Stroke color.

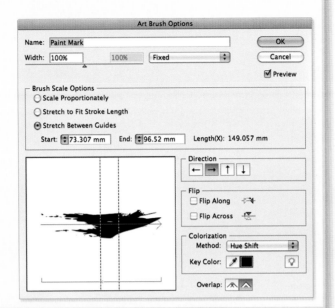

Step 4 **Art brush options**
The Art Brush Options window allows you to edit the proportions, directions, and color settings of your new Art Brush. At the top, name your brush so you can locate it in the Brushes palette. In the Brush Scale Options section, you can decide how your brush responds to the path on which it sits. In this instance, we have chosen Stretch Between Guides, and dragged the guides (dotted lines) in the preview box beneath to set which parts of our brush stretch to fit the line (the middle section), and which form the ends.

Set the direction of your brush using the Direction arrows. The preview box will indicate the start and end points for your brush. This means that the first point on a path will be at the start of the arrow, and the last point on the path will be at the tip of the arrow.

Step 5 **Set new art brush**
When satisfied with your brush, click OK. Your new brush will appear in the Brushes palette. Select it within the palette, then draw a path using any of the path creation tools, remembering to set the stroke color.

Step 6 **Edit art brush**
Brush options can be edited by double-clicking on the brush in the Brushes palette. This will open the Art Brush Options window so that you can change how your brush responds to the path, its color options, and so on. Click on the Preview checkbox to see changes to your applied brushes as they are made in the Options window. After clicking OK, you can choose to apply changes to existing paths where the brush is used, or leave existing uses as they are, applying the new brush settings only to new examples.

Pattern brush

The Pattern Brush allows you to produce brushes that adapt to the changing nature of drawn paths. Using sets of tiles, they are designed to take advantage of dramatic changes in path direction, such as strong right angles, introducing different elements of the brush according to the type of change detected. One particular use for the Pattern Brush is to create frames or vignettes, although there are numerous other uses depending upon the elements used within the brush, and the kind of path created.

Here we're going to create a simple vignette using the Pattern Brush.

Step 1 Draw

Open both the Brush and Swatches palettes. The Swatches palette will be used to define the elements contained within your pattern brush. Create two new shapes. Try to keep them simple with a flat fill color, and Stroke set to none. You can make them more complex as you get to grips with the Pattern Brush. The first shape will be your corner tile, and the second the side tile.

Step 2 Add to brushes swatch

When complete, select all parts of your corner tile shape, and drag as one object onto the Swatches palette. This will create a new Swatch of this object. Locate it and double click to name your new swatch. We'll call this one "Flourish." Click OK, then repeat this step with the side tile object, naming this swatch "Pattern Main."

Choose the appropriate pattern from the selector to apply it as your new pattern.

Step 3 Pattern brush options

In the Brushes palette click on the New Brush icon. Choose Pattern Brush from the dialog window and click OK. This brings up the Pattern Brush Options window. Name your new brush "New Pattern." Each element of the Pattern Brush has its own window with a diagram indicating its function. Click in the window labeled Side Tile (first on the left), and from the list below select "Pattern Main." This sets this tile type to the swatch created in Step 2. Now select the next tile window along, named Outer Corner Tile, and select "Flourish" from the list. Leave the other three tiles blank. Set Fit to Stretch to Fit and Colorization Method: None. Click OK when complete.

Step 4 Apply pattern

Locate and select your new brush from the Brushes palette. Draw a square using the Rectangle tool, setting Fill to none and Stroke to black. Your new pattern will be applied.

Step 5 Change properties

To change properties such as the scale of the pattern or color settings, double-click the brush in the Brushes palette. In 5b, the scale has been reduced to 35%.

Name your pattern to help you identify it in the Pattern Brush window.

Your pattern will appear in the Brushes window, with a thumbnail image of how it will look.

Scatter brush

The Scatter Brush allows you to generate multiple copies of individual objects, distributed along a path. The power of this kind of brush is in its ability to control the distribution and characteristics of your chosen scattered object, allowing you to create ordered or random placements, scale, and rotation. Combined with the ability to edit the path and therefore further refine the look of your scattered objects, this makes it a powerful tool for a number of applications. This feature, for example, is particularly useful for quickly generating visual effects such as a flock of birds or comet trails.

Step 1 Create shape
Create a snowflake object using the Pen tool. Use a combination of Reflect and Rotate to copy sections of the snowflake, and the Pathfinder tool to create the symmetrical arms.

Step 2 Add to brushes palette
Open the Brushes palette and drag your snowflake shape onto it. Select Scatter Brush from the New Brush dialog window and click OK.

Step 3 Scatter brush options
In the Scatter Brush Options window, name your snowflake Scatter Brush "Snow Scatter," and for now leave the brush settings to the default and click OK.

Step 4 Paint with new brush
Select your Snow Scatter brush from the Brushes palette. Using the Brush tool draw a curved shape on the artboard. You will see a line of snowflakes following the path you have just drawn.

Step 5 Edit scatter brush
In order to get the "scatter" effect, you need to edit the Snow Scatter brush. Double-click on the Snow Scatter brush in the Brushes palette. Click on the Preview check box so that you can see changes as you alter the settings. In the drop-down menu next to the Size slider, change the setting from Fixed to Random. Drag the arrow underneath the Size property slider to the left. Here we've set an amount of 30%. A second arrow will appear, set at 100%. Drag this arrow to the right—here we've set the amount to 121%. Your snowflakes on the path will now individually be assigned a random size between these two values. Adjust the drop-down menus and sliders for the Spacing, Scatter, and Rotation properties until you are happy with the results. Click OK to confirm your brush changes, and select the Apply to Strokes option from the dialog window that appears.

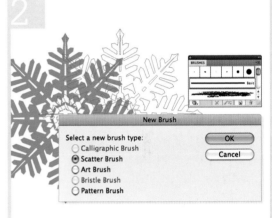

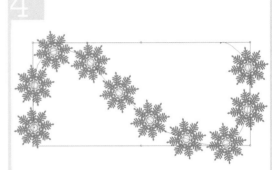

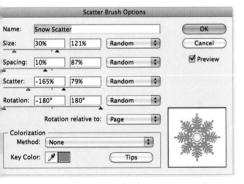

Changing the Scatter Brush Options allows you to control how your brush looks. The Random option allows you to create patterns that look unique and organic.

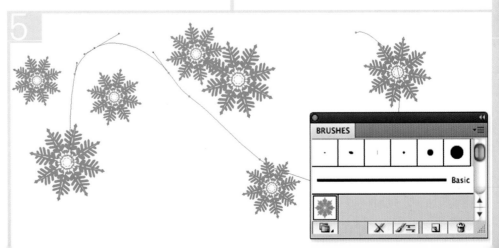

making pattern swatches

The ability to quickly create and alter patterns within vector software is one of its main advantages over analog illustration. Patterns can be created within a matter of minutes, although more complex forms still require forethought and planning.

Patterns in Illustrator are based upon a tiling system. This means that a pattern can be produced by constructing one tile of the pattern, which is converted into a pattern swatch using repeats of this tile to fill shapes, and applied in exactly the same way you would use a solid color fill. While this system is highly effective, it is limited to rectangular shapes and therefore you will need to consider how the tiles will repeat in relation to adjacent tiles.

The following section covers the creation of a basic pattern. Later you'll learn how to create more complex repeating patterns.

Step 1 Make filled shape
Make up a simple pattern fill using shapes contained within a square or rectangle. Go to Window > Swatches to open the Swatches palette.

Step 2 Add to swatches palette
Once the shape is completed, select and drag it as one object onto the Swatches palette. Locate the new swatch icon and double-click to bring up the Swatch Options window, where you can name your swatch.

Step 3 Fill
Create or select a new object to apply your pattern fill to. In the Tool Options bar, click on the Fill icon, and then from the Swatches palette select the new pattern fill.

Step 4 Edit pattern
You can edit your pattern in order to adjust colors, size, or content by dragging the pattern swatch from the Swatches palette onto a clear area on the artboard. This will create a single tile of the object for you to edit. Select the tile. This object is currently a group of the shapes made to construct it, and includes a rectangular bounding box added during the swatch-making process. In order to edit this shape, go to Object > Ungroup. This will allow individual shape objects to be edited.

Grouping can allow you to arrange shapes together for simplicity— use Ungroup to separate out already grouped shapes.

Step 5 Add to swatches palette
Make adjustments as necessary and, when complete, drag the edited tile back onto the Swatches palette. In this example, the color has been changed.

A Fill pattern applied to a shape. Pattern fills are a great way of creating repeating fills such as brick, metal, or similar materials.

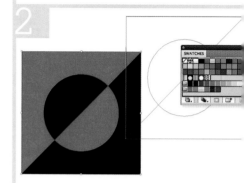

More complex patterns

The production of more complex patterns requires some thought as to how sides of a pattern tile relate to each other. For example, to create a diagonal stripe pattern, you need to understand how the bottom part of the tile relates to the top of the objects beneath it. Failing to correctly account for these relationships can mean the difference between seamless patterns and the sudden appearance of white or transparent lines, or misaligned sections that fail to register.

The steps here introduce you to the creation of a diagonal tiling pattern and point out what you need to be aware of in such pattern-production techniques.

Step 1 Set up grid
First, set up a grid to help you correctly align your objects. Choose View > Show Grid and View > Snap to Grid. Snap to Grid means that the points of new lines and objects are attracted to grid intersections, helping you align points accurately.

Step 2 Draw diagonal line
Draw a diagonal line using the Line Segment tool and set the Stroke to 6 points. Select Object > Path > Outline Stroke. This will convert this path into a solid object with a fill and no stroke set. At this point, we can make

use of the Pathfinder tools to edit this shape to fit within a rectangle for tiling.

Step 3 Draw rectangle
Draw a rectangle with no stroke and fill set to white over the top of the diagonal line so that the corners of the line remain visible. As you have Snap to Grid toggled on, the rectangle should fit perfectly.

Step 4 Intersect
Select both objects, then go to Window > Pathfinder to open the Pathfinder window. Click on the Intersect button to define a new shape based upon the overlapping areas of these two shapes. Change the fill color to black.

Step 5 Add to swatches palette
Drag your new pattern tile to the Swatches palette, then try applying it to a new shape. Note how the corners of each individual tile do not align correctly, each requiring a triangular corner to complete the ideal unbroken line. To correct this, make a copy of the existing diagonal line on the artboard using Object >Transform > Rotate. Set the angle to 90 degrees in the Rotation window and click Copy.

Step 6 Correction
With the new diagonal line, select the Direct Selection tool and choose the three points at the lower right-hand side of this object. Press Delete/Backspace to remove them. Select the remaining triangle shape, and repeat the copy procedure from Step 5, but this time setting the angle to 180 degrees. Place the new triangle in the bottom right corner of this rectangle. Select all objects together and drag to the Swatches palette. Apply the pattern fill to any shape to test and adjust as needed.

Outline Stroke offers a quick way of creating a filled object from a single path, and is particularly useful if you need to edit the look of a line.

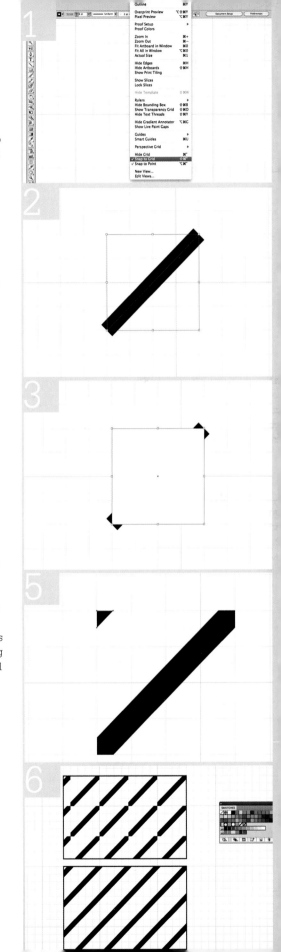

51 making a patterned image

While vector art is often associated with block color and simple shapes, modern artists and illustrators have made good use of the medium to produce complex and intricate artwork. Modern digital illustration often displays levels of intense detail and patterning, bringing images to life and creating interest for the viewer.

Although this development has partially been the result of new aesthetics within digital illustration, it can also be accounted for by artists becoming more familiar with the opportunities offered by vector software. Digital techniques provide a means of replicating styles and visual languages that were once restricted to complex printing methods or hours of laborious work. Now complex patterns can be completed in minutes or hours, and can also be easily reworked, revised, or enhanced without prohibitive outlay of time, money, or effort. For the amateur artist, this means that techniques and certain means of visual communication are no longer beyond their reach. For professional artists, this can mean significant savings in terms of time and effort dedicated to getting exactly the right aesthetic or meeting the demands of clients.

The following sections cover some of the techniques available to artists using vector-based software when developing patterns or details, either as a primary visual form, or as elements of broader digital practices.

Step 1 Create a new document
Start by creating a new Illustrator document in landscape format. Elements of this lesson rely on creating images that are symmetrical and, therefore, it is a good idea to use a grid to help with the layout and scaling of your shapes. Go to View > Show Grid to turn the grid on.

Step 2 Start creating a pattern
Zoom into the artboard so that you have two large squares of the grid visible. Set the Fill color to blue, and Stroke to None. Select the Ellipse tool and make a small circle within a 2 x 2 grid area that overlaps both large grid boxes. Next use the Pen tool to create the

lower shape shown. Ensure that the left edge is perfectly flat—adjust with the Direct Select tool if necessary.

Step 3 Create a teardrop
Select the shape you have just created and choose Object > Transform > Reflect. Set Axis to Vertical and click Copy to create a mirror image duplicate. Move the two objects so that they just meet.

Step 4 Duplicate the shape
Use the Unite tool in the Pathfinder window to create one single shape from the two joined halves. Make copies of the teardrop object using the Copy and Paste options. Rotate each of the copies by 45 degrees and shrink slightly.

Step 5 Create new pattern swatch
Make duplicates of each teardrop shape using the Reflect option. Finish the shape with multiple triangles that are 1 grid box high and 2 wide running underneath the teardrops. Select all of the objects created so far. Go to Window > Swatches and, in the Swatches window, click on the New Swatch icon at the bottom to make a Pattern Swatch from the selection. In the New Swatch dialog, enter the name "Droplets Pattern1."

Step 6 New fill
Delete the existing pattern objects and zoom out until you can see the entire artboard. Select the Rectangle tool and create a long thin rectangle. Click on the Fill box in the Tool Options bar to bring it to the front, then select the new swatch thumbnail to set it as the fill.

Step 7 Create new patterns
Continue to create new pattern objects using simple shapes with flat colors. Use pleasing color combinations, and shapes that can be effective at different scales.

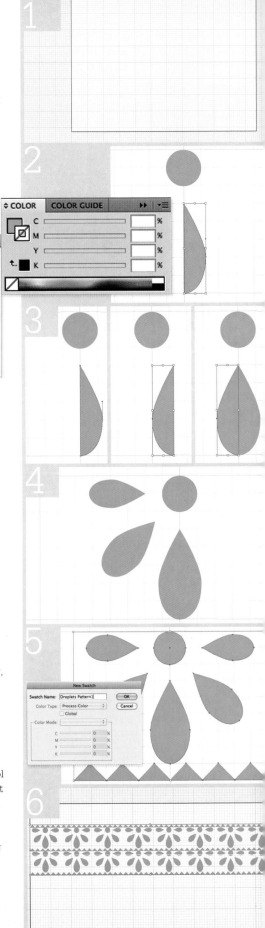

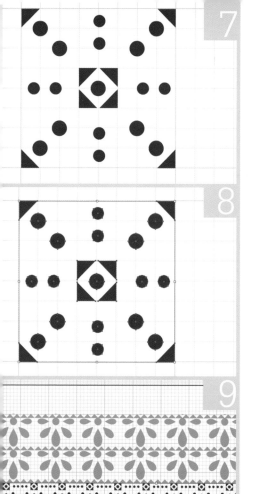

Step 8 **Create new swatches**

After creating each new pattern swatch, create a new swatch from it as before, and clear the artboard of the original.

Step 9 **Add to the existing areas**

Create more areas to fill with each new pattern.

Step 10 **Add bounding box**

On occasion you will need to create pattern objects that do not tile at the visible edges. In this example, the shape would normally tile at the bounding box as seen. Instead, create a new Rectangle shape that defines the desired bounding area to add space between the repeated pattern.

Step 11 **Drag selection**

With the new bounding shape, set both the Fill and Stroke to None. Select the bounding box object and the pattern object using a drag selection—with the Move tool, click and drag over all objects, then release to select. Create a new swatch from this object and test by filling a new rectangle.

Step 12 **Add bands of color**

Patterns of banded color can be created simply using small rectangles that are vertically aligned—it is often best to duplicate the boxes so that their widths match. Finish the image by creating multiple areas of pattern using individual rectangular shapes. Make different swatch sizes by dragging pattern swatches from the Swatches palette to the artboard, resizing the swatch object, and then dragging back to the Swatch palette. This method can also be used to make individual examples of the pattern tile.

The final image using patterns and pattern instances (dragged and dropped from the Swatches window).

patterns and details
Catalina Estrada

The versatility of vector-based software—its simple scalability, ease with which colors and paths can be altered, and the clean lines and fills that are characterized by this way of working—has led to a number of artists using vector applications for the creation of visually rich and elaborate images made of patterns and repeating objects.

An excellent example of this can be seen in the work of Catalina Estrada. Catalina makes use of traditional subject matter in her work—plants, flowers, and animals—but uses rich coloration and gradients to create sumptuous imagery. The color palette is limited but not sparse, and the combination of colors is considered in order to help create the sense of depth that characterizes this work.

Catalina shows an effective use of vector imagery that extends beyond the flat block color that stereotypically characterizes this method of image making. She has created imagery that is visually complex and engaging, using techniques that are deceptively simple. However, her originality and creativity in using the software results in unique and appealing imagery that transforms a series of patterns into a landscape.

Use of gradients

Catalina's use of gradients, which include simple color blends and opacity blends, also helps to create depth in her images. Rather than a series of flat layers that appear 2D, the contrasting colors, blurred edges, and the suggestion of shadows, create depth and space, as if the image were created from layers of paper floating on top of each other.

Positioning of patterns

Careful consideration has also been given to the ways that the patterned objects relate and co-exist on the page. Rather than square blocks, areas of transparency have been used to make each element relate to others. Elements such as the birds' tails overlap effectively with other ornate elements such as the vignettes and leaves. Furthermore, while the heart-shaped areas surrounding the birds create spaces for the eye to settle upon and explore, the interaction of elements that extend beyond these areas creates a sense of movement and helps lead the eye around the image, making it cohesive.

CASE STUDY

Levels of detail

Catalina has also considered the different
levels of detail used within separate elements.
Leaves, flowers, and areas of the vignettes
contain details such as veination, while other
areas are more symbolically represented.
Again, this creates areas for focus, while
allowing the eye to take in other areas
much more quickly.

characters and figures

Creating characters—human or otherwise—is often an essential part of image making. While landscapes and inanimate objects may form significant parts of an image, characters create a narrative, add meaning for the viewer, and are a point of interest. Creating or adding characters with movement, depth, and emotion can create a great image. Alternately, static and motionless characters make for dull images overall because they fail to create a connection between the viewer and the image.

This section starts off by looking at the use of references for character development, before considering the creation of dynamic poses and the interaction of characters to create tension within an image. It finishes by considering the use of figures in Lucy Evans' work.

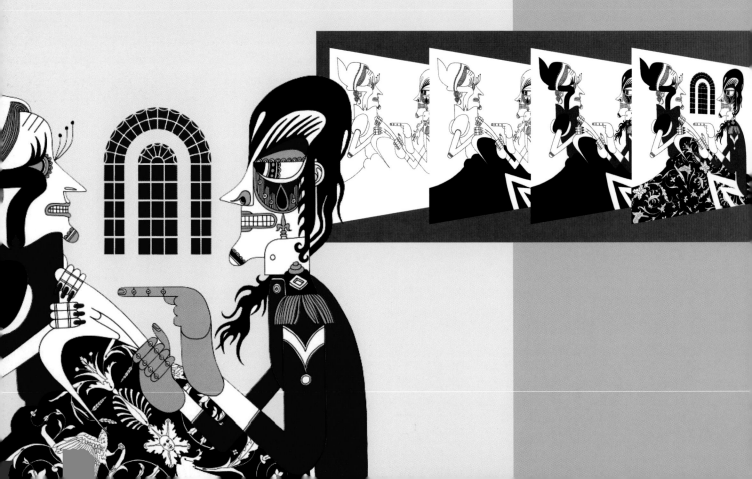

references for character development

Tracing photographs is an effective way to capture accurate and anatomically correct figures. You can use images of figures in your reference library (see pages 42 and 153) in two ways to construct and contribute to your artwork.

You can either drag digital images directly into your layered document (see page 55), using the Photoshop editing tools to amend and reposition, or print the reference material and use this as a basis for drawings on paper—as in the example on this page—that can be reintroduced as digital components via the scanner.

The example on this page demonstrates how a simple line drawing becomes the basis for a multilayered final design, providing the necessary scaffolding to construct an accurate and precise composition.

Step 1 **Select a photograph**
Choose a suitable photograph from your reference library. In this case, a symmetrical pose is decided upon to emphasize confidence and aggression.

Step 2 **Print, trace, and scan**
Print the photograph and make a traced line drawing. Scan the image and refine it using Curves in Photoshop (see pages 50 and 53).

Step 3 **Apply black fill**
Use the Magic Wand to select confined areas within the drawing. Create a new layer called "Fill Black." Fill the selected areas with black. These solid black areas break up the consistent line quality and provide contrast.

Step 4 **Add abstract marks**
Find an abstract mark in your image library and introduce it to the composition on a new layer called "Texture." This texture provides tension and movement. It also emphasizes the aggressive theme of the portrait.

Step 5 **Duplicate texture layer**
Duplicate the texture layer and call it "Texture Edit." Turn the original texture layer off using the visibility (eye) icon in the layer window.

Step 6 **Erase**
Remove areas that obscure key parts of the drawing with the Eraser tool. The finished artwork reveals how raw, accidental textures and marks can be used to emphasize mood.

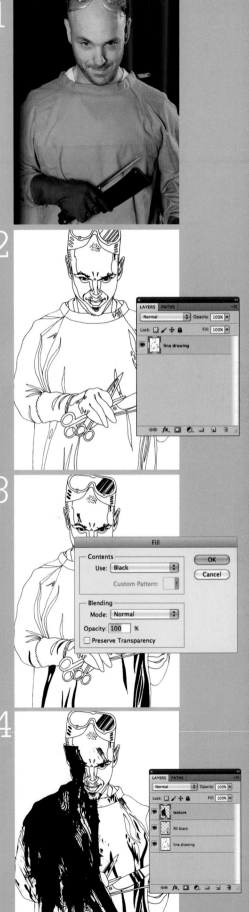

53 creating movement

P Movement is an attractive and, at the same time, baffling element for the visual artist. No sooner does a particular movement attract your eye than it is gone, replaced by another set of shapes and visual relationships that has passed equally quickly into another.

When trying to capture movement within an image, consider using abstract forms to suggest energy. You could also use simple motions and gestures, such as portraying a figure in a relatively still pose but moving head and limbs, or turning slightly, or preparing to get up from a chair to walk away.

In this example, a simple black-and-white drawing is embellished with a variety of shapes and objects to help emphasize a dynamic pose.

There are many sources of copyright-free graphic imagery, or clip art, available in print and on the Internet. A wide variety of this imagery has a very specific original function in mind but can be recontextualized by the enterprising digital artist. Here ornamental graphic devices are applied to a drawing in order to add depth and movement. Try to maintain an innovative approach and keep an open mind when constructing your images.

Step 1 Open line artwork
A line drawing is made of a figure with swirling hair. This is scanned and opened in Photoshop. Levels are adjusted in order to refine the scan (see page 52).

Step 2 Emphasize key features
Apply tonal areas to the face to emphasize certain features.

Step 3 Introduce abstract form
A solid black smear of ink is added to the drawing. This abstract form is placed alongside the line artwork and suggests motion and movement. Notice how the motion of the ink bleeds from the same direction as the hair and face.

Step 4
Add graphics
An ornamental graphic device is introduced and placed over the figure's eyes to suggest a mask.

Step 5 Distort
A shape is distorted using Photoshop's Transform tools (see pages 76–77) and placed in the top left of the frame, running down over the face. Notice how this shape travels in the same direction as the hair and ink smear, reemphasizing the movement.

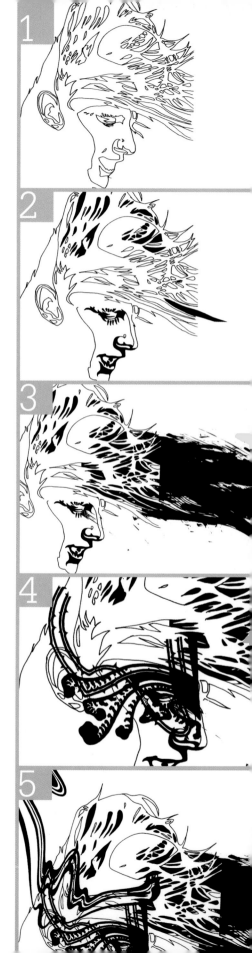

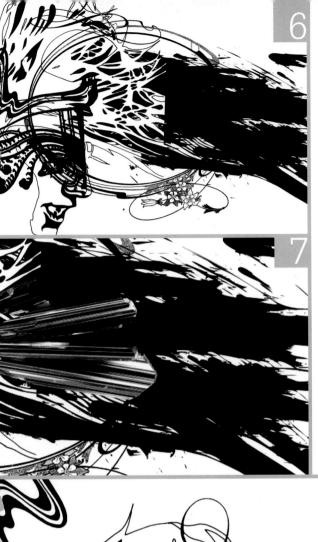

6

7

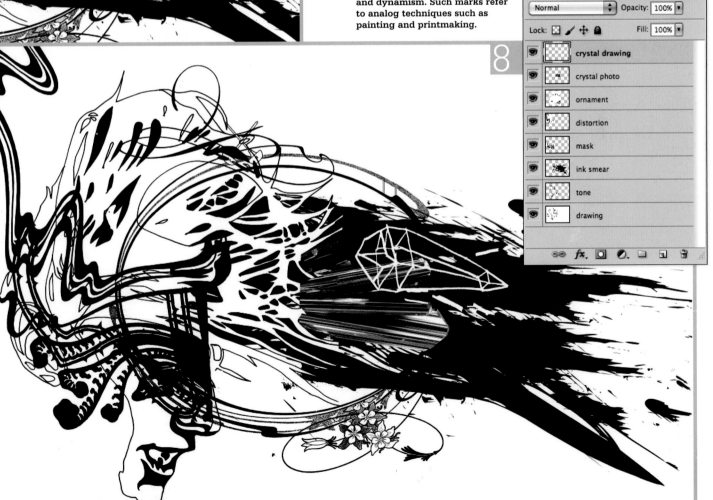

8

Step 6 **Lead the eye**

Another ornamental element is situated in the middle of the composition. Notice how this circular linear shape draws the eye to the center of the image.

Step 7 **Create contrast**

A photograph of crystal forms is introduced to provide contrast with the drawn elements. The crystals reach out in the direction of the ink and hair.

Step 8 **Further contrast**

Finally, crude hand drawings are applied to provide additional contrast with the refined, intricate elements of the composition.

Working with a lot of layers within one Photoshop file can be confusing. Always name your layers so they can be easily recognized within the Layer window.

Hand-drawn elements can provide a sense of movement and dynamism. Such marks refer to analog techniques such as painting and printmaking.

54 figure interaction

When constructing images that include multiple figures, the artist has to consider how the figures should interact. This provides the opportunity to apply the principles of composition referred to in Part 2 (see page 34). For example, the artist needs to consider how scale and foreground/background can be used to emphasize the action or drama taking place, or how variations of color and texture can be utilized to enhance key aspects within a composition. This example examines this creative process and explains why decisions are made in order to achieve the most effective and harmonious outcome.

Layers provide the means to manipulate compositional components. They are a huge advantage when you are trying to assemble complex character interactions, as they allow you to duplicate objects and figures. Use these duplicated layers to explore alternative poses and use blending modes to examine how color, tone, and transparency are manipulated to provide emphasis.

Step 1 Create a new layer

Create a new layer called "White Canvas" and fill it with white. This will provide the flat background for the artwork. Drag into the document your first figure line drawing. With the original line drawing layer selected, change the blending mode to Multiply. In this instance, this will convert the opaque layer into a transparent one.

Use the Blending Mode drop-down menu to select Multiply. This will create a transparent effect.

Step 2 Introduce second figure

Bring in the next figure and again select the Multiply blending mode. Because both layers are now transparent, they can be positioned with ease. If a figure needs to be resized, select the relevant layer and go to Edit > Transform > Scale.

Step 3 Start filling in

Begin to fill defined shapes within the drawings. Use the Magic Wand to select certain areas and fill with the Paint Bucket tool. Dynamic black-and-white forms are used to begin with to establish tonal balance. This helps create a sense of harmony between the flat tone and negative space within the composition.

Step 4 Alter background

Here a black background is considered. Notice how this emphasizes the shape of the figures.

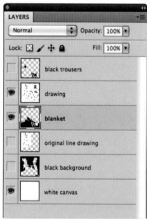

Use the visibility eye icon in the Layers window to switch layer content on and off.

Step 5 Alter foreground

Here a black fill is applied to the foreground of the composition. Notice how the black trouser layer and the black background layer have been switched off using the visibility eye in the Layers palette. This is in order to retain features within the figures and maintain the balance within the composition.

Step 6 Add more black

Other black components are added to the top of the image to help emphasize the figures' features and also to balance the dominant black area at the bottom of the page.

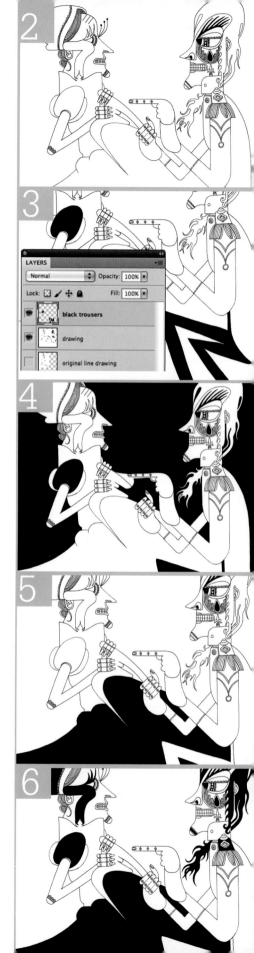

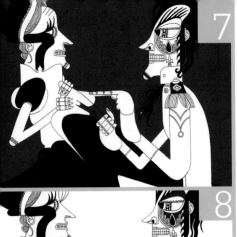

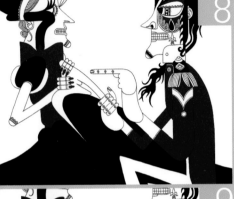

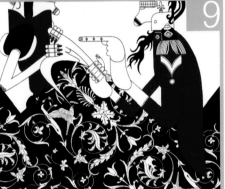

Step 7 **Blue background**

Here a blue background has been added. Notice how this emphasizes the shape and details within the white figures.

Step 8 **Add color**

Begin to apply color to defined shapes within the figures. The blue background is switched off in the Layers palette so that color provides further emphasis for the figures.

Step 9 **Add pattern layer**

A patterned layer is added. This is a black-and-white graphic that has been taken from the image library. It sits above the blanket layer.

Step 10 **Change blending mode**

With the pattern layer selected, set the blending mode to Lighten. This option lightens, or masks, any black areas that sit above the white canvas. This action results in the pattern following the contours of the black shape beneath in the blanket layer.

The blue background is switched off and color applied to areas within the figures.

Step 11 **Final component**

A black window graphic is added and placed in a central position between the figures. This architectural feature is included to create the illusion of depth, and its formal shape also contributes to the historical setting the artist is trying to convey.

Step 12 **Blue screen**

A new blank layer is created and filled with the same blue color used on the figures. This layer is placed just above the window layer, and its blending mode changed to Screen. This places a blue screen over the original black window shape. This ensures the window does not distract from the two prominent figures rendered in black.

Step 13 **Final pink layer**

A final touch of color is applied to defined elements of the illustration to draw attention to detail and emphasize features and emotion.

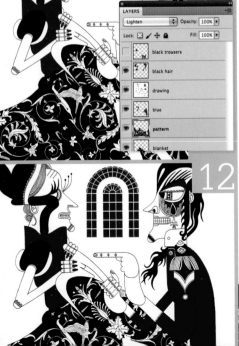

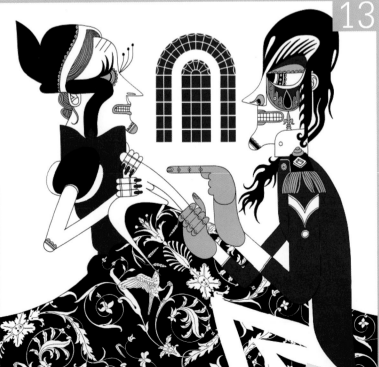

The final outcome employs texture, color, and intricate detail to draw our eyes toward interaction between the figures.

enhancing a figure
Lucy Evans

Lucy Evans is an illustrator who combines conventional pencil drawing with digital effects and layers to produce dreamlike, ethereal images. An analysis of Evans' process reveals how high-quality photographic reference has informed the drawing. These photos provide an accurate basis for her drawing.

A model was sought out and photographed within a lit studio environment. Evans often collaborates with studio photographers to get the best imagery possible for her artwork. In this example, she worked with photographer Luke Hutchings, and

was responsible not only for constructing the image but also for the styling and direction of the photo shoot. This demonstrates a willingness to engage with all aspects of the creative process to achieve the desired outcome.

Notice the variety of techniques Evans employs here—from detailed pencil drawings to abstract ink imagery. The computer provides a simple, but also vital, function; it provides the means to pull together these traditional media, but also lets Evans control and manipulate how all the disparate elements are viewed.

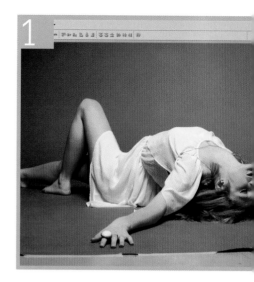

Step 1 Photo shoot
Studio lighting is used to emphasize the figure in the photograph. We are not concerned that the floor and tape are visible. The model is shot against a plain background to make it easier to cut out in Photoshop at a later date. A number of photographs are taken at this stage, and these are edited down so that Evans finds the exact pose she requires.

Step 4 Ink images
Abstract images are made with ink on paper. These experiments will be used to represent water and will form part of Evans' visual library (see page 153). The images are scanned as RGB color files.

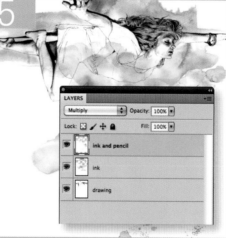

Step 5 Adding layers
These abstract color images are then introduced in new layers within the composition. Using Blending Mode > Multiply gives a transparent effect to the layer content and helps to create a sense of depth.

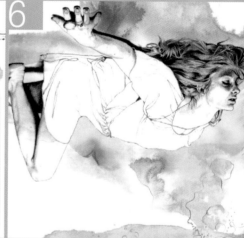

Step 6 White layer
A white opaque area is applied in a separate layer to help emphasize the foreground and enhance the figure. This flat color is applied using the Brush tool and Color Picker found in the Toolbox.

CASE STUDY

Step 3 **Pencil drawing**

An original pencil drawing is made of the photograph using a lightbox or tracing paper. This is then scanned as a grayscale file. All graphite pencil work should be scanned as grayscale, never full color. A grayscale scan desaturates the drawing and removes any unwanted color information that could potentially spoil the quality of the image. When the image is opened in Photoshop, it is converted back to RGB color. This will retain the flat grayness of the drawing, but allow color to be applied above the drawing in new layers.

Step 2 **Explore composition**

Before beginning the drawing, Evans uses the studio photographs to explore potential compositions. This particular process acts as a sketchbook or storyboard. A variety of compositions and poses are examined. In this example, the model is inverted and inserted into an underwater scene. This particular pose provides the reference for the final illustration.

Step 7 **Detail**

A small blue area of ink is applied to the hair on the figure. This subtle creative decision helps integrate the figure into the background and removes a starkness around the hair. Here the Soft Light Blending mode was used at an Opacity of 90%.

location, landscape, and architecture

Setting the scene is an important factor in creating believable images, but it also helps us to understand the intended mood and atmosphere that your image intends to convey. For example, think about the ways in which environments seem different at night compared to the day. Horror films make use of lighting in such a way. Similarly, mood and atmosphere can be affected by the depth of the scene, our closeness to the characters or objects, and the overall surroundings.

This section looks at techniques that can help you to develop some of these aspects within your work. It also looks at creating architectural elements that fill the spaces within your images, create backdrops for your characters, and communicate the context of your scene.

location and landscape

Choosing the right context—the location, setting, and atmosphere—for your illustration can be a key part in how it communicates itself. Given an appropriate context, characters, objects, or events can evoke key moods and atmospheres in your work; however, getting it wrong can drastically alter the way your image is received and understood.

Even the simple addition of a block of color to an image, if in the right location, can change the way in which an image communicates its meaning or mood. Similarly, a change in the way that a subject is lit or is perceived to be lit by the range and tonal values of colors can affect how we understand an image and what it means. Here are some simple examples of how this works.

1 Change background

In this example, we can see how the use of an urban landscape compared with a brighter location changes our understanding of the central characters. While the first image may make us consider the characters as adversarial, the second brighter image offers a softer and less aggressive understanding, either because these characters appear out of place, or because the colors used create a warmer feel to the entire image.

2 Change scale

Here we can see how a simple change of scale and location of the characters in relation to the background changes how we relate to them. Note, as the characters appear to recede further into the background, a new kind of narrative is created. We no longer look so much at their posture to create an understanding, but start to consider the narrative behind their position in this landscape. Are they walking toward or away from us? Are they lost? Are they waiting for

you to enter the space and join them? Notice how the change in scale can create a perceived depth in this image, even though it is essentially a series of flat shapes.

3 Change mood

Changing the background and character colors can imply a change in lighting and subsequent mood of the overall image. Here, the above image is charged with a somber and darker tone while the below image indicates a charged atmosphere between the main character and the off-screen character. Notice also how the white shape to the left in the above image implies depth and space surrounding the character—some kind of dark room that is mysterious and unsettling.

56 understanding lighting

Understanding and using lighting effectively can make your image more believable, add depth, and create mood and atmosphere.

Lighting effects can be easily created in Photoshop using a number of tools, in particular the Dodge and Burn tools. However, it is a good idea to work with reference material to help develop your understanding of how lighting works in order to make your characters, objects, and worlds realistic. This lesson will look at using digital photography in combination with directional lighting to create references, which we will then use as a source for creating lighting effects.

The lighting setup here comprises a simple table lamp that has a positionable head. Such a lamp makes for a cheap yet effective light source in the absence of professional lighting tools. For small-scale projects, high-powered LED or halogen flashlights are equally effective.

Lighting solid objects

Lighting solid objects tends to produce uniform shadows that model the object in a way that is easy to visualize. It is, therefore, quite simple to mimic these shadows by developing an understanding of where your light source is in relation to your object.

Lighting 1 Ambient
Ambient light found in a room can produce shadows and highlights, but these tend to be weak and ill defined. It is, therefore, often best to accentuate this with direct lighting.

Lighting 2 Top
Lighting from directly above produces shadows cast down the length of an object with highlights on top.

Lighting 3 Front
Frontal lighting (in which the light source is behind the viewer) throws shadows behind the object so that they are partially or entirely obscured by the object, with the highlights reflected back toward the viewer. These two lighting positions tend not to produce very interesting images, as they remove many of the visible ground shadows and render the object or image flat in appearance. You need effective shadows to help model and describe the shape and depth of your object.

Lighting 4 Left
Lighting from the side produces more effective images. In this example, the shadow is thrown on the ground to the right of the object, while the shadow on the object itself enhances its round base and curved surfaces. The strong shadows of side lighting, however, while atmospheric, can look unnatural.

Lighting 5 Three-quarter
The last image uses lighting set slightly above and to the left of the viewer. The shadow on the ground recedes toward the background to the right, while the object's shadow helps to describe both the base of the object and the curved surface as it bends around and away from our view. The highlights move closer to the center of the object and the tone of the entire shape becomes less saturated and more even than the side-lit image.

Back lighting

Other effective lighting includes backlighting, which can produce very atmospheric images. Backlighting produces highlights that surround an object, and throw the front of the object into shade. The most dramatic example of backlighting is the silhouette, in which only the outline of the object is discernible. It is often a good idea, therefore, to combine backlighting with other ambient or direct lighting to illuminate the details of your subject matter from or near the front.

Lighting different materials

Different materials respond to light in different ways. Understanding how specific materials react to light, therefore, can help you recreate the look of materials in various types of digital illustration.

Metals tend to produce strong highlights and reflections. Shadows can often be pronounced but do not always appear as you would expect. Due to reflections of light from ground surfaces, shadows on metals tend to occur a little way inside the shape and then lighten toward the object's edge. Metals can also be highly reflective or dull—the former producing clearly defined highlights, the latter making more diffused shadows but larger highlight areas.

Plastics tend to react similarly to metals in terms of shadows and highlights, showing less reflectivity but often strongly defined areas of shadow and bright crisp highlights.

Cloth, such as cotton, tends to exhibit dull highlights and shadows that gently fade. Shadows are often uneven and broken by the weave and pattern of the cloth, and are rarely crisp and uniform. The exceptions are materials such as satin and silk, which are more reflective.

Natural wood exhibits very subtle highlights, although polish and paint can accentuate the reflectivity and shadow definition. Individual grains can create small highlight areas on certain types of wood surfaces—particularly rough sawn wood—although these highlights are unlikely to be very strong.

Surface textures

Very few surfaces are totally flat and smooth. Materials such as natural leather illustrate this perfectly, and in fact nearly all surfaces have minor bumps, grains, or scratches that distort the surface. These surfaces, therefore, determine how light is reflected and can be replicated by using filters (such as Photoshop's Noise filter) to break up highlights and shadows, making them appear more natural.

Use photographic references to help understand surface textures and lighting, but also try out combinations of scanned or photographed textures to break up surface features such as highlights and shadows. This will help your objects appear more natural, realistic, or stylized.

A great example of effective use of lighting is Robert Proctor's image in which he makes use of shadows and colored accent lighting to enhance his "Claudia" character. Robert uses two key light sources in his image. One is an ambient source that produces the main highlights and shadows giving his character a three-dimensional look (left). The second is an accent light that produces the blue highlights and adds to the mood of this image (right).

57 depth and perspective

There are a number of tricks that you can use to create depth and perspective in Photoshop, allowing you to create huge vistas and broad landscapes or cityscapes simply and effectively. In the first lesson, we'll use a combination of the Hue/Saturation and Gaussian Blur commands to give the perception of depth to an image. In the second, we'll use the transformation tools to create the illusion of perspective and depth through receding objects.

Depth

This first lesson uses a common effect used in painting to create the illusion of depth. As objects recede into the distance, they not only appear smaller but also become less saturated in color, they look lighter, and have a tendency to appear bluer.

Step 1 Draw some shapes

Start by creating a series of shapes like those shown. Use the Polygonal Lasso tool to create a new shape, then fill the shape with Edit > Fill. Ensure that each of your mountain shapes has its own layer. Name them appropriately so that you can easily switch between the layers.

Step 2 Gradient fill

Create a new Gradient Fill using blue and white Foreground and Background Colors, respectively. Gradient fill the bottom layer so that will become your sky, with the blue starting at the top of the page and ending ¾ of the way down.

Step 3 Select mountain layer

Select the mountain layer that is uppermost in the Layers palette. Use the Magic Wand tool to select the colored portion, go to Edit > Fill, and fill using a deep blue color. Make it quite dark by selecting the button next to the B of the HSB color section of the Color Picker and using the vertical slider to make the color darker.

Step 4 Select next mountain layer

Deselect the current selection, choose the next mountain layer down in the Layers palette, and select the colored area with the Magic Wand. Use the Eyedropper tool to sample the color from the top mountain layer. Select Edit > Fill to fill the current selection, choose Color from the Use: options. The chosen color in the picker should be the same as the first mountain color. Use the vertical slider again to lighten the color by about 10% and click OK. Repeat this step for all of the mountain layers, selecting the previous layer's mountain color each time.

Step 5 Hue/Saturation

Use the Hue/Saturation command to further create the impression of depth. Select the Mountain 2 layer, then go to Image > Adjustments > Hue/Saturation. Set the Saturation slider to −10 and the Lightness slider to 10. Click OK. Repeat this action for each mountain layer between 2 and 5, setting each layer an additional −10/10 to the Saturation and Lightness values. The lighter colors help to reinforce the sense of perspective.

Step 6 Add blur

Now return to the Mountain 2 layer and choose Filter > Blur > Gaussian Blur. Set the Radius to 2. Repeat for each subsequent mountain layer, increasing the Radius by 1 each time. The increased blur will also help to recreate the sense of perspective. Try this technique out on other images that have multiple layers. It can be particularly useful for cityscapes and can also be used with many more layers and images containing much more detail. Play around with the values to get the appropriate feel for your image.

By changing the Blue value (B) you can create variations of the shade without using the Color Picker. This is useful for accuracy.

Perspective

This lesson looks at creating a skyscraper image that makes use of perspective to give the illusion of height. The method used here, however, is not restricted to tall buildings and can be used also to create long corridors such as hotel hallways or grand buildings. Notice how this lesson also makes use of adjusting the point of view and utilizes different viewing angles to add interest to the image.

Step 1 **Open skyscraper image**

Start with a new Photoshop document. We have skipped the creation of the skyscraper facade in order to save space; however look at the lessons on using the selection tools, fills, and brushes to help you create this image (see pages 82–87). Place the image on a layer called "Skyscraper" and leave the Background layer white.

Step 2 **Perspective**

With Show Transform Controls selected in the Tool Option bar, begin to create the sense of perspective by going to Edit > Transform > Perspective.

Step 3 **Drag corners**

Start by dragging the top right or top left corner control of the transformation box toward the center of the object. This will move both controls inward and add perspective to your image. Play around with their position until you are happy with the effect. Drag the bottom corner controls outward to make the base of the skyscraper wider. Press the Return key when you have finished your transformation.

Step 4 **Adjustment layer**

In order to improve the look of the skyscraper, we are going to adjust the saturation so that the top of the structure is less saturated and lighter than the bottom. In the Layers palette, select the Skyscraper layer and click the Create new fill or adjustment layer at the bottom of the palette. Select Hue/Saturation and in the adjustment window change the Saturation to –25 and Lightness to 25.

Step 5 **Layer Mask**

The adjustment layer comes with a Layer Mask that is automatically selected by default. Select the Gradient tool from the Toolbox and set the Foreground Color to white and the Background Color to black. Apply the gradient by dragging from the top of the skyscraper image to roughly half way down the image. This will fade the Hue/Saturation effect so that the lower area retains full saturation.

Step 6 **History**

Save this image. The next step introduces the creation of a two-point perspective version. After saving, open the History window (Window > History) and scroll back through the actions until you locate your original image.

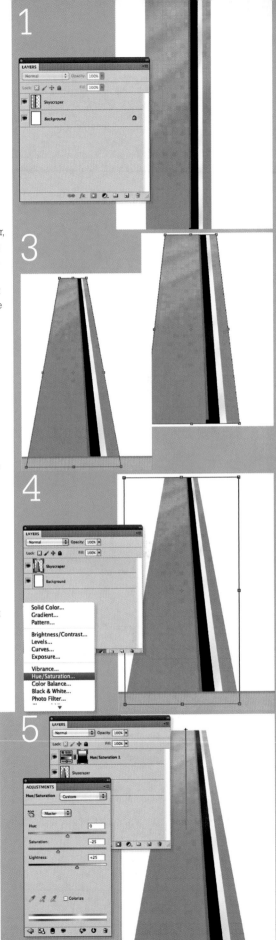

Step 7 **Perspective**

Apply the Perspective transformation once again as before, but this time also drag the central left controller down to create a downward slope from right to left at the top of the skyscraper. Then drag the top central controller to the right until you have a perfect vertical line at the right of your skyscraper. You may have to readjust these controls a little until the perspective looks right.

Step 8 **Duplicate layer**

Go to Layer > Duplicate Layer to make a copy of the Skyscraper layer, then select Edit > Transform > Flip Horizontal. Use the Move tool to align the copied layer so that it touches the right side of the original.

Step 9 **Hue/Saturation**

Select the Skyscraper copy layer and go to Image > Adjustments > Hue/Saturation. Decrease the lightness to indicate shade on this side of the skyscraper. We have used a value of –37.

Step 10 **Merge layers**

Merge the two Skyscraper layers by selecting both with the Shift key and choosing Layer > Merge Layers. Now apply a Hue/Saturation adjustment layer to this layer as you did in Step 4. Use the same settings, and remember to apply a black/white gradient to the adjustment layer's Layer Mask.

Step 11 **Finish**

The final image has had a number of adjustments to enhance the impression. First, a sky image was applied as a backdrop. A Hue/Saturation adjustment layer was then reapplied to the Skyscraper layer to help it merge more realistically with the background, and a Gaussian Blur command with Radius set to 4.0 was also added to soften the edges. Finally a Brightness/Contrast adjustment layer was added, with brightness set to 150. The Layer Mask for this adjustment layer had a black/white radial gradient applied to the bottom left quarter to produce the skyscraper's highlight

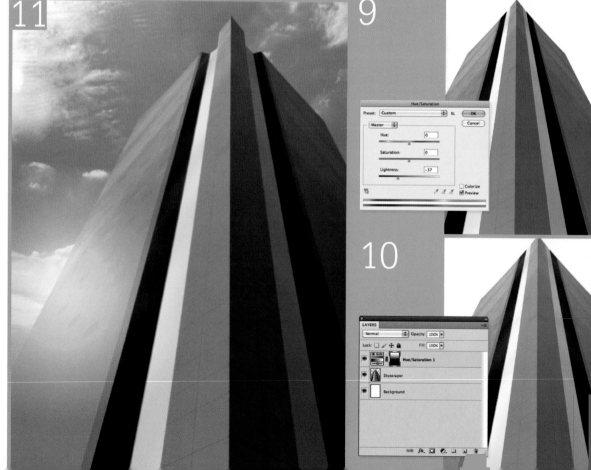

architectural detail

This lesson will show you how to quickly create buildings and some simple architectural details that can be expanded to recreate and form a variety of manmade elements. This example uses a simple graphic style; however, there is plenty of scope for refining the look of the final image using what you have learned so far.

Step 1 Create new document
Start by creating a new document in Photoshop set to a letter size (A4) landscape format. Leave the Background layer blank and create a new layer called "Brick Layer." Select the Rectangular Marquee tool and change the Style to Fixed Size with dimensions of 100 px width and 50 px height.

Step 2 Draw Marquee
Create your Marquee anywhere on the page, then zoom in. Set the Foreground Color to a reddish brown, then select Edit > Fill using Foreground Color to fill the selection.

Step 3 Create multiple copies
Select the Move tool and while holding Alt/Option click and drag your brick shape to create multiple copies as shown. Leave a small gap between the bricks and ensure that they are aligned. Now create a new layer called "Mortar Layer," select it, and place it below the Brick Layer. Use the Marquee tool to create a selection over your bricks ensuring that there is a slight gap at the bottom and left of the lowermost brick.

Step 4 Adding mortar
Choose a mortar color and fill the selection with Edit > Fill as before. Now select both the Brick and Mortar layers by holding the Shift key. Use Layer > Merge Layers to create one layer.

Step 5 Define pattern
With the selection area still active, you will now define your pattern. Choose Edit > Define Pattern from the menu. Name your pattern "Brick Pattern" and click OK to confirm.

Merge Layers can be used to join layers together, which is useful when an effect or filter will be applied to the same element, or to cut down on the number of layers in use.

Use Define Pattern to create your own pattern sets.

Step 6 **Create brick fill**

Hide your Brick Layer by clicking on the visibility eye in the Layers palette, and create a new layer called "Brick Fill." Select Edit > Fill and choose the Pattern option from the Use menu of the Fill dialog. Select Brick Pattern.

Choose Pattern from the Use box of the Fill window, then select the pattern you have just created.

Step 7 **Completed wall**

You should now have a page full of your brick pattern. You can use this technique to create any kind of repeating patterned detail such as stone, wood, or tiles. Try using different patterns and textures to enhance the look; however, be aware that, as this is a repeating pattern, complex bricks may look strange if they repeat too often. Another option is to use a blend layer over the top of your pattern to create random textures.

Step 8 **Add detail**

Now that we have a base, we can add details such as windows. Create a new layer named "Window Layer." Use the Marquee tool to define a suitably sized window (use your bricks as a guide) – here we used a 6 x 20 brick count as a guide. Go to Edit > Fill and fill the selection with white.

Modify allows you to adjust a selection. Contract lets you shrink a selection area uniformly, while Expand does the exact opposite.

Step 9 **Create glass area**

Keeping the original selection, go to Select > Modify > Contract. This will allow you to shrink your selection in order to create the window's glass. Set the contraction to 40 px.

Step 10 **Setting glass colors**

Set the Foreground and Background Colors at the bottom of the Toolbox to blue and white, respectively. Select the Gradient tool (shares with the Paint Bucket tool) from the Toolbox. In the Tool Options bar, click on the Gradient pull-down box colored blue/white to open the Gradient Editor. Click beneath the blue/white gradient bar preview in the Gradient Editor to add extra colors to your gradient and alternate their color between blue and white as shown. Click OK

Step 11 **Add the glass**

Click and drag using the Gradient tool within the selected area in a diagonal direction from top left to bottom right. Try different angles and lengths until you get a reflective glass look that you are happy with.

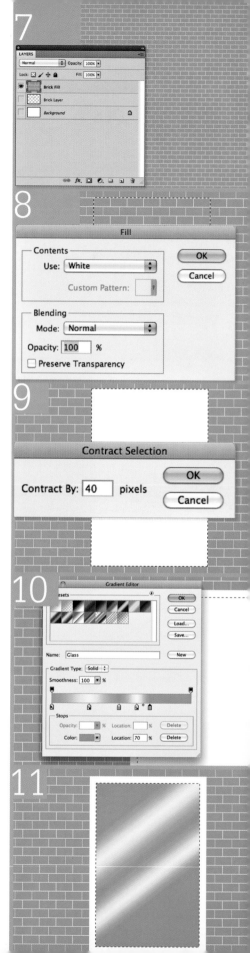

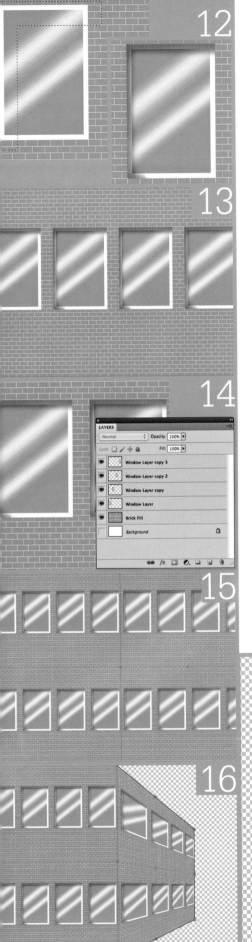

Step 12 **Create a shadow**
Deselect the current selection with Select > Deselect, then using the Marquee tool or Polygonal Lasso tool create an inverted L shape over the top and left of your window. Select the Burn tool from the Toolbox and set Range to Highlights and Exposure to 50% in the Tool Options bar. Use successive passes over the window with the Burn tool to create a shadow effect. Don't click repeatedly but rather click and draw once over the L shape. Unclick and return to the starting point to repeat until you are happy with the result, then deselect.

Step 13 **Copy the window**
Select the Move tool, hold the Alt/Option key, and click and drag multiple copies of your window. Try to ensure that they are level with each other and keep the spacing consistent. You can hold the Shift key while making the copies to force the duplicate to restrict vertical movement (or horizontal movement if you were copying upward). Make four windows.

Step 14 **Select layers**
In the Layers palette, use the Shift key and click on each layer in turn to select them all except for the Background layer. Go to Layer > Merge Layers to group the selected layers.

Step 15 **Make copies**
Go to Image > Canvas Size, and resize your current layer until it is roughly half the width and height of the current page. Now, using the Alt/Option-drag method, make four copies of the wall. Place them as shown, then select the two rightmost walls and merge the layers. Do the same with the left pair of walls. Name them "Windows Right Side" and "Windows Left Side."

Step 16 **Skew**
Select the Windows Right Side layer and from the menu choose Edit > Transform > Skew. Drag the corners on the right-hand side so that your wall looks three-dimensional rather than two-dimensional. Drag one corner at a time and try to make sure that they align vertically with each other.

The Skew transform option lets you tweak a layer to achieve perspectivelike imagery very quickly. You can also use Perspective or Distort for similar results.

Step 17 **Repeat**
Repeat the above step with the Windows Left Side wall, this time dragging the left-most corners of the transformation box. You may need to play around with the angle and location to ensure that your walls do not look distorted and appear to be sitting at right angles to each other. Using what you have learned, try to add more layers, creating extra walls or even other details such as doors.

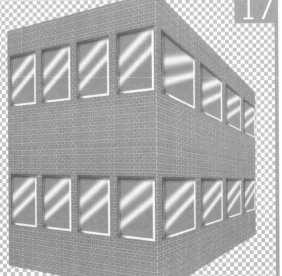

creating architectural details
Nicholas Saunders

Nicholas Saunders' "Moving Jobs" image is an excellent example of an image maker using digital technology to rapidly produce architectural details as a major element within an illustration. Saunders makes use of a traditional print aesthetic in his work, and therefore his images use predominantly flat areas of color with a limited palette.

Saunders is not a purely digital artist, and elements of his image start as drawings that are then scanned. Digital technology plays its part in allowing for rapid duplication of patterns, details, and objects—as explored in the Architectural detail (see page 147) and Making pattern swatches (see page 126) lessons—and also allows for experimentation with color and composition.

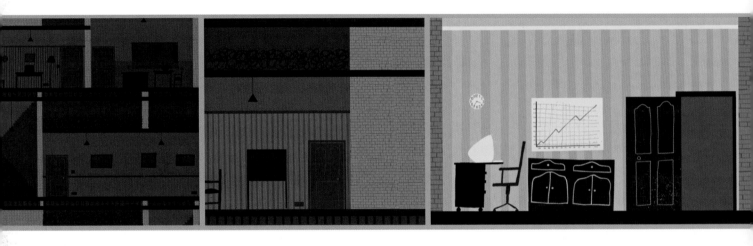

Duplication
Elements such as doors, chairs, and lamps have been duplicated in a variety of locations, allowing building furniture to be rapidly deployed, with the result that both interiors and exteriors are quickly filled and given character. Similarly, wallpaper patterns appear to have been duplicated in order to fill in spaces quickly and effectively.

Brick details
One prominent use of repeat patterns is the brickwork. A small rectangular area of brickwork has been drawn and scanned into Photoshop. Multiple duplicates have then been made to provide larger area coverage. Digital technology enables the artist to draw and scan small areas of pattern that are offset and repeated to fill walls. This can be most effective where changes such as flipping or minor scale changes to duplicated areas hide obvious repeats, and, in Nicholas Saunders' case, allows the image to retain the hand-drawn look.

Scratches and texture
Again, to emphasize the handmade quality of the work, Saunders has made limited yet effective use of scanned textures. This serves two purposes within this image. First, it helps to reinforce the idea of the image being created with traditional materials and to build upon the hand-drawn/print aesthetic; perhaps, more importantly, details such as scratches on doors and wooden textures on the trees help to add interest and detail to the image. In the case of the former, it also helps to add to the narrative of the architectural space—ideas of age and use come into play and add an additional dimension to the architectural aspects.

This latter feature can be an important part of creating spaces within your illustration. The character that can be imparted by details, such as scratches, brickwork, uneven shelves, or any other feature, helps to create spaces that appear more believable, despite being in an illusory and two-dimensional world.

CASE STUDY

59 **textures:** photographing materials

Having a range of textures available to use within your work can be essential for a number of styles and techniques. As a digital artist you should always be on the lookout for interesting textures to photograph or scan. This section looks at a number of materials that are easily accessed and can form the basis of a strong texture library

Common textures available around the average home include wood, bricks, and stone. Roads and sidewalks also provide interesting surfaces. Rusting metal and peeling paint allow you to create images that appear dated, or feature surface textures for retro techniques and styles. Consider the kind of image you like to make and the resources and locations that you have available to you to help decide what would make good textures to record.

Take photos in good light and avoid using flash as this will tend to flatten the texture of the image. Daylight, either slightly overcast or sunny, can make for good conditions. Allow natural shadows to accentuate the texture but not overpower it—harsh shadows can be counterproductive. Also take photos while positioned directly opposite your source rather than at an oblique angle—this can distort the image and make it unusable. Although angles and perspective are easily created in Photoshop, they are harder and more time consuming to correct.

When you find a good source for images, such as a weather-beaten piece of timber, take photos along its entire length. This will add flexibility in terms of your image choice when using a texture in your work, and allow you to build more advanced texture layers by combining multiple images.

Most digital cameras provide adequate image quality for use in your digital projects, although you should capture images at the highest resolution. It is always better to scale down a digital image than to scale it up; and higher resolutions allow you to choose the area of the image that you use rather than be forced to use the entire image. If your camera supports it, you could also use the macro function to get high-quality close-ups for even more flexibility and greater range of textures.

The images shown here are mainly from artificial objects or inorganic materials, but don't overlook natural and organic subjects such as leaves, tree bark, and so on, as well as cloths and other materials. Finally, don't forget to scan paper, paint, and other art materials, and be on the lookout for interesting and unusual examples, such as handmade papers. While it is possible to mimic these surfaces with a large enough texture library, the original source is often preferable and makes for less work.

1 Stone textures can be used to mimic paper... **2** ...or similar rough grounds... **3** ...as well as making useful brush textures... **4** ...and scenic elements such as mountainous backgrounds. **5** Close-up textures can appear larger than they are to make rock or mountain textures. **6** Tighter patterning is often useful for breaking up flat color... **7** ...or entirely new fills can be created from interesting natural patterns. **8** Wire fencing or skyscraper walls can be made using the right combination of image adjustments from tiles or similar images. **9** More subtle textures with gentle transitions help to create print textures (for lino or silk-screen mimicry). **10** Wood grain in a variety of forms provides excellent resources for architectural textures and features... **11** ...as well as grounds for retro paint and print style images... **12** ...or smoke and clouds.

building an image library

A successful and busy illustrator relies on a stockpile of digital components to get the job done. These elements can be relied upon to construct meanings and help identify your own unique visual language. This library of images can consist of abstract textures, brush marks, or photographs of found objects. Anything you like. They will establish your identity as an illustrator, helping form your particular artistic style.

There are no hard and fast rules here. Your visual library will be unique to you, referring to your enthusiasms and recurring themes that you enjoy employing within your artwork. The limitless potential of digital composition should be reflected in the breadth of this library.

The scanner provides the means of recording all these elements. Be curious and scan any objects or material that could inspire you. Random patterns, found imagery, accidental mark making, and printing errors can all be documented and contribute to a digital illustrator's arsenal.

In the example below, we can see how a Photoshop file was constructed using a variety of drawings, photographs, and textures. Photoshop's layers give you the opportunity to blend a variety of different media and materials. Experiment!

1 Smear of silver enamel paint. 2 Photographic image of metal shards. 3 An abstract ink shape that suggests movement and also liquid. 4 Photographic image of ruby. 5 Simple, crude line drawing of crystals. 6 Bold black-and-white line drawing of a figure. 7 Photograph of urban architecture and iron implement. 8 Final outcome.

8

using texture to build an image
Matthew Johnson

In this case study, we will examine the process illustrator Matthew Johnson uses to construct images. Johnson's artwork documents his process, and many of his creative decisions are visible within the composition. Johnson's images utilize photographic reference for accuracy, but he is also very insistent on creating digital artwork that retains the raw gestural qualities of a sketch. This approach replicates the way in which a traditional painter would apply layers of color, reminding us how an image has been constructed by letting us glimpse mistakes and the visual thinking that has taken place.

It is an understanding of texture and form that informs this particular technique. Concentrated areas of intense, frantic mark making are offset with larger areas of flat color. Positive and negative silhouettes are also used to interrupt the conventional outlines of the head and body. Also notice how Johnson uses blending modes to create transparency and increase luminosity, so replicating the qualities of paint and ink.

In the following 13 steps, we can analyze how an image evolves over the process of its construction. Every separate layer of this Photoshop document assists the artist in creating the desired effect.

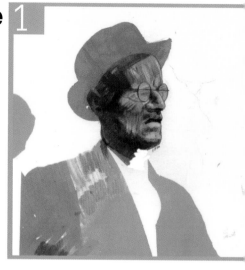

Step 1 Drawing
Johnson begins by scanning a color original drawing to form the basis for the image. This layer is named "drawing." Although the manner in which Johnson applies marks can appear frenzied and chaotic, all his figurative work is underpinned by accurate photographic reference.

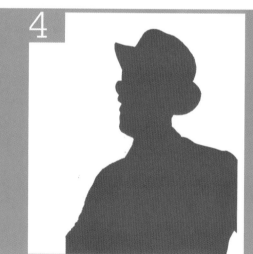

Step 4 White silhouette
Using the Magic Wand tool, Johnson makes a selection around the figure and a new layer called "white silhouette," then he fills the selected area with white. This background is then flipped horizontally.

Step 5 Copy layer
The White Silhouette layer is copied and placed on top of the Face layer, and Johnson changes the blending mode from Normal to Luminosity.

Step 6 Yellow silhouette
A selection is made around the figure with the Magic Wand tool. A new layer called "yellow silhouette" is made and the selected area is filled with yellow, using the Color picker dialog box.

CASE STUDY

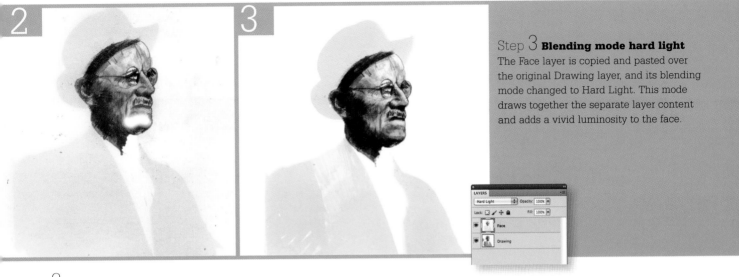

Step 3 **Blending mode hard light**

The Face layer is copied and pasted over the original Drawing layer, and its blending mode changed to Hard Light. This mode draws together the separate layer content and adds a vivid luminosity to the face.

Step 2 **Face**

A complementary, detailed, graphite drawing is scanned and named "Face."

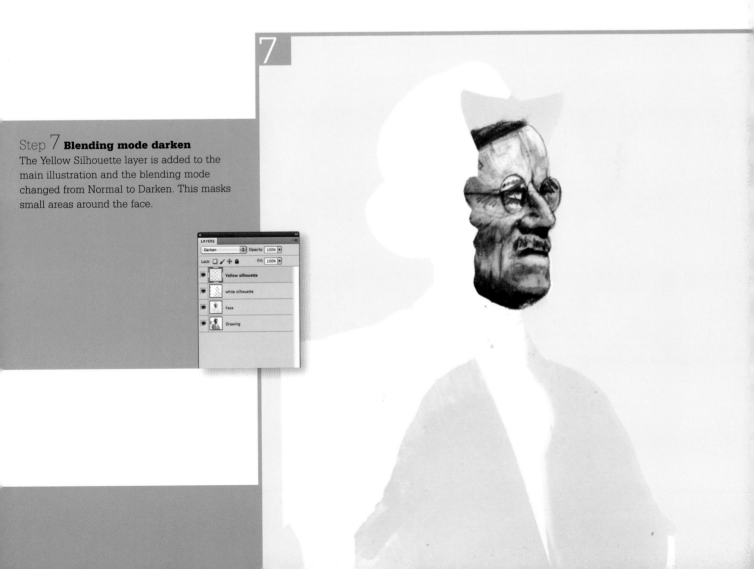

Step 7 **Blending mode darken**

The Yellow Silhouette layer is added to the main illustration and the blending mode changed from Normal to Darken. This masks small areas around the face.

using texture to build an image

On these pages, the case study continues to show us how the blending modes found in the Layer window provide a startling array of visual effects. These effects include "Luminosity," "Hard Light," and "Darken." Blending modes such as these provide the means to instantly evolve an image, adding luminous hues and unpredictable transparent colors. In this way, blending modes fulfill the role of creative accidents for the digital artist. Explore the blending modes yourself, and take note of how they distort and mutate layer content.

Step 8 **Scan jacket**
Johnson then creates a gestural and loose drawing of the subject's jacket. Differing colors, felt pens, and inconsistent marks are applied to the paper. He then scans this, calling the layer "Orange Jacket."

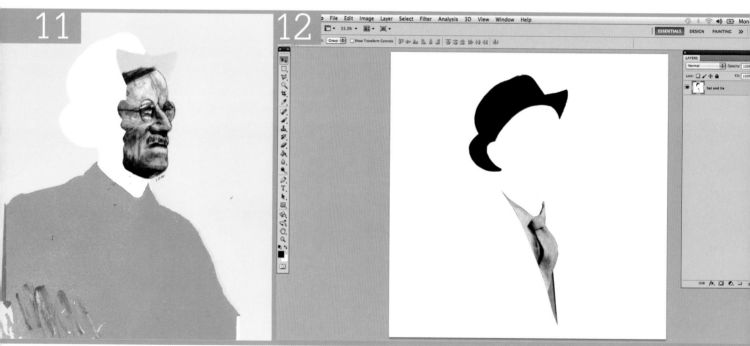

Step 11 **Blending mode normal**
The Blue Jacket layer is added to the illustration, and this time the blending mode is set to Normal, so that it retains its opacity.

Step 12 **Scan photographic elements**
Photographic elements are scanned and tinted with color. This layer is named "Hat and Tie." The yellow tinting is created by using the Brush tool and the Color Picker to paint over the desired areas.

CASE STUDY

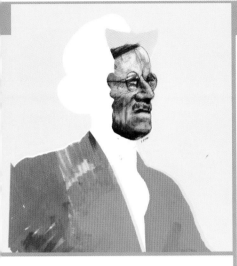

10

Step 10 **Jacket silhouette**

A complementary blue paper silhouette is made of the same jacket. This is also scanned and named "Blue Jacket." Johnson intentionally uses a wide variety of paper textures and gestures to multilayered, contrasting effect.

Step 9 **Add layer**

Again, this layer is added to the top of the Layers palette of the main illustration and the blending mode is set to Luminosity.

13

Step 13 **Add layer**

The Hat and Tie layer is applied to the image, with blending mode set to Normal. These graphic elements form the final layer and contrast with the hand-rendered marks used to create the face. Notice how the flat, black silhouette of the hat draws the attention toward the figure and acts as a balance to the expressionist line work.

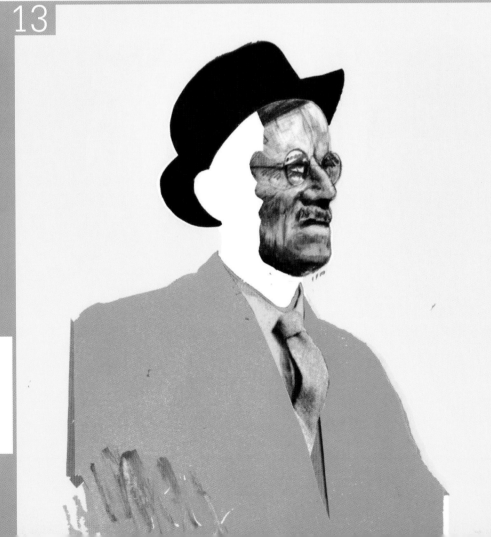

61 allowing for imperfections

P The key to successful digital artwork is for the artist not to be dominated by the technology. Countless options and effects can mask a good idea and, as with any creative practice, sometimes mistakes lead to new ways of thinking and innovations.

The tendency to rely on the computer to edit and correct an image can often leave it looking flat. Many successful artists and illustrators retain their voice by including intentional mistakes that refer to traditional methods of production such as painting, printmaking, graffiti, and so on. Keep a library of scanned textures, marks, and patterns that you can use in your compositions (see pages 42 and 152).

Step 1 Import
Scan and import a line drawing. Use Levels to correct any tone left by the fine paper grain (see pages 52–53).

Step 2 Magic wand
Select the Magic Wand tool from the Photoshop Toolbox. Make sure that the Tolerance for the Magic Wand tool is set to around 33 in the Tool Options bar. Then select areas to fill. Holding the Shift key down enables you to select multiple areas.

Selecting the Magic Wand tool at step 2.

Step 3 New layer
In the Layers palette, click on the Create a new layer icon. Fill this new layer with a color of your choice (in this example, black). Everything selected by the Magic Wand tool will become black.

Step 4 Make new file
Open a separate file that you want to introduce to your composition (in this example, a pink dot pattern). Using the Move tool, drag this new file into your original Photoshop document and place in position.

Step 5 Opacity
At this stage it is worth experimenting with the Opacity slider found in the Layers palette. By adjusting the Opacity of a particular layer you can increase its transparency. To create another transparent effect, experiment with the various blending mode options. Here the pink dot layer was set to Multiply with the result that the black hair overlays the pattern.

Always create a new layer when filling selected areas of a drawing. Filled shapes on separate layers provide you with more options.

Use the blending modes found in the Layer palette to create transparency and suggest depth.

Step 6 **Make selection**

Go to your library of textures and marks and find another file (in this example, an ink splat). Open the file and use the Magic Wand tool to make a selection.

Step 7 **Fill**

In this new file, create a new layer and fill your selection with a color.

Step 8 **Add to composition**

Drag this new image into the original composition. Use the Opacity slider and blending modes options in the Layers palette to experiment with transparency. Remember, you can also move layers up and down to obscure or reveal elements of the composition.

Step 9 **Apply more**

Continue to apply more shapes, textures, and accidental marks in this way until the composition is complete.

Use the drag-and-drop method explained on page 55 to move layers between Photoshop files. Once new content is introduced use the Layer window to explore how the order of layers can reveal and obscure.

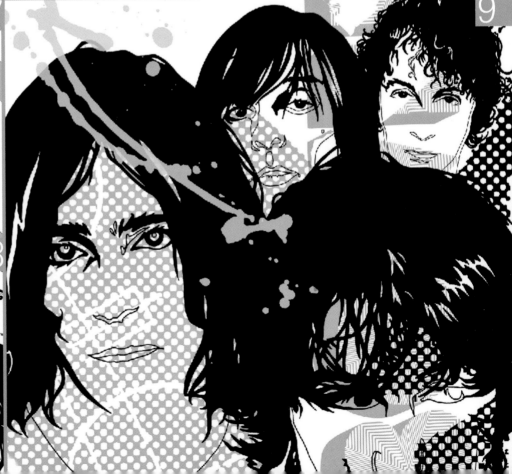

stylistic techniques

Since the beginning of digital image making, a number of different styles have been explored. Early computer graphics were of low resolution and images were blocky, leading to the creation of pixel art. This style, which at the time was dictated by the technology, has been more recently adopted by a new generation of artists either looking to add a retro feel to their imagery or to find alternative methods of image making that they can explore.

Similarly, a number of much older techniques such as wood or lino cutting and screen printing have become popular again, and advancements in digital technology (both in terms of the software to create such images and the hardware to run it) have enabled the digital artist to create imagery that is often difficult to distinguish from handmade versions. In fact, many artists use these techniques in combination, moving from analog to digital throughout the process in a seamless manner.

This section looks at a variety of these styles and the techniques that can be used to create them.

creating texture and grain

In order to create more effective paint textures or to give your images a hand-rendered feel, use found imagery and Photoshop's custom brushes. These add texture that can mimic different papers, brush bristles, and more. Although Photoshop's default brushes can produce a variety of effects, the ability to create your own and utilize additional brush options to emulate real paint effects gives you even more control. Here we'll create a custom brush to mimic watercolor paint.

Adjustments to the Brush settings such as wet edges can give you very different brush textures from the same pattern.

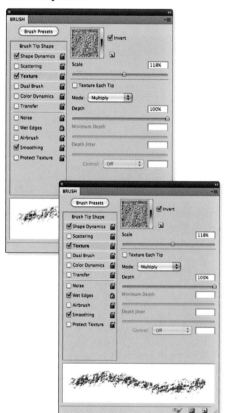

Step 1 Find a suitable pattern
Start by finding a textured pattern that will be the starting point for your brush. You can use a scan, photograph, or a found pattern, or, alternatively, you can make use of online texture libraries. Open your image in Photoshop, then select Image > Adjustments > Threshold. Adjust the Threshold Level until you have an interesting black-and-white textured pattern.

Step 2 Invert the image
In order to find a suitable area, the image was inverted using Image > Adjustments > Invert. This changes white to black and black to white. As this image contains few areas of white, this helps to isolate more black areas of the image that will form the brush.

Step 3 Select an area
Zoom in and scan your image for an appropriate area of the texture. Use the Rectangular Marquee tool to select an area, aiming for a pattern roughly 50–100 pixels wide and high. Once selected, choose Edit > Define Brush Preset. Name your brush "Textured Brush" in the Brush Name dialog.

Step 4 Experiment with the brush settings
Locate the Brush and Brush Presets windows (Window > Brush and Window > Brush Presets). Scroll to the bottom of the Brush Presets window and select your newly created brush. In the Brush window, check the box next to the following settings: Shape Dynamics, Texture, and Wet Edges. You can leave the settings at default, although feel free to adjust and experiment with the different settings under each section. Note how the preview at the bottom of the window adjusts each time.

Step 5 Watercolor
To further enhance the brush, set the opacity to around 67%. This will mean that successive layers of paint overlap and build up like real watercolor. Try out the brush to test its appropriateness and adjust or turn off any settings that don't work. The image shows tests with the brush set to the following from top to bottom: Brush with no settings selected; Shape Dynamics selected; Shape Dynamics and Texture selected; all of the above plus Wet Edges.

the artist's hand
Mike Harrison

In this case study, Mike Harrison uses digital technology to replicate a handmade effect. The face is overlaid with ornamental patterns that are reminiscent of ethnic or tribal art. These concentrated areas of decoration add a complexity to the features of the face and allude to potentially magical properties or rituals. The artist's intention is not to create a photographically accurate portrait, but rather a symbolic, evocative representation of a face.

Complex repetitive gestures are used to form the drawing. These decorative areas, particularly concentrated in the cheeks and hair, provide texture and tone. Harrison uses these intricate components in conjunction with negative space to create a sense of balance within the composition. A limited color palette is also employed, placing emphasis on the quality of the line work and pattern.

In order to create a sense of authenticity, Harrison decides to include crude paper textures and ink stains. These intentional accidents are used by the artist to maintain a human presence within the image. They express a desire to maintain artistic control and integrity within such a potentially flawless and accurate digital environment.

Step 1 **Introduce scanned drawings**
Intricate line drawings are scanned and composed in separate layers in a new Photoshop document. These scanned line drawings have been adjusted and enhanced using Curves and Levels (Image > Adjustments > Levels).

Step 3 **Introduce color wash**
A subtle color overlay is added as a new layer. Notice how this layer cancels the starkness of the white background. Additional patterns are added to the face in similar color tones.

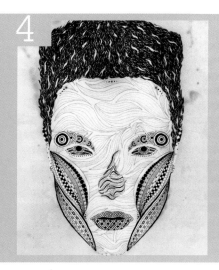

Step 4 **Add black for contrast**
Areas within the face and the hair are filled with black to enhance contrast. The intricate patterns are selected using the Magic Wand tool found in the Toolbox.

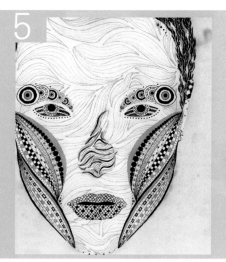

Step 5 **Add blue**
Blue is applied in order to emphasize patterns and add further points of interest within the image. The Color Picker is used to select the appropriate hue, the limited color palette emphasizing the intricate line work.

CASE STUDY

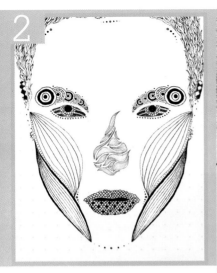

Step 2 **Additional drawing added**

Additional decorative drawings are applied to emphasize features. These additional elements have been adapted to fit using the Transform tool (Menu > Edit > Transform > Scale).

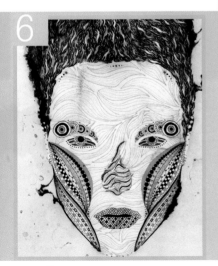

Step 6 **Introduce stains**

Finally, "accidental" ink stains and paper texture are introduced to maintain the presence of the artist's hand. This is reminiscent of the technique outlined on pages 158–159.

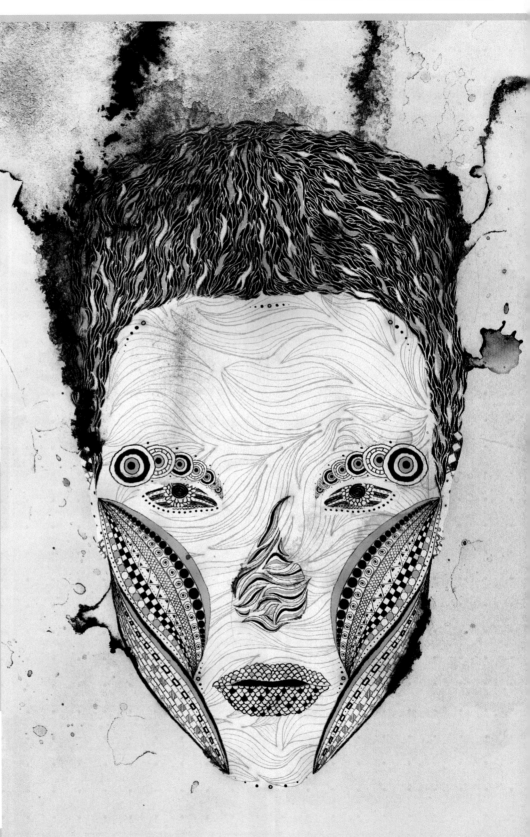

63 stylistic techniques:
lino and woodcut

Traditional image-making techniques such as lino and woodcut are still popular today, and many artists have made use of digital technology to produce images that replicate these styles. The advantage of using digital technology is that the process is much quicker and does not require the use of print presses and messy inks.

While it may be preferable to scan actual examples of print on paper as a texture source, it is possible to use other textures to mimic the surface of a woodcut—in this case, a photograph of a rock. This will need adjusting, however, before it is a workable imitation.

Use Cutout to create flat areas of color for the texture layer and remove areas that are grainy.

Step 1 New document
Open a new landscape document in Photoshop. Ensure the Background layer is filled with white. Add a silhouette layer that will form the basis of the woodcut image—in this case, a ready-made chicken outline. On top of that, add a new layer with the photograph of the texture, which will provide the ink surface.

Step 2 Adjust the texture layer
Select the Texture layer and choose Image > Adjustment > Curves. You are aiming to produce a dark gray/black image with some highlights. The curve shown provides a good model for getting the best result. Click OK to apply the adjustment.

Step 3 Cutout
Now choose the Cutout filter (Filter > Artistic > Cutout). Set Number of Levels to between 4 and 6, raise Edge Simplicity to anywhere between the middle and right of the slider, and set Edge Fidelity between 2 and 3. Click OK to apply.

Step 4 Change blending mode
In the Layers palette, change the Texture layer's blending mode from Normal to Screen. This will reveal the layer underneath while applying the texture.

Step 5 Add to the cutout
Select the Chicken Cutout layer. This was created using the Polygonal Lasso tool and features sharp, angular edges. Use the Polygonal Lasso to add more areas for the inked section of the image, giving them sharp edges. Use Edit > Fill to fill each new area, using black as the fill color.

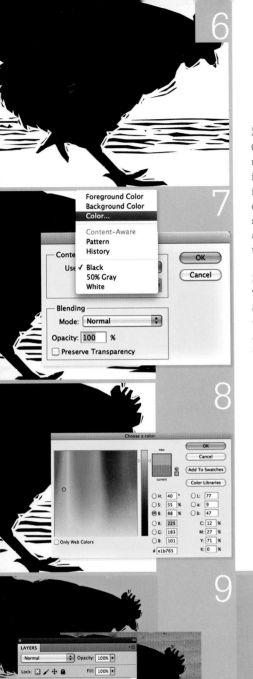

Step 6 **Finish the woodcut**

Continue to build up the image with black using the Polygonal Lasso and Fill until the image is completed. In this example, the image is monotone; however, you could use different color fills within the image. If so, be sure to create individual layers for each color and ensure that they are all placed below the texture layer.

Step 7 **Alter background color**

Traditional images such as woodcut and even contemporary prints are rarely made on pure white paper. Select the Background layer and choose Edit > Fill from the menu to adjust the color.

Step 8 **Select the color**

Click the Use: option box and select Color. Select an eggshell/orange color from the picker. Select OK in both the Color Picker and Fill windows to apply the color.

Step 9 **Add additional texture**

You could leave the image at this stage; however, to further enhance it, we're going to add an additional texture layer to the background. Go to File > Open to choose a second texture for the background. In this case, a rough wood texture has been chosen, although rough cloth or paper textures would be equally appropriate. Copy and paste the image into the linocut document, and place between the Chicken Cutout layer and Background layer.

Step 10 **Change blending mode**

Select the Wood Texture layer and change the blending mode to Overlay. This will apply the texture to the Background layer while retaining the background color.

Step 11 **Adjust opacity**

As a final refinement, reduce the opacity of the Wood Texture layer to 35%. This makes the effect more subtle—less woodlike, and more like a textured paper. Adjust the opacity as necessary, depending on the background texture intensity.

64 screen print effects

Traditional screen printing uses flat, bold colors to produce startling and graphic images. Andy Warhol and many of the underground psychedelic artists of the 1960s used vivid and shocking color combinations to make their famous screen prints. This analog technique has many correlations with digital media, especially in terms of how areas of color are applied in layers.

It is an effect that is easy to replicate in Photoshop and Illustrator, and provides illustrators with an appealing handmade aesthetic in contrast to the predictable mathematical logic provided by the computer. As with other creative digital effects, it is the artist's hand that provides the illusion of authenticity, by using intentional "accidents" such as misregistration and smudges.

To begin this task you will need a digital photograph that already has clearly defined shadows and highlights. If your image is too tonally even, you will find it difficult to distinguish between areas once the required adjustments have been made.

Use the three tiny triangular arrows below the Input Levels histogram to control highlights and shadows. If the Preview box is checked, the alterations to your image will be visible immediately.

Step 1 Open
Open a color image in Photoshop. Go to Image > Mode > Grayscale to convert this image to grayscale.

Step 2 Adjustments
Next, you need to increase the contrast to see a starker difference between black and white areas in your image. Go to Image > Adjustments > Levels to bring up the Levels dialog box.

Step 3 Input levels
Under the Input Levels histogram, drag the black arrow on the left in toward the center gray arrow. Notice how the shadows in your artwork get darker. Next, drag the white arrow on the right in toward the center. Notice how the highlights in your artwork become brighter. The image now has much greater contrast. When you are satisfied with this alteration click OK.

Step 4 Color range
Next go to Select > Color Range to bring up the Color Range dialog box. Under the Select: drop-down menu choose Shadows and click OK. All the black areas within your image will now be selected.

Step 5 New layer
Create a new layer (see page 57) and name it "Green." Press OK.

Step 6 Set foreground color
In the Layers palette, select the new Green layer, then click on the Set foreground color box at the bottom of the Toolbox to bring up the Color Picker window. Choose a green color and press OK.

Step 7 Paint bucket
The Set foreground color icon on the Toolbox should now contain the green you picked. Now use the Paint Bucket tool to click within the selected area on your image. This fill will apply the green color to the Green layer.

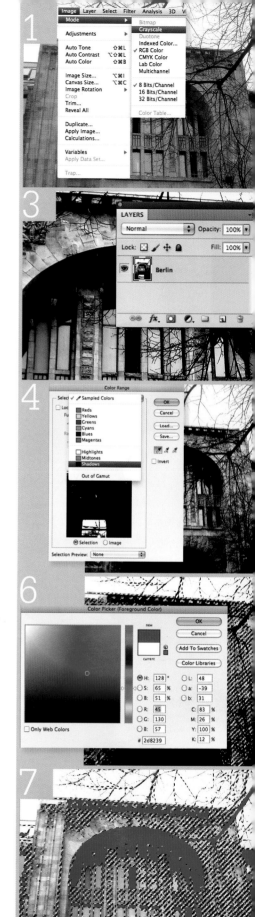

Step 8 **New layer**
Go to Select > Deselect to clear the shadow selection. Now create a new layer as before and call this "Yellow." Press OK.

Step 9 **New color**
With the new Yellow layer selected in the Layers palette, click Set foreground color and select a vivid yellow/green color from the Color Picker dialog. Use the New/Current box to find a corresponding color that matches your previous selection. Press OK.

Step 10 **Fill layer**
The Set foreground color icon on the Toolbox should now contain the yellow/green color you picked. Now use the Paint Bucket tool to click within the layer entitled Yellow. This action will fill the entire Yellow layer.

Step 11 **Change layers order**
In the Layers palette drag the Yellow layer below the Green layer. This changes the order of the layers and reveals the high contrast green fill while masking the original photograph.

Use the arrows on the spectrum slider in the center of the Color Picker dialog box to select an appropriate color. A specific color can also be selected using the numeric boxes on the right-hand side of the dialog box.

Step 12 **Duplicate layer**
Select the Green layer and go to Layer > Duplicate Layer. In the dialog box, call the duplicated layer "Green Copy." Press OK.

Step 13 **Hue/saturation**
Select the Green Copy layer in the Layers palette. Go to Image > Adjustments > Hue/Saturation, and in the Hue/Saturation dialog box drag the Hue slider toward the right to create a bright purple color. If the Preview check box is selected, this will directly affect the color of the Green Copy layer and you will be able to see the layer content change immediately. When satisfied, press OK.

Step 14 **Move layer**
Select the Green Copy layer in the Layers palette and drag it just below the Green layer. This will mask the new purple color. Now use the Move tool to click and drag the Green Copy layer from underneath its green mask. This reveals the purple a fraction and gives the effect of a mis-registered image.

In this final step, you can see that the purple color is revealed below the green fill. This intentional accident refers to analog print-making processes and also creates depth and interest.

retro styles
Jennifer Bricking

Retro styles in the digital arts draw upon traditional techniques such as wood or lino cut, print or paint, and aesthetics from a number of periods. These are often combined with more contemporary content to create new hybrid forms of art.

Jennifer Bricking makes use of digital painting and textures to achieve a semi-retro look to her illustration. Although the characters are contemporary, the aesthetic is handmade, as if the image was painted on wood. Jennifer's image is a perfect example of the use of digital brushes and textures layered together to create a handmade look within a digital image.

These techniques can be explored in detail in the Brushes (see pages 94–95), Stylistic techniques: lino and woodcut (see page 164), and Creating texture and grain (see page 161) lessons. You should also look at the Textures: Photographing materials lesson (see page 152) for hints and tips on sourcing textures in order to help recreate this style.

The use of earthy colors further enhances the retro and painterly feel—if the colors were too vibrant, the effect would be spoiled—while texture layers add to the handmade and rough quality by breaking up smooth surfaces, which are characteristic of digital illustrations.

Step 1 Textured background
The basis for this image is a scanned textured background. A basic color layer with rough edges provides the base layer, while a scanned texture layer is placed on top (and remains on top throughout the process) to give the unique surface texture.

Step 4 Fleshing out detail
Bricking then proceeds to enhance the details throughout the image. As well as fleshing in details such as the headlight, clothing textures, and the moped's fairings, she adds a shadow to the underside of the moped and creates leaves using a custom brush.

CASE STUDY

Step 2 **Adding elements**

The image is painted using textured brushes and basic shapes, created over a number of layers. These elements help to rough-in the shapes that will make up the final image and are later tweaked to provide more details. By turning the topmost texture layer on we can see how it can apply a rough surface to the areas of flat color, and gives the characteristic retro feel to this image.

Step 3 **Further elements**

More elements are painted in and start to create the main structure of the image. Many of these layers are flat fill layers, while others are painted. Again, it is the interaction of these flat color layers with the top texture layer that gives these layers interest. However, Bricking has decided to accentuate the texture for the monster creature by applying an additional texture layer over the monster layers. This further enhances the hand-painted feeling by making the flat colors more rounded and detailed.

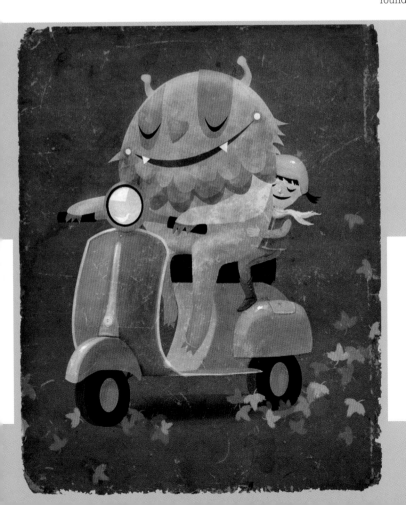

Step 5 **Finish off**

The final image makes effective use of multiple layers to help build the image. Multiple layers allow for quick changes and the addition of detail to enhance the image without spoiling or altering the base layers. For a practicing illustrator who may be asked to make changes to an image as the commission progresses, the ability to make such changes and alterations with multiple layers can be a valuable time-saving aspect of image making.

65 filters

P Photoshop has a large collection of filters, and some are more useful than others. While these can often be powerful tools that achieve rapid and effective results, they can often be overused. This is not to say that all filters are bad, but rather that you should use them to help you perform specific tasks rather than forming the backbone of your image making.

The following lessons will look at a number of useful filters and how to use them effectively to improve or support your illustration.

Introducing filters

Filters are accessed from the Filter menu and Filter Gallery. At first, there appears a startling array to choose from, but the organization of the individual filters into separate categories should help you to locate the effect you are looking for. In this first lesson, we'll look at some of the filters that are available and how to adjust and apply them to a layer. This example makes use of a simple image. For many filters, the precise effect that is achieved is dependent upon the range of tones and colors and the image's resolution. The example image provides a suitable range of both to help demonstrate how filters work.

Step 1 **Open an image**
Open your chosen image (ensuring that the layer you wish to apply the filter to is selected), then select Filter > Filter Gallery from the menu. This will open the window that allows you to preview and adjust most of the available filters.

Step 2 **Select a filter**
To the left-hand side of the Gallery window is a preview of your image with the current selected filter applied. The specific filter is selected by category from the central menu and then by clicking on the appropriate filter thumbnail button (in this case, Colored Pencil). Individual controls are available for each filter, and these are displayed to the right of the Filter Gallery depending upon the filter selected. In this example, we have adjusted the settings for the Colored Pencil tool, including the Width, Pressure, and Brightness settings.

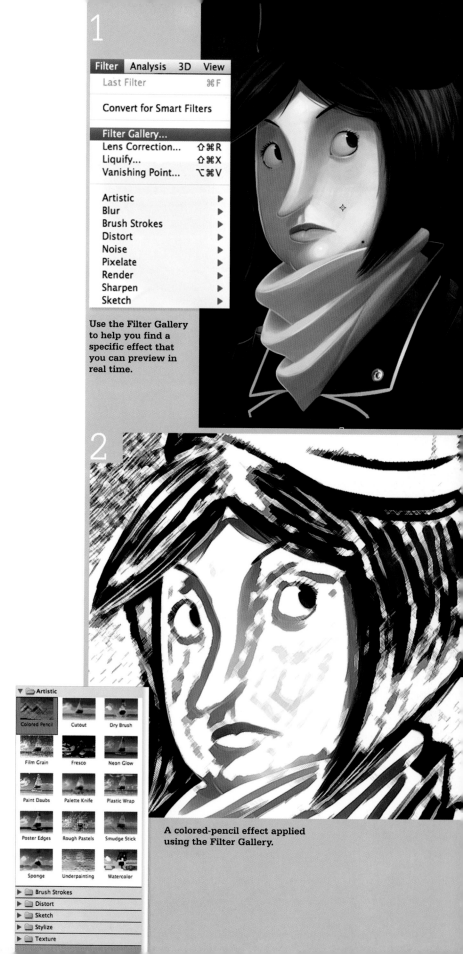

1

Use the Filter Gallery to help you find a specific effect that you can preview in real time.

2

A colored-pencil effect applied using the Filter Gallery.

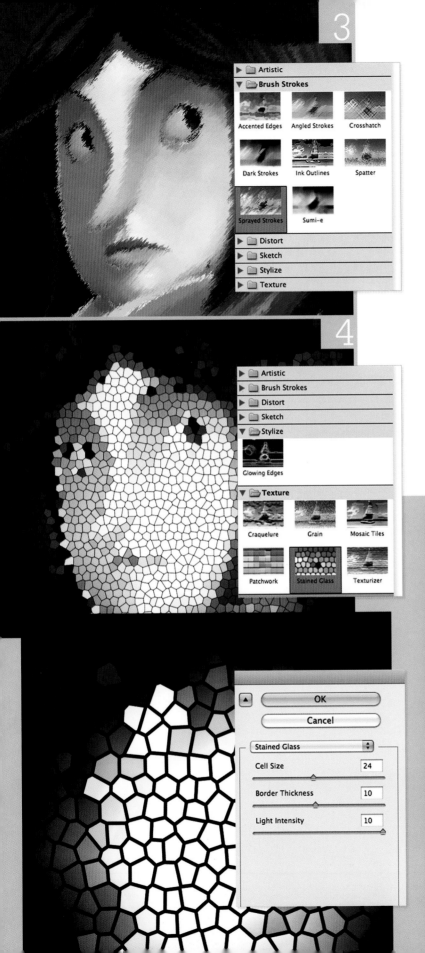

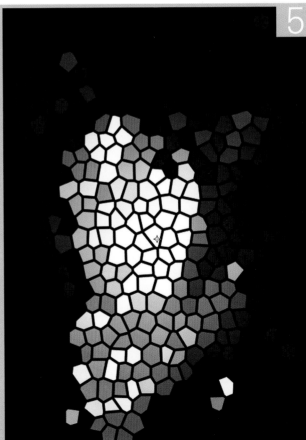

Step 3 **Filter types**

The first set of filters, Artistic, offer tools that mimic specific artist media. The Brush Strokes set replicates certain brush styles. Settings for these filters tend to allow you to adjust the angle, size, and pressure of the filter being used via sliders or by entering numeric values.

Step 4 **Adjusting filters**

The Texture set replicates certain base media. Filters like Stained Glass allow you to not only create a stained glass effect, but can also be used to rapidly create images of objects such as plant and animal cells, tiles, and so on. Adjustments to the individual sliders can produce a variety of effects—in this case, scaling the size of individual cells and cell walls, and adding a source light.

Step 5 **Applying filters**

Filters are applied by clicking the OK button within the Filters Gallery. Cancel will stop any of the filters you have tested from being applied.

Blur

One of the key filters within Photoshop for a number of digital image applications is the Blur filter. It offers the ability to add degrees of blur to your layers to make them seem out of focus, or equally can be used to soften edges of hard lines or pixels.

The Blur filter, therefore, has a number of useful applications. It can suggest depth within your image by defocusing backgrounds and foregrounds, so helping focus the viewer's eye on key areas. It can also be used to suggest movement of objects by applying directional blur that represents speed. Finally, it can be used to make pixels blend together, and therefore help soften images where hard edges can appear unreal. This is particularly useful when brushes or scanned images appear too harsh.

Step 1 **Choose an image**

Open an image that makes use of multiple layers. In this example, we have used an image created by Robert Proctor that contains a number of layers, including a background sky layer, mid-ground monster and ship, and foreground waves. Select the bottom layer (in this case, the sky), then choose Filter > Blur > Gaussian Blur.

Step 2 **Gaussian Blur window**

In the resulting Gaussian Blur dialog, you can control the level of blur using the Radius slider. The image viewer lets you preview the setting as applied to a specific region of the image. A subtle blur for this high-res image occurs at 10 pixels Radius. Try to avoid totally obscuring your subject matter.

Step 3 **Motion Blur**

Select a mid-ground layer—in this case, we have chosen the monster layer. This time we are going to apply a Motion Blur, which can be used to indicate speed and movement. Choose Filter > Blur > Motion Blur.

Step 4 **Motion Blur adjustments**

The Motion Blur tool lets you adjust the distance the blur spreads and also the angle at which the blur moves. Larger distance values create a bigger blur, although high values should be avoided for most images. The angle of the blur can be changed using either the control box or by dragging the rotation button within the Blur window. Click OK to apply.

Step 5 **Feather**

For areas or layers where blurs need to be applied selectively, you can make use of the Marquee or other selection tools to define the area to be affected by the filter. In this case, we wish to add a blur to the waves farthest from us but keep the closer waves in focus. The Elliptical Marquee tool is selected with a feather set to 150 pixels. This will cause the selection to fade and create a smooth transition. Select an area for the filter, but note that the feather will cause your selection to shrink once completed. The filter is then applied for effect.

Step 6 **Blur to soften**

The blur tool is also effective for softening harsh edges and pixels. Start by creating a new file and then use Filter > Noise > Add Noise to fill the image with random pixels. Next, select the Gaussian Blur tool. Change the Radius to suit the image, although a value of between 1 and 3 is often best. This method is often a quick way to produce a textured layer for an image—for example, when replicating the texture of a rough wall.

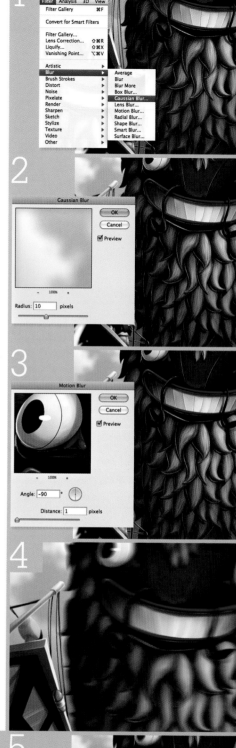

Render filters

There are a few filters that can produce useful effects without relying on an image to work. One such example of this is the Noise filter, as seen in the last lesson. These filters allow you to produce useful areas of random color and tone that can then be reworked to enhance your image.

Step 1 **Render Clouds**

The Render Clouds filter is a helpful tool in some situations. It allows you to create a random cloudlike image based on the foreground and background colors selected. It can be used as a texture layer, a mask where fog or smoke is needed, or simply used as clouds! Create a new Photoshop document, set foreground and background colors to black and white, then select Filter > Render > Render Clouds. The current layer will be filled with the cloud image. Change the foreground and background colors at the bottom of the Toolbox and re-apply the filter to try out different combinations of color.

Step 2 **Fibers**

The Fibers filter works in a similar way to the Clouds filter but offers more control over the effect produced. Create a new document and then select Filter > Render > Fibers to bring up the Fibers window. Again the rendered effect is determined by the foreground and background colors selected in the Toolbox.

Step 3 **Fibers settings**

The Fibers filter has two sliders. Move the Variance slider to the right to produce small, more closely packed fibers, and to the left for low-density single fibers. The Strength setting determines how straight the fibers will be.

Step 4 **Color Halftone**

The Color Halftone filter replicates the four-color printing process. Open an appropriate image in Photoshop and go to Filter > Pixelate > Color Halftone. The Color Halftone window will appear. The main control is the box marked Max. Radius. This sets the size of the halftone effect, mimicking magazine and newspaper print.

The filters described here are only a small fraction of what's available. By all means, take time to go through them to see what effects can be achieved—but remember to avoid overusing them.

66 out-of-register duotone

P The duotone was a traditional print technique used to provide a cheap alternative to the full-color process. Today, illustrators replicate the technique to desaturate full-color images, so providing a useful means with which to manipulate and merge disparate photographic elements within one composition. By removing the color content and reducing the image to tone, the artist takes increasing ownership of the imagery.

In this lesson, we will create a duotone image, and then use layers and blending modes to produce graphic compositions that are reminiscent of poorly registered analog printing.

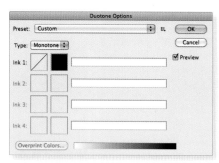

Use the drop-down menu in Duotone Options to select Type > Monotone.

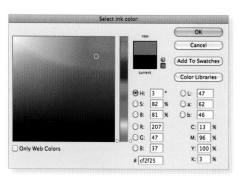

Use the long white dialog box next to Ink 1 to name this particular color channel "Red."

Step 1 **Grayscale photo**
Open a color photograph in Photoshop. Go to Image > Mode > Grayscale to convert the color image to a grayscale one.

Step 2 **Duotone**
Next go to Image > Mode > Duotone.

Step 3 **Monotone**
In the Duotone Options window, make sure the Preview box is selected so you can see the changes as you make them. Set the Type drop-down menu to Monotone. Notice the two highlighted squares called Ink 1. Click the color square on the right (here shown in black) to bring up the Select ink color: window.

Step 4 **Select ink color**
In the Select ink color: dialog, select a vivid red. This color overlay may obscure details within the photograph; if so, this can be amended in Step 6. Press OK.

Step 5 **Duotone options**
Having selected a color, you will be returned to the Duotone Options window. Call the Ink 1: color "Red."

Step 6 **Duotone curve**
Return to the two highlighted squares entitled Ink 1. Click the square on the left. This will open a window called Duotone Curve. Drag on the curve and notice how it affects the contrast within the image. Use the curve to draw out more detail from beneath the saturated color. When you are satisfied with the results, press OK. Return to the Duotone Options window and press OK.

Step 7 **Duplicate layer**
Go to Layer > Duplicate Layer. In the Duplicate Layer dialog box, call the new layer "Skyscraper Copy." Press OK. A new duplicated layer will appear in the Layers palette.

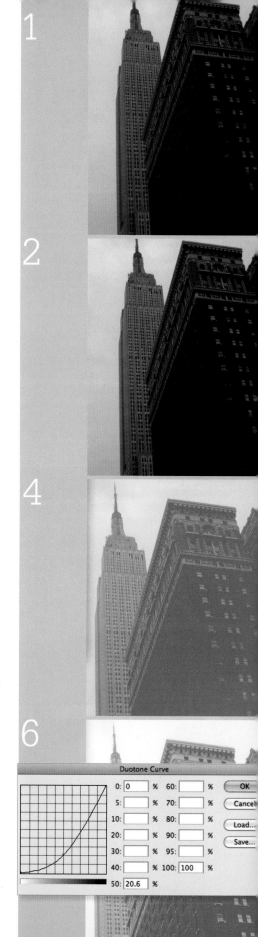

Step 8 **RGB mode**

Select the skyscraper copy layer in the Layers palette and go to Image > Mode > RGB Color. A dialog box will appear warning you that changing modes can affect the appearance of layers. Click Don't Merge. This will let you manipulate your new layer.

Although the Merge button is highlighted in blue, you need to click the Don't Merge button.

Step 9 **Hue/Saturation**

Next, go to Image > Adjustments > Hue/Saturation to call up the Hue/Saturation dialog box. Drag the Hue slider to the left to select an alternative, contrasting purple color. When satisfied, press OK.

Step 10 **Multiply**

In the Layers palette, set the skyscraper copy layer's blending mode to Multiply. This will convert the skyscraper copy layer to a transparency.

Step 11 **Move**

You can now use the Move tool to drag this transparent layer and intentionally misregister your image.

67 halftones and offsets

A halftone is a distinctive and popular digital effect that refers to the manufacture of graphic material, and is used by illustrators to reference art history—pop art in particular. The halftone process was originally devised to replicate paintings and photographs for industrial printing. It uses dots of varying sizes to create the illusion of color and tone. The CMYK color model is the most common example of this process, and uses four layers of semi-opaque ink to mimic color photography. CMYK refers to the four inks used for printing: cyan, magenta, yellow, and black (or key).

The tools to replicate this technique can be found in the Filter menu in Photoshop. We will examine two separate ways in which to recreate it. The first example utilizes the Color Halftone filter, and applies a basic adjustment to your image. This filter imitates the CMYK process in that it divides a color photograph's full color content into just four areas of color and tone.

The Max. Radius box is the means by which the halftone pixel dimensions are controlled.

Color halftone filter

Step 1 Open

Open a color file in Photoshop. This image should have clearly defined shadows and highlights. If your image is too tonally even, you will find it difficult to distinguish between areas once the filter has been applied.

Step 2 Color halftone

Go to Filter > Pixelate > Color Halftone.

Color Halftone is one of the many digital effects found under the Filter menu.

Step 3 Max. Radius

In the Color Halftone dialog box, locate the box labeled Max. Radius. This is the most important means of controlling the filter, and by increasing its value the radius of each dot grows, distorting your image. The four Channel windows refer to the four CMYK colors and control separate channels within the digital file. In this example, Max. Radius is set to 8. Press OK.

Step 4 Apply

The Color Halftone effect is now applied to your image.

Step 5 Zoom

Use the Zoom tool to magnify the image. This will help you examine how this filter affects the artwork. Notice how the details and tones within the original photograph have been converted to just four separate colors, CMYK.

Black-and-white halftones

When applied to color or grayscale images, Photoshop's Halftone Pattern filter converts the content into a black-and-white pattern, similar to how images appear in traditional newspaper print. The filter provides control in terms of how you distort your image by allowing you to preview alterations in a separate window called Halftone Pattern.

Step 1 Open
Open a bold, clearly defined Photoshop file. Go to Filter > Sketch > Halftone Pattern.

Step 2 Halftone pattern
The Halftone Pattern filter window lets you control the filter and also previews how your adjustment will affect the original image. Initially, the software makes an assumption and the filter is automatically applied to your image. For a more dramatic and graphic quality, the image can be amended using the controls on the right of the screen.

Step 3 Control size
To control the size of the dots within the halftone pattern, use the sliding controller to increase their size from 2 to 5.

Step 4 Contrast
To control the contrast within the halftone pattern, use the sliding controller to increase the contrast from 5 to 19.

Step 5 Line pattern
The default pattern type is Dot, but other patterns can be applied. Use the Pattern Type: drop-down menu and select Line. This converts the artwork into a horizontal, linear pattern that uses the density of the line to convey tone.

Step 6 Circle pattern
Select Pattern Type > Circle. This converts the artwork into a circular, linear pattern that also uses the density of the line to convey tone.

The Halftone Pattern filter window interface. Use the sliding controls to increase the size and contrast of the pattern. The adjustment will be visible as a layer at the bottom of the interface. Use the eye icon to switch between the original artwork and the pattern effect.

68 coloring halftones

P Flat, black-and-white, halftone artwork can be colored and blended to produce vibrant, seemingly accidental, layered artwork.

Step 1 **Color range**

Open the halftone image and go to Select > Color Range to bring up the Color Range dialog box. Under the Select: drop-down menu pick Shadows and click OK. All the black areas within your image will now be selected.

Step 2 **New layer**

Create a new layer (see page 57) and name it "Red." Press OK. A new layer will appear in the Layers palette.

Step 3 **Color picker**

Select the new Red layer in the Layers palette, then click Set foreground color at the bottom of the Toolbox. The Color Picker dialog box will appear. Use this interface to select a bright red color. Press OK. Now use the Paint Bucket tool to click within the selected area on your image. This fill will apply color to the Red layer. Deselect the selection with Select > Deselect.

Step 4 **New layer**

Create a new layer as before and call it "Blue." Press OK. A new layer will appear in the Layers palette.

Step 5 **Color picker**

Select the Blue layer in the Layers palette, click the Set foreground color box at the bottom of the Toolbox, and in the Color Picker dialog select a dark blue color. Press OK.

Step 6 **Fill**

Now, with the Paint Bucket tool, click within the layer entitled Blue. This action will fill the entire Blue layer.

Step 7 **Order layers**

Select the Blue layer in the Layers palette and drag it below the Red layer. This changes the order of the layers and reveals the red artwork while masking the original photograph.

Apply color halftone adjustments to a photographic image, such as this one by Ruth Patrick, and notice how saturation is enhanced and distorted.

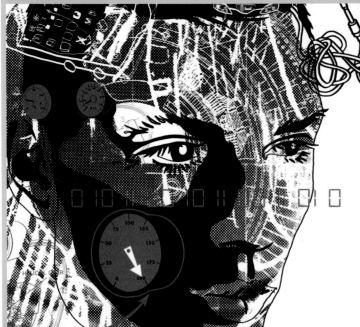

The final artwork uses two vivid colors to provide contrast and a vibrant graphic effect.

This portrait uses a black-and-white halftone pattern to create texture within the face. Color elements are then introduced in separate layers to provide points of interest and balance.

69 replicating graffiti stencils

P This sequence demonstrates how Photoshop's Brush and Gradient tools can be used to produce an authentic-looking street-art style. We'll show you how the mechanical precision of digital airbrush techniques, which can appear artificial, can be made to look more authentic with the use of customized brushes that replicate the paint functions and applications particular to the urban graffiti genre, such as the spatter effect in which spray paint is condensed or applied inconsistently.

The Brush Tool Options bar lets you control the application of paint. In this example, an extra large brush is used to best demonstrate how this technique works. Reduce the brush size if you require more detail.

A gradient fill provides the means to blend colors within selected areas, replicating the mechanism of an airbrush. These fades are controlled using the Gradient Fill Options bar.

Step 1 **Open a source image**
Open a flattened black-and-white file with clearly defined contrasting areas, such as this "floating silhouette." Make sure the image is in RGB color mode (Image > Mode > RGB color).

Step 2 **Create a new layer**
Go to Layer > New > Layer to open the New Layer dialog box. Call the new layer "Canvas." Click OK. In the Layers palette, the canvas layer will appear above the floating silhouette. Select this layer.

Step 3 **Fill dialog box**
Next go to Edit > Fill. In the Fill dialog box, select White in the Use: drop-down menu. Set Mode to Normal, and Opacity to 100%. Click OK.

Step 4 **Color Range**
In the Layers palette, drag the canvas layer beneath the floating silhouette layer. Next go to Select > Color Range to bring up the Color Range dialog.

Use the menu to find Color Range. Use this dialog box to select the silhouette figure.

The stark black-and-white contrast of this image is ideal for demonstrating how the Color Range dialog box can be used to select content.

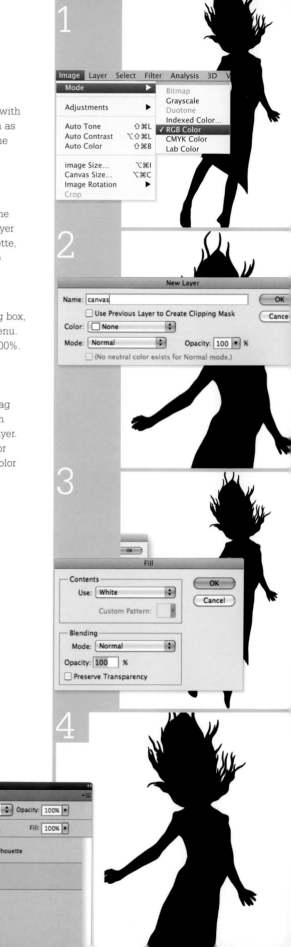

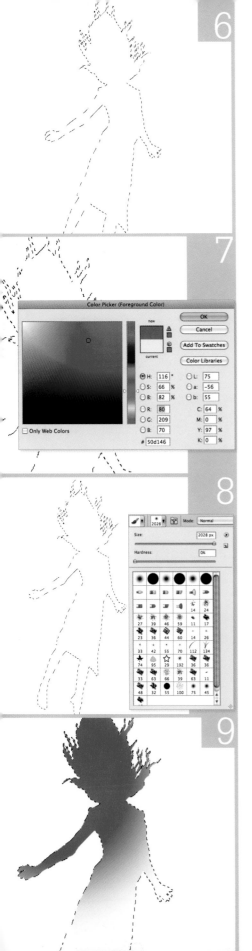

Step 5 **Select Shadows**

Use the drop-down menu at the top of the dialog box and select Shadows. The Shadows option will select the black areas within your artwork. Click OK.

Step 6 **Select the silhouette**

An active selection will be visible around the silhouette. Select the floating silhouette layer in the Layers palette, and click the visibility eye icon to switch off this top layer. Next, select the canvas layer.

Notice how the selection window in the Color Range dialog box reveals the silhouette figure when the Shadows option is selected.

Step 7 **Open the Color Picker**

Click on the Foreground Color box at the bottom of the Toolbox to open the Color Picker. Use the spectrum slider and picker to select a green color. Once you have made your selection, press OK.

Step 8 **Select the brush**

The Foreground Color at the bottom of the Toolbox is now green. Select the Brush tool. Use the Tool Options bar at the top of the screen to select the Brush Preset picker. Select a soft round brush. Use the slider to increase the size to around 2030 pixels. Set Hardness to 0%. In the Tool Options bar, set Flow to 56%. Flow controls the density with which the paint is applied and will create the sense of the spray paint being applied at a distance. These settings will provide a brush that replicates spray paint.

Step 9 **Apply the color**

Use the Brush tool to fill the top half of the selection. This will produce a graduated airbrush effect, with no visible hard lines.

Step 10 **Switch colors**

Locate the Switch Foreground and Background Colors icon at the bottom of the Toolbox. Click this double-arrow icon and notice how the Foreground and Background Color squares swap position. The Foreground Color is now black. Click the Foreground Color box to activate the Color Picker dialog. Select a pink color and press OK.

Use the range of colors available in the Color Picker and the sliding spectrum to find the exact hue you require.

Step 11 **Select the Gradient tool**

The Foreground Color now displays pink. Select the Gradient tool from the Toolbox. This is located in the same position as the Paint Bucket tool.

The Gradient tool can sometimes be concealed because it shares the same position as the Paint Bucket tool in the Toolbox window.

Step 12 **Draw the gradient**

The Tool Options bar provides a variety of gradient fill options. Select the Linear Gradient icon, set Mode to Normal, and Opacity to 100%. Start at the top of the silhouette and drag a line down toward the bottom. This line determines the depth of the color transition.

Step 13 **Gradient fill**

The Gradient fill is revealed within the selected area.

Step 14 **Create a new layer**

Go to Layer > New > Layer and in the New Layer dialog, call the layer "New Canvas." Press OK.

Step 15 **New brush**

With the New Canvas layer selected, select the Brush tool. In the Tool Options bar, click on the Toggle in the Brush panel icon. Use the Brush panel to pick a soft round brush. Use the Brush tip shape options to select Noise. This produces a rough, diffused brush tip. Use the slider to increase the brush size to 220 pixels. Set Hardness to 0% and Spacing to 127%. Spacing controls the consistency of the line and will create the sense of the spray paint being spattered at intervals across the canvas. These settings will provide a brush that replicates condensed spray paint.

Step 16 **Spatter paint**

Use this brush to paint within the selected shape. Notice how the brush reacts in an unpredictable way, replicating the spatter and imperfections of spray paint. Experiment with this tool until the desired effect is reached.

Step 17 **View final artwork**

When you're happy with the results, go to Select > Deselect and Layer > Flatten Image to save the finished artwork.

Always create a new layer when applying a Color fill. This provides you with more creative options when composing your artwork.

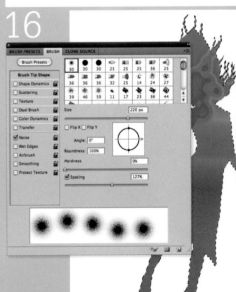

creating spatter effects

P

This lesson looks at creating a brush to mimic spatter effects. Brushes offer a quick way to replicate this look, although it is often best to create a variety of brushes to achieve random spatter patterns.

Step 1 Create a new document
Start a new document and select the Brush tool. Change the brush type to a standard round brush and set Hardness to 90% so that it has a slightly soft edge.

Step 2 Paint circular shapes
Make a number of circular shapes using single clicks. Keep changing the brush size to create smaller and smaller dots that resemble small drips of paint. At the same time, combine shapes to create larger spatter areas.

Step 3 Define the brush
Once completed, use the Marquee tool to select your spatter, ensuring that the entire area is selected. Choose Edit > Define Brush Preset. In the Brush Name window, name your brush "Spatter Brush."

Step 4 Adjust the brush settings
Go to Window > Brush and Window > Brush Presets to open both the Brush and Brush Presets windows. Select your new brush, which you'll find at the bottom of the Brush Presets window. In the Brush window, tick the checkboxes next to Shape Dynamics and Wet Edges.

Step 5 Adjust Shape Dynamics
Select Shape Dynamics in the Brush window. Set the Size Jitter to 50% and change the Control selection to Fade with the steps set to 25. For the Angle Jitter, set the first box to 75% and again set the Control to Fade at 25 steps. Finally, set the Roundness Jitter to 60%, Fade with 25 steps, and Minimum Roundness to 25%. Note how each change alters the brush preview.

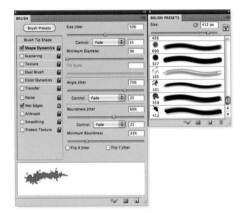

Use the Shape Dynamics options to create more random effects for your brush. Experiment with different settings to create a variety of brushes.

Step 6 Test the brush
Having set up the brush, try different sizes and colors to see how well they work. At this stage, you should also try adjusting the settings to achieve the effect you want. For example, you may wish to turn off the Wet Edges option in the Brush window to create more solid brush spatters such as those created by Ink, or adjust the Fade or Size Jitter settings to make the brush strokes cover more page space. Create multiple brushes using this technique to ensure you have a good range of spatters to use in your projects.

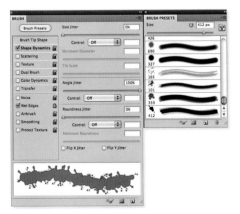

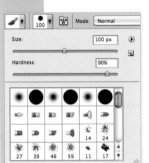

1

2

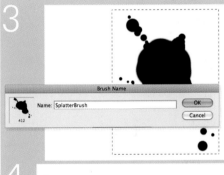

3

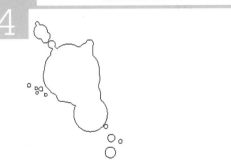

4

6

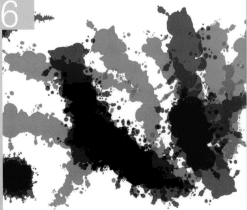

71 pixel art

P Pixel art is a popular form of digital rendering. It has its roots in early computer game graphics, early image-creation software, and the Internet. However, it continues to be used as a method of creating online game characters, or avatars, and is utilized heavily by web-based formats. It also has applications in a wider range of illustration styles such as certain types of poster and editorial work that seeks to communicate a retro 1980s/90s feel.

Pixel art is a time-consuming method for creating images, as it relies heavily upon generating individual pixels one at a time. Short cuts and work-arounds tend not to give the desired results that this aesthetic demands. It, therefore, requires patience and attention to detail.

Pixel art comes in two main forms. One is largely based upon representational images within a two-dimensional space, making use of the pixelated look to provide a retro look. Computer game characters and avatars also fall into this category. The other form seeks to mimic three-dimensionality using orthographic projection. However, setting up Photoshop for the creation of both these ways of working uses identical settings.

Setting up Photoshop for pixel art

Step 1 **New file**
Go to File > New to create a new document. Pixel art images make use of a limited image size and low resolution. In the New document window, set the image size to 150 pixels wide by 150 pixels high. Set pixels/inch to 72 (the standard resolution for pixel art). Set Color Mode to RGB and ensure that 8 bit is selected from the selection box to the right. Click OK.

Step 2 **Preferences**
Go to Photoshop > Preferences > General, and in the Preferences window set Image Interpolation to Nearest Neighbor. This will ensure that any scaling or transformation will retain the hard pixel edge you need for this technique to work effectively.

Step 3 **Change cursor types**
In the Cursors section of the Preferences window, change both of the cursor types to Precise. This will enable you to accurately place individual pixels.

Step 4 **Change pixel preferences**
In the Guides, Grids & Slices section of the Preferences window, set both the Gridline Every: and Subdivisions: boxes to 1 pixel. This will allow you to use a grid to accurately place individual pixels. Press OK when you are done. Go to View > Show > Grid to turn the grid on.

Step 5 **Set brush size**
Choose the Pencil tool from the Toolbox (it shares with the Brush tool), and using the Brush Preset picker button, ensure that the brush size is set to 1 pixel and hardness is set to 100.

Step 6 **Set eraser mode**
Finally, select the Eraser tool from the Toolbox. Set the eraser mode from the drop-down menu to Pencil, and copy the settings above so that the eraser works in the same way as the pencil. You are now set up for your first pixel art image.

Make sure that you change your Brush tool to Pencil mode for pixel art.

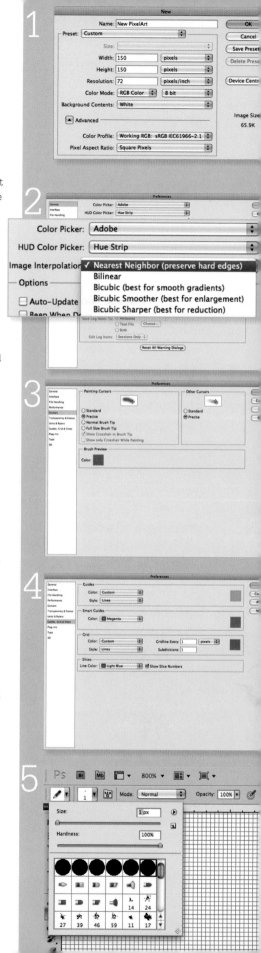

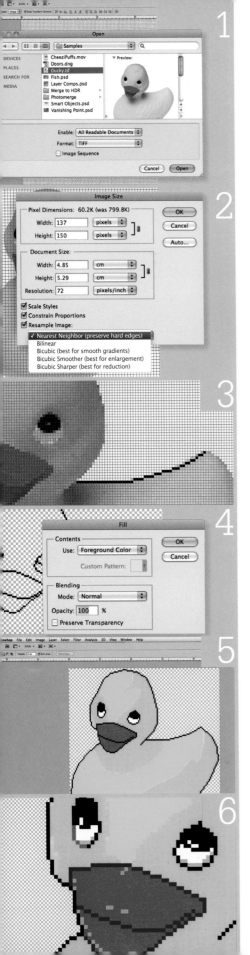

2D pixel art

Pixel art is often easier when you have an original drawing or photograph to reference.

Step 1 **Open image**
Open a suitable image in Photoshop—in this example, we will be using the Ducky.tif image located in the Photoshop Samples folder.

Step 2 **Resize**
Once opened, go to Image > Image Size to scale to a suitable pixel art size. In this example, we have set the width to 137 and the height has automatically adjusted itself to 150 pixels. Make sure that you have Resample Image turned on, otherwise, you will not be able to scale in pixels. It is also a good idea to set scaling to Nearest Neighbor.

Adjust the image size appropriately for tracing in pixel art.

Step 3 **Trace image**
Once your image is opened and scaled, create a new blank layer by clicking the Create new layer icon at the bottom of the Layers palette. Turn on the grid using Show > Grid. Zoom in to a reasonable distance to your image, choose the Pencil tool, and start to trace around your image. You can speed up this process by clicking once to add a single pixel then holding shift while clicking in a new location. This creates a straight line between these two points. However, as you are working at such a low resolution, the line will retain the characteristic jagged edge. Trace all around the image, and also the eyes and beak.

Step 4 **Add color**
Name your current layer "Outline," and then create a second layer called "Color Fill Body." The Outline layer should always remain at the top of the layer stack. With the Outline layer selected, choose the Magic Wand tool. Set tolerance to 1 and deselect Anti-alias. Click anywhere within the traced body to set the selection. Change to the Color Fill Body layer. Click on the Set foreground color box at the bottom of the Toolbox, select a bright yellow in the Color Picker, and use Edit > Fill with Use: set to Foreground Color. Create additional layers for the beak and eyes and color them in the same way, using red for the beak and black and white for the eyes. Once done, check for unfilled areas and retouch with the Pencil tool.

Step 5 **Add shading**
Return to the Body Fill layer, and using the Magic Wand, select the yellow filled area. Move the original duck layer to beneath the Outline layer so that it is now visible, then reselect the Body Fill Layer. Now switch to the Lasso tool, and while holding down the Alt/Option key, draw around areas within the ducky image that are brighter yellow. This will deselect these areas and leave a selection based on shadow areas only. Once done, hide the ducky layer by clicking its visibility (eye) icon in the Layers palette, select a darker yellow for the shadow areas, and use Edit > Fill to fill the current selection.

Step 6 **Add highlights**
Deselect (Select > Deselect), and using the Pencil tool, draw in extra areas of shadow—these are likely to occur near the base and edges of your fill color. To finalize your image, use lighter colors to add area highlights at key points (simply use a lighter color than the main fill color). A further convention in pixel art is to set internal lines (in this case, the outlines for the beak and whites of the eyes) from black to a darker tone of the fill color. Change the Foreground Color and use the Pencil to adjust these colors on the Outline layer. Finish by cleaning up your image and flattening your layers before saving the file.

Orthographic pixel art

Orthographic pixel art creates the impression of three-dimensional space using orthographic projection. Objects are rendered as if viewed from above and as if rotated 45 degrees. While this mode seeks to mimic three-dimensional space, orthographic perspective does not give a true three-dimensional space, and images that are overly long in any one dimension can look distorted, as their size does not shrink as they recede toward the horizon.

In order to achieve this look, it is essential to learn the basics of creating cuboid objects effectively, as these often form the building blocks of more complex shapes.

Step 1 **Create new document**

Create a new document using the settings discussed earlier (see page 184), and set to roughly 100 x 100 pixels. Zoom in to your new document using the Zoom tool until you can fit around 30–40 grid lines vertically on the screen.

New documents for pixel art should always be created using the Pixels setting. Horizontal and vertical pixel numbers are usually low—between 50–700 pixels.

Step 2 **Pencil tool**

Create a new layer and select it in the Layers palette. Select the Pencil tool, and using black as the foreground color (this is default), start to draw a single vertical line that is roughly 15 pixels high. Hold the Shift key while drawing the line to draw a straight line. Draw a second parallel line approximately 15 pixels away from the first, making their heights even. If you make a mistake, switch to the Eraser tool and delete any wayward pixels.

Step 3 **1 up, 2 across**

Pixel art orthographic projection relies upon a system known as the "1 up, 2 across" method for creating angled lines. This means that all the lines that run to an imaginary vanishing point mimic a 26 degree angle of projection by stepping up or down by 1 pixel for every 2 pixels drawn across. Starting at the bottom of the first vertical line, move to the right and down by 1 pixel and draw a 2-pixel-wide line. Move 1 pixel to the right and 1 pixel down again and draw a second 2-pixel-wide line. Continue in this way until you get to the midpoint of the two lines, then reverse the process, stepping up 1 pixel for every 2 horizontal pixels drawn.

Step 4 **Reverse**

Reverse this process at the top of the 2 vertical lines, moving 1 pixel up from left to center, then one pixel down from center to right, drawing a 2-pixel-wide line each time.

Step 5 **Set foreground color**

Click the Set Foreground Color box to bring up the Color Picker and select a new light blue foreground color for your Pencil tool. Create a mirror image of the uppermost inverted V-shape that is formed underneath it, leaving a single pixel horizontal line empty in between (5a). Next, draw a vertical line from the base of the blue V-shape to the top of the black inverted V-shape (5b). Turn off the grid lines using View > Show > Grid.

Step 6 **Fill**

To complete the 3D effect, color the faces of this cuboid to mimic a light source. First of all, select the Magic Wand tool and click inside the rightmost face of the cube. This transparent area will be selected, shown by the dashed line (6a). Choose a new foreground color, this time a darker blue than that selected in Step 5, and use Edit > Fill to fill this area. Do the same for the top face. Finally, select the last remaining face using the Magic Wand, and selecting a darker blue again, fill this area (6b).

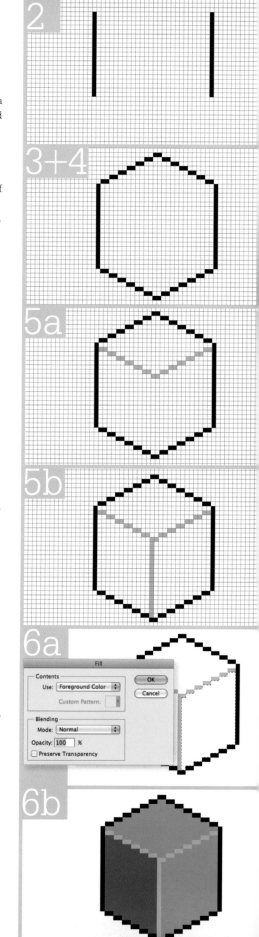

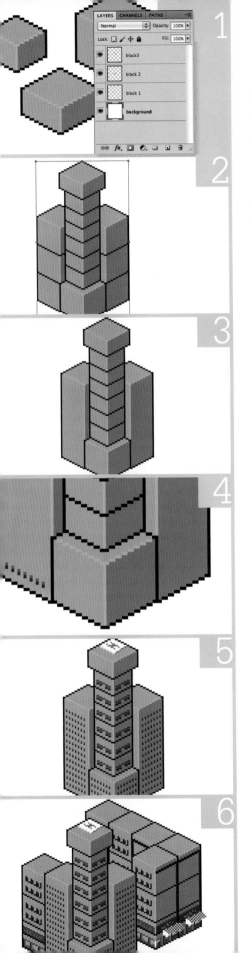

Building blocks

Many artists who use pixel art create modular elements (reusable parts) that can be lined up, stacked, or duplicated to rapidly create scenes. In this lesson, we will stack together a number of simple box shapes to create a simple scene. These modular units will then be edited to give them individual character.

Step 1 **Create blocks**

Create a new 400 x 400 pixel document. On separate layers, construct a number of different-sized blocks (between 30–50 pixels in width and height) and call them block 1, block 2, and so on. These will be your modular units for this lesson. However, you need to make one important change—at the foremost corner of each block use a 3-pixel-wide line instead of 2-pixel-wide. This will be important when you come to stack your blocks, as it creates a more aesthetically pleasing join.

A pixel block showing highlights, outline, and shaded side.

Step 2 **Stack blocks**

Move your original modular units to one corner of the document so that you can access them but they are not in the way of your construction. You want to keep these safe, as they are the original template that you will be working from. Select a starting block as the first part of your construction, and, while using the Move tool, hold the Alt/Option key, click, and drag your new block into a suitable location. Repeat this with a second block and stack it on top of the first. You may need to adjust the layer order to ensure that the correct block is in front/behind by dragging the block layers up/down.

Step 3 **Duplicate and stack**

Continue stacking boxes, using combinations of your modules, remembering to make duplicates of the originals. Once you have a shape you are satisfied with, select all of the layers that make up this shape by holding the Shift key and clicking the individual layers. In this case, it should be all of the layers that aren't block 1, 2, & 3. Once selected, select Layer > Merge Layers, which will collapse all these individual layers into one. Rename this layer "Building 1."

Step 4 **New layer**

Click on the Create a new layer in the Layers palette. This will be used to make adjustments and add detail to your current building object. Select the Pencil tool, set size to 1 pixel, and color to match the face color of one of your building sides. Draw over joining lines between the blocks so that they create one solid face. Change colors for the alternate side and repeat until your building blocks look smooth. Merge the Building 1 and detail layers.

Step 5 **Windows**

Create another new layer, which will be used to add windows. Select a new color for the window (this example uses blue). It is best to use the Color Picker palette for this (click Set Foreground Color at the bottom of the Toolbox), as you want to use a limited palette of similar colors to create your windows all around the building. Start drawing in your windows as single blocks, evenly spaced horizontally using the 2 across, 1 up principle. Draw a second darker color underneath each lighter pixel. When one line of windows has been created, duplicate the layer and move the line upward by several pixels. Repeat this process until one wall is complete. Duplicate this layer, go to Edit > Transform > Flip Horizontal, and place on the other face of the building. Merge the window layers.

Step 6 **Merge layers**

Continue adding details, such as doors, windows, signage, and so on. Once you have finished a building, merge all layers together and put aside. Return to Step 1 and continue to create different buildings. When you have a selection, combine them to create a scene.

72 vector-based urban art

Although the vector style of digital illustration is often associated with a glossy aesthetic and clean lines, other artists have made use of this method of image production to create a rougher, urban visual style. Subject matter tends to be centered upon architectural details and inner city locales, street furniture, and cars.

While a similar aesthetic can easily be achieved using Photoshop, this vector-based approach allows you to add multiple layers within your composition. It makes use of Illustrator's trace feature to quickly build areas of block color and gradients, and, importantly for a working illustrator, is quickly editable in terms of the color palette, composition, and so on.

The first lesson covers image selection and quick editing, while the second focuses on details and composition.

Step 1 Open some appropriate material

The first step is to select a variety of suitable images. Here a number of images were chosen from various travel photographs, archived work, and other samples. Try to use your own material where possible. Once you've identified a selection of suitable material, start a new Illustrator document (this image uses a letter size [A4] landscape format), and go to File > Place to place each of the images within your document.

Step 2 Select a single layer

Hide all but one of the images using the visibility (eye) symbol next to each object in the Layers palette. Select the remaining visible image using the Selection tool, and go to Object > Live Trace > Tracing Options.

Step 3 Tracing options dialog

In the Tracing Options dialog, select the Preview button so that you can see any changes made to your chosen image. Set Mode to Black and White, and then adjust the Threshold slider until you arrive at an appropriate balance between dark and light areas. Try to capture the detail within your object and make individual features distinct enough for you to recognize them. Select Ignore White in the Trace Settings box so that white areas are not rendered. Finally click Trace.

Step 4 Edit the trace

In order to edit the newly traced object, you need to expand and ungroup it. Start by selecting the traced object, then go to Object > Expand. In the Expand dialog, ensure Object and Fill are checked, then click OK. Next, select Object > Ungroup to separate the black-and-white areas of your object and repeat to ensure that all of the individual shapes are selectable and editable.

Step 5 Editing the trace

Now that the trace is editable, you can clean up or remove areas you don't want. Choose the Lasso tool from the toolbar and draw around anchor points that you wish to remove. When highlighted, go to Object > Path > Remove Anchor Points to delete them.

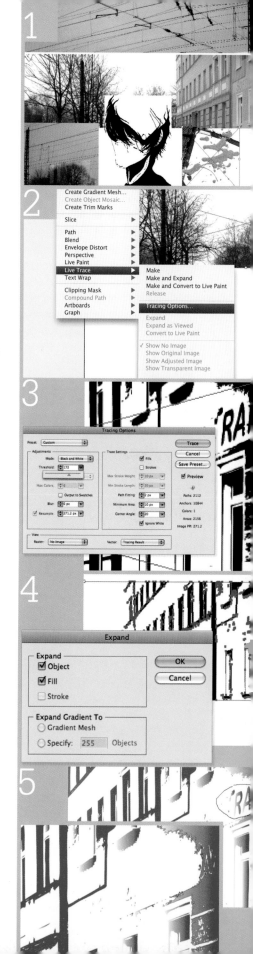

Step 6 **Apply a color Live Trace**

Next, select a new object to apply a Live Trace. This time set Mode to Color. The chosen image contains a number of colors; however, here the colors have been isolated to three to create distinct objects. Adjust the Path Fitting, Minimum Area, and Corner Angle settings in order to ensure the right level of detail is taken from your image—trial and error, luck, and mistakes can often give the best results!

Step 7 **Isolate areas of interest**

Use Expand and Ungroup as before to separate out certain objects again, and then select areas of interest with the Selection tool. Hold down the Shift key and click to select unconnected areas. Also be on the lookout for interesting patterns emerging from the dismantling of this image—elements such as this stripe/dot pattern may be useful later and should be kept somewhere safe to one side of the artboard.

Step 8 **Arrange the composition**

Start arranging the various elements on screen, using scale and rotate to see how best the components fit together. Also consider your color palette—try to limit your range of colors to three or four with some

gradients in between. Note how the trees in this image match the color of the sculptural shape on the left.

Step 9 **Hide the edges**

Keep adding elements, taking care to hide edges. Note for example how the face image has been used to cover the top of the buildings to hide the severe cutoff. Use roughly drawn shapes behind transparent areas to help mask off areas.

Step 10 **Clipping mask**

In order to hide the image elements overlapping the artboard, draw a rectangle over the artboard, select all objects by going to Select > Select All, then chose Object > Clipping Mask > Make. Save the image.

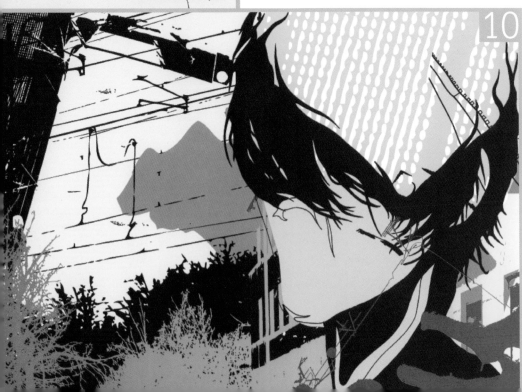

The final composition using multiple vector layers. Play with the composition to get the best from each object.

73 3D and digital graffiti

An interesting avenue of expression has developed through 3D experimentation, moving graffiti and urban calligraphy style beyond flat artwork into architectural and structural imagery.

This section looks at techniques using Illustrator's three-dimensional effects tools. The first sections cover some of the tools available, and the last focuses upon composition and finalizing your artwork.

The 3D Extrude window, which allows you to create 3D objects from 2D shapes.

Extrude

The Extrude command lets you turn two-dimensional objects into three dimensions by expanding the layers so they appear visually to move toward/away from you into what is known as the Z axis (X and Y being across and up/down the screen, respectively). This will create an instant three-dimensional effect. In the case of Illustrator, you can also manipulate these objects to edit scenes.

Step 1 **Create a pattern**

Go to File > New and create a new landscape Illustrator document. Using the Pen tool, start to draw in basic interlocking shapes. In the Tool Options bar, set Fill to light gray and Stroke to black. Try to keep a reasonable and consistent distance between the shapes and consider the relationship between objects. Once you have an interesting pattern of shapes, start creating new shapes that overlap the first, using them to divide up the internal spaces of each.

Step 2 **Extrude and bevel**

With the drawing complete, go to Select > All to select all of your shapes, then go to

Effect > 3D > Extrude and Bevel. The Options window for Extrude and Bevel will appear. At the top are the settings for the viewpoint, titled Surface. Beneath are the controls that set the Extrude Bevel options. At the bottom are the Surface options, which allow you to control the lighting and finish of your 3D object. Select More Options to see all of the Surface options.

Step 3 **Preview**

Click the Preview checkbox to see your extrusion in the artboard. By default, Illustrator sets the extrusion amount to 50 pts. In the Position area, click and drag the blue cube to rotate the viewpoint for your object and choose a view you like.

Step 4 **Expand appearance**

Once happy with your viewpoint, click OK. You will now be returned to the artboard. Individual elements are editable still, including their size, shape, rotation, and color. Try selecting individual 3D shapes and moving them around—notice how they retain a 2D shape for selection when moving. In order to set your shapes so that they can be rotated as a group and also retain their shape when scaling, select them all and choose Object > Expand Appearance.

Step 5 **Arrange**

With all of your shapes still selected, rotate to create a suitable composition and finalize any placements of individual shapes. Using the basic shapes tools, create a rectangle that covers the entire artboard, then send to back using Object > Arrange > Send to Back. Set the fill color to a gradient (see pages 108–109).

Step 6 **Expand image**

You can expand your image by duplicating elements from your image. In this example, all the 3D shapes were copied using Edit > Copy and Edit > Paste. The fill color and outline were then changed to black and white, and the entire shape was flipped using the Transform tools. Individual elements were then interweaved using the Arrange options in the Object menu.

3D Revolve

Revolve is another useful three-dimensional tool that allows you to spin a two-dimensional shape around an axis to create a three-dimensional object. The options available with Illustrator allow for some fine control over this process, so that you are not limited to full rotations only, but also various angles in between. The Offset options allow for further enhancement.

A simple filled path that forms the basis of the 3D object.

Step 1 **Create shape**

Open a new landscape Illustrator document. Select the Pen tool and create a shape. The key is to not worry too much about the exact shape, rather consider the aesthetic of the curves and angles. Make sure you close the shape by clicking on the starting point once the shape is finished. In the Tool Options bar, choose and apply a flat fill color for your object and set outline turned to None. For the moment, this color will act as a temporary color for previewing your 3D shape before we consider applying the final finish to your object.

Step 2 **Revolve options**

Go to Select > All to select your shape, then go to Effect > 3D > Revolve to bring up the 3D Revolve Options window. Click the Preview check box to see the 3D rendering of your object. At the top of the window are the position settings containing boxes for setting rotation, and an interactive cube that can be dragged to adjust the viewing angle of your object. Rotate your object until you have an interesting view of your 3D shape.

Step 3 **Revolve**

The Revolve section allows you to set the amount of revolution applied to your shape. 360° will set the rotation to one full rotation, 180° to one half, 90° to one quarter, and so on. The Offset allows you to define how far from the left edge of your object the rotation center is set. Set Angle to 120°, Offset to 0, and readjust your object's rotation in the Position area to take account of the new shape.

Step 4 **Surface**

The surface section allows you to control how the surface reacts to lighting, and also to add light and shadow to your object. Click on the More Options button to see the surface lighting controls. Adjust the light position by dragging the white dot positioned over the sphere in the thumbnail lighting window until it is just off center. Set Ambient Light to 25%. Ambient light is the light that exists within a 3D world when no other light is present. Lower levels make darker shadows.

Step 5 **Color**

When you are finished, click OK to complete the transformation. You can now move your object like any other. However, be careful of rotating, as it will result in a readjustment of the revolution and the object will be re-rendered. You can adjust the color of your object by adjusting the fill color. If you wish to edit the shape entirely, go to Window > Appearance and click on 3D Revolve to return to the editing window. Save this file for later use using File > Save As and set the name to "3D revolve.ai."

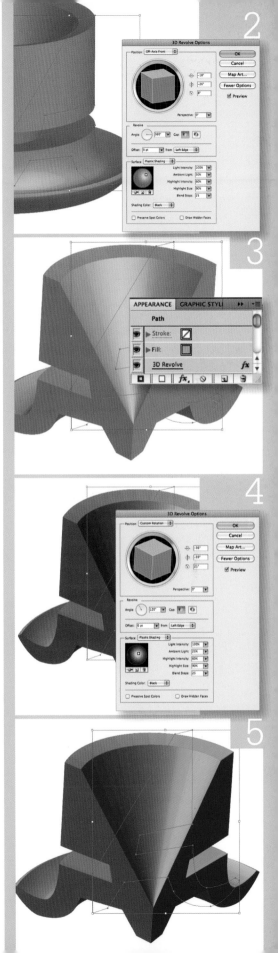

Mapping artwork

Using the three-dimensional object from page 191, we will now map artwork to the surfaces of your new object. If you do not have it open already, use File > Open and open the file saved earlier.

Step 1 Create symbol

First, you need to make an image to be mapped on to your 3D object. Find a blank space on the same artboard to create your new surface image. This example uses three colors (black, mid-gray, and light-gray). Areas without color will be transparent when mapped, and will therefore retain the original surface color of your 3D object. Make your image's shapes angular and spiky. In order to map artwork to your object, the chosen image for mapping needs to be a symbol. Select all parts of your mapping image, and drag on to the Symbol palette (Window > Symbol). Name this symbol "Texture 1" and click OK.

The Symbol Options window for creating a new symbol.

Step 2

Appearance

Delete the surface image from the artboard and select your 3D object. Go to Window > Appearance, and select 3D Revolve to open the 3D Revolve Options window.

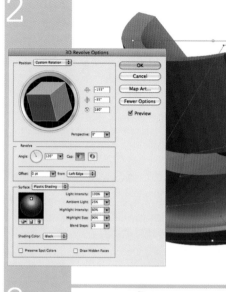

Step 3 Map art

In the 3D Revolve Options window, click on the Map Art button to open the Map Art window. At the top left is the symbol selector that allows you to choose the image to map. Next to that is the surface selector that defines which surface (highlighted in red on your 3D object) your symbol will be mapped to. The large image is a visual of the face that you are mapping and also indicates how the symbol is applied. Use the surface selector to choose a face near you so that you can see the mapping by pressing the arrows to the immediate right or left of the face number indicator.

Step 4 Apply symbol

In the Symbol selector, click on the menu arrow, and scroll down until you locate Texture 1, then click on it. This will apply your symbol to the currently selected face. Check the Preview option, and you will be able to see the symbol applied to your chosen face of your object on the artboard. Click the Shade Artwork button to ensure the applied symbol matches the lighting applied to your 3D object.

Step 5 Map symbol to each face

Work your way through all of the faces of your object, mapping your symbol to each face. To add variety, you can move, scale, and rotate your mapped symbol in the Map Art window using the Main Face Indicator box—simply drag your symbol or the resize boxes as you would an object on the artboard.

Step 6 Invisible geometry

Once you are happy with your mapping, click on the Invisible Geometry check box. This will make the 3D surfaces where mapped art have not been applied transparent, including areas where your applied symbol was transparent. You can now exit the Map Art editor by clicking on the OK button. Check the orientation and lighting of your 3D object in the 3D Revolve window, then click OK to return to your artboard. Save your document as "Mapped Revolve.ai."

Mapping the symbol to the 3D shape.

Compositing

This section will look at creating a final composition from the elements created in the previous two sections. While it draws heavily on the model created in the second section, you may wish to draw upon new models or create a brand new 3D revolve/extrude to follow this lesson. In fact, the more variety you have in terms of models the better, so feel free to expand upon the basic objects used in this example.

Step 1 **Open**

Open the Mapped Revolve image from the last section if it is not already open. The example used here is the same image, but viewed from a different angle.

Step 2 **Copy and revolve**

Select the revolve object and use Edit > Copy and Edit > Paste to make a duplicate. Select one and go to Window >Appearance. Click on 3D Revolve to bring up the 3D Revolve Options window and re-edit your object. In this example, the view angle and lighting have been adjusted. You may also wish to remap some of the image maps although this is not necessary given the dramatic change in view angle.

Step 3 **Expand appearance**

Make multiple copies of each of your objects. Select two of them and choose Object > Expand appearance. For these objects, any changes made to rotation or scale will cause the entire object to transform proportionally. For those objects that have not been expanded, transformations will cause distortions and fracturing. We will use this to our advantage, however.

Step 4 **Make copies**

Starting with the expanded objects, start to transform them so that they fill the artboard. Make copies as you go so that you have multiple instances of the same object. Make use of different scales, rotations, and overlaps to obscure the repeating objects. Now try scaling and rotating the unexpanded objects. Notice how they fracture and distort. Use these objects to create areas of interest, and break up the more solid areas of the image.

Step 5 **Explore**

When you discover an interesting fracturing on one of the unexpanded objects, duplicate it, expand its appearance to retain the shape, then duplicate again. You can now continue to explore the fracturing process, but also use the current shapes to form your composition. Use the final copy to scale/rotate further.

Step 6 **Background**

Once you are happy with the composition, add a background using a Rectangle tool, with Fill set to an orange/white gradient. Select all of your objects, except for the background. Open the Transparency palette (Window > Transparency), and using the drop-down menu choose Multiply. This will make your objects partially transparent (see pages 59–61 for more details). Deselect, then choose random objects, and set to Overlay from the same menu. Adjust your composition as necessary.

Step 7 **Clipping mask**

To finalize your image, draw a rectangle shape over the artboard, select everything using Select > All. Then choose Object > Clipping Mask > Make to crop your image to the artboard only and hide those elements outside it.

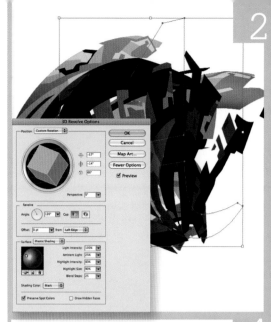

Use a linear gradient applied to a rectangle shape to create the background.

digital graffiti
Benjamin White

Benjamin White's images consist of a variety of interesting and often intense visual spaces. While his portfolio contains a variety of different approaches, his images retain a consistency in terms of an abstract or chaotically mathematical approach, which also draws upon visual styles associated with contemporary digital graffiti.

His work consists almost entirely of digitally created imagery, although in this example, use of subtle photographic elements such as landscapes or found textures can be detected. These photographic elements form punctuation points within the image, while abstract shapes made from curves or planes make up the majority of the image. Combinations of these intersecting vector-based planes and surfaces fool the eye into believing that the resulting shapes recede into the scene, and create a 3D space—an effect reinforced by subtle use of shadows, highlights, and gradients. Images such as White's tend to make use of a combination of digital software, often starting with Photoshop as a tool to enhance and refine photographic imagery, and build textural elements, before moving into vector software such as Illustrator for compositing and combining these elements with bold vector shapes, and 3D or fake-3D renders and effects.

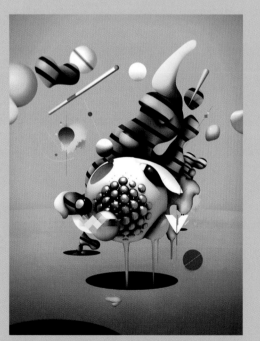

3D elements, as seen in the image above, can be created in specialist applications, or for relatively simple shapes using the 3D effect in Illustrator, as seen in the digital graffiti lesson featured on pages 190–193.

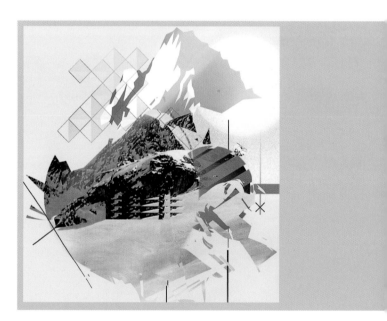

Creative perspective
Objects in these landscapes seem to float in a futuristic or technological environment, although closer inspection reveals multiple planes and complex interactions between foreground elements and background spaces, further fracturing the environment and adding to its magical or other-worldly qualities. Areas of 2D imagery are fragmented and criss-cross, making some spaces appear as if seen through a kaleidoscope or distorted lens.

CASE STUDY

Futuristic concept

White's images allow the imagination to wander and make associations between objects to other familiar images such as microscope photographs of nanotechnology and viruses, retro sci-fi worlds, or digital dreamscapes. They therefore create effective illustrations that allow the viewer to draw upon their own experiences and references to make sense of these worlds. The majority of the image spaces make use of limited colors, and subtle tonal changes give White's images a clean and futuristic feel, holding the image together through tonal continuity. Other areas are punctuated with intense bursts of brilliant color that help the viewer to navigate the space by creating areas of focus.

new contexts

Illustration is an ever-evolving practice. With the advent of digital technologies, illustration has continuously developed both in terms of its visual aesthetic, and in terms of where we expect illustration to be seen. This next section identifies some of the new contexts evolving for illustration in the digital environment.

Illustration has long been associated with print and publishing, and, therefore, with traditional methods and mediums of communication. With steady advances in digital technology and the associated ease of access by an increasing number of people to more sophisticated platforms, digital illustration has moved from being a subgenre of mainstream illustration toward an essential aspect of most professionals' practices. Even the most "traditional" illustrators are often found working across analog and digital mediums.

However, as shown in the previous sections, digital illustration still shows itself as a distinct visual form in some areas—pixel and vector art being two prime examples.

The proliferation and advancement of digital technology pushes the boundaries of what is considered illustration practice, allowing digital artists to explore and work in areas that were beyond their reach only years earlier—such as animation or digital publishing.

Digital artists have also helped to shape digital illustration by finding innovative ways and mediums through which to communicate their messages. One of the most prominent of these areas, as mentioned above, is animation. Evolving from simple Gif animations used on various Internet platforms, digital illustrators have also come to grips with increasingly sophisticated animation software in order to produce a variety of outcomes. Flash and After Effects in particular offer integration with image-editing software to allow the simple movement from static to moving images, often resulting in highly sophisticated results.

The starting point and processes for these contemporary "moving illustrations" are often diverse and draw upon a number of techniques, including stop-motion, rotoscoping, digital animation, and video montage. Similarly, the contexts for these works have expanded. Naturally, the Internet has provided a significant avenue for such work, but so too have movies, television, advertising, and video games.

The future is full of possibilities. With increasing developments in mobile computing and communication devices, and in particular the advances being made in digital paper and digital ink, opportunities for developing illustration beyond its traditional confines continue to grow.

The following lessons will give you a brief glimpse of the possibilities available to you.

making animated gifs

Animated Gifs were one of the earliest methods of digital animation easily available to the digital artist. The ability to simply create small files that could be viewed on web sites allowed this format to flourish, and despite advances in digital software offered by Flash and other media-delivery formats, Gifs can still be seen across various web sites as a simple and effective way to introduce moving content.

This section will introduce you to some simple beginner steps to allow you to animate a digital image and create an animated Gif image, which you can then build upon.

Step 1 **Arrange pixel blocks**
Start by opening or recreating the simple pixel block from the pixel art lesson on page 186. Ensure that the block is on a separate layer from the background (1a). Make three copies of the block layer using Layer > Duplicate Layer. Arrange the blocks as shown (1b), ensuring that the initial block layer remains in place and sits behind the three new layers.

Step 2 **Animation palette**
Open the Animation Palette using Window > Animation. The animation palette appears as a long palette at the bottom of the screen, and will show you an initial frame that is a thumbnail image of the current document (2a). At the bottom right of the animation palette is a button that allows you to switch between animation modes. The current mode, as indicated by the text at the top of this palette, is the Frame Mode. Click this button to change to Timeline Mode (2b).

Step 3 **Timeline mode**
The Timeline Mode of animation allows you to control aspects of individual layers by inserting Keyframes, indicating start and end properties of objects such as position or opacity, allowing Photoshop to calculate the in-between steps. Each layer has its properties listed underneath the layer name in this palette. In order to view these properties, click the arrow to the left of the layer name for Block copy 3. You will now see the following properties listed: Position, Opacity, and Style.

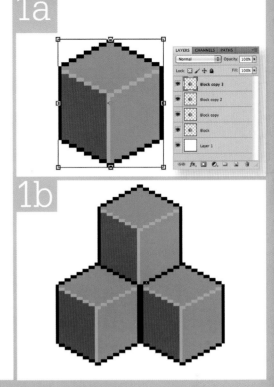

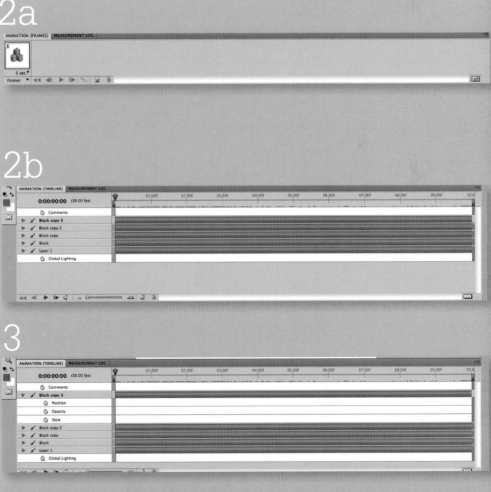

Step 4 **Setting the timeline**

In order to animate this layer, we first need to set a start and end position for actions on the timeline. At the top of the animation palette, run a series of red numbers that indicate the amount of time in seconds. To the left of these numbers (where we would expect to see "00:00f") indicated is a blue curved arrow with a vertical red line passing through it. This indicates the current position on the timeline. Click and drag this timeline marker until it is over 05:00f, i.e., 5 seconds into the animation.

Step 5 **Animate the layer**

Click on the small stopwatch icon located to the left of the Position property for the Block copy 3 layer on the Animation Palette. Any changes to the position of this layer will now be recorded. Note that a small yellow diamond shape has appeared on the timeline beneath the timeline marker, in the row for the Position property. This records the current position information for this layer. Drag the timeline marker back to the start position, i.e., 00:00f and, using the Move tool, move the Block copy 3 object in the main document window to a new position. Note how a second Keyframe diamond marker appears at the timeline marker's new position.

Step 6 **Animate remaining layers**

Press the play button at the bottom of the Animation Palette to check that your animation is working correctly, then repeat Steps 4–6 for each layer. If you wish to adjust the position of any layer, move the timeline marker so that is sits directly above the Keyframe diamond for that layer, then move the object. The timeline marker is in the correct position over a Keyframe when a small yellow diamond appears to the left of the Position property stopwatch. Making position changes to the layer while the timeline marker is not over an existing Keyframe will result in an additional Keyframe being added to the timeline for that property. This is how you create more complex animations.

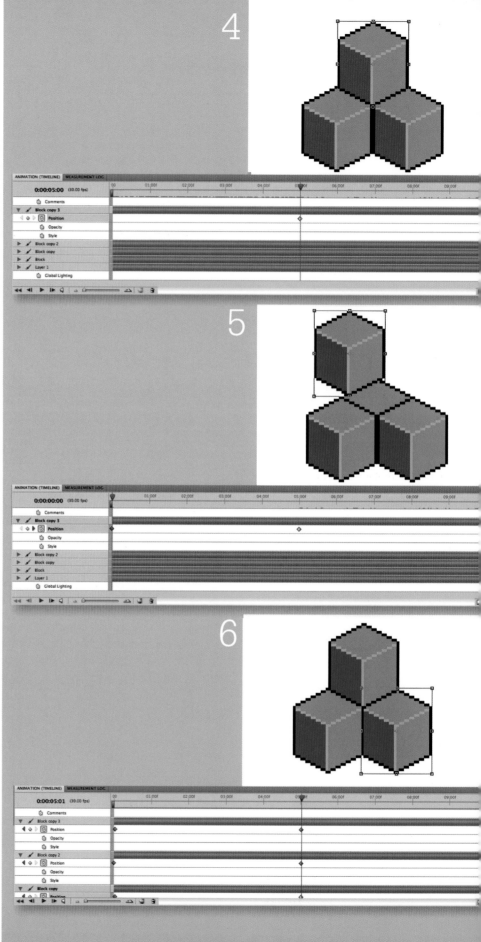

saving animations

In order to make your animation viewable outside of Photoshop, you need to save it as a Gif format. The simplest method of converting an animation to a Gif is through Photoshop's Save for Web option. This file can then be viewed in a web browser such as Firefox, Internet Explorer, etc. It is often best, however, to save a Photoshop psd. copy as well, in case you wish to edit the animation at a later date.

Step 1 Prepare for trimming

Before saving, you should check and optimize your animation. In this case, we are going to ensure that the animation is not too long. At each end of the timeline area are blue curved rectangular markers that represent the Work Area of the animation. In order to cut the animation to a shorter duration, drag the right Work Area marker to 06:00f.

Step 2 Trim your animation

At the top right-hand side of the Animation Palette is the options button. Click this to see the animation options available. Select Trim Document Duration to Work Area. This will shorten your animation, cutting areas outside of the Work Area. Check your animation's new duration before moving on by playing or dragging the timeline marker.

Step 3 Save for web and devices

From the menu system, choose File > Save for Web and Devices. The Save for Web window allows you to convert and optimize your files for web-based images and animations. In the center is the image to be saved, the right offers format options, and the left a toolbar for navigation and simple editing of objects. On the right, check that the second menu selection box down indicates Gif as the format—if not, select and change to Gif.

Step 4 Format options

While you should be mindful of the options in the right of the window, this example does not require much adjustment to the format of this image; however, you should be aware that the Gif format has a number of advantages and disadvantages. Gifs are limited in their color palette—images should use less than 256 colors. Optimization is therefore key to creating animated Gifs. As a positive, Gifs can make use of transparency, and therefore take advantage of colored backgrounds in web browsers and layering.

Step 5 Review your animation

At the bottom of the screen are the animation settings relating to your Gif export. Use the Play, Forward, and Rewind buttons to review your animation. Set the Looping Options selection box to Forever to ensure that your animation repeats, then click Preview to check the final animation as it will appear.

Step 6 Save your animation

Click the Done button if you wish to review your animation and make changes, which will return you to Photoshop. Otherwise, click Save and chose a name and location to save your file. Check that the Format is set to Images Only, and Settings is set to Default. Click Save. You can now open your Gif file in a browser and enjoy.

Use the Trim Document option to reset the animation's duration. Trimming ensures that excess parts of the animation are not rendered in the final animation.

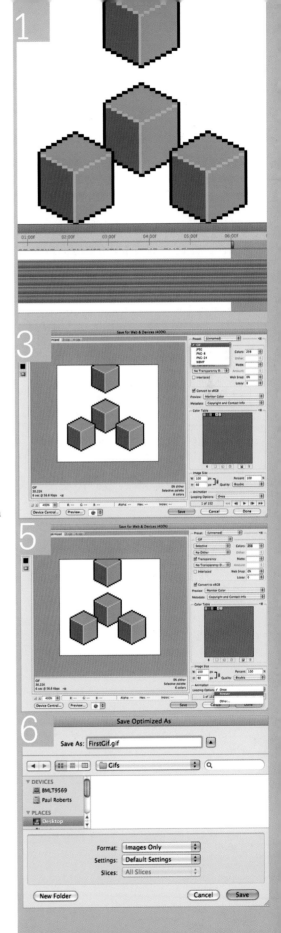

76 stop-motion movies

Stop motion uses individual frames spliced together and played back rapidly to create the impression of movement. This method is the basis for traditional forms of animation that use individual cells—drawings and paintings—recorded onto single frames of film.

A simple digital camera, even with low resolution, and some suitable software is all you need to get started. It can often be helpful to have a tripod for your camera to help stabilize the image and reduce camera shake. However, a camera carefully balanced on a book or table may suffice.

This technique has many uses. It can produce frames or video that can form the basis of rotoscoped animations, be used to animate handmade collages or drawings, or even to produce cell animations. Once you understand the basics, it is easy to develop this technique in any way you see fit. This demonstration will make use of a simple hand-drawn image as the basis of its animation.

Step 1 **Equipment setup**
The first step is to set up your equipment. Here we've used a simple wooden board with a piece of paper taped onto it. The camera is positioned in front, focused on the paper, and propped on some books to keep it steady. Make sure your setup is stable and not likely to fall or get damaged. Set the camera to take low-resolution pictures of between 2 and 3 megapixels. This should be sufficient quality to give a good animation, but isn't so high that it slows down the animation process in Photoshop. Consult your camera manual for help with this. You should also ensure that you have sufficient space on your camera's memory card for at least 100 images.

Step 2 **Start drawing**
Once you are set up, slowly start your drawing. Aim to create small steps, maybe half a centimeter of line at a time. Every time you add a new part to your drawing, take a photograph. It is best to use a pen for your drawing, as this will show up better than pencil lines.

Step 3 **Slow and steady**
Keep building your drawing, ensuring that you are not getting carried away and doing things too fast. You will be working initially to a 10-frames-per-second timing, meaning that each photo is a fraction of a second of the entire piece.

Step 4 **Download the images**
Once you have produced approximately 70–100 photos, connect your camera or memory card to your computer and download the images into a new folder named "Stop Frame." It is important that you use a separate folder, as Photoshop will read the contents of this folder to construct the animation.

Step 5 **Set Frame Rate**
Open Photoshop. Go to File > Open and locate your folder. Select the first photograph in the folder, and then click on the box marked Image Sequence. This will ensure that Photoshop opens all of the files that follow and designate them as part of an animation sequence. In the Frame Rate dialog box, which will open automatically, set fps (frames per second) to 10.

Step 6 **View the animation**
After loading your sequence, you will see the first frame of your animation. Go to Window > Animation to open the animation window where you will be able to view the sequence. Click the play button icon at the bottom left to view your animation.

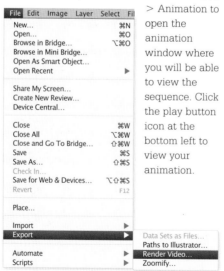

For animations use Export > Render Video to create your animation, but don't forget to save your Photoshop document as well!

Step 7 **Adjust contrast**

Depending upon the ambient lighting, use of a flash, or other conditions, you may need to adjust your image to improve the tone and contrast of your animation. In the Layers palette, create a Brightness/Contrast adjustment layer. Use the Adjustments window to boost the brightness and contrast until your paper looks lighter and your lines show up effectively.

Step 8 **Remove color cast**

You may also notice, depending on the lighting, that you have a slight color cast to your image (usually yellow or blue depending upon the lighting). If your drawing was made using only black pen on white paper, use a Hue/Saturation adjustment layer with Saturation set to −100 to remove this cast. Readjust your Brightness/Contrast adjustment layer to compensate for any tonal difference this makes to your image.

Step 9 **Create a new layer**

We are now going to add more animation elements digitally to enhance the stop motion video before creating the final movie file. Start by renaming your existing video layer "Hand Drawn." Then create a new layer and call this "Ground Color."

Step 10 **Add color**

In the Layers palette, change the Ground Layer blending mode to Multiply. Select the Brush tool and adjust the brush settings as necessary to get a nice textured brush (see page 161). Using a grassy green color, paint in your ground area. It may be useful to advance your animation further along to a point where you can see where this should be. Click on one of the red/black numbers in the animation window above the green bars to advance to that part of the animation. The left side marked 00 is the first frame of your animation, further right moves toward the end of your animation. Continue to add color and additional elements until you are satisfied with the result.

Step 11 **Render the video**

Once you are happy with your animation, select File > Export > Render Video. This will create a final video format that you can watch and share outside of Photoshop.

Step 12 **Save the video**

In the Render Video dialog, set the file name to First Stop Motion and choose a location to save to using the Select Folder button. The default File Options setting will be fine for now, so you can leave all of those areas except for the size option, which you should change to NTSC DV. Finally, check that the Frame Rate box is set to 10, then click Render. Once it is finished rendering, locate your video and enjoy!

rotoscoping

P Rotoscoping is an effect used by animators and movie-makers to give a drawn or cartoon look to live-action film. The real process is often a long and laborious one, involving the tracing and coloring of numerous individual frames. The effect, however, can be quite impressive.

The method used in this lesson is a quick way of achieving a rotoscope look. It makes use of the Cutout filter in Photoshop to achieve a similar aesthetic, and to quickly produce the individual frames. Here we're using a set of photos taken on a high-speed camera; however, you could use frames from a stop-motion animation or import a movie.

Step 1 Collect images
Place your images to be rotoscoped in a single folder for easy access. Make sure that they are numbered in a sequence to ensure that you can easily organize them for playback. Open the first image.

Step 2 Cutout
Go to Filter and select Artistic > Cutout.

Step 3 Settings
Adjust the Cutout settings to the following: set Number of Levels to either the highest setting or just below. In this example, we're using 6. This will define the complexity and number of colors used in your image. Set Edge Simplicity to 0 in order to get the most definition for your edges. Use a maximum Edge Fidelity setting of 3.

Step 4 Apply and repeat
Click OK to apply the filter, then save your image in a new folder. In this example, we have created a folder called Rotoscoped Images. Save your image as a JPEG and call it 001.jpg. The numbering system is important and will be used later to create your final animation. Repeat this process with all of your images in order, saving the second image as 002.jpg, the third as 003.jpg, etc.

Step 5 Image sequence
Once you've applied the filter and saved all images, go to File > Open. Find your Rotoscope Images folder, select the first image (001.jpg), and check the box marked Image Sequence. This will link all of the sequenced images to this file. Click Open. As you have set the file to open as an Image Sequence, you will now be asked to set the frame rate for your sequence. As this is a small sequence of images, we will set the frame rate to 8. You should avoid using frame rates below this number. Most movies have a rate of 24–30 frames per second.

Step 6 Animation
Go to Window > Animation to view the animation timeline. Click the play button at the bottom left to test the playback speed and ensure that your frames are in the correct order. If the images are not flowing correctly, rename the files to the correct order and re-open.

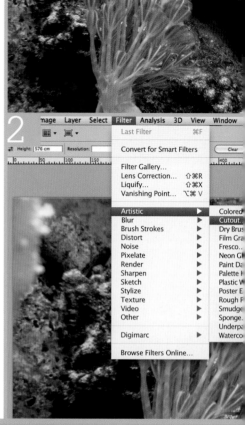

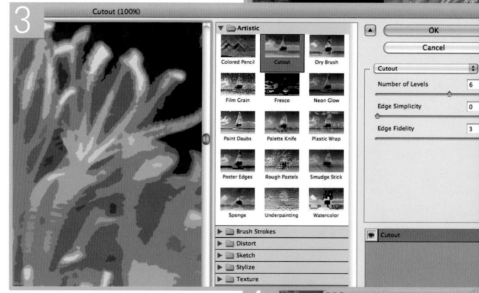

The timeline showing the layers to be animated. Drag the blue marker to change the frame that is currently seen.

Step 7 **Image size**
Animations have a set size for output, particularly if you intend to edit them in external applications or view on a TV screen. You should therefore check and resize your images to match your intended output format. Go to Image > Image Size.

Step 8 **Smart layer**
We are going to resize this animation to an approximate TV Standard Definition format. Check the Resample checkbox and make the width 720 pixels. For the U.S. NTSC format, set the height to 480; for the European Pal TV format set the height to 576 pixels. Click OK. You will be asked to convert the video layer you have just opened into a Smart Layer. Click Convert.

Set the video resolution video format and use Convert to apply to the Smart objects layer.

Step 9 **Render video**
You are now ready to render the video. Go to File > Export > Render Video.

Step 10 **Choose location**
In the Render Video export screen, choose a save location for your animation and name your video file "rotascopeVideo." You can leave the rest of these settings as they are for the moment. (See pages 208–209 for further explanation of video exporting.) If you are working on a PC, you may be presented with AVI instead of Quicktime under the File Options. Both formats will work effectively for these purposes. Click Settings in the File Options area.

The Render Video window—select a name and location for your video and click Render to see the results!

Step 11 **Settings**
In the Movie Settings window, uncheck the Sound and Prepare for Internet Streaming checkboxes. Click OK to confirm these settings. Click Render.

Step 12 **Exit**
Your file will now be rendered to the location set in step 10. Exit Photoshop, locate the file, and open it to see your final animation.

78 animating in photoshop

P With more recent versions of Photoshop—from CS3 onward— it has become possible to produce simple animations using the Animation palette. Although older versions of Photoshop allowed for animation based on layers, the new versions include frames, which enable you to develop anything from simple drawn animations to full-motion graphics. The abilities of the tools within Photoshop are still limited in comparison with Flash, After Effects, and other dedicated software; however, they do provide a good entry point for coming to grips with digital animation and a stepping stone into more advanced approaches for the digital artist.

Step 1 **Open a suitable document**

Open an existing Photoshop file, preferably one that contains multiple layers. Make sure that it is a landscape-formatted image, or one that can be cropped to a landscape image. Go to Image > Image Size and set the width dimension to 720 pixels. The height dimension will automatically adjust as long as you have the Constrain Proportions box checked.

Step 2 **Open the Animation palette**

Go to Window > Animation to open the Animation palette. This palette will be set up in one of two ways. If it is set to Frame mode, you will notice a small square thumbnail of your image at the left of the palette. If, however, you notice a blue horizontal bar and layer names, click on the palette option button at top right and select Convert to Frame Animation.

Step 3 **Add a new frame**

Return to the Animation palette options and select New Frame. This will add a second frame to the timeline, giving you two thumbnail images at the far left of the Animation palette.

TWEENING

Tweening is a term used in animation to describe the process of producing frames that sit between key frames—those that denote key positions and moments of objects and characters. For example, a ball bouncing on the floor might have three key frames: the position from which it drops, the moment it hits the floor, and the apex (top) of the first bounce. The tweens are therefore all of the frames between these positions.

Many animation programs allow you to automate tweening, drawing in the filler frames between key frames for many characteristics. These include position, scale, rotation, and opacity.

Choosing appropriate key frames and using tweening can help you to rapidly generate movement in your animation, and is a key technique for digital animation. However, it can't solve all problems, and changes to your image that are organic and not based on simple movements still need to be done by hand, or mouse.

Use the delay option for individual frames to set how long a frame is visible before moving on to the next.

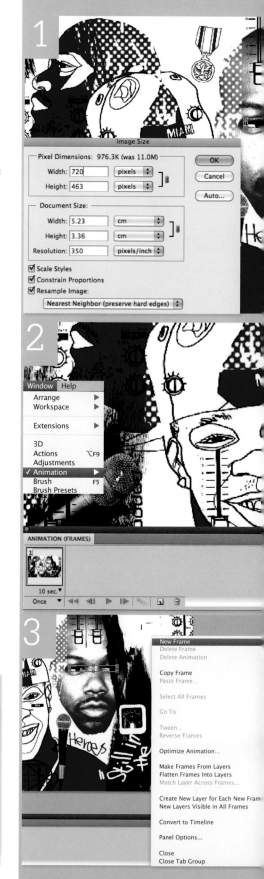

Step 4 Start the animation

Now you have two frames, so you can animate your layers. Select the first frame by clicking on it, and then start moving individual layers around your image. In this case, we've placed a number of layers off-screen. Now select the second frame and return these layers to their correct location. Switching between the two frames should cause images to jump between their two respective positions.

Step 5 Alter the frame rate

Beneath each frame thumbnail is a number—in this case, 10 sec. (seconds). This determines how long the frame stays on screen before moving to the next. As this is an animation, we want to set a much faster speed. Click on the arrow next to the number and select 0.2 seconds for both frames.

Step 6 Auto animate

Select both frames by holding down the Shift key and clicking on each thumbnail. Next, Photoshop will calculate the changes between the two frames and animate the results. Click on the Animation option button at the right and select Tween. In the Tween dialog, set Frames to Add to 50—this will create 50 new frames between the original two images, with each animating the movement of the layers that were edited in Step 3.

Animations have to be exported to be visible by others. Render Video allows you to export to a variety of formats, including traditional video formats or newer online encodings and compression.

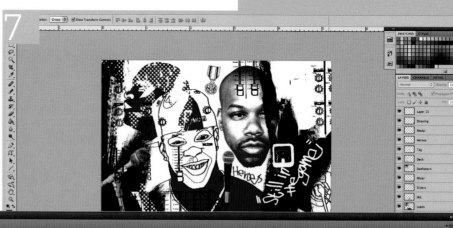

Step 7 **Animation window**

You will now notice that your Animation window is full of thumbnails.

Step 8 **Editing an animation**

You can edit an animation in a number of ways. First, by clicking on the button labeled Once at the bottom left of the Animation palette, you can select the looping options for your animation—in other words, the number of times the animation will run. Selecting Forever is particularly good for online GIF ad animations.

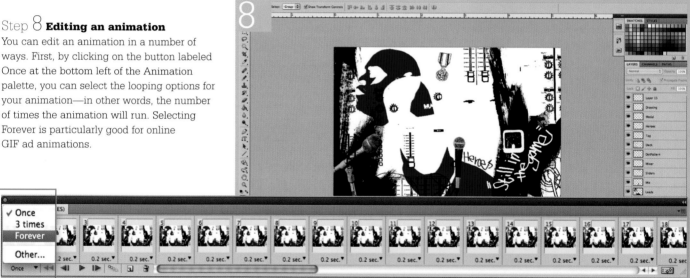

Step 9 **Deleting frames**

If there are frames that you don't want, simply select them, then click on the Trash icon at the bottom of the Animation window. You can also select multiple frames while holding Shift and then drag all of them at once to the Trash to delete them.

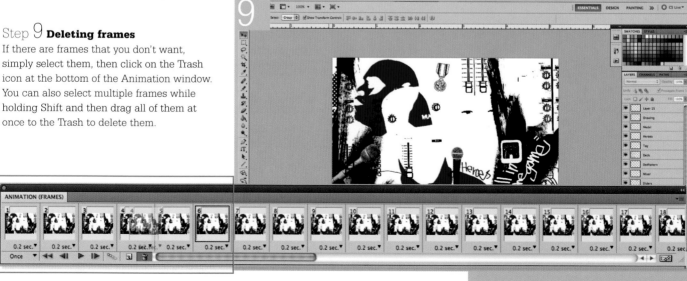

10

11

Step 10 **Adding animation effects**

If you want to add animation effects, just add new frames (see Step 3), change the appearance between the two, then Tween in between them. In this example, a new frame is placed at the beginning of the animation. A layer with a black fill is added. In frame one, the black fill obscures all of the other layers; however, in the other frames (2–52), the black frame layer is turned off.

Step 11 **Tween**

Next, select frames one and two and then choose Tween. This will gently fade from the black screen to the animation.

Step 12 **Render video**

Once the animation is finished, save it as a Photoshop file, then select Export > Render Video to export it. See Finalizing your Animation, pages 208–209 to complete the process.

See Finalizing your Animation, pages 208–209 to complete the process.

TIPS AND TRICKS FOR ANIMATION

Animation can be quite an intensive process and may sometimes put quite a strain on your computer. You should not always expect your animation to play back perfectly using the play button, because you are making your computer show many images very rapidly. Here are some hints and tips for getting your animations to work better in terms of playback, as well as improving your production process.

1. Make sure that your image size is low enough. Images over 1280 pixels wide and 960 high are a waste of time and effort. Animations will play back better at lower resolutions. Use the Preset values to help you choose an appropriate size for new documents.

2. Close any other open applications. The more memory that you assign to Photoshop, the better it will be able to process your animation. Other applications will drain this memory away from Photoshop.

3. Reduce the Frame rate. Frame rates are important for some kinds of animation, but if you are just experimenting, you can set the number of frames to be shown per second to a lower rate. Use the Animation window's Document settings option to reduce the rate to between 7–15 for faster animation.

4. Remove or flatten non-essential layers. Layers make for bigger files. Merge layers that don't need to be animated separately, and delete any that may not be visible.

12

79 **finalizing your animation**

One of the most daunting aspects of animating in Photoshop is the Export Window and its associated sub-windows. Knowing how to navigate around these allows you to effectively create an animation that works and can be enjoyed almost immediately.

This lesson covers some popular and useful formats in which to export your animation, and provides the information you need to decide on the best settings for your particular usage. It builds upon the previous section covering the "hiphopanim" animation.

Use Quicktime or AVI for normal video output, or image sequence for more advanced uses.

Click on the Settings button to bring up further options for adjusting your video settings, such as the filters, video size, and compression.

Step 1 **Render video**
Once your animation is completed, save it as a Photoshop document. Then go to File > Export > Render Video. This will open the Render Video window.

Step 2 **Save location**
Click on Select Folder to choose a save location for your animation. It is best to avoid external hard drives, and save directly to your computer's hard drive. This is because the computer hard drive can read and write data faster than external drives and is less prone to errors. Avoid saving to USB data sticks and similar formats.

Step 3 **File options**
In the File Options section, select the file format for your output. Depending on your operating system you may have the options for AVI/QuickTime Export as default. Choose QuickTime Export or AVI, then click on the Settings button to the right of the selection box to bring up the Movie Settings dialog box.

Step 4 **Movie settings**
The Movie Settings box contains information about any compression (file size reduction) that will be carried out on your animation, alongside options for changing the playback size, audio quality, and streaming aspects of your video. You can uncheck the sound and streaming options in this case, as you are likely to be playing this on your home computer, and as no sound has been added.

The Render Video window allows you to control the output of your final animation.

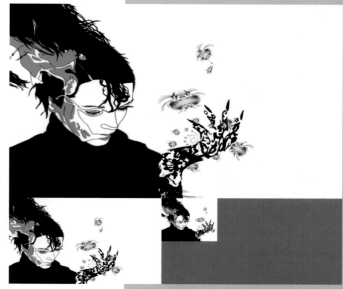

At right is a comparison of relative video output sizes. Top: HDTV video format (1920 x 1080 pixels). Bottom left: NTSC format (720 x 480 pixels). Bottom right: Internet video (320 x 240 pixels).

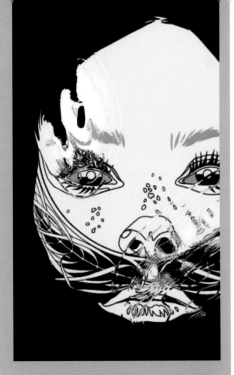

Compression and video format can affect the quality of your final video. The top image is a frame from a video rendered in Quicktime format with compression set to None. The bottom image is from the same video rendered out as an MPEG4 file set to h.264. Note the artifacts (blurry areas) that result from this compression. Compression compromises quality for file size.

Step 5 **Compression options**

Click on the Settings button in the Movie Settings window to view the compression options. It is often best to set Compression to None if possible. While this creates a large file size, it also means that future uses of this video (for example, as part of a larger animation) will have the highest-quality video to work with. Similarly, if you plan to use this video in other editing software, set Compression to None. Further information regarding compression can be found online from many sources.

Step 6 **Set output size**

Click OK twice to return to the main Render Settings window. The last aspect to tweak is the output size. You can leave this set to Document Size at this point; however, it is best to set the size correctly if it is to be viewed on specific media. There are many sizes, but two standard formats are NTSC (for the U.S.) and Pal (for Europe). Newer high definition screens make use of the various HD formats that you may be familiar with. Other sizes you might encounter are those used for web formats, including YouTube. For these,

choose custom settings and use sizes of 640 x 480 pixels or 1280 x 720 for HD videos.

Step 7 **Internet video options**

For Internet video, it is often best to set your video format to the MPEG-4 format.

Step 8 **Data rate**

Leave the Data Rate at 256 kbits/sec, and change the image size to one of either 640 x 480, or 1280 x 720.

Step 9 **Set file format**

Once selected in the main Render Video window, click on Settings and set the File Format to MP4 and video format to H.264.

Step 10 **Create an image sequence**

Another option for exporting video is to create an image sequence. This creates a series of files representing each individual frame. This is a good option for images that you may wish to reprocess, export to other programs, or print out. Do make sure that you specify a folder that is not the desktop if using this option, as you may end up swamping your desktop!

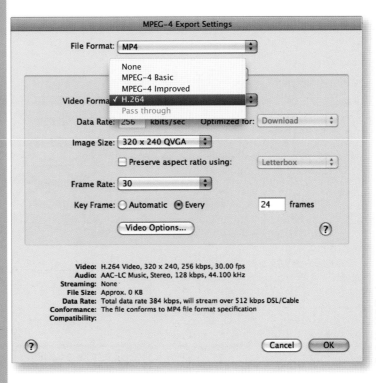

Use the MPEG settings for publishing video to the Internet—the H.264 format offers good compression and video quality.

80 where to go from here

The lessons in this book provide a good introduction to many of the techniques and tools available to you as a digital artist. You will have discovered methods of working that suit your individual style and found some aspects more enjoyable and beneficial than others. So how can you develop your work from here on?

First, like any form of art, practice is key. The more you test out what you have learned, the more techniques you experiment with, and the more images you produce, the better you will become as an artist. It is also worth noting that the techniques covered here are not necessarily the only way of creating styles and images—you should aim to expand on nearly all of the lessons in order to find a unique style and voice. Don't just copy what you have learned here, but keep pushing at the boundaries—combine techniques and try new things. As an artist the more novel your work is, the more it will stand out.

New contexts

Many of the later techniques have looked at broader contexts for digital artwork. Digital technology is continuing to expand into areas where traditional techniques previously dominated, and the increasing popularity of online platforms and mobile technologies have created new areas for artists to explore. Web site design, computer game graphics, and online publishing are just some of the emerging media into which artists and illustrators are delving. Modern illustrators are also working in moving images—animations and motion graphics—that combine unique visual communication skills with the addition of narratives and sound. Music videos, commercials, and even short movies are also potential arenas for the digital artist. Software development in these areas is helping the digital artist to integrate motion graphics into their portfolios—the almost seamless integration of a timeline into Photoshop being one example.

Developments in digital technology—particularly in digital printing—have also allowed artists to start creating a whole array of products and artifacts that incorporate their visual styles. Print technology used to be limited to large runs in order to be cost-effective, and high-quality printing of artists' images was limited, except to those with good financial resources. Digital printing, and in particular online print services, has enabled artists to produce relatively inexpensive short runs of posters, greeting cards, and even books and magazines. This makes books, promotional materials, or even money-earning posters and products showcasing the work of digital artists increasingly affordable.

Digital printing

It is now possible to print onto or produce materials for a variety of products. The work of Valistika Studio shown here demonstrates a number of examples of contemporary contexts for digital work, indicating the versatility of digital imagery to modern products.

Screen printing or the creation of printed decals is now incredibly simple using digital images as a starting point.

So is printing onto a variety of fabrics. Online digital printers can convert your digital image into reality at a relatively low cost.

They can also provide you with materials that you can sell yourself. Artists are no longer restricted to large and expensive production runs, and can become entrepreneurs in their own right.

New avenues

The introduction to motion graphics and animation given in this book barely scratches the surface in terms of the possibilities for developing your work. Although some powerful effects can be achieved within Photoshop, animation software such as Flash or AfterEffects allows you to develop your image making even further. Most animation software integrates well with two-dimensional imagery, and can be seen more as a continuation of the processes and techniques you have already learned rather than entirely new ways of working.

This book has also touched in a limited way on 3D image making, using Illustrator's tools to create 3D effects. Although Illustrator's 3D tools are limited, the concepts are broadly the same no matter what application you're using. Many 3D applications are now available for free or are relatively inexpensive compared with a decade ago. They provide a means to create more or less whatever you can imagine, and usually integrate seamlessly with 2D software. With some 3D programs, you also have the ability to animate your objects, and even start creating games or add-ons for existing ones. Many artists have also been successful in reintegrating 3D work back into two dimensions, and the possibilities for this kind of work are limitless, if underexplored so far. Three-dimensional illustration may not be for everybody, but for those looking to push into new directions with their work, it's certainly worth a try.

The next chapter of the book will look at developing your potential career as a digital artist. As you can see from the above discussion, the possibilities for digital image making are huge and the field keeps expanding year after year. As a professional artist, however, the challenges and opportunities don't just end with creating the work, but also involve ensuring that your work is seen.

Animation in Flash can offer a simple step into the larger world of digital animation, as well as a platform for interactive technologies such as the web or mobile communication devices.

More advanced animation can be developed using After Effects or similar software packages. The ability to integrate sound, and other formats such as 3D and live action, push the possibilities even further for the digital artist.

3D software such as Blender allows you to create any object you can imagine, building entire worlds or fully poseable characters. The opportunities to integrate these back into your 2D work, or even develop games and videos from your content, means that the opportunities offered by digital technologies are virtually limitless.

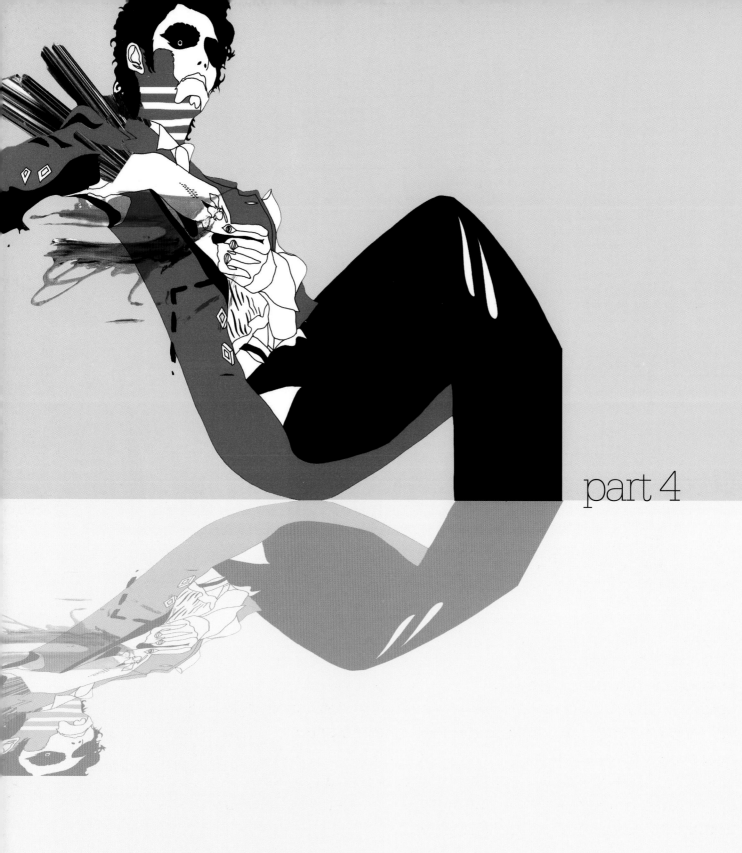

part 4

Professional practice

Developing effective skills in digital arts is only one part of being a professional artist or illustrator—the other is getting your work out into the world and getting it seen. The next section looks at some of the skills, practices, and further considerations that can help you develop this next stage of an artistic career.

You will be introduced to methods used by professional artists in presenting their work, developing a portfolio, and advice in approaching potential clients. It considers aspects of the profession such as focusing your work toward particular audiences, and the potential contexts for your style and approach to digital image making. It also considers the emerging area of authorial illustration, considering artistic practices that allow you to pursue your own interests and develop a visual language that is both unique and appealing.

81

presentation and promotion

Illustration is a fiercely competitive industry. It is a rewarding profession reliant on innovation and a constant demand for new ideas and means to communicate. The number of new artists seeking careers as illustrators will always outweigh the potential opportunities available. For an illustrator to succeed, he or she will need to identify an audience for his or her work, create demand, and learn to present work professionally.

The audience

Who is going to want to use your work? Where would you want to see it? Identifying your audience is fundamental if you want to make a career out of illustration. The key here is relevance. Think objectively about what you make and where it could be utilized. Research the marketplace, seek out contact details, and create a personal database of potential clients that suit your style.

Don't confuse your potential client with a variety of styles. Research is vital. Make sure your style is relevant to the client's concerns.

Demand

It's essential that you offer a distinctive and consistent approach that will be recognizable in a crowded visual environment. The demand for creative content is shifting from traditional print media toward new digital platforms. How does the illustrator respond to these new developments if these trends continue? By finding new means of communication and expression. In this regard, be ambitious for your practice.

Right work—right context

Be innovative when considering potential contexts for your work. Employ an entrepreneurial approach to your practice, and look beyond the traditional platforms for illustration such as book jackets and newspaper features. Potential new contexts might include exhibitions, digital applications for mobile devices, merchandise, toys, promotional material, and so on.

One of the best examples of this can be seen in the work and web site of the Peepshow illustration collective. While their web site shows off the traditional and digital imagery that constitutes their primary illustration work, they also point to more

authorial projects, experimentation in animation and exhibitions, and products available to buy. They therefore offer something for everyone, and display an innovative and playful approach to creative solutions, while still retaining their own unique styles and attitude to work.

Portfolio

How you present your work implies its value. Getting the presentation of your artwork right is a key concern for the professional artist. Your portfolio should demonstrate that you are someone who can be trusted; someone who cares how the work is displayed. The quality of finish and attention to detail here is critical.

Edit and select images carefully before inclusion. If you are lucky enough to have a large body of work from which to pick, get lots of feedback and advice from trusted friends and peers on what are the most effective images. This is not a one-off exercise—your portfolio should be under constant review.

Find the singular strengths in your work and build your portfolio around these. Remember that your portfolio does not

The web site of Mike Harrison is dominated by visuals and makes an immediate impact on the viewer. Instant access to visual content, and one-click navigation to individual images, make this a good format for digital artists seeking to make a good first impression.

The Peepshow collective make use of a simple gallery format to show off their more traditional work, which identifies and establishes them very quickly for those seeking 2D illustrative work. However, they also provide quick links to alternative forms of creative practice such as experimental work (Projects) and motion graphics (Animations) for those seeking broader creative solutions.

necessarily have to be a conventional black folder: it could be a pdf, Quicktime movie, web site, and so on. Whatever kind of portfolio you choose has to be relevant to your practice and aspirations.

The key word for any portfolio is "consistency." Clients will view the portfolio as an indication of what to expect if they commission you. They will need to be assured that, if commissioned, you will produce artwork that resembles the content of your portfolio.

Remember, you will also need to talk through the portfolio with any potential client. You will have to narrate it and explain your creative decisions. Your portfolio is the tool with which you are selling your particular service, and it provides the most direct means of getting employment as an illustrator.

Presentation etiquette

If called to present your portfolio follow these simple guidelines:
• Aim to be 10–15 minutes early.
• Let the clients turn the pages themselves.
• If the book is shown to other people, take note of who.
• Be quietly confident when discussing your work, but don't come across as arrogant.
• Look on the encounter as relationship building, not just an opportunity to get the job.
• If appropriate, ask to leave a simple sample of your artwork.

Authorial illustration

Authorial illustration has become an increasingly important area for illustrators in terms of marketing work to a wider audience, and opening up new contexts for the profession. Proactive designers/illustrators are constantly pushing and reinventing their practices by pursuing exciting self-initiated projects—their primary motivation being self-expression rather than satisfying the demands of a restrictive brief.

Authorial projects presented in the portfolio can also lead directly to client interest and big commissions. The authentic and undiluted quality of this personal work is more often preferred to previously commissioned pieces that can seem predictable or compromised in comparison.

Illustration is often accused of being decorative and safe, more aesthetically driven than conceptually sound. Authorial illustration offers the opportunity to alter this misgiving, creating a body of work that can alter attitudes and effect change.

Illustrators have the opportunity to form new visual vocabularies to satisfy our constant demand for new ideas and innovative solutions.

Illustration is a vibrant and exciting marketplace in which a creative individual can excel, generating a great reputation. With a lot of effort, your creative vision could have a positive impact on visual culture and tastes.

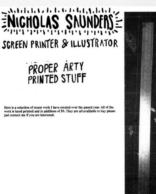

Julian de Narvaez's web site makes use of large imagery, composed of details of his illustrations. This is an effective technique for his work which relies upon rich details and engaging characters. The correct tone is struck throughout the site—an undistracting simple font is used for links, and adequate space is given throughout the site to promote the visuals. A quick link to new work allows clients to quickly locate new directions and potential uses for this style.

Nicholas Saunders' web site instantly promotes his individual style and traditional roots through the use of hand-drawn lettering—a less formal approach than employed by some other artists.

82 web sites and online presence

One key part of presenting yourself and your work to potential clients is through an online presence. Most professional artists and illustrators have their own web sites or similar form of portfolio representation that showcases their work and contact information. These range from very simple single pages to elaborate interactive sites. Below we outline a few ways that you can develop an online presence for your work and some guidelines on approaches.

As a digital artist, presenting your work to the outside world is key to moving from hobby to profession. Developing the right solution to present your work is often just as important as the work you create. The methods and formats discussed above should give some indication of the route you may wish to take and what is right for you. The numerous free services that are available are worth investigating and experimenting with to see which works best for your needs, before plunging into potentially more expensive solutions.

The traditional web site

Creating your own web site to showcase work can be a relatively simple task if you have the design skills, but can also become quite complex if your demands go beyond a basic web presence. You can build simple web pages using Photoshop or Illustrator, and even create hyperlinks between pages. In order to develop more complex sites, however, it may be necessary to use dedicated web-development software such as Dreamweaver,

Flash, or various other applications. Most web-design software works on the WYSIWYG (what you see is what you get) principle, and is therefore relatively easy to engage with. There is, however, a small learning curve in learning how these applications work, and an understanding of web languages such as HTML and CSS may help you to get the most from these applications.

The key to developing a good web site is to plan it carefully first, paying particular attention to what pages you need and how your pages link together. You should consider that a gallery of your work and contact details are an essential element, although information pages, a list of clients or professional work completed, and sections for different kinds of work may be further considerations. Use thumbnails to work out how these pages are linked and then consider how your navigation (the buttons or text that are used to link to these separate pages) will work. Keep it simple and easy for the user.

In addition to building your web site, you need to have it hosted on a server so that the world can see it. In addition, you will need a domain name (the .com bit of your web site). Both of these aspects of a web site cost money, usually a small annual fee of between $20–40 for both.

You will also need a method of deploying your web site to the server using FTP software. Some applications and web hosts provide such facilities, but you may wish to download freeware or shareware applications that can do this for you—of which there are many.

Designing your own web site gives you a great deal of control over the look and feel of your web presence, but it can be a daunting task and will require some time to learn new applications and ways of working. You could

hire a designer to create a site for you, and he or she will often take care of other aspects such as hosting. However, this could be an expensive option and best left until your professional needs allow for such expenses. You may, therefore, want to think about using some of the other tools available to help create your web presence. These are often much simpler to use and can give impressive and professional-looking results more quickly.

The designer blog

A recent trend among artists is to use weblogs to showcase their work. Sites such as Blogger, Wordpress, or Tumblr are easy to use, guide you through the creation of your blog, and come with templates that allow you to customize your content and add a professional touch almost instantly. The other advantage of using blogs as a method of showcasing your work is that they are quickly altered so that the design and look of your blog can be adapted to your changing needs or developments. More advanced features include the ability to develop your own templates and navigation features to make your site even more personal to you and your work. Furthermore, the nature of blogs means that you can alert potential clients to new work and therefore engage your audience further.

Blogs tend to follow a standard format that may not be suitable for all purposes. They are

The traditional web site is still an important promotional tool for any artist, and should not be overlooked in favor of other means of promotion. Many artists and clients prefer strong, visually led designs over wordy, text-driven content.

not always ideal for showcasing large galleries of work, and are often better at showing individual images. You may therefore need to plan how your images are presented or make use of alternative methods of delivering your work. A combination of a blog with a web site or downloadable digital portfolio may be options to consider and are popular methods for many artists.

Online magazines

A more recent development for showcasing work comes in the form of sites that allow you to produce online magazine formats—the most prominent provider of which is Issuu. Uploaded digital files are presented like a book or magazine, allowing you to showcase work as if seen in a portfolio, and include turning pages and the ability to zoom in on page details. Individual magazines are hosted on the Issuu site, although there are opportunities to host your magazine on your own web site or blog.

The simplicity of this format and professional presentation method makes this an ideal method for showing off your work. Consideration does need to be given to page design, however, and you may need to make use of additional software such as InDesign or Word in order to produce a .pdf document to upload in order to make your magazine.

A simpler method of developing this approach could be to create a .pdf portfolio of your work that is hosted and can be downloaded from your web site or weblog. While this method lacks the sophisticated presentation style outlined above, it has the benefit of being easily accessed on and offline by clients, and can be printed for further sharing.

Other presentation methods

Other methods of presenting your work include image-hosting sites such as Flickr and Picasa. Similarly, art and design communities such as deviantART allow you to present your work simply and to a broad community. These solutions may provide a quick method of getting your work out to a broader audience, and to seek comments and guidance from others. In terms of showcasing professional work, however, these methods may not be ideal and should therefore be considered a starting point only for developing your work before seeking out some of the solutions presented above.

Another consideration may be to produce video formats for showcasing your work. YouTube and Vimeo are obvious solutions for hosting a video showcase of your work, and simple videos can be produced using Photoshop or a variety of other applications.

This may be an ideal way of showcasing animated work or slideshows, although be aware that the relatively low resolution and quality of online video may not be ideal for all kinds of digital work.

Keeping the client updated

As a digital artist, your work is likely to develop quickly, and hopefully you should be creating new images quite frequently. Keeping potential and existing clients aware of these developments is key in a fast-moving and competitive environment, and therefore you should consider how a digital presence can be developed that can keep clients updated to your developing portfolio. The weblog format has been discussed as one method for updating clients. You may also wish to consider using Twitter as a method of alerting people to new work, or even using e-mail newsletters to keep a contact list updated. Similarly, a Facebook presence for your work could provide an effective solution in some cases.

Blogs offer an exciting and rewarding way of keeping potential clients and peers aware of your work. A good blog can make up for the problems inherent in constantly redesigning a web site, and allow for feedback from the broader art community on what you do. Both Blogger and Wordpress have positioned themselves as leading blog providers, and offer a quick and easy route into this area of self promotion for the digital artist.

glossary

Aesthetic Refers to a sense of beauty, or sensual aspects of a piece of artwork. Can also refer to a certain style or look of an image, e.g., an urban aesthetic is one that draws upon styles and techniques associated with urban forms of image making.

After Effects An application produced by Adobe, used for making animations and motion graphics.

AI The native Adobe Illustrator file format, which uses the .ai file extension.

Analog Refers to a value on a sliding scale rather than an incremental. Analog in this case refers to image making that is created outside of a digital environment such as a drawing or painting.

Application A self-contained computer program dedicated to a specific task or series of tasks. Examples of design applications include Photoshop, Illustrator, Paintshop Pro, and Flash.

Artboard The area in Illustrator where an image is made, the "drawing" surface.

Authorial illustration A recent emergence within illustration practice where artists set their own briefs according to their interests or areas of work they wish to explore. Authorial work can often be used as a method of developing a portfolio for more commercial work.

Blog An abbreviated version of "weblog." A popular web format used by writers, journalists, and artists. Used by many artists to promote their work.

Blogger A free online platform used to create and host blogs.

Brief A descriptive set of instructions or guidance given to an illustrator by a client. May include aspects such as elements to include, the format of the work required, and other information to help the artist fulfill a commission.

Browser A digital application used for accessing web pages. Popular browsers include Safari, Firefox, Internet Explorer, and Chrome.

Cells The individual frames of a traditional animation. Cell-based animation is best characterized by animations produced before 3D and digital animation became popular, such as the classic Disney films and Warner Brothers, etc. Still a popular, though time-consuming, method of animation.

Compositing The act of arranging visual elements when using design applications. This may include positioning and scaling of elements or their interaction through layering and blending.

Composition The arrangement and interaction of visual elements within a defined physical or digital space.

Constrain A method of linking values together—such as width and height—used in digital software in order to scale values relative to each other.

Crop The act of trimming a document or aspects of a document, to reduce its physical size. Parts of a document within a defined crop area are retained, while those outside the boundary are removed.

CSS Cascading Style Sheets. A set of design templates used to control the look and formatting of web pages.

Cursor A moveable visual representation (usually an arrow symbol) of a location within an application, used to interact with buttons or other features, usually controlled with the mouse or trackpad of your computer. The cursor icon is likely to change based upon the task or tool that is currently being undertaken or used.

DeviantArt An online community and image-sharing site for digital artists.

Dreamweaver An application made by Adobe, and used for the creation of web sites.

Export Means of converting a file from one format to another. In Illustrator, Export is often used to create pixel images from vector images. In Photoshop, Export can be used to create animation files.

Fill An area of block color, graduated color, or pattern used in digital applications. In pixel applications, Fill areas are often defined by document or pixel boundaries. In vector applications, Fills are bounded by an Objects Path.

Flash An application produced by Adobe, and used for the creation of web sites, animations, and other interactive files.

Flickr An image-hosting web site where users upload their own images and share them with others.

Freeware Software, often produced by enthusiasts or those interested in sharing their creations, that is free to download and use. Shareware can often provide alternatives to paid software solutions. For example, GIMP, an image-creation program, is considered a shareware alternative to Photoshop.

FTP File Transfer Protocol. FTP applications are used to transmit files between computers. This is a method commonly used to upload images to clients because it can handle large file sizes better than e-mail, and does not rely on physical media such as CDRs or other portable storage devices.

GIF A file format used by web sites and similar applications, and notable for its ability to produce low-fi animations. Makes use of limited color palettes to compress images. Uses the .gif extension format.

Gradient A transition in color between two or more colors. Gradients can be linear or radial.

Hard drive A piece of digital equipment used to store files. Hard drives can be internal or external. Internal drives are built into your computer and contain the operating system for your computer, plus any applications

(i.e., Photoshop) and files. External drives are portable versions for storing or backing up files.

Hardware Denotes physical computer equipment, such as the computer itself, and any peripheral device such as the monitor, speakers, scanner, printer, keyboard, mouse, etc.

Histogram A visual representation of the tonal range of an image or layer. Histograms usually use a pure white tone on the left, and pure black on the right, with tonal variations in between these two points.

HTML The file format used to make Internet pages. The acronym stands for Hypertext Markup Language.

InDesign An application made by Adobe, and used for the creation of digital documents such as books, leaflets, and similar files. It shares many functions and elements with Illustrator.

JPEG/JPG A file format used for storing image files. A common format used on the Internet and digital cameras, and also popular for sharing files. Uses the .jpg extension.

Juxtaposition The placing side-by-side of elements that creates a dialog and new meaning between them.

Key Frame/Keyframe A frame in an animation that indicates the beginning or end of a moment of transition such as movement, rotation, etc. Animation software makes use of Keyframes, linked together with Tweens, to create movement of objects or layers.

Landscape (format) The format an image of any kind takes, with specific reference to its relative width and height dimensions. An image is said to be landscape when it is wider than it is tall.

Linear Moving, or acting like a line. A linear process is one in which each step is followed one after the other without deviation.

Mac Refers to the Macintosh computer and its operating system which is called MacOS. Macintosh computers and the software made to run them are both made by Apple.

Montage A technique that makes use of multiple image elements from a variety of sources to create a single image. Often makes use of photographic sources, but may include line drawings, painting, printed materials, and digital elements.

Motion graphics A form of animation. It is possible to distinguish motion graphics from other forms of animation in that they tend to rely more on movement and transformations than the more traditionally hand-drawn, cell-based animation method.

Mouse An input device used to control the computer and many applications. Often makes use of an optical system underneath to record movement over a surface. Two buttons are normally placed on the top for control, although many additional features such as scroll wheels and extra buttons are common.

Online magazine A form of magazine or journal that is published on the Internet rather than (or as well as) in print. Can vary from simple HTML formats to more complex forms that use page-turning features and traditional page design formats.

Operating system The collection of applications, codes, frameworks, and interfaces used to run a computer. The two most common operating systems are MacOS, which is made by Apple, and Windows, which is made by Microsoft.

Orthographic A method of drawing that creates the impression of a 3D image on a 2D surface. In orthographic projection, parallel lines do not converge on one point on the horizon (a method used in perspective images) but rather remain parallel forever.

Palette An area within an application dedicated to a specific task or set of tasks. Common palettes in art and design software include the Brush Options, Navigator,

and Color Picker. The term is used interchangeably with "Window."

Path A single or series of lines or curves created using vector-based applications that define the boundaries of a shape.

PC An abbreviation of Personal Computer. While PC may refer to a variety of computer makes and models, it is often used in relation to computers that run the Windows operating system and does not therefore include MacOS-based systems or Apple computers. Any reference to PCs made in this book uses this distinction.

PDF Acronym for Portable Document Format, a file format that is effective for sharing image and text documents across formats and operating systems. Uses the .pdf extension format.

Perspective The effect created by parallel lines converging toward a single or multiple points on a real or imagined horizon.

Picasa A digital application made by Google that enables you to import, organize, and share digital photos.

Pixel A single dot containing color information (RGB). Computer programs use multiple pixels to represent images. Applications such as Photoshop manipulate the color value of pixels in order to create images.

Portfolio A presentation format for artists' work. Usually these come as plastic or leather-bound clear pages, containing a showcase of an artist's work. More recent practices involve artists creating online or digital portfolios using pdf documents or web pages.

Portrait (format) The format an image of any kind takes, with specific reference to its relative width and height dimensions. An image is said to be portrait when it is taller than it is wide.

Practice While sometimes referred to in the context of this book in relation to practicing a technique, practice may also refer to the

glossary

processes, techniques, visual language, and outputs of a digital artist in their total—a practicing artist is often therefore one who makes a living from making art, i.e., a professional artist.

Preset A set of file templates in popular formats such as Web, Print, or Screen, where dimensions, resolution, and color modes are selected appropriate to the intended output type. Preset options are available when starting new documents in many digital software applications.

Printer A device that converts computer-generated imagery into physical printed forms. Printers usually come in letter format and use either inkjet or laserjet ink systems.

PSD The native Photoshop document file format. Uses the .psd file extension.

Radial To radiate from a single point. For gradients, a radial gradient fill is one in which a color transitions from one central color outward toward another

Render In digital arts, particularly those relating to 3D or digital animation, rendering is the process by which a final animation or image file is generated by the computer.

Resolution The number of pixels fit into a physical space. High resolution means more pixels are fit within a given space.

Rotoscope A form of animation that takes live-action stills or film and draws or traces over the top to create a stylized sequence. While some versions are created by hand, digital formats have enabled this process to be sped up considerably.

Scanner A flat rectangular device used to transform physical (analog) imagery such as drawings, paintings, or photographs into digital files that can be manipulated with design applications.

Shareware Software, often downloaded from the Internet, that is free to use for a trial period. The software can then be unlocked by paying for the program after the trial period

has expired. Shareware programs may have some features disabled during the trial period.

Software Refers to any program, application, or tool that is used to run or interact with a computer and associated devices. The term is often used in conjunction with or in distinction to "hardware."

Stop motion A method of animation that uses individual frames, often captured with a still camera (as opposed to a film camera), which are then spliced together to create an animation. Traditionally used for Claymation and some live-action films, it has been adopted by artists as a method for creating animations in a variety of ways.

Stroke A visible or invisible line that is defined by a path in vector-based applications. Strokes can have varying weights or colors applied.

Template A predefined document format set up for common tasks. Templates in digital software often include web, print, and mobile device templates. More common in interactive software applications but found in most design applications.

TIFF Acronym for Tagged Image File Format. A popular file format used by designers and artists. Uses the .tif file extension.

Toolbar An area within a design application that contains a variety of tools used to interact with or add content to your image. Toolbars are often long vertical windows, containing a single or double row of buttons such as the Brush or Pen tools.

Trackpad An input method used by laptops in place of a mouse or similar input devices. Comprised of a flat, touch-sensitive pad that is controlled with the finger, it usually has buttons beneath or built in to replicate the left and right buttons on a standard mouse.

Transform A tool or option used to alter the size, scale, rotation, or other aspects of a digital object.

Tumblr A free online platform used to create and host blogs.

Tween/Tweening Refers to the frames that sit in between the key frames of an animation. Tweening is a method used in Photoshop and Flash to automatically alter the size, rotation, opacity, and other aspects of a layer or object between two key frames.

Twitter A popular message service that allows users to post comments or statements on any topic using a limited number of text characters. Used by artists to announce updates and share their views.

Vimeo A video-hosting web site that allows users to upload and share their content.

Visual Language The combination and arrangement of elements in an image that convey meaning. Think of image elements as words, with texture, tone, size indicating volume, tone of voice, and the grain and inflection.

Weight The thickness of a line or typeface. This term is often used in relation to a stroke applied to a path in vector-based applications.

Window An area within an application dedicated to a specific task or set of tasks. Common windows in art and design software include the Brush Options, Navigator, and Color Picker. The term is used interchangeably with "Palette."

Windows A term used to refer to the Windows operating system, which may include windows Vista, Windows XP, or Windows 7. Windows is produced by Microsoft.

Wordpress A free online platform used to create and host blogs.

YouTube A popular video-hosting web site that allows users to upload and share their content.

resources

Professional bodies U.S.A.

The Society of Illustrators

128 East 63rd Street (between Park and
Lexington Avenues)
New York, NY 10065
Tel: (212) 838-2560
E-Mail: info@societyillustrators.org
www.societyillustrators.org

The Society's mission is to promote the
art of illustration, to appreciate its history
and evolving nature through exhibitions,
lectures and education, and to contribute the
services of its members to the welfare of the
community at large. Founded in 1901, the
Society has had a distinguished yet lively
history as an active participant in the ever-
changing field of illustration.

Graphic Artists Guild

32 Broadway,
Suite 1114
New York, NY 10004
Tel: +1 (212) 791-3400
www.graphicartistsguild.org

The purpose of the Graphic Artists Guild is
to promote and protect the social, economic,
and professional interests of its members. The
Guild is committed to improving conditions
for all graphic artists (including, but not
limited to animators, cartoonists, designers,
illustrators, and digital artists) and to raising
standards for the entire industry. The Guild
embraces graphic artists at all skill levels.

Professional bodies U.K.

The Association of Illustrators

2nd Floor
Back Building
150 Curtain Road
London, EC2A 3AT
Tel: +44 (0)20 7613 4328
Email: info@theaoi.com
www.theaoi.com

The AOI was established in 1973 to advance
and protect illustrators' rights and encourage
professional standards. The AOI is a non-
profit-making trade association dedicated to
its members' professional interests and the
promotion of illustration.

Self-promotion U.S.A.

www.directoryofillustration.com

The *Directory of Illustration* is one of the
foremost annual source books and online
portfolio sites in the U.S.

http://playillustration.com

PlayIllustration.com showcases professional
artists and design firms with experience in
the toy and game industries. Artist skills
include illustration, 3D, modeling, animation,
storyboarding, character development,
concept art, and package design. All artist
portfolios are reviewed prior to acceptance
on the site to ensure a professional level of
talent that is applicable to the market.

Self-promotion U.K.

www.aoiimages.com

Images is one of the U.K.'s leading illustration
competitions. It is also an annual awards
show and touring exhibition dedicated to
showcasing the very best contemporary
illustration. The annual celebrates illustration
excellence, and is distributed to a specially
targeted list of international commissioners
and sold worldwide.

Images is unique in that it is Britain's only
jury-selected illustration competition. Each
entry is marked according to how well
the work fulfills the brief, originality, and
technical ability. Only the highest scoring
images are invited to feature in the annual.

www.contact-creative.com

CONTACT Illustration is one of the leading
annual source books in Europe—the
European equivalent of the U.S. *Directory of
Illustration*, but with a distinctly U.K. flavor.
As well as the printed version, this title has
also been produced as a CD and more
recently as an online digital book.

Web

www.illustrationmundo.com

Illustrationmundo is a free site for aspiring
and professional illustrators to promote
themselves.

www.etsy.com

Etsy provides a vehicle for illustrators to sell
their products directly to consumers.

Community

http://illustrationvoice.com

Ongoing blog that discusses current
illustration practice, ethics, and new
developments within the industry.

http://illustrationfriday.com

Illustration Friday is a weekly high profile
illustration challenge that also acts as an
art forum. A topic is posted every Friday and
then participants have all week to come up
with their own interpretation.

http://drawger.com

Drawger is a blog site, and individual
members manage their own areas. Drawger
sites are available by invitation only and provide
up-to-the-minute access to professional
ilustrators' most recent commissions.

https://www.3x3mag.com

3x3 is a magazine devoted entirely to the
art of contemporary illustration. It's 80-plus
pages of the best illustration has to offer. Fall/
Winter, Spring, and Summer. One of these
issues is the international annual juried
show, which includes the best illustration
in advertising, books, editorial, gallery,
unpublished, and children's books.

The Illustrator's Guide to Law and Business
by Simon Stern, published by The
Association of Illustrators.

The *Illustrator's Guide* is an invaluable
guide to the business of illustration and the
potential pitfalls of self-employment. It deals
with licensing artwork, negotiation with
clients, and copyright. Essential.

index

A

Adobe Illustrator see Illustrator
Adobe Photoshop see Photoshop
AfterEffects 23, 196, 211
AI 48
Al Madani, Saeed 17
allowing for imperfections 158–159
analog techniques 31
animation 45
 animated Gifs 197–198
 animating in Photoshop 204–207
 finalizing your animation 208–209
 rotoscoping 202–203
 saving animations 199
 stop-motion movies 200–201
Apple Mac 28
architecture 140
 architectural detail 147–149,
 150–151
Art Brush 122–123
Atay, Duncan 32
atmosphere 140, 141
authorial illustration 215

B

background 141
back lighting 143
balance 34
Belin, Stephanie 16
black-and-white halftones 177
Blender 23, 211
blending modes 59, 96–97
 overlay and lighten 60
 screen and multiply 61
blocks, building 187
Blur 172
Bricking, Jennifer 35, 168–169
Brush tools 94
 create your ideal brush 95
 custom brushes 122–125
 pixel art 184
 replicating graffiti stencils
 180–182

C

Campbell, Aaron 15
careers 213
 presentation and promotion
 214–215
 web sites 214–215, 216–217
CDs 28
characters 132
 references 133
clients 213, 214
 keeping client updated 217
color 31, 32, 33, 64
 adding color 86–87
 adding fill color 57
 adding flat color 68–69
 adjusting colors 72–73
 color halftone filter 176
 Color Range 81
 coloring halftones 178–179
 fills and gradients 108–109
 identifying and altering colors
 66–67
 image adjustments 70
 Invert 71

Live Trace 120–121
 out-of-register duotone 174–175
 selecting colors 65
Color Range 66
compositing 193
composition 31, 32
 composing objects within frame
 36–37
 picking the viewpoint 37
 principles 34–35
computers 28
 hard drive 28
 input devices 29
 output devices 29
 RAM (Random Access
 Memory) 28
 screens and monitors 28
 storage media–29
concept development 40–41
 construction 39
 editing 39
 sketching 39
contrast 34
copyright issues 43
CorelDraw 23
Corel Painter 22
Corel PaintShop 22
correcting mistakes 74–75
Curves 52, 53
cutout techniques 80–81
 cropping and cutting 82–83
 cutting out hair 90–91

D

Deligaris, Nick 18
De Narvaez, Julian 38, 64,
 100–101, 215
depth 35, 144
Descreen 51
design elements 32
designer blogs 216–217
digital art 8–9, 10–11, 21
 allowing for imperfections
 158–159
 hardware 28–29
 illustration 196
 Illustrator 26–27
 new avenues 211
 new contexts 210
 Photoshop 24–25
 software 22–23
 staring new project 46
digital cameras 29
digital graffiti 45, 190–193, 194–195
digital montage 98–99
digital printing 210
distorting objects 77
document formats 47–48
drag and drop 55
drawing tablets 29
DreamWeaver 23
duotone 174–175
DVDs 28

E

Einstein, Albert 40
Elfaki, Husain 12
Elliptical Marquee 57, 80
equipment 28–29

Essan, Ian 19
Estrada, Catalina 35, 130–131
Evans, Lucy 36, 132, 138–139
Export Window 208–209
Extrude 190

F

faking screen print 166–167
figures 132
 enhancing figure 138–139
 figure interaction 136–137
 movement 134–135
 references 133
file types 48
filters 170–171
 Blur 172
 Render filters 173
FinalCut 23
Flash 23, 48, 196, 197
 Animation 211
Flurry, Leigh 38
form 32, 33
Fuzziness 72

G

Gifs 196, 197–198
 saving animations 199
GIMP 23
Gradient tools 108–109
graffiti 45, 194–195
 replicating graffiti stencils
 180–182
 3D and digital graffiti 190–193
grain, creating 161

H

Hadley, James 37, 102
hair 90–91
halftones 176
 black-and-white halftones 177
 color halftone filter 176
 coloring halftones 178–179
handmade effect 162–163
hard drives 28
harmony 34
Harrison, Mike 15, 19, 162–163, 214
Hayes, Lyndsay 11
History panel 74
hue 59
Hue/Saturation 70
Hutchings, Luke 138

I

illustration 196
 authorial illustration 215
 careers 214–215
Illustrator 8, 23, 45
 basic shapes 103
 Brush tools 122–125
 creating document for print 48
 creating document for web 48
 creating new document 48
 layers 117
 making pattern swatches
 126–127
 Pathfinder tools 110–113
 toolbox 26–27
image libraries 42–43, 153

image-making 45, 46
 image adjustments 70
imperfections 158–159
Invert 71
iPhoto 23

J

Johnson, Matthew 154–157
JPEGs 48

L

landscape 141
laptops 28
Lardner, Joel 34, 35, 36
Lasso tools 57, 64, 80
 cropping and cutting 82–83
Layer Mask 81
layer masks 62–63
layers 56
 adding fill color 57
 blending modes 59–61
 creating transparency 58
 figure interaction 136–137
 Illustrator 117
 layering 96–97
 opacity 58
 using layers creatively 100–101
Levels 52
Lighten 60
lighting 142
 back lighting 143
 lighting different materials 143
 solid objects 142
 surface textures 143
line 32
 line styles 107
 line weights 106
lino 164–165
Live Trace 118–119
 color settings 120–121
location 141
logo 112–113

M

Magic Wand tool 57, 72, 80
 adding color 86–87
 selecting elements 84–85
Magnetic Lasso 57, 80
mapping artwork 192
Marquee tools 64, 80
 cropping and cutting 82–83
Maya 23
mirror duplication 78–79
mistakes 74–75
 allowing for imperfections
 158–159
montage 98–99
mood 140
 changing mood 141
movement 35, 134–135
Muir, Martin 33
Multiply 61
Murto, Perttu 13, 14, 33

O

online magazines 217
online presence 216–217

Opacity 58
orthographic pixel art 186
out-of-register duotone 174–175
overlapping 96–97
Overlay 60

P

Paint Bucket 86
Painter 22
PaintShop Photo Pro 22
Pathfinder tools 110
 making logo 112–113
 recreating complex shapes and
objects 111
paths 105
Patrick, Ruth 179
pattern 35, 130–131
 making pattern swatches
 126–127
 making patterned image 128–129
 Pattern Brush 124
Peepshow 214
Pen tool 104
Pencil tools 94
 pixel art 184
perspective 31, 145–146
photographs 133
 montage 98–99
 photographing materials 152
Photoshop 8, 22, 45, 46
 animating in Photoshop 204–207
 creating document for print 47
 creating document for web 47
 creating new document 47
 drag and drop 55
 Export Window 208–209
 History panel 74
 Layers palette 56
 refining edges 85, 92–93
 selecting appropriate color
 mode 47
 setting up Photoshop for pixel
 art 184
 toolbox 24–25
 Transform 76–79
Photoshop Elements 22
Picasa 23
pixel art 45, 184
 building blocks 187
 orthographic pixel art 186
 2D pixel art 185
PNG 48
Polygonal Lasso 57, 80, 82–83
 editing a scan 54
portfolios 213, 214–215
practice 210
Premiere 23
presentation 214–215
 presentation etiquette 215
printers 29
print formats 48
Proctor, Robert 37, 143
professional practice 213
promotion 214–215
PSD 48

Q

Quick Mask 57, 81
Quick Selection tool 80, 88–8

R

RAM (Random Access Memory) 28
Rectangular Marquee 57, 80, 82–83
references 42–43
 character development 133
 copyright issues 43
 importing references 116
 reference libraries 42–43, 153
 sourcing images 43
Refine Edge 84
 Refine Edge dialog box 85
refining edges 85, 92–93
Render filters 173
Replace Color 66, 72
retro styles 168–169
Revolve 191
rotating objects 77
rotoscoping 202–203
roughs 38
 sketching and editing 39

S

saturation 59
Saunders, Nicholas 13, 16, 32, 34,
 150–151, 215
scale 45
 changing scale 141
 rescaling objects 76
scanners 29, 49, 51
scanning
 drawings 49–50
 editing scan 54
 importing sketches and
 references 116
 refining with Curves 53
 refining with Levels 52
 unfamiliar objects 51
Scatter Brush 124
Screen 61
screen formats 48
screen print 166–167
selecting 84–85
 selecting colors 65
shape 32, 33
 basic shapes 103
 complex shapes and objects 111
sketches 38
 editing 39
 importing sketches 116
 sketching 39
software 22–23
space 31
spatter effects 183
stop-motion movies 200–201
storage media 28–29
Studio Max 23
stylistic techniques 160
 creating texture and grain 161
 faking screen print 166–167
 filters 170–173
 halftones and offsets 176–179
 handmade effect 162–163
 lino and woodcut 164–165
 out-of-register duotone 174–175
 retro styles 168–169

T

texture 32, 33
 building an image 154–157
 creating texture and grain 161
 photographing materials 152
 surface textures 143
3D 190
 compositing 193
 Extrude 190
 mapping artwork 192
 Revolve 191
TIFF 48
Tolerance 72, 84
tone 32, 33
traditional materials 29
Transform 76
 distorting and rotating objects 77
 mirror duplication 78–79
 rescaling objects 76
transparency 58
Trim 199
tweening 204
2D pixel art 185

U

urban art 188–189
USB flash drives 28–29

V

Valistika Studio 18, 33, 114–115, 210
vector art 45, 102, 114–115
 basic shapes 103
 fills and gradients 108–109
 line weights and styles 106–107
 Live Trace 118–121
 making pattern swatches
 126–127
 making patterned image 128–129
 Pathfinder tools 110–113
 pen tool 104
 pros of vector art 102
 refining paths 105
 vector-based urban art 188–189
viewpoint 37

W

Warhol, Andy 166
web sites 216, 214–215
 designer blog 216–217
 image-hosting 217
 keeping client updated 217
 online magazines 217
 traditional web sites 216
White, Benjamin 33, 34, 194–195
Windows 28
woodcut 164–165

Z

Zoom tool 54

acknowledgments

Quarto would like to thank the following artists for kindly supplying images for inclusion in this book:

Aaron Campbell www.ectsy-arts.com p.15t
Benjamin White http://nvlnvl.co/ p.33bl, p.34b, p.194–195
Catalina Estrada http://catalinaestrada.com p.35br, p.130–131
Dunya Atay www.behance.net/dunyaatay p.32c
Husam Elfaki www.husamelfaki.net p.12b
Ian Essom www.ianessom.com p.19b
James Hadley p.37, p.102.
Jennifer Bricking http://jen.carbonmade.com p.35t, p.168–169
Julian De Narvaez www.juliandenarvaez.com p.38bl, p.100–101, p.215bl
Leigh Flurry www.mrflurry.net p.38br
Lucy Evans http://lucy-e.com p.36b, p.138–139
Lyndsey Hayes http://lyndseyh.redbubble.comp.11
Martin Muir p.33br
Matthew Johnson p.154–157
Mike Harrison http://destill.net p.15b, p.19t, p.162–163, p.214bl
Nicholas Saunders www.nicholassaunders.co.uk p.12t, p.16b, p.32t, p.34cr, p.150–151, p.215br
Nick Deligaris www.deligaris.com p.18t
Perttu Murto http://perttumurto.com p.13, p.14, p.33tr
Photography Kevin Perry p.52
Ruth Patrick p.179tr
Saeed Al Madini www.Qa9ed.com p.17b
Stephanie Belin www.stephanebelin.com p.16–17t
The Peepshow www.peepshow.org.uk p.214br
Valiska Studio http://valistika.com p.19b, p.33tl, p.196b, p.210

All other images are the copyright of Quarto Publishing plc. While every effort has been made to credit contributors, Quarto would like to apologize should there have been any omissions or errors—and would be pleased to make the appropriate correction for future editions of the book.